A Weymouth Childhood
in the 1950s

About the Author

Although born in Enfield, north London, the author grew up in Weymouth after his family moved there in 1945. The family left Weymouth and moved to Berkshire in 1959. With an ambition to be a drummer, he commenced to play with many bands, playing jazz together with the emerging Blues and heavy Rock and Blues as the various genres emerged.

He played alongside the names of Kenny Ball, Acker Bilk and the Temperance Seven in the early sixties, played the Blues with Mike Cooper and the Blues Committee, where they shared the stage with Yardbirds, Rod Stuart, Graham Bond, John Mayle with visiting American blues singer, John Lee Hooker, Jimmy Reed, Howling Wolf and many more. He was drummer to Billy Davis, with her hit single 'Tell Him'. As the music scene changed, his bands shared the stage with the Walker Brothers, The Animals and The Who. He was a one-time member of the Famous Cure, which became Hawkwind. His career took him on a number of tours here and abroad. After the frustrations of the music industry's prejudiced contractual abyss, a change of career, but still playing semi-pro, led to various senior positions in industry, which included the aircraft and the commercial lighting industries. Finally, he enjoyed early retirement after running his own company. He lives in West Berkshire with his wife, where family life is enjoyed with his children and four grandsons. He is still playing the drums after more than fifty years of 'tub-thumping'. He is writing his memoirs of life as a drummer, entitled *How's My Drumming?* under his drumming name of Eddie Page.

A Weymouth Childhood
in the 1950s

EDWARD PAGE

AMBERLEY

For Alexander, William, Jude and Sacha. 'I was young once, boys.'

1

First published 2010

Amberley Publishing Plc
Cirencester Road, Chalford,
Stroud, Gloucestershire, GL6 8PE

www.amberley-books.com

Copyright © Edward Page, 2010

The right of Edward Page to be identified as the Author
of this work has been asserted in accordance with the
Copyrights, Designs and Patents Act 1988.

British Library Cataloguing in Publication Data.
A catalogue record for this book is available from the British Library.

ISBN 978 1 84868 878 0

Typesetting and Origination by FONTHILLDESIGN.
Printed in Great Britain.

Contents

Researching some of the history of both the town of Weymouth and its environs, I found some facts and figures as well as some interesting information about my family that I was completely ignorant of as a child, one of which was the fact that I had no idea that our favourite uncle went to prison during the war as a conscientious objector, or that my grandmother's uncle on my mother's side, Charles Morton, was the greatest and biggest music hall owner in London. Plus I learnt about all the local history of the town I grew up in, including why Chapelhay, one of our best play areas, was so badly bombed during the war despite having no strategic purpose at all.

Like all things where questions are asked, one only finds a fraction of the truth and fact in the answers, although a lot can be gained from the smallest of detail. The start of this book is about very narrowly missing death as a six-year-old and being saved from a watery grave, but not knowing who by, and later not only finding out who this mystery saviour was, but the fascinating background this person and family had. Without that person, I would be unable to have done all the very many and various things in my life, including having four grandsons, Alexander, William, Jude and Sacha, to whom this account is dedicated, along with, of course, the brave man who saved my life so many years ago.

Prologue

We sat at the restaurant sipping our wine, chatting whilst waiting for our order. The four of us had driven a long way for this lunch, and for three of us, this was to be a very special lunch; my sister Pat, brother Frank and myself accompanied by my dear wife were dining high above the tranquil harbour view.

The restaurant had been our family home during the austerity period of the 1940s and 1950s, moving in a month after war ended. A large family home we all loved. Like all families, we had our ups and downs living there during this difficult after-war period, but like all strong families, we took the rough with the smooth, helped each other as we grew up and grew a little older in this wonderful, old seaside town.

'This was one of the visitors bedrooms,' I heard Frank say.

'Yes, I think painted in dark-cream-coloured distemper and stippled in panels of pink distemper. Very tasty at the time I think, it must have been a delightful guesthouse,' I replied.

'Yes, all that work Dad had to do to make the place look good,' one of us remarked.

As we enjoyed the restaurant's cuisine, many memories for the three of us came flooding back as if it were yesterday. Pat, my sister, remembered the many breakfasts she had served to the holidaymakers here, Frank remembered the many exciting Christmases we both woke up to, and I quietly remembered a misfortune with a happy ending, an unforgettable event, but said nothing, just smiling and happy at being there listening to my siblings chatter with me, answering a few questions from my wife.

The restaurant was at 19 Trinity Road, located by the harbour in the picturesque seaside town of Weymouth, a town we all moved to over sixty years ago. My brother and I had a wonderful place to grow up in during our formative years, our first real home after war-torn London.

As we grew older, we explored many areas (some without permission) of land and seascape, as far as small boys could venture in those innocent, halcyon days of growing up in the late 1940s and early 1950s, in a place where the sunshine never seemed to hide, where we all felt safe.

Here are some of those memories I would like to share with you, and I hope you can still find the hidden gems, areas we used to venture far afield

to and in safety. Most are still there, but most have changed a little as time and tide moves on.

But to start those long-remembered memories here, I tell of that unfortunate incident I was reminded of as we sat and lunched in our old happy home.

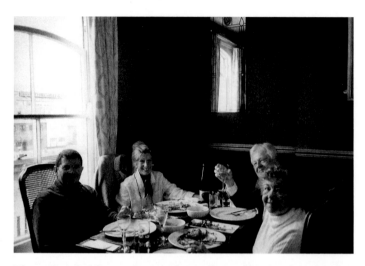

The author (holding a glass) with members of his family at lunch at 'Som Pee Air' (2001).

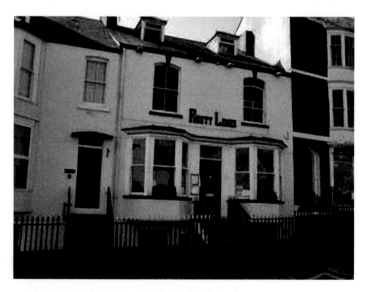

19 Trinity Road today as a restaurant/pub.

chapter one

A Ducking and a Dive in

'Tis conker season and home from school, but the inviting water is dark and deathly cool.

On the day that I nearly drowned, the summer season had closed after many busy weeks of tourists visiting Dorset's scenic coastlines. The splashing paddlers that had delighted the many visitors had been moored for their coming winter's hibernation along the harbour jetties. The town was quiet now that the last of the holiday visitors had departed for home, refreshed after a summertime break enjoying the sands, sea and the elegant paddle steamers at Weymouth. Around the harbour, the sunny days of summer had been transformed into the changed colours of a cool, coastal autumn.

In the harbour, I lay in the cool water looking up and facing the quayside. My mind was empty and I had no thoughts, none of any kind, as to how or even why I was there. A seemingly short while passed, maybe seconds, minutes, or perhaps longer, I don't know. My attention was drawn to a young woman who I recognised walking by on the unpaved road that bordered the quayside. 'That's my Sunday school teacher,' I began to think as my young mind vaguely adjusted to the beginnings of the equally vague reality returning to me and to where I was. Looking at her, I could see she gave just a momentary glance in my direction, then she stopped, quite still, comprehending what her eyes were now seeing; then the sudden bursting realisation that what she was seeing was real caused her reactive signals to generate an impulsive waving of arms and running around on the same spot. Although my slow transition to an unknown void was without sound, I could see she was shouting in an urgent and panicking way ...

I wasn't really sure how I had fallen in the water. I had come out of the Victorian school entrance as usual, expecting my mum to be waiting for me and my younger brother Frank, who had just started school for this new autumn term. Frank, unlike me, had quickly settled into this routine business of learning to read and write. Although at first unsettling for me when I had arrived at the school a year before in 1947, I was now an old hand and knew the ropes at St Mary's Infant School, which stood near the centre of Weymouth Town.

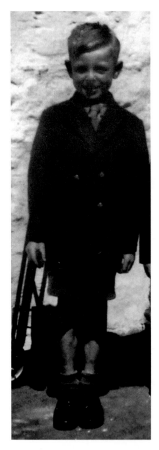
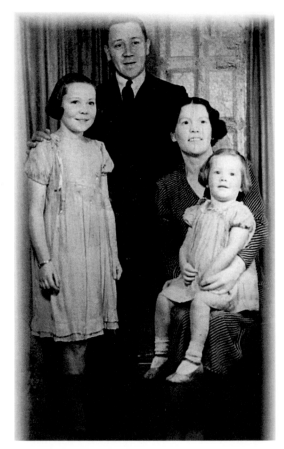

Above left: The author as a six-year-old schoolboy, 1948.

Above right: The author's parents and sisters.

As I waited for Mum, I was happy, thinking about the new game – new for me, anyway – of hitting the fruit of the horse chestnut tree threaded with string, called 'conkers', which I had played with the other boys during the morning break. But, after a while, I became puzzled, as there was no sign of Mum. Had she forgotten me and just collected my brother? Frank was not waiting there either.

Whilst waiting and still looking up and down the busy lane, I could hear music playing. I had heard this music playing before but was not sure what it was or even where it was coming from. The sound, I soon discovered, became louder as I walked the short distance away from the school entrance to the other side of the narrow School Lane that formed a short cut from the busy main St Thomas Street to Commercial Road. Walking over to a large door that was slightly ajar, I opened the door a little more and could see musicians on a stage playing what was now, with the door more open, much

louder music. Later, I learnt that this was a dance-band music rehearsal for the Gaumont cinema's adjacent dance hall. As a six-year-old, I became immediately entranced by these men blowing shining brass instruments, which I later learnt were called trumpets and saxophones, and a man behind a drum set making some great noises left me wide-eyed. After a short while of listening, a passing stranger also came over to listen to the band playing, and in so doing, he prised the door open a little more, so when the band stopped playing, somebody inside the ballroom came over and pulled the door hard with a bang. So, with the band music now gone, I continued to look and feel more anxious for Mum and wonder what could have happened to her.

After waiting a little while longer, I suspected that I had now missed her, so I started to make my own way home, alone. Walking past the Salvation Army Hostel in School Street and turning right at Whittles the florist shop into the busy St Thomas's Street, I walked past people, cars and shops, heading over the Town Bridge and was in sight of home, which was No. 19 Trinity Road, Weymouth, a large Victorian terraced house overlooking the Town Bridge and harbour. As a family, we called the house St Pierre, which we pronounced as 'Som Pee Air', so this was the way in which we affectionately referred to the house. My family, including my parents and my two older sisters, had lived in 'Som Pee Air' since 1945, just a few months after that horrible war had ended.

At home, I found the green, painted door with its polished, brass knob locked. I tried reaching up to the big, black knocker, but it was just out of reach for a six-year-old. I looked around, uncertain what to do next.[1]

For a while, I banged my small hand on the firmly shut green door, but as I became aware that Mum and my brother had not come home yet, I wandered off in search of goodness knows what and to where, but an attraction soon presented itself. Moored up for the winter at Trinity Quay and not returning for pleasure steaming until next year was one of our paddle steamer friends, PS *Empress*. For a small boy looking at the paddle steamers, with their big, splashing paddles and puffing steam and smoke, it had always been love at first sight. This now-hibernating, majestic ship was moored to Trinity Quay's small jetty just a few hundred yards from our house. PS *Empress* had been very busy that season, steaming to Lulworth Cove, the Shambles Lightship or Britain's large and grand fleet of naval warships moored in Portland Harbour. All for the delight of the many summer visitors who had left the city smoke for the fresh air, sea and Dorset's scenery. The clear, still water of the harbour was reflecting a perfect mirror image of the ship with its huge paddle wheels and was, without doubt, a magnetic attraction for any child, especially this in-love six-year-old.

I watched the water ripple as the reflection of the ship moved gently to and fro because of a limp-hanging rope partially dangling in the water from the paddle steamer to the small jetty. Standing on the jetty, I must have decided to

climb down to the bottom of the quay's jetty steps and hit the water with my new, large, shiny conker that I had received in the post from my Uncle Fred. This conker, I thought to myself, will make the ship's reflection ripple a little bit more if I stretch down and dangle the string and then hit the water with it; splash, splash, splash, and the big paddle wheel's reflection would ripple in the water; then SPLASH, I was in the water, the tide was out and the bottom of the steps had exposed the treacherous, slippery, green seaweed.

How or why did this young, faithful Sunday school teacher appear there on the quayside? Pedestrians walking over the Town Bridge who need to turn left into Trinity Road habitually cross over the road to the long pavement on the other side near the houses; the short pavement they have just left ends after a hundred metres or so, making walking any further along the unpaved harbour quayside insecure, as your back is to the oncoming traffic and the quayside water's edge is unguarded, but on that day, someone, by chance, who happened to be my Sunday school teacher decided to walk all along the unguarded harbour side. Was her presence luck, fate, or, as she was my Sunday school teacher, had she been given some divine guidance to be there? Was it just, as I suspect, a coincidence? But there she was … 'Miss Cuddly', shouting and waving for help.

Although this roly-poly, jolly Sunday school teacher with a big handbag probably didn't do rescue dives, her actions had caused a large crowd to gather quickly and look on in interest or perhaps concern at my plight. I could feel large hooks on rods brandished by people both on the unguarded quayside and from the side of the paddle steamer trying to pull at me without success. The paddle steamer was not occupied; however, someone knew where to find these long poles with large grappling hooks on them. I don't remember feeling cold from the very cool October's slightly salty sea and river harbour, nor do I remember feeling frightened; instead I felt relaxed and peaceful. My clothes had become heavy with the water and I could feel my blazer, new for school that term, going for good to the harbour's bottom as it gently slid off my arm. I was now drifting towards and under the paddles of the motionless paddle steamer, salty water was now in my mouth as I disappeared under the cold, dark water, unaware, unconscious, and now seemingly gone.

With sudden and now sickening consciousness, I found myself awake and lying on the quayside being very sick, shaking and now feeling very frightened and very miserable. Standing up, I could see my home and to this safe haven I ran as fast as I could. If someone had decided to take me home, I was not going to wait for them. I ran quickly and passed Hayman's fishing tackle and chandler's shop, then the Frying Pan fish and chip shop with its frying smells drifting along the pavement, and then passed the Kings Arms Pub. Somehow Mum, brother, and sister were there. They had crossed over the Town Bridge driven by concern for my whereabouts and had seen the large crowd that had gathered a short distance away. Mum exclaiming in horror: 'That's Ed!'

At home, I was given a hot bath filled with the gurgling water from the explosive and temperamental bathroom geyser. I stepped in and added more of my wretched, empty stomach into my warm bath, then headed for bed and to a deep sleep. Awake in the morning and none the worse for that horrid dream of yesterday, it was, minus new blazer, back to school.

So who was this good and brave Samaritan who made that rescue? Mum tried to show me the next day's local newspaper, the *Dorset Daily Echo*, which had confirmed that my horrid dream was real and had been reported. I just ran away from the newspaper and hid; it was never read. I could not make up my six-year-old mind if I should be ashamed, told off for being naughty, or accept the kindness I was being shown for a thing that was or was not my fault. What I was told later by Mum and Dad was that this man who rescued me was a sailor who could not swim and that he came back to the house sometime later in the evening to see if I was all right. Dad had offered him a week's stay at our house, our new guesthouse, at any time he cared to visit the town. Had I, as a six-year-old, not been so ashamed and read the newspaper, which I could have done, I would have known who this sailor was, although would I have remembered his name?

Some fifty years or more later, I was determined to find out the name of my rescuer. I needed a finishing chapter to a long-remembered bad dream. All kinds of questions crossed my mind. How near to a submerged grave had I been? Why had none of the many locals who had gathered to watch my plight made no attempt to save a six-year-old but allowed a stranger to make this rescue? Would this hero still be alive? How old would he be now? What would be his reaction if I did make contact? Where could I begin my search?

Whilst my search for my unknown hero might take a little time, I cast my thoughts back to the days of living and growing up in Weymouth where shortages for all things was normal. Looking back to those halcyon days of growing up, it seemed an existence full of charmed innocence.

chapter two

'Tired, Broke and Busted'

Judiciary spoke and we all acquiesced, our clothes were worn and over rationed food we obsessed.

'Tired, Broke and Busted' Floyd Dixon would gloomily sing that song, and that was also how Great Britain was at the end of the Second World War in 1945. That costly, devastating war was followed by a period of acute austerity. The tiara was still in place and the ball gown ready to wear, but the caviar and the champagne would be long absent from the table. Great Britain had won her war with Germany, Italy and Japan but lost her empire, her wealth, but not her crown. Standing alone to face a tyrannical foe, Britain had bankrupted herself to defend her most intangible, expensive and valuable raisons d'être, her Freedom and Democracy. So with the war now over, the pulling together that helped all in that hour of need was also now needed to rebuild the country from so much destruction. Britain did not suffer from the tyranny of minorities then. The first, next, and last, whether short or tall, male or female, you and they were all part of the majority, which resulted in little conflict with only simple, pedestrian crime to distract and contend with. If King, Church or the judiciary spoke, we all took notice and accepted its dictum, or at worst, we would acquiesce. All the ingredients were there for a perfect new recipe to now build that perfect new Great Britain out of her austerity; a new blank canvas was ready to paint and all with the coming help of Mr Atlee and his large Labour majority at the polls. For this grand plan, we would have 'a brave new world'. Of course, this was dependent on our cousins from over the pond lending us the 'dosh', with Mr Bevan going cap in hand with a rather large begging bowl in tow.

Growing up in this austere period was just normal for my brother and me. When you are born to the new and fresh adventure of life, you know of no other period to make a comparison with, so although material things were in short supply, we didn't miss what we had never possessed. That 'never never land' of 'before the war' did not exist to us; 'this is it, you have just left a new starting line', not that we were capable of being that profound at the tender ages of five or six years old. So from 1945 until about 1955, this was just a time of normal growing up, even a bar of

chocolate was a rare, once-a-month treat. We had no idea what corporate life or its comforts would be like; in fact, most people go through life without experiencing wealth and never feel deprived. For Mum and Dad though, the good times 'had since rolled' and the hated ration books were here to stay. 'Make do and mend.' 'It will do for another day.' 'Do you know how many coupons that cost?' Those words of conversation were the routine of many households that had to overcome the practical problems of shortages.

Owners of country properties were able to live off the land right through the war, and of course, if you had the money, the town and city folk could live well, even if it meant eating out at the restaurants, although shortages of the exotic affected all. A description in one of G. B. Stern's many books involves a naval officer being the proud possessor of a lemon; he and friends decide the best use for this precious, unobtainable citrus delight was to go to the Ritz and eat oysters, and as they had the money, they were prepared to pay 'lemonage'.

The country made the brave decision to host the 1948 Olympic Games in London, an added expense on top of the birth of the costly National Health Service, both of which it could ill afford given the dire straits of the economy; perhaps things don't change. This sporting moral booster was to try to show the world that Great Britain was climbing back on top and out of its busted state; an event as grand as a large village fête by comparison to future world Olympic Games. This shows the extraordinary disparity between today and the forties and fifties.

A good example of this is how large supermarkets with their storage and refrigeration capabilities have transformed our attitude towards food. Whereas we have offers of 'buy one get one free' today (which means often, by the time you are ready to eat, the 'one free' is past its sell by date and is thrown away), in the forties and the fifties, food products had no sell by date; if the food didn't move by itself, it was good enough to eat; if it did move, it was jokingly classed as a 'movable feast.' Homemade jam, mostly blackberry picked in the early autumn, might have a thick film of mould on top when the jar was opened, so thick sometimes we would mockingly groom the mould first, but really it was no problem and we were happy to just scrape it off and eat the rest. No one died or became ill with mouldy-headed jam. Most children had aversions to a particular food type, be it Brussels sprout or cabbage; we, in fact, seemed to be averse to the grey-coloured roast beef. We could never develop the right chewing technique, due to childish impatience, I suppose, but the multi-coloured mottled lino flooring in the dining room would camouflage the surreptitiously dropped, half-chewed rubber roast beef on the floor. The fifties was the boom time for tinned food, when many people never bothered with fresh food anymore: it was in the tin. The handicap of this tinned (and other

preserved) food was that consumption of sugar increased by 400 per cent. We were entering a gastronomic wasteland.

Then there was the opposite of yesterday's weak and expensive consumer supply: 'three for the price of two', '50 per cent off marked prices', 'we can't store any more!' There was often a chalkboard sign used in this austerity-period shop communication system, which would warn the customer rather than invite them in. 'Queue this side for horse meat', 'Butter due in next week', or 'One banana per customer.' A 'Slimmer of the Week' contest would have been a cruel joke. It seems now that the more food we *waste*, the more our *waist's* grow and that's with a third of the food bought never passing our lips.

The weekly menu for us would typically comprise of roast beef on Sunday followed on Monday with the roast beef served cold with bubble and squeak made from Sunday's leftover vegetables. Monday's leftovers would be minced and made into rissoles for Tuesday. Wednesday would be soup made from the bone of the Sunday roast and, to give interest, it would be served with bread cut up to make 'ducks' floating on the 'pond-flavoured' soup. Thursday would be cabbage, carrots, potatoes with maybe some spam, and on Friday we would be given fish with a parsley sauce and mashed potatoes. Saturday was the highlight of the week, with sausages and mash with gravy. The deserts, or 'afters' as they were known, were typically prunes, rhubarb, apple pie or shortbread. All these dishes suffered from a tidal surge of overflowing Bird's custard, which became its main ingredient, perhaps for good reason; even so, it has given me a dislike for custard ever since. No meal was complete without being served with a cup of tea and bread and butter mixed with margarine. Butter for the taste and margarine for volume, known to us as the foodie female, Marg Butt.

Today, of course, is very different, as many people have ballooned with the easy access to food. Slimming courses are everywhere, and you could say that they suffer from the Catch 22 syndrome and are in danger of cancellation, as the applicants can't get through the now narrowing doors. The good times have re-rolled since the age of reticence, moving into an age of display, where the anatomy has had a great time expanding and showing itself off, with huge bellies and chafing thighs as a result of the easily accessible, sought-after comforts obtained from the cathedral-sized, belly-filling edifices where the world and his wife now give thanks with a shopping trolley; a new calling where repentance falls into place after the waistbands refuse to join up. 'Mum, why have you bought ten Christmas puddings?' 'Well, there was a special offer so, as there will be ten of us for Christmas, we can have one each.'

Booking a flight today can be met with a smiling but cynical comment to the passenger from the check-in desk: 'I am afraid that you will have to

buy an extra ticket, the seats are only so wide and your frame will need two seats.'

'What?' the passenger would utter from its three-chinned face.

'Well, look on the bright side, you will get two in-flight meals.'

This was not a conversation one could imagine having fifty or more years on from the forties and fifties. The world population then hovered around 2.9 billion and the food supply chain was still struggling after the Second World War shortages. Who would have predicted that, by the end of the next fifty years, from the late fifties to today, world population would rise to nearly 6.6 billion, with a prediction of world population to be 9.0 billion in 2050, and that tiny Great Britain would be sinking under the population weight of 61 million by 2009?

But back then when 'Dame Austerity' ruled Great Britain in 1945, all of today's (albeit hollow) prosperity was very far away. War had just ended and we, now considered an innocent age, were at the start of a new beginning in Weymouth town, Dorset – England's 'Bay of Naples'.

chapter three

Moving In

The gem was not hidden, but to some eyes unseen, would we wake up to that promised good dream.

Mum would have caught her first sight of the house as she and Dad crossed over the Town Bridge. It would have been a welcome sight after arriving from that grubby, long train journey from war-torn London to Weymouth Station with her four children in tow, which included my two older sisters who were old enough to walk, talk and sulk in equal quantities. The walk to our new home was taken along the Esplanade with its sea and sands, where all the family made their first venture onto Weymouth's beautiful sandy shoreline, although visitors still had to share it with the barbed wire and concrete tank traps. It had been a year ago that the free world had held its breath as the Allies took off for the French beaches. A year on, this now-local stretch of fine sands was waiting for the defences to be cleared since an invasion had thankfully never come.

I can imagine the mixed anticipation that Mum and Dad must have had on that June day in 1945. Mum would have been excited about a new start after the war, concerned that she was so far from her roots, but looking forward to her new life living by the sea. She may have believed that living by the sea would be a utopia; after all, people go to the seaside for a holiday, to refresh themselves, to enjoy the clean, fresh air away from the smoggy air of London, and maybe to meet some new friends, but most importantly, this would have been seen as a safe place for the children to grow up in. Dad would have been nervous about how his wife would react to the new home that only he had previously seen. Our new home was not a new house; 'Som Pee Air' at No. 19 Trinity Road was quite old. Although the house had a Victorian look to it, some parts must have been older as the rear of the house was constructed of whitewashed rough stone, no doubt from a previous smaller property, which would have been part of the town in its early construction.[2] This prime-position land would, in the past, have had a building of some sort constructed on it, as it would have been very convenient for the activities of a busy harbour, the lifeblood of the town.

As soon as the front door was opened, or as Dad would have noticed, fell off its hinges, we were inside our new home in Weymouth. I remember

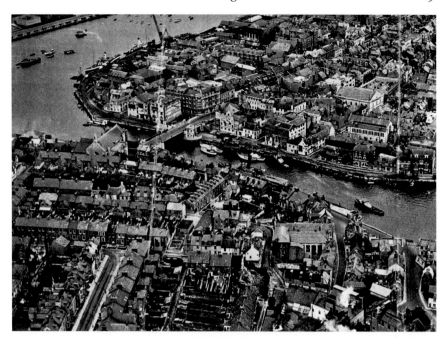

As a family, this is the area scene we would have seen arriving in 1945. It is also the aerial view of what the German bombers would have seen as they arrived to bomb the bridge and harbour, but missed and hit Chapelhay instead.

being let off from a securing hand at long last and running excitedly straight into and up to the very overgrown, tiered garden at the back of the house, and running through the head-height, long weeds where I cut my leg badly on some old, hidden, rusty wire. That must have been a good start, having a three year old yelling his head off with blood pouring from his leg; just what was needed after that long, tiring journey on a clapped-out train. Still, it must have taken Mum's mind off the 'condition' of No. 19, with Dad welcoming my painful distraction I would suspect. But what would have been Mum's first thoughts? All those months had now passed since Dad suggested the move, selling our existing nearly new house at 88 Woodstock Crescent, Enfield, a little suburb called Ponders End, or Ponders Plonk as some of the locals say. We had lived in a thirties new property that dad had bought with a deposit from winnings on the football pools in 1936. The move had meant taking my two sisters out of school and work; Peggy was an eight-year-old schoolgirl and my sister Pat was in her first job at a local office. They had had to pack and move furniture; the latter, designed for a three-bedroom semi, was now to settle in a seven-bedroom Victorian town house.

It must have been an exciting time for Mum, but the wrench of saying her good-byes must have been hard, as she left her mother behind (my Dad had left his mother behind too).

But now she was about to see her new home for the first time, because this was a property that she had never seen before, not even in a photograph or a sketch. All the information had been provided by Dad's glowing description. They were moving so that they could open a guesthouse and also so that they could have a fresh start after the awful times in war-torn London and the short stays in evacuation places together with Dad away so much on war work. Mum must have wondered what it would be like to run a guesthouse, taking care of the visitors at the seaside. Did she feel apprehensive about coping with a house full of strangers all living under the same roof? Did she wonder whether they would be drunk or sober and end up in each other's unlocked bedrooms? In any case, this would be a venture where previous experience would be in short supply. Did Mum want to be a seaside hotelier cooking hundreds of breakfasts each week? Or Dad – did he want to be a maître d'?

But 1945 was a new beginning, and there we all were looking at our new home. At the time, I was three years old, and it would not have been the first time that I had travelled so far from London. London had been subjected to Hitler's Vergeltungswaffen with the arrival of the Doodlebugs and V11 rockets a year earlier; Hitler's last throw of the dice to bring our country into submission. So it was evacuation time again and back to Gloucester with Mum and my two sisters, this time with two babes in arms – Frank and myself.

This evacuation in July 1944 was named Operation Rivulet by the Government; even as a three-year-old, I knew and vaguely remember this threatening menace, but not of the travel or the cramped and begrimed accommodation with 'Aunt Ruth' in Gloucester.

Our new home of 'Som Pee Air' at 19 Trinity Road was close to the Town Bridge and Trinity church as well as the harbour with its views reaching out to the distant sea. The family consisted of Mum and Dad (Marion and Ernest) and sisters, Pat, also known as Patti, and Peggy, myself, and my brother Frank. It is worth mentioning here that as our surname began with a 'P' (Page), Mum had wanted to name all her children with a 'P' first name, therefore making us all 'PP's, but why, I'm not sure, because surely any mail delivered to us addressed to P. Page would probably be opened by the first 'P. Page' to pick up the letters from the front door mat; what fun that would have been. My brother and I could have browsed through the new ladies' undergarment catalogue whilst my sisters could have enjoyed the new catalogue range of Dinky Toys and Hornby train set signalling systems. This plan was quickly changed, as the third newcomer, myself, was, after some lengthy discussion, finally considered to be a boy and the name of Primrose, which Mum had had ready, was not used. Shame, I would have grown up to be the toughest boy in the neighbourhood. Then my brother came along and his future 'P' name can't be put into print; even for a girl, it was interesting.

Joining us soon after moving in was my other widowed grandmother, Rose Willatt; Gran lived with us at 'Som Pee Air' for a short time. Like us, she was living in London during the war, and when war ended, she also came down to Weymouth and lived in our draughty attic for a while, until the many stairs took its toll on legs and lungs. She found a place of her own at Lansdown Square, off Wyke Road, which was only just a ten-minute walk to 'Som Pee Air'; a walk that would take her through the bomb-damaged Chapelhay. So she came from bomb-damaged London to the most bomb-damaged part of West Dorset. Gran had been a widow since 1936, when her husband Frank, the other granddad that Frank and I never knew, died in Reading of rheumatic fever. He was fifty-eight and died on 11 August, which happened to have been the same birth date as his wife Rose, our Gran. Granddad was a soldier in the First World War and was a corporal in the Royal Engineers. He was one of the older conscripts and must have joined up at about the age of thirty-six, such was the desperate need for men at the time. I can't imagine the thoughts he must have had, now mature, married with three children, able to understand the huge loss of life of the British army on the Western front and then told he must join the army and accept the risk of dying quickly, which he nearly did, as his troop was gassed and many did die.

But what of Weymouth itself? Dad may have had a general idea of what the place was like, as he had been working nearby at Portland during the war. Mum may have visited the library and researched information about the town and its environs, but they would have really learnt about their new home town as time passed.

Weymouth, on the south coast of Dorset, is an area located, as the name suggests, at the mouth of the River Wey, which is south of the town centre. The River Wey begins its journey at a general point near Portesham, in the Abbotsbury area, and gently winds its way down hills until reaching and running through the picturesque village of Upwey, famous for its wishing well, then, with a little hesitation, it continues meandering into Radipole with its lakes and then into the inner harbour at Weymouth known as 'The Backwater.' The area now known wholly as Weymouth was, in the fifteenth and sixteenth century, a very divided place as a result of the physical separation of the two sides of the River Wey. By this very separation, each side developed its own ideas, customs and social behaviour. The north side of the Wey, with its town, quay and its sandy shore and bay, was named Melcombe, with its royal tail of Regis, added later. The other side, of course named Weymouth, had its own little town, suburban streets and quay. The 'sands' and Weymouth bay were to be proclaimed, in later years, 'England's Bay of Naples', due to the wonderful sandy beach curving around a bright-blue, sparkling sea. One wonders

what the real Bay of Naples must be like in the middle of January, even those well-to-do travellers on the European 'Grand Tour' would have only witnessed a gentle Italian climate change, rather than the 'flaming June' to 'freezing January' of Dorset.

The separation of the two areas, Weymouth and Melcombe Regis, was kept lively by much animosity between them, with each running its own separate shipping enterprises. Weymouth was very much involved in the shipping for the wool trade, with Melcombe Regis involved in importing fine wines from France. Now, it would take very little thought to work out that if one side is sending out and the other side is bringing in, then revenues are piling up in Weymouth and revenues are depleting in Melcombe Regis, assuming they drank many of those fine wines. Now, in spite of the exasperation between the two sides, each must have had a necessity to trade with each other.

'We in Melcombe Regis own the farms, but we need to export our wool to pay for our fine wines.'

Likewise in Weymouth: 'There's nothing like a good wine to wash down an excellent dinner.' Middlemen by day and middlemen by night would have been very busy shipping the wool out and shipping the wines home.

Later, 'our middleman has had a message from the other side's middleman about doing a bit of co-operation in putting down the Froggies and this damned 100 years war.'

'Irksome, but a good idea. When it's all over, of course, it's back to the status quo; can't have their primitive ways bringing ours down to their level,' and so on.

Parliament was now getting a little frustrated by this damaging squabble and an Act of Parliament in 1571 instructed them by decree to agree with each other. Thus the two sides became renamed, but not, understandably, without a lot of heated discussion that probably dragged on for weeks and was, no doubt, only resolved after an all-night sitting whilst consuming some of those fine wines. It was probably the cleaning lady, who, as she was clearing up the many empty wine bottles from another all-night sitting, could not help listening, who suggested, after momentarily removing a mouth-clenched clay tobacco pipe from her whiskery chin, that they, the delegation, call it, 'The Borough of Weymouth and Melcombe Regis'. She was ignored, of course, the assembled discordant saying nothing but each attempting to hold one eye open and to concentrate on looking at each other; so, after much shovelling up of the many remaining empty wine bottles, she went home.

The representatives from Weymouth and Melcombe Regis listened for the door to click shut as the assiduous cleaning lady finally shuffled out of this no man's land on a wet and windy night for home, to go to an equally inanimate male gathering waiting impatiently for their food to be cooked

and served. With all bleary eyes now trying to focus on the equal bleary-eyed chairman, who stood in a propped position and suggested that a 'man' from both sides make a dual suggestion for a name.

'What about calling it,' they croaked in unison, 'The Borough of Weymouth and Melcombe Regis.'

'Well that might work; good suggestion, men. I knew we would get there in the end.'

'All agreed?'

All were now wearily nodding and prodding the comatose to also hold up their empty wine goblets.

'Good, ah, how about a little wine to celebrate?'

The confirmed unification of Weymouth and Melcombe Regis took place in the same year as the Act of Parliament in 1571, which was granted by Elizabeth I, although the Melcombe Regis side of the harbour still remained for many years as the 'Port of Melcombe Regis' or as 'Melcombe Quay' or 'Key.' Much later, in 1974, the next Queen Elizabeth revoked the charter when the new borough of Weymouth and Portland was created. This agreement allowed the first Town Bridge to be built in 1597, and was to replace the ferry of the Tudor period that operated to and from the Weymouth side, which was pulled back and forth by a rope: 'the fery-bote they use no ores'. The bridge was of a wooden construction with seventeen arches, a drawbridge and a swing bridge with a cost of £20,000. Whilst unrecorded, it is assumed that the 1597 bridge would have had chronological accretions, each slightly changing its original construction design, giving the effect of new bridges being built. In 1824, a new bridge was built in its place and this was demolished in 1928, with the current bridge, a lifting bascule bridge, being built and opened in 1930. This is the same bridge on which Frank got his head stuck fast in the balustrade, which required the fire brigade to be called to release him. He could not have been the only little boy or girl to get their head stuck in this bridge, as it provided a tempting seagull's eye view through its narrow balustrade to the harbour below.

Little squabbles[3], such as the Civil War, caused heated combat between Weymouth and Melcombe Regis to be revived seventy years later. It must have been confusing who was on each side; nevertheless, the parliamentarians attacked from the Weymouth side and the Melcombe Regis supporters of Charles I from their side. This no doubt led to the drawbridge being left closed until the situation was resolved by acute commercial necessity: 'the cellar's dry m'lord.'

Whilst at junior school, we were taught about the general details of the Civil War and we were told that the cannonball lodged in the side of a Tudor house in Maiden Street was the result of a skirmish during the Civil War. Now, this building in the fifties was a public convenience

(and still is, a listed piece of Weymouth's history that the powers that be deem to be worthy of a public lavatory) and we imagined that anybody attending a call of nature would have been quite disturbed by the sound of a cannonball hitting the outside wall and would have wondered what on earth their digestive system was up to – not that we described it as elegantly as that. That's the result of the lack of a longer history lesson. There is an unconfirmed tale that argues that this cannonball is made of wood, as it would be too dangerous to keep a heavy iron ball held aloft for so long. Well, the height at which this cannonball is held is such that, even if it were made of wood, it falling on your head would still cause 'eternal rest'.

Weymouth today is still predominantly a seaside town that nestles on the south coast of England, with a population now of some 52,000 people. Frequented by past royalty and the well-to-do all wanting to take the 'air and sea', Weymouth has, over time, reinvented itself. An example of this is present in the Backwater or inner harbour, now remodelled into a marina with its moored 'gin palaces'. Lost also is the backdrop of the illustrious gasworks. Yes, a smelling and smoky coke-fired gasworks and a marina would seem odd bedfellows. Many properties that had views of this backwater area must have renamed their houses, with the name of 'Marina View' now supplanting its original endearing name 'Rusty Old Ship Repairer's View' or, for the more avant-garde and snobbish, 'Gasworks View'.

Weymouth still has the original ingredients of a place you must visit. It has a wonderful sandy shore, the 'sands', extending coastlines, lush countryside and quaint villages. Weymouth, however, is a name that conjures up the 1950s ingredients of 'the sands, ice-cream, a paddle and pubs', of which past London holidaymakers partook in droves. Now, if one wants to go more up-market into the new Millennium, the town's fathers could have reverted to the 'posher' name of Melcombe Regis, with its royal connotation (yes, I hear the yawn), where those same ingredients would be marketed as 'activity beach', 'arctic extravaganzas', 'walking the salt' and 'gastro experiences.' But why complicate life? To me its the sands, ice-cream, a paddle and, of course, the pubs.

To us boys, growing up in Weymouth, Weymouth always seemed to be said and heard as 'Weymuff'. I think maybe this was due to a lot of influence from London visitors with their lazy pronunciation – the 'innit' or 'dunno' tribes – whereas Melcombe Regis, once you have raised your superciliousness, would always come over as 'Melcombe Regis', with its proper pronunciation from the 'don't you think?' or 'I don't know' people. Then, on the other hand, to anybody male who went to Melcombe Regis Boys' School, as Frank and I did, 'Weymuff' seems the best name. It has to be said that this boys' school may also have educated the town's

fathers. The school, with its history and its buildings, has sadly gone, as has its discipline-observing, acerbic headmaster, Mr 'middle pointy finger' Brown.

As a place to grow up in, Weymouth was an almost magnetic place for a child. I use the word magnetic because of the huge variety of places that we were attracted to and where we were able to explore, play, or just mess about; yes, that's the thing about being young – messing about has always been a crafted occupation. Why walk a mile in a straight line when you can take five miles all over the place? Weymouth had, which, of course, we took for granted, everything: sea, sands, surf, scenes, sunshine, spray, snoozing, ships, seagulls, sailors, show night, skating, swimming, swans, singing, sitting, standing, swings, see-saws, steaming, swearing, and for us boys, school, with smacking for smirking, to name but a few of the activities to entertain and amuse using just the 's' words, although I'm not sure which activity the 'sailors' fit with, perhaps 'swigging'. It was, to quote Horace Walpole in 1754, not that records state old Horace came to the seaside town, 'serendipity on wheels'. Well, the 'wheels' are my addition; I needed a poetic addition to complement old Horace's brilliant word, which he in turn, of course, nicked from Ceylon (Sri Lanka). The consequence of Serendipity is sometimes a brilliant discovery; Weymouth is never sometimes, it's always.

So a magnetic place it was, and the more we got to know Weymouth's wider area of Dorset, or 'Darrset', as the real natives living in the outlying settlements would say, the richer the folklore became. Dorset is rich in its myths and legendary spoken accents, from the self-imposed isolation of Portland, with its panic horror of anybody uttering the word 'rabbits', the furthest southerly tip of Dorset, to the uncharted northern hinterland. I use hinterland because, once we were able to explore Dorset, we realised that other recognised forms of life did exist, and if you can get a 'rustic' into conversation, with lots of arrrs and more arrrs and some shouting and fist shaking, it will usually translate into a rich accent. For example, if you chance upon a rustic gathering, their warm greeting 'e baint be one of we' will mean a stranger has come amongst us.

Dorset's hinterland and dialogue is best summed up by the extract of Kate and Richard from the agrestic poem 'The Farmer's Boy' by Robert Bloomfield, which must be read with the 'Darrset' burr, straw in your mouth, a pint in your hand, of course, man's best friend sitting at your feet and, if you are lucky, you will also have your dog sitting with her.

'Come, Goody, stop your humdrum wheel,
Sweep up your orts, and get your hat;
Old joys reviv'd once more I feel
'Tis fair day; – ay, and more than that.' [...]

She straight slipp'd off the Wall and Band,
And laid aside her Lucks and Twitches:
And to the Hutch she reach'd her hand,
And gave him out his Sunday Breeches.

His Mattock he behind the door,
And hedging-gloves again replac'd;
And look'd across the yellow Moor,
And urg'd his tott'ring Spouse to haste. [...]

Now friendly nods and smiles had they,
From many a kind Fair-going face:
And many a pinch KATE gave away,
While RICHARD kept his usual pace.

At length arriv'd amidst the throng,
Grandchildren bawling hem'd them round,
And dragged them by the skirts along
Where gingerbread bestrew'd the ground.

For Thomas Hardy's Wessex, Weymouth was renamed 'Budmouth' in three
of his novels, with most other places also given assumed names, as his
stories plotted fact into fiction. Some of his place names are less fun than
the real names, as some of Dorset's places are real gems. Hardy's Oxwell,
for instance, has the real name of Poxwell, and some of Hardy's names are
as confusing as the real name: Nuzzlebury has the real name of Hazelbury
Bryan. Then there are the Piddles. Piddletrenthide, Piddlehinton, and the
Puddles, Puddletown, Affpuddle, Turnerspuddle, Briantspuddle and, of
course, Tolpuddle of the martyrs' plight, which Hardy gave the not-so-
memorable name of Tolchurch.

*So with Piddles and Puddles, Barmouths and Poxwells, Hardy's infusion
of naming confusion is wrought from linking and inking his story's
illusion.*

Hardy did live, although briefly, in Weymouth at Wooperton Street, a few
hundred yards from the sands where he enjoyed a swim. His rented house
lay only a hundred yards or so from our old school, Melcombe Regis Boys'
School. All that time at that school and none of us knew that he lived so
close to our seat of learning. We could have had trips to view the outside
of this small edifice. 'If you look at the upstairs window, boys,' we look
in hushed silence and awe, 'you can see through the opaque glass in its
aluminium frame a partially used bottle of Fairy washing up liquid.'[4]

After a long day sweating over the drawing board working on Trinity Road's new 'Weymouth' church, I imagine T. H., now in a fetching, striped one-piece bathing costume, riding up under his chin and stretching down to his toes, clambering out of a bathing machine and into the water. This sea-entering decorous costume probably should have been named the 'drowning suit', as the weight of water it held when wet was reckoned to more weigh the swimmer down in the water than allow them to swim or even float. Although, as modesty and decorum was the prerequisite of the day, the public's view was 'never mind if you drown, Tom; don't let anybody see those naked elbows.'

Thomas Hardy was a great writer, if a little depressing at times, and is still read all over the world. He is a great influence for Dorset as well as his country. The question I ask myself is: will his writing be as evergreen as, say, Shakespeare in the many years to come? Perhaps, like Shakespeare, Hardy will be revived and revered in the coming two or three centuries, global warming and high tides permitting.

Weymouth always attracted more visitors than the other 'Wessex' resorts such as Lyme Regis, West Bay or Poole and Swanage, although Lyme Regis had the 'Jet Set' or the 'OK magazine celebs' of the day, no doubt, hurrying down to the south coast to be amused by the local traditions and lore.

The ancient records of Lyme Regis afford some interesting reading and reveal much that is instructive concerning life there in its early days before the 'celebs' arrived in their numbers. In 1595, the mayor, a Mr Ellesdon, would administer punishment to those caught carrying out a misdemeanour, the records state.

Four yards of canvas to make a coat to whip the rogues in (3s).
Making the same (6d).
Whipping of three of the ship boys for stealing of Mr. Hassards salmon fish in the Cobb (1s).

The charge of fourpence for whipping a boy appears to have been the standard rate of payment, but the flogging of a woman, especially if she was a native to the area, was deemed worthy of a higher remuneration. Yes, I imagine it would, as the records show:

1625. For whipping William Wynter's boy (4d).
[For whipping] Agnes Abbott twice (2s 4d).
1644. Paid two soldiers to attend the whipping of a woman, payment to attend the whipping (2s 6d).
Paid to whipping four women (4s).

So the more women the mayor had to whip, the more he got paid, but why he needed a coat made of four yards of canvas I am not sure. A bespoke canvas whipping coat, with matching hat and whip perhaps.

Lyme Regis had the imperishable links with Mary Mitford, poet, playwright and also known for her sketches of rural life. Jane Austen, Daniel Defoe, poets Wordsworth and his sister Dot, Crowe as well as 'Fuller the Jester', as he was known. Thomas Fuller, the English church historian, was known not only for his witty and humorous style, but also for his profound quotations, such as, 'If we are bound to forgive an enemy, we are not bound to trust him.' In other words, shake his hand but keep that club hidden behind your back ready to knock the bugger out; also, Thomas Fuller noted, 'A hog in armour is still a hog.' This was a reference to poor and ill-dressed elderly people dressing themselves up in expensive clothes, i.e., armour to make themselves appear above their station, or as we say today, mutton dressed as lamb, now with the added lipstick. Like today's celebs, who partake in sniffing and smoking the 'funny stuff', these past visitors had their odd moments, such as when William Wordsworth borrowed a horse from Racedown Lodge, where he and his sister stayed briefly. Wordsworth had borrowed the horse to ride to Lyme Regis but walked back having forgotten that he had borrowed it, which was not unusual, as Wordsworth much enjoyed walking and animated thought. Now, you would have imagined that the horse journey riding out to Lyme had taken no time at all, but the journey back would take ages. This alone might have set him thinking: 'Getting there, no time at all; but the return time seems to take, well, a lot longer.' With his head in the clouds in elevated composition in verse or prose, he may not have noticed.

On his return, Dorothy probably said to him, in her genteel way: 'Oh! poor you, did that naughty horse hide when the inn shut?'

Wordsworth, looking puzzled, probably thought to himself: 'Hmm, a horse? Yes, of course. Some back steps I will take, and untie that nag from the gate.'

'Just nipping back to the inn, dear; remembered I have left something there.'

Perhaps he later wrote:

I wandered lonely to Racedown Lodge,
Many drinks at Lyme I could not dodge,
My homeward walk was such a task,
Perhaps a lift I could presume to ask,
Then me thinks a horse I knew is sitting and doth bask.

The combined towns of Weymouth and Melcombe Regis had some well-known parliamentary figures in the past to represent them. Sir Christopher

Wren was one, although very briefly in 1702; another was Joseph Hume. Hume made his money from the East India Company, amassing a fortune of £40,000 and spending £10,000 with the help of the Duke of Cumberland in 1812 to buy his seat in Parliament. Joseph Hume was by all accounts a good parliamentarian and made it his business to be a public watchdog. He would drag the debate on to well into the night sustaining himself by eating a steady supply of pears, which I suppose made him just a seasonal debater. £10,000 to be the MP for Weymouth and Melcombe Regis would have been a huge amount of money in 1812, as it is worth about £340,000 in today's money (2009). I suppose that could never happen now, as, no matter what wealth you may have, only the ballot box will give you a seat, although nearly half a million pounds would certainly buy the candidate an awful lot of advertising, which could today be claimed back on expenses.

In 1584, Sir Francis Bacon was also the MP for Melcombe, Dorset (this was before the Regis bit was added), although in 1621 he fell from grace for being in debt and was also charged with corruption and fined £40,000. The fine was cancelled by King James. James sent Bacon to the Tower of London from where he wrote to the King begging for mercy. As he contemplated his fate and hoped to be released, he concluded that 'hope is a good breakfast but a bad supper'. The King released him after a few days. In other words, he took the rap for King James's misdeeds, but £40,000 in 1621 would be worth £3,840,000 today, which is a lot of money to repay. All the more difficult when in debt.

The celebrated Bubb Doddington, the son of a Weymouth apothecary, was also an MP and he was the first Lord Melcombe when, in 1761, he was raised to the peerage as Baron Melcombe of Melcombe Regis. Bubb Doddington was a Franciscan, a member of the Hellfire Club. which met at the ruined Cistercian abbey in High Wycombe, Buckinghamshire.

By far the most popular MP was Sir Henry Edwards, a do-gooder on a grand scale. A statue to Sir Henry Edwards stands at the corner of Alexandra Gardens. His statue is one that I must have walked past a thousand times, but I never paid much attention to it as no history lesson included him and, as Weymouth never had a museum, we had little opportunity to gain knowledge about him, which considering his standing in the community, seems somewhat lacking. He was also known as linseed Edwards, after the way he made his money. Sir Henry was good enough to provide homes for the elderly as well as to fund an annual dinner for the old people in the town. Furthermore, he built and furnished the working men's club in Mitchell Street and funded the workings for Queen Victoria's Jubilee Clock when money from public subscriptions ran out. As MP from 1867 to 1885, he declined the Freedom of the Borough, so instead, the townsfolk paid tribute to him by having this solitary statue erected and paid for by some deep-pocket-digging public subscriptions.

The conservative MP whom I most remember was Hinchcliff who represented the constituency during the fifties. His slogan was 'Vote for Hinch to fill the Pinch', a slogan that reflected the tight money squeeze of the early fifties.

Already living in Godmanstone, Dorset, was my uncle Fred and his partner John, of whom more is written later. So, continuing the political issue, one story I remember as amusing, although rather black comedy, was that Uncle Fred and John, as political agitators, would turn up as Labour supporters to local Conservative political meetings held in town halls, village halls, etc., and heckle the local bigwig or MP. At one time, both Uncle Fred and John were sitting listening to the speech and John became incensed at the 'unfair and unjust' proclamations being made, so he quickly stood up to shout his objection and, to his horror, the man next to him dropped down dead from a heart attack. I can imagine a draughty village hall in some remote backwood village in Dorset on a cold winter's evening, men in overcoats or raincoats wearing trilby hats, some ladies, who may have been allowed out for a few hours, would be present, but most people would be smoking, coughing, clearing throats, picking their nose, nodding off or just scratching their bums listening to the party windbag making pre-war pronouncements on how everything was wrong with the Labour government of the day or yesterday. All a little bit bored and thinking about the log fire in the pub and some warm beer afterwards, and then there is this outburst, like a sudden bolt of thunder crashing through the roof, the poor gentleman probably miles away in thought, is hit with this outburst and his ticker packs up, bang dead! John vowed never to attend another political meeting again.

'The charm of history and its enigmatic lesson consist in the fact that, from age to age, nothing changes and yet everything is completely different.' (Aldous Huxley) Which is very true of Weymouth.

chapter four

'Som Pee Air'

We didn't despair; the rooms need repair. Some paint and a scrub and it's fit for a lord mayor.

No. 19 Trinity Road had had six war years of military personnel billeted there creating much wear and tear, coupled with little or no maintenance being carried out during its occupation. Every internal door had been used to hang the obligatory dartboard for the bored conscripts to idle and target their time away. Dad told me that the internal doors had so many holes in them that a large hole, as big as the dartboard could be obtained if you gently pushed the centre of the door. Those doors that were already completely holed were covered with crudely nailed cardboard. Having these large holes in the doors, of course, would have been helpful to the sergeant major, who could stick his head into the now-holed door to the room with the sleeping soldiers and 'request that the chaps might like to attend breakfast', which, of course, is a useful asset but not its intended design. How many military personnel would have slept in each room and were they all in bunk beds? Were they crammed in as tightly as possible? If there were that many men, how on earth would they have organised the lavatory arrangements with just two separate WCs? Did they have a rota? Probably. 'You half go on odd days and you lot go on even days.' Or perhaps they had the use of Mk III 'gozunders'. No wonder the garden needed much work to neutralise the soil before Dad could get anything to grow; that's the failure of rotas.

Being only a three-year-old, I would not have been aware of the subtle and sulky comments that must have passed between Mum, Dad and my two sisters. I and my younger brother Frank, who was still in arms, were too young to appreciate the 'excitement' they must have all felt as they all stood there in awe of No. 19 Trinity Road; awe at the magnitude of the repair work required, amazement at the size of the house and its many rooms. Still, when you are at a point of no return, one can only look forward to the challenge. On the bright side, they were fairly young with Dad aged thirty-nine and Mum aged thirty-eight. As they examined their new home, Dad promised to work all hours to bring it up to pristine condition with all the mod cons.

No. 19 Trinity Road was purchased for the pricey sum of £500.00; I suppose not a bad price for such a roomy house. Dad had heard that this house would be for sale whilst working at the naval dockyard at Portland during the war. Looking through some of Dad's old documents after he died, we found a receipt for £5.00 as the 1 per cent deposit on the house (this was a large document with a postage stamp affixed and two signatures from the selling agents, all for the receipt of £5.00). The balance of the purchase price by a mortgage with the Halifax Building Society, 'Can we manage to pay back that £495.00 back dear, we have only thirty years to do so?' A whole fourteen-roomed house purchased for a cost similar to a quite modest month's shopping today.

Our house was to be converted into a guesthouse (well, I don't think it was a guesthouse before the military occupied it, unless one includes a load of reluctant conscripts); so, after much work, repairing replacing and renovating, it then became a guesthouse. Repairing and renovating a large property from 1945 onwards would have meant problems in obtaining the materials to complete such a task. Wallpaper was not obtainable. You could find paint for a battleship, yes, so distemper, with its delicate and comprehensive range of colours, cream, brown, pale green and pale pink, was the dynamic forerunner to emulsion paint and was the only order of the day. The task of bringing the house up to a good standard required stripping of the old wallpaper after finding multiple layers in each room. It was no over statement that after the removal of many sheets of old wallpaper in one particular room, it allowed for a double bed to be used instead of a single bed. Remembered is a pattern of wallpaper in one of the rooms that consisted of a design of red parrots, which we all found appealing, but it was stripped and replaced with Dad's all-distempered internal walls. First he would paint the walls with a pale-cream colour, then he would draw rectangular bands of panels on the now-plain distempered walls, distemper the rectangular bands in brown, then 'stipple', or dab, with a sponge other various colours of distemper within these panels to create a mottled effect.

The doors, made of pine, were converted to simulated oak, which was achieved, after the woodwork was repaired, by using a base coat of cream paint applied to the whole door, and when dry, a top coat was applied to the cream base with brown paint, then with the brown paint still wet, he would brush it with a wire comb to obtain a wood grain effect then with rag-covered finger replicate the larger grains of oak on the combed brown top coat, a process known as 'scumbling' – a delightful, short word to describe a lengthy process. This was one of the many old and innovative ideas Dad used in lieu of new materials, so the colour scheme order of the day was cream, brown, pale green, and pale pink. The dining rooms were finished halfway up the walls with an 'easily scrubbed and washed' covering

called 'Lincrusta'. It was as ghastly as its name. This innovative austerity decorating experience was known as DIY, 'Drab Interior Yardage'.

With doors and windows attended to, the whole house, back and front, was given a new and fresher-looking coat of paint. The final crowning detail was the naming and the fixing of the nameplate by the front door. The house name was resurrected by Mum and Dad as St Pierre (St Peter), or, as Londoners and locals pronounced it, 'Som Pee Air', when given the French accent emphasis. We would then mimic this in the Dorset accents in which we heard passers-by mutter its name. I think the recent past occupants had a connection, nautically or geographically with the Channel Islands with its French influence; either way, St Pierre is the patron saint of fishermen, although the way we spelt it represents what fishermen do when no one is looking. Dad made the name sign from part of an old wardrobe front; well, I don't imagine many shops had a stock of signs that read 'St Pierre', not in Weymouth anyway; perhaps Melcombe Regis. Maybe some of Weymouth's ready-made signs could be bought, reading 'Men and Dogs Only' or 'Scrubbed Women Only Considered by Appointment', but these would have given out a heterogeneous message for future visitors, and we didn't want to be seen as too posh at 'Som Pee Air'!

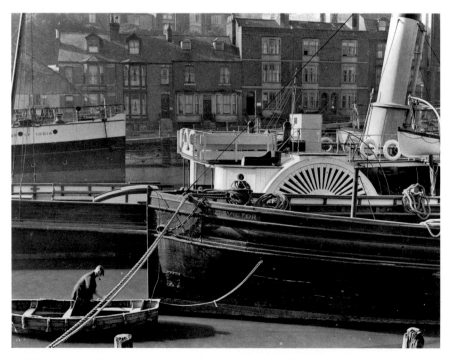

Paddle Steamer *Albert Victor*. In the background is 19 Trinity Road on a spring day in the 1920s.

Crossing the Town Bridge after the walk from Weymouth's 1857 Brunel-designed railway station, which has now sadly been demolished and replaced with an off-the-shelf flat-pack job, No. 19 Trinity Road would have come into view. Mum and Dad would be able to see that the size and shape of the property was similar to all of the buildings in Trinity Road, which were of the large terrace type, all built to reflect the Victorian style, which they still mostly retain, with front entrance, or as with ours and the houses near the Town Bridge, two front entrances, one at ground level and the other entrance level with the road. All the houses had various quantities of harbour-facing windows and were completed with slated roofs.

No. 19, now 'Som Pee Air', had two grand sash bay windows that would give a view of both directions of Trinity Road, excellent for gossip behind the forever-twitching curtains. These rooms would be for sitting and for reception occasions. Central to these two windows was the front door, which was accessed by a set of five steps from the pavement, all of which was surrounded by green painted railings on each side mounted onto a low wall. Above these two windows were two more sash windows, flush with the walls, and these were the two front bedroom windows. Above these were two dormer windows set into the roof for the attic rooms. To complete the front of the house were two sash windows at basement level, known to us as the dungeon[5], where the cook, servant or housemaid would work – sounds like the job description for my Mum. All the front-facing sash windows would rattle at once when a strong wind blew in from the sea, making them sound like the milkman's float returning to the depot over a rough road with a load of empty milk bottles in their wire storing trays. Dad fixed them all, much reducing the need for all of us to shout at each other or write notes on windy days. The back of the house had six sash windows but no dormer windows in the roof, the attic had a one way aspect, north over the harbour and town. Inside, the basement, or dungeon, there were four rooms, which had low ceilings. These were the kitchen, dining room, sitting room and the sea-green, seascape-mural bathroom, which had water heated by a califont gas heater. This gave a loud bang every time it was lit for a bath, so only the very brave were clean and wore their campaign medals with pride.

All these dungeon rooms were divided by a narrow central hallway and stairs leading to the first floor or, if one continued through the narrow hallway, this would lead to the back yard and the tiered gardens. We called the basement rooms 'the dungeon' as it always seemed very dark and musty, even on a bright summer's day, but as we got familiar with the dungeon's layout, we were able to feel our way around quite easily with a sort of blind man's buff daily ritual.

The entrance to the lower pavement level was known as 'the canal' as heavy rain sometimes flooded this low passageway. Dad kept a purpose-

made board at hand to fit behind the already high doorstep in case of a flash flood. He did consider adding a lifebelt and distress flares to hang in the hallway but this was not thought necessary, as he knew we could all swim away from the upper entrance door. The dungeon's front door would have been the tradesmen's entrance as well as the entrance for the maid or housekeeper. Coal, dustbins, and provisions would all have been humped through that door, and certain bodily contents not worth keeping, before main drainage was installed, would be despatched into a certain moving water of a certain nearby harbour to join other certain floating contents all waiting for a certain outgoing tide to whisk them away to land on a certain sandy shore.

Moving up the stairs from the dungeon, you would reach the long hallway to the sitting and reception rooms. There were, in effect, four rooms. The back room and the front room to one side of the house had a double folding door that separated the two rooms with both rooms having large fireplaces. We never used the two rooms as one. This option of opening up the two rooms would have been used by past occupants to entertain visitors and would have been large enough to accommodate the Victorian ladies' voluminous dresses and hats, no skimpy tee shirt and faded denims then, just well-tailored and considered style, a style, of course, lost, as most clothes now need to have weak elasticity built into them.

At the back of these two rooms lay two bedrooms, one of which my brother and I slept in in the winter. The high ceilings were designed to accommodate large wardrobes so that small boys could make inspection jumps from the top of the wardrobes on to the beds below to test that the springs were in good working order. We always knew they were substandard by the sore bottom Dad gave us for our helpful efforts. We also needed a room with a big fireplace, as we were told that some overweight, bearded gentleman wearing a red outfit and bearing gifts might sneak into our bedroom round about late December. He was never caught.

The folding doors between the back room and the front room always remained closed and locked. The front half of the double room was the sitting room, complete with piano, three-piece suite, marble fireplace, with a looking glass over the mantelpiece and rugs on a linoleum floor. The upper 'posh' entrance was where Frank and I used to play at 'posh' visitors and loopy servants, one of us knocking on the door and the other letting them in whilst bowing. Knock, knock, open door, bow, then close door, run downstairs, out the dungeon door up the wall steps to the outside pavement leading to the 'posh' door, knock, knock. 'All those toys to play with and I keep thinking there's a policeman outside – stop it,' Mum would say. Whenever there was a knock on the door, either the downstairs door or the upper front door, Mum would always say to us that it sounded like

a policeman's knock. What was she expecting? The knocking probably sounded so loud because 'Som Pee Air' was a large house in comparison to the house in London, and any knocking on doors would resonate much louder, but of course it may have been to remind us that naughty boys always had a policeman calling on them.

With the four bedrooms on the second floor, which were accessed from the hallway on the first floor, there were some stairs, which we named the 'slide' due to its alternative method of descent – a long banister – and at the top of the stairs was a landing. This had standing room for about six or seven ghosts who would congregate as night fell. This landing then led to the austere attic, which was two very large rooms each having a dormer window overlooking the harbour. In the summertime, this was a pleasant place to sleep, but on some occasions, Frank and I had to sleep in this sparse attic in the winter. We were probably being very disruptive and had been consigned to the attic until hostilities had abated. The ceiling of the attic had a thin plaster covering over the rafters under the roof slates, and it was always freezing. Of course, there was no central heating then, just a boarded-up fireplace to stop the draught blowing in. Frank and I would, when it was so cold, get into bed without undressing with our pyjamas already between the sheets. Our plan was that, as soon as the bed and pyjamas had warmed up by our body heat, we would dart out of bed, quickly undress, and quickly put on our pyjamas, which were now warm, and leap back into a now warm bed. Needless to say, one or both of us dropped off to sleep before we could race into this exercise; therefore, when waking up in the morning, we were, on the plus side, already conveniently dressed, although on the minus side, one or two small, crumpled tramps would emerge for breakfast.

'Have you two been sleeping in your school clothes again?'

'Eh no, Mum, we forgot to fold them up.'

'They need ironing,' Mum would murmur, although she never made any move to do so. I suppose two boys lying on the ironing board would interrupt the flow of breakfast too much.

The attic is where the maid or housekeeper would have slept. A Miss Susan Valance was a maid recorded in the 1901 Census. The owner of the house from about 1871 to about 1891 was Caroline Handcock who owned some lodging houses. She had two recorded servants listed over the years, one was Anne Frampton and the other was Annie Sergeant, both in their teens. Winter or summer, the attic rooms would have been either freezing or too hot. I would think the servant girls were better organised than us boys and would have used a warming pan or a bit of hi-tech gear called a hot water bottle to warm the bed, or perhaps they would have been allowed to have a fire if they had the strength to haul the coal up five sets of stairs but then there was the possibility of having the coal scuttle

upset by the lurking ghosts as these overworked young girls passed by them on the landing.

The house had a back yard accessed from the basement hallway. Along one side of the yard was a long workshop where dad would make, repair or just fix things. On the other side of the yard was a coal bin, and an outside lavatory, known as the 'house of wind' with its fifties roll of sharp-edged, tough, crinkly, Izal, prison-issue toilet paper, which was fixed to its green painted door (any door I see painted green will always be known as 'lavatory green'). The saving grace the lavatory paper had was that it made a good comb-and-paper orchestrated sound where Frank and I would strike up the band as we 'tinkled' in time. To add to the 'mod cons' of this little room was a miniature paraffin lamp that helped the occupant to see the general outline of the seat but not the mammoth spiders hiding and lying in wait nearby, although if the spiders knew that someone was about to use the facilities, they would be kind enough to all move to the sides, but only for so long. Beside the outside toilet would be the outside dustbin area and entrance to the steps that led to the gardens. All very compact, but moving all goods and household items, such as bin collections, bikes, garden plants, ladders and coal deliveries, all of these had to go through the hallway, which for modern living conditions must have been very inconvenient. But we all thought that we lived in a very grand house. Dad, who had lost his own father at the age of thirteen and had experienced a very lean time as he was growing up, must have thought, as he screwed the Som Pee Air/St Pierre nameplate up, 'that he had arrived at last'.

Mum and Dad were soon well organised. In the dining room, they put up notices for the mandatory meal times that were to be taken and any other 'dos and don'ts' that Mum and Dad thought would be of use to their visitors.

The holiday visitors who came to Weymouth were known as 'holidaymakers'. That name as a boy always had me thinking that when they arrived they would have a special kit in a box marked 'holiday', which you would unload from a suitcase and 'make', a bit like a flat-pack self-build kit, Dad puzzling and puffing over the 'putting-together tool' with Mum holding up the instructions. Step 1. Fit all sides together to face sunshine. Step 2. Tie handkerchief with a knots in each corner and place on head. Step 3. Set body clock for Breakfast at 8.00 a.m., SHARP. Step 4. Familiarise yourself with riot act from the landlady about 'evening meal times'. Also, don't forget to close your eyes as you digest the cabbage that has been on the boil since 9.00 a.m. (yesterday). Step 5. Have contingency plan ready in case you are late back from the pub as to where to sleep for the night. You all will have been locked out. TIP: the sands are the most comfortable, and your children will be familiar with it … and so on. As with many sayings and names, 'holidaymaker' now seems a little passé,

a name associated with the forties and fifties. 'Holidaymakers' who go to Weymouth stay in guesthouses. The 'smart set', of course, go to Melcombe Regis and are invited to stay at the hotels. The 'very smart set' has a pilot to guide them to the marina. The very, very smart set jet off to their private island in the Caribbean. But here were Mum and Dad ready, willing and able to cater for all their guest's needs … hopefully.

I seem to remember that the menu was the same each week, i.e., Monday's shepherd's pie and tinned fruit and custard, etc., was repeated on the following Monday, and so on. Breakfast, served through a newly built hatch from the kitchen to the visitors' dining room, would have been the same time each day, with fresh grapefruit cut in half with a cherry in the middle, cereals, toast and the 'guesthouse special', which was 'a cholesterol fry-up' complete with cups of tea and, for the more adventurous guests, a cup of coffee from that exquisite brand 'Camp' with its picture on the label of an Indian servant serving the seated sahib in the Raj.

As a guesthouse, we had the summer visitors migrating from London and the provinces staying usually for two weeks. The busiest period was the last week in July and the first week in August. This was national factory closure fortnight when the world and his wife all crowded into every seaside resort. Frank and Peggy and I were removed from the big bedrooms on the second and third floors to the top of the house and into the hot and cold attics. Peggy would be in one room, which she decorated herself, as she had become one of those 'teenagers', and Frank and I in the other, all for the visitor duration. We made no fuss about this annual arrangement; it seemed normal, going up all those stairs to sleep in the attic in the summertime. We believed it was okay as it would be devoid of ghosts, any light that would emit from the annex-cum-large-cupboard-lavatory-cum-washroom's window would keep the ghosts at bay, unlike those tedious, dark nights of winter. The ghosts would always lurk and snigger at us within the darker shadows of that top-stair landing. They knew they could get away with their mocking mirth, as there was no electric light on this landing. We would run headlong up the many stairs, using that well-known tried-and-tested technique, approved internationally, of waving your arms above your head and at the same time shouting Aaaaa noises. It worked amazingly well, as we would always arrive at our attic bedroom untouched and unharmed.

The summer visitors came from the Midlands, Wales and, of course, London and consisted of all types in all shapes and sizes; tall people, short people, loud people, quiet people, people with children and people with a mothball-smelling granny in tow, never a pipe tobacco-smelling grandfather. They were either dead or probably had better ideas than to go on holiday with the sober in-laws. The visitors all had one thing in common: they all worked for British Railways. Mum and Dad advertised

the guesthouse in the *Railwaymen's Guide*, as 'Som Pee Air', a one-minute walk to be beside the sea'. It was, in fact, only a five-minute journey, or less, for us boys to be by the sea; that's if you knew the short cuts and could run very fast, which with a mothball-laden granny in tow might be misleading. 'Ready, Grandma, running shoes on?' I think Mum thought that, as we were only 20 seconds from the harbour, we were 'by the sea'. So the workers could have a holiday by the sea and some subsidised travel thanks to the taxpayer through their railway social clubs.

Some of the visitors were very generous to Frank and I with pocket money or a present, such as a book, which they gave to us when leaving for the return rail trip home, and some visitors who had children of our own age were kind enough to take us with them on various trips. This we would accept if the visitors had a comfortable car or had proposed a paddle steamer trip that sold ice-cream, which one family of six were able to do as they had an eight-seater Dormobile and also liked paddle steamers. What a sleek modern car the Dormobile was then; looking at rare examples still running today, this car looks decidedly antiquated rather than vintage. This generous family, Mr and Mrs S. and Mr and Mrs C. would be some of the new holidaymakers to shun the train and enjoy the freedom that popular motoring would begin to offer the holidaymaker. Motoring gathered momentum with weekend trips to the coast soon becoming de rigueur, until guaranteed sunshine was on offer cheap at the Costas. We would encourage Mum to give those generous visitors a priority booking should they want to come again next year.

Many of the visitors we had staying each year were repeat bookings made sometimes at the point of departure the previous year. Some visitors would send a postal order deposit as soon as they had returned home, such was their enjoyment at 'Som Pee Air'. They were attracted by the air and sea, fresh after the London smoke and choking smog, and the sand, which was always clean to walk on barefooted. There always seemed to be plenty of sunshine too. It seemed to shine every day, and with that and Mum's excellent cooking, staying at 'Som Pee Air' was probably their idea of a little utopia. Mum had fairly strict rules with meal times and visitors had to be on time. There was no breakfast served between given times; just the one time, if you please. There was no drifting in later even if yesterday you had a long day and night at the pubs. Once, a young boy, the first arrival, aged about eight or nine years came down for breakfast without a shirt on, making him naked from the waist up. As he was the first down, Mum advised him that it was not good manners to eat breakfast partially dressed like that and sent him back to his bedroom. I am not sure how I would have treated such an incident. Can you tell a child not to partially dress like that without agreement from his parents? Mum was strict with her standards and I do not remember any complaint except perhaps

the incident concerning young Tony who had accompanied his mother Mrs W. each year. One year, young Tony had a mishap in the bed and, for some reason, Mum scolded the poor lady about the soiled sheets. Mrs W. who had been a good, regular visitor never came back again.

Mum could be very amusing. She would sing to herself whilst cooking or cleaning or carrying out some other chores. A typical moment of amusement in running the guesthouse was that after all the visitors had finished dinner and left the house for the evening, Mum, with the help of Pat and Peggy, would carry out the washing up in the dungeon's kitchen and any plate considered to be cracked was passed to Mum for her final judgement and, if found damaged, would be discarded for health reasons, as germs can breed in those tiny cracks. Having confirmed the plate could not be used, Mum would merrily toss the plate out of the kitchen window for it to land on the hard surface of the yard and completely smash to pieces, amusing all within earshot as a way of dealing with redundant goods, although I am not sure what the neighbours thought of this regular smashing of flying plates.

Conversely, Mum could be scathing about other people's good fortune: 'brown boots and no breakfast' was one of her common sayings; in other words, they had gone without to show off, rather than accepting that maybe they were unable to afford both the brown boots and the breakfast. Mum's expertise in the kitchen, the quality and generous portions she served were always appreciated; how the rationing system worked I am not sure, but food for the visitors was always plentiful.

We were a fortunate family, as we had an income from the guesthouse, Dad's job, and Dad's carpentry work making items for basket making for Uncle Fred. Dad could repair or make anything, so no maintenance bills had to be paid. In fact, Dad roped my brother and myself in on many occasions to help him make or repair some part of the house, which in later life was to prove very useful, as we in turn have spent very little on employing a tradesman. 'Keep your index finger straight on the handle this will help to cut a straight line' and 'Let the saw do the work.' I can still hear Dad's words as he allowed us to carry out the hard work for him.

The visitors enjoyed the pubs, and boy did Weymouth have some pubs. Most of the pubs must have originated to accommodate both the military and seaport activities, with the Temperance Society no doubt jumping up and down until the drinking water quality improved. By then, of course, the pubs were built, with the navy from Portland and the many holidaymakers each sniffing out the nearest 'Red Lion'. Frank and I used to play a game of listing the pubs at bedtime whilst lying in bed. 'Walk from Trinity Road to the Jubilee Clock via St Mary's Street and back along St Thomas Street', 'No, you missed out Black Dog.' so the game went on until we fell fast asleep, pub-crawling for lemonade and Smith's crisps in the land of nod.

There are unconfirmed reports that suggest that if all the pubs were closed down, Weymouth would have to build a loony bin. There's nothing like a business that enjoys repeat business, amen.

The guesthouse would always be full in the summer season and a notice would hang in the window reading 'No Vacancies'. When 'Som Pee Air' was full, about twelve or fourteen people would stay the two weeks, that is twelve to fourteen visitors sharing the one lavatory-cum-washroom facility located on the middle landing for the two week stay. This diminutive ablutions room was an unconventional construction of a small room, about the size of a small hotel lift, with the outside tacked and covered with corrugated iron, located about twenty-five feet above the ground, affixed to the outside wall and supported by two large wooden supports at a 45 degree angle, almost a little shanty town palace dreamt up by a previous owner. Overcrowding of this green-painted corrugated box hugging the wall always gave the notion that it could fall or slide off at any time. Whilst it never happened, if it had become a little overcrowded, then, 'middle floor, going down, outside lav, coal bin and workshop.'

Prior to us moving in, the entrance door to this reduced ablutions room had replaced a sash window that once had given light to the stair landing. The later construction of a door created a dark landing, of course, much to the ghosts' delight. How all the visitors managed to extract the best from those limited facilities is one of the past's practised skills, with the word 'en-suite' then light years away. However, manage they did and apparently without complaint. I suppose if you lived in a property where the 'privy' was somewhere at the end of the garden, where calls of nature on cold, dark and wet nights required a candlelit lantern, this modern sanitary arrangement must have been luxury with its rolls of Izal lavatory paper, paper that was as rough as a camel's tongue, as flimsy as today's tissue paper, with a sheen like today's bacon foil, although better than yesterday's tabloid threaded with string hung on a hook above the cistern. The visitors had to form a cross-legged queue in order to access these facilities with the smart visitor commenting to the rest of the queue that 'a full bladder needs no prompting folk', but manage the holidaymakers did. I suspect that some sort of one-upmanship was used with their home neighbours: 'Oh yes, "Som Pee Air" has inside facilities, you know.' If only they knew.

I have to admire my Mum for the work she carried out in the kitchen. This was the late forties/early fifties and the revolution in kitchen design and equipment in America was beginning to arrive in Britain, although the majority was unable to afford and enjoy such labour-saving gadgets. America was the real winner of the war and the country had quickly changed its vast military manufacturing machine for building tanks and ships to building domestic appliances such as washing machines, refrigerators bigger than our outside lavatory, toasters, electric can openers,

ice-cream makers and food mixers. Mum had none of these to help her. She had just two cookers; one gas while the other one was electric. All the food preparation was done by hand and most of the work was done with a sharp knife, a fork, a spoon and a rolling pin. I still have my Mum's old scissors that she used to cut the rind off the breakfast bacon. The only gadgets were a runner bean shredder and a boiled egg cutter; this last item looked like a miniature harp on a wire frame, good for the eggs but was not going to get the nation singing to the music it made. From memory, we had no outbreak of botulism during the summer season.

So there was Mum cooking breakfast and evening meals, and sometimes making sandwiches, for twelve or fourteen people, all of whom would congratulate her on her excellent cooking, whilst we as a family agreed it was okay, bearing in mind that Mum slaved away for all of us as well. Mum nevertheless felt that some of the visitors own cooking efforts at home must have been wanting. I think that was some sort of inverted self-praise she made for herself. I think it helped that all the food was fresh. It had to be fresh because we had no refrigerator, only a safe which was a very low-tech hinged box with a wire mesh front to keep any flies off the meat, so it was to the shops every day. What a chore that must have been, probably an average weekly shop each and every day during the summer season.

Vegetables always seemed to be in good supply and were mostly bought from Dennetts' Fruit and Vegetable shop in St Edmund Street. I assume most vegetables were English grown from the fields of east England and the fruits from 'The Garden of England' in Kent that could only supply the standard cooler climate fare of apples, pears, plums and cherries with probably only the apples available all year, as they could be stored for longer. The Channel Island ships brought in the 'new' potatoes and tomatoes, then quite an event, with tomatoes supplied in thin pliable wood baskets fitted with a metal handle and the new potatoes in large, thin pliable tubs or barrels, each part filled with earth to retain freshness.

The most glamorous and cosmopolitan supplier was the Frenchman complete with his onion-strung bicycle. Strings of onions would be attached all over a pedal-pusher complete with the traditional French striped jersey and beret for this Gallic rider. He would knock on the door and in his poor English sell a string of the imported onions to Mum, which meant him writing down the price and quantity on a notebook for Mum to read. I don't think they were any cheaper than the shop-bought onions but this Frenchman with his old bicyclette strung with smelly and tear-jerking onions gave Weymouth an air of exotic colour and mystique, as this method of supply was not ordinarily encountered, and it was coupled with his warm smile and traditional Gallic shrug. This delightful man must have arrived in Weymouth on one of the many ships docking from France

or a hop, skip and a jump via the Channel Islands. What was questioned, after he'd made a sale with us, was where did this gentleman sleep at night? Or perhaps it was just a regular day trip. If he did stay the night, we could not imagine a landlady at a B & B putting up an unwashed Frenchman smelling of garlic and carrying hundreds of onions on his person. *Quelle horreur!*

One other innovation that helped the busy guesthouse kitchen was the arrival of sliced bread. A loaf was chosen from the baker's shelf and he would, with theatrical flair, proudly add it to his new piece of stainless steel equipment sitting centre stage in the shop window for passers-by to stop and admire its hey presto! magic. With a final flourish, the machine, after cutting perfect slices, would finally wrap the bread.

After finishing the evening meal, all visitors would leave the house to either sample the pubs again, or to take a quiet walk and enjoy the views again. Their coming and going would present a small problem regarding when Dad could lock up the house, as it was never certain if they had all returned, drunk or sober. 'Som Pee Air' had not progressed to visitors' own keys. 'This is "Som Pee Air" not the Ritz you know,' Mum or Dad might remark. Dad set about constructing a visitor indication board in which the visitors could indicate whether they were 'in' or 'out'. This consisted of the room numbers listed on a plywood board made with a sliding cover to cross over the board that either blanked out one of the two words, 'in' or 'out.' This was a great idea, very imaginative we thought Dad was, and those visitors who worked for the railway and were used to such coming or going systems would abide by the new rules. The problem was that those who might have used such a system but had been the last to leave the pub were perhaps in a condition that may have made them forget which room they were staying in, let alone to move the pointer. You could tell when they didn't know their room number, as you could hear a door or two open followed by the hushed 'sorry'. The result was that Dad either had to wait up for the visitor who was now tucked up in bed or lock up only to hear a knock on the door an hour later when poor Dad was dead to the world. The knocking on the door would, of course, wake up some of the other guests and the resident head cook and bottle-washer, who had to be up early to cook breakfast.

We had an incident where sailors were passing by the house on their way back to their ship. Suddenly a window was heard to smash; a beer bottle had been thrown through one of the bay windows while we were all tucked up in bed and most were in the land of nod. The noise that a heavy, glass beer bottle makes coming through glass is quite loud, in fact, very loud. This seemed to wake every soul in the place with most of the female guests 'assembling' in dressing gowns and hair curlers talking to Mum, as Dad made a hasty repair to the window. So it would seem that even after

five years of the war ending, sleeping easy could still be interrupted by any unusual and sudden noise. The men, apart from Dad, of course, never stirred.

As the late forties/fifties were a lean period, seaside guesthouses were generally the only type of holiday ordinary, and perhaps some fortunate, people took in post-war Britain. It would seem to be all they could afford, unless they chanced their arm with the fledgling, Spartan, now-redundant military camps, renamed, and some restarted, 'holiday camps'. Lucky them; we never went on holiday. Mum said that, as we lived at the seaside, there was no need to go anywhere. I suppose Mum's PR line must have rubbed off in later life; 'accentuate the positive,' she would drum into us all. I suppose if it were decided we should go on a holiday, two questions would arise: where would we go? To the seaside? Well, we are already there. Or when do we go? As this would have to be out of season, we would miss school: 'yes, please, Mum.' Once, we did go out for the day at the end of the season to Bournemouth to spend some of the guesthouse takings at the shops, Mum to buy a fur coat or two and a frock or coats for my two sisters. This shopping trip ended with a Knickerbocker Glory sundae at Forte's ice-cream parlour, a treat for us two boys after being dragged around the town's shops before we caught the old steam train to rumble home in.

Sometimes Uncle Fred, who ran the well-known bamboo business at Godmanstone, near Dorchester, called Whines & Edgeler, The Bamboo People, would take us all out in his Bradford van which had only two proper seats with the rear doors kept open when getting in or out by wedging a large old bone down the side of the door; this old, shaped animal bone did a perfect job to hold open a dodgy door. So six or, with Gran, seven people would be crammed into this little van to be driven all the way to the New Forest or Cheddar Caves, perhaps minus Dad, who preferred to work; although sometimes he could be persuaded to come along on these trips, if he could sit in the front. It wasn't an ideal way to travel. After all, it was a van with just two seats and six or seven people crammed in sitting on boards, boxes and old cushions with a blanket should it become cold later and surrounded by a picnic stove and food. There were no safety belts, crumple zones or air bags and yet we felt it was hi-tech when Uncle Fred told us that he had the brakes fixed, rather than stopping the van by throwing his hat out of the window.

For most people, travelling by car was not an option; they had to travel by train, the day-trippers by motor coach, although a few were starting to come by car. Weymouth railway station was a very busy place during summertime weekends in the late forties and fifties, as most long-distance visitors arrived by train. On a Saturday morning until lunchtime, boys with all sorts of shaped handcarts would collect the departing holidaymakers

with their suitcases from the guesthouses and take them to the station, then wait for the arriving trains bringing in the new visitors at around midday. The various designs of handcarts that the boys used to transport the cases and bags were either a Heath Robinson work of art, i.e., an orange box on four pram wheels all of different diameters with a rope handle to help tug their crude wheeled contraption, or a workman-like designed cart built by their Dad with the cart painted in a unique maroon-coloured livery complete with a blackboard to show the 'low' price charged from the station to the guesthouse. The low price was just there to tempt a punter; it would soon rise as the enquirer stated the address they wished to go to: 'Oh, that's a long walk, mister; can't do that for 2s 6d; that'll be five bob.' (And a tip was expected). Then without waiting for a reply the cases would be on the cart and the holidaymakers, wearing their best suits and ties or a new summer frock complete with tight-fitting new court shoes recently bought for the holiday, would huff and puff and shuffle along behind the fast disappearing handcart, only for it to arrive at a guesthouse just around the 'detoured' corner.

Competition was fierce with the older, more experienced boys elbowing out the younger kids, although some of the older boys would drag their younger brother along with them to learn the ropes to later take over this valuable temporary job when big brother started work properly; the younger boy had agreed a negotiated price for the purchase for big brother's old cart beforehand. Before the peak season fortnight, the boys' price would be competitively low, rising to a non-negotiable high price during the peak-period fortnight. The price was based on the distance to the guesthouse and the number of cases the visitors had brought with them and, if the guesthouse was a long walk, the boy would suggest that he didn't know the way, or use the usual 'it's a long walk, mister' routine. Luggage boys had to know the short-cut routes to the guesthouses so they could be back at the station for more customers asap or lead the holidaymakers a dance around the long routes if there was a lull in trade. Nothing was unusual in this movement of suitcases and trailing holidaymakers on mobile orange boxes on a hot summer's day. Now, it would seem like an entry into a third-world railway station.

For Frank and I, Weymouth became the only place that we knew. Our world consisted of sands to build castles, a harbour with little fishing boats, a fort with soldiers, the sunshine and the sea, not forgetting the smiling people who came each summer to our house. Weymouth is Weymouth; you either went there and loved the place or you didn't.

As children growing up in such a small town, it was easy to get to know most of the places we could explore, whether it were winter, springtime, summertime or autumn. Winter was, as with most seaside towns, a total contrast to the glorious summertime; then, Weymouth is best described

as 'dead' or at worst 'very dead'. It was like having a really good party going in full swing, then a slight chill would descend with longer shadows forming and the revellers would quickly fade behind their retreating dust. In late autumn and winter, the town could be almost deserted at night-time. The Esplanade would be quiet and shuttered with the sand now gathering under closed doorways caused by the steady but persevering cool breeze coming off the sea. The many pubs, of course, would confirm to the out-of-season visitor that the world had not yet ended.

The transition from Weymouth's busy summertime lemming intake to its winter would be a slow descent into a darker and lonelier place, unlike inland towns, which have a consistent ebb and flow of people all year round. Winter would give a mysterious and empty feel to the town. Groups of buildings around St Mary's Church were surrounded with dark alleys and windy corners with a lone, seemingly dubious person hidden behind warm clothes moving quickly and silently, a glowing cigarette in their mouth. I always suspected these nocturnally inclined beings were from the moored ships in the harbour, going about some shady business as people usually did on dark nights near ships moored in harbour, although the reality probably was that he was just the butcher's boy dashing between the two girlfriends that he had on the go. Areas near to water in winter remained dark no man's spaces, unused and menacingly cold. Weymouth certainly could be a little dormant and austere in a 1950s winter.

Perhaps I remember Weymouth in winter as being an empty and fearful place, but I, as a small boy, had moved there in June, just at the end of the Second World War, and had seen the effect of war damage, mostly at Chapelhay, also seeing bombed buildings during the train journey from London; this had made a frightening impact on me. Why should people want to drop bombs on other people's homes and kill them? When would the next bombing start again? These questions always seemed without answer.

I sometimes wondered what Weymouth town must have been like during wartime; very bleak in winter, that's for sure, as not a light would be seen anywhere. Only on moonlit nights would you see white horses galloping up to the sands then disappearing back to the sea the way they came. All reference to the name signs for the town and its railway station, Weymouth, would have been removed to confuse the enemy as it landed on the beaches. This planned confusion was the idea of the novelist Dennis Wheatley whilst working for the Joint Planning Staff as a deception planner at the War Office, using his thoughtful espionage and sabotage knowledge gained through his writing. The Home Guard, or Dad's Army, as it was affectionately known, would have been sent hither and thither to investigate the many reports of German paratroopers landing. One such report claimed that paratroopers had landed on the Weymouth approach

road at the Ridgeway, but the 'invaders' turned out to be sheep. How could sheep in a distant field be confused with paratroopers? Perhaps the sheep formed themselves into circles and all jumped up and down at once. All these reports underlined the high state of alert to an invasion at the time.

Amidst all the serious work during war, there would still have been time for recreation. Mostly, this would consist of many sailors and soldiers looking for pubs and then hopefully meeting some girls to kiss and cuddle in a cold, windy doorway. For many people, the places to go were the various hotels that had a dance floor where the single young ladies, and perhaps the lonely married ladies, would dance the jitterbug to the music of the local, and mature, members of the Artie Shaw-sounding band, making the already nervous GI sailors and soldiers, now very far from home, feel more homesick, with only an unknown, perilous future before them.

Going to the sands would not have been a case of enjoying Downton's donkeys or the antics of Punch and Judy; instead, it would have been a shared experience with swirls of barbed wire, military vehicles and personnel exercising, and in 1944 the GIs would be marching to a secret area where they will return from after enacting another exercise in readiness for the great day, D-Day, an event from which some of them would not be returning. Of the 500,000 estimated to leave Dorset on that 4 June 1944, 2,200 would be killed on that very first day on Omaha Beach.

Whilst it was probably a dark period for both residents and any visitors, some visitors still visited Weymouth for a holiday break. I have a postcard dated 1943 in which 'Pearl' writes of 'having a good time' to her friend 'Hetty' who is stationed at RAF Station, South Cerney, Gloucestershire. Although I imagine her 'good time' didn't involve a bucket and spade.

After that terrible war, with just the Chapelhay bomb damage to remind me of what wartime must have been like, we had a visitor at 'Som Pee Air', who was, of all people, a shot-down Luftwaffe officer; this must have been about late 1948 or early 1949.

Godmanstone's POW camp prison in Dorset was one of over 600 such camps dotted across Britain. The location of the POW's prison huts was at the side of Uncle Fred's bamboo business in a field adjoining a farm lane, known as Frys Lane. The Godmanstone camp held about fifty German prisoners, who were housed in two huts and released each day to work on the surrounding local farms.

Uncle Fred, with partners John and Bernard, was living and working out of the high-wheeled gypsy caravan premises at Godmanstone in close proximity to the German POW camp, which was just fifty or sixty metres away. This near accessibility allowed them all to become friendly with each other, more so as the prisoners were allocated to work with the bamboo stripping (cutting) and were further encouraged by a few who managed to creep out of the huts and spend the evening playing cards and drinking

with Fred, John and Bernard. One such German POW nocturnal visitor was also our visitor, named Gunter Sauberlich, who became a very good friend of my uncle and partners. While a prisoner in England, he took the opportunity to learn, speak and read English. When the war ended, Gunter Sauberlich remained in England working for the bamboo business until the late 1940s. On two occasions, I can remember Dad taking me with him to my uncle's business for the day. This was either before starting school or during a holiday period from school. I excitedly caught a futuristic-looking Diesel single-carriage train, known as a 'Streamlined Rail Car', which was a regular commuter train that held just sixty people, which quietly whizzed us along at 60 mph to Dorchester. We then caught the down-to-earth trundling bus to Cerne Abbas, stopping at Godmanstone. This visit, I would suspect, was in the early days of being in Weymouth when plan 'A', Dad working at the bamboo business, was in its infancy. Although I remember the trips to 'God', as Uncle Fred called Godmanstone, very little is remembered of the men and the work they carried out there. Gunter was working for the business either in the latter stages of prisoner status or was by then a DP, or displaced person, released but not returning home yet.

Dad had got to know Gunter, hence the visit to us at 'Som Pee Air' with Uncle Fred and John in the then-new company transport, an ex-army open-topped Austin car. It is ironic to think of Uncle Fred, an ex-conscientious objector, now at the wheel of an army car, albeit an ex-military car. Mum and Dad played host in the 'posh' first-floor sitting room. I don't know if Mum welcomed this role. I suppose if not, then she probably would

German POW Gunter Sauberlich second left with my sister Pat, with Uncle Fred (right). Far left is business partner John. 1947/8.

not have entertained the idea; perhaps she was more curious about the old enemy than eager to welcome a new friend. Strangely, it would seem that there was very little general animosity in Britain towards the German POWs, in spite of the trouble they caused the world; however, there we all were, an English family with an ex-German prisoner of war in our best sitting room being entertained with rationed cups of tea or 'Camp' coffee and maybe some alcohol was present, some beer or whiskey perhaps, with Uncle Fred acting as the combined host toasting with 'Prost' and the German acknowledging with a brave English response of 'cheers'. I remember as a boy looking wide-eyed and thinking of those bombs he dropped on people. But by all accounts, he seemed a very good person, a very well-mannered, polite German who was liked by the family. From my memory, he was tall, dark, had curly hair and, for a prisoner, was smartly dressed. Whilst the war had ended in 1945, many of the prisoners that were still here in Britain were allowed to mix and visit people outside the POW camp, although this was a compulsory period of association as they were helping with war damage repair work. Gunter gave me a toy of some sort as well as providing some bracelets for Mum and my two sisters, all made himself. I think the toy was taken away by Mum after he said his good-byes and left for a walk around the Nothe Gardens with my two sisters, Uncle Fred and John. We called John an 'uncle' until we were about twelve and then it was dropped. This was a shame as, although John was not, as we later realised, an uncle, he was always with Uncle Fred and, therefore, part of the family. In fact, they were also 'partners of a different kind', although in the fifties it was taboo to mention 'those' relationships.

But, for Frank and I, Weymouth was to be the place where we could enjoy the excitement of the coming summer seasons, with the interesting prospect of getting up to no good at times, harming no one, but hopefully making our formative years enjoyable and to be remembered.

chapter five

The German Rock and Spider Crabs

The Germans will hop from our big rock. The generous Yanks, although kind, don't take our stock.

A ten-minute walk from 'Som Pee Air' along the harbour, the Nothe Fort is located at the tip of Weymouth Harbour, jutting out into the 'Bay of Naples' with Osminton Mills shimmering in the rugged background against distant shores, inhabited by strange folk and their strange customs. Visitors taking the air were able to view the distant George III commemorative statue hollowed out of the distant hills above Osminton. Argument has it that King George III has his back turned away from Weymouth with the royal rider thinking he was snubbed by the town.

The Nothe Fort was one of many areas that formed part of our territorial playgrounds; with its big guns pointing out to sea, the occupied military fort we knew and enjoyed was an area full of secrecy, imagined or real.

In front of the fort was the Stone Pier, a breakwater pier to one side of the entrance to the harbour with a pier on the other side of the harbour known as the Pleasure Pier. The Stone Pier, otherwise known as the Breakwater, is used for various activities such as fishing, strolling or just enjoying and taking the wholesome Dorset fresh air. The Stone Pier also entertained another function as a place for Weymouth Sailing Club to start the yacht racing. This activity was carried out from the sailing control centre near the Nothe Fort and faced the Pleasure Pier and Weymouth Bay, where it housed its various starting equipment, although to correctly identify its nautical origins, in the fifties it was a small garden shed. The racing was started and finished by the firing of two small cannon guns on a small platform affixed to the pier railings. The person who had the enviable job of firing these weapons of peace was my Dad. How he got involved with the Weymouth Sailing Club racing, I have no idea, although my sister suggests it was part-time paid employment. All I remember is him raising and lowering the various flags, firing the cannon guns and looking at the yachts dashing about in the bay with his binoculars.

Playing near the Stone Pier was not only the best place, it was free. We could catch fish and climb the flashing beacon tower at the end and look out for enemy invaders. This was one of our best-enjoyed playing areas.

My father starting or finishing
Weymouth's yacht racing. 1950.

Not as many visitors during the summertime would visit the Stone Pier compared to those visitors that frequented the Pleasure Pier, although the Stone Pier always had holidaymakers trying to catch a fish, with their long-suffering, seated wives pretending to be bored, although they would seem content with knitting and reading a *Woman's Own* magazine or gossiping non-stop to another, equally bored fisherman's wife about the technical merits of her husband's fishing ability.

Barrie said, 'I know, it's worn by the soldiers up at the Nothe Fort.'

'Why?' we asked.

Barrie continued, 'When the soldiers are on guard looking out for Germans they can't leave their post to go for a pee so they put one of these on and have a pee in it, then in the morning they throw it into the sea.'

We stood there open-mouthed comprehending this revelation, but nodding agreement.

'Okay but what about the halves of grapefruit floating near them?'

'I know,' said Frank, 'the soldiers need to keep awake at night so they suck the grapefruit.'

'Why?' we asked again.

'It tastes horrible. Mum serves it to the visitors,' added Frank. 'One suck and I bet you can't sleep for ages; I bet they go "ugh, that's a horrible taste".'

After sorting that out, we planned our next move.

'Let's climb the German rock.'

The incoming tide washed all sorts of flotsam and jetsam into the area around the Stone Pier, fort and the solitary German rock. Most mornings, during the school summer holidays, we would be out surveying our territory. The four of us would cast wonder at the many mysterious looking condoms and halves of grapefruit that always seemed to float there. We reasoned that these floating items must be essential for the soldiers guarding the fort to allow them to get through the long night.

The German rock was still partly in the sea at low tide and located near the bottom of the sea facing Nothe Fort's walls, and by scrabbling over the smaller rocks we could reach this mighty, roundish rock, as big as a large motor car, which the four of us would clamber and sit on, sometimes to fish from but mostly just sitting and talking or plotting or waiting for the rising tide to surround us, then scrabbling off the rock at the last minute before the now-growing salty moat cut us off, all daring each to be the last off. We named this huge boulder the German rock. We reasoned that, should the Germans start another war, we, the four of us, would help drop this big and heavy rock onto Germany to expedite a speedy surrender. We knew how bad the Germans were because of the damage they had done with their bombs at nearby Chapelhay. Of course, how we would get this giant of a rock airborne was never discussed, but our *coup de grâce* was there in readiness.

The four of us were Barrie, Ronald, my brother Frank, and me, and we were called the 'Quads Gang'. Brothers Barrie and Ronald were our first

The Quads Gang. Barrie, Ronald, Frank and the author.

two friends we made outside school and were living in Cove Row with their little sister Norma and their mum and I think also with their gas repairman, errant dad. Whilst Barrie and co. were always casually well dressed with proper play clothes, we, who lived in the big house near the town, were dressed as model waifs and strays, wearing only clothes that were redundant worn-out school clothes, all worn without the luxury of underpants. The latter were, I think, an unnecessary luxury to our Mum. So, there we were, the prime of Weymouth's boyhood, mischievous, committed and organised and prepared to act on the last orders given: 'Don't be late for tea the pair of you, and no, you can't have any underpants, you'll want servants waiting on you next.' Mum's sayings were often unfathomable. One that really bemused me was her reply when we asked for something that she could not or would not let us have. She would say: 'Sit down and I'll jazz to you.' This unfathomable saying would cause the whole house to rush for the nearest chairs, a bit like the game of musical chairs with some of us falling over in the rush, but her 'jazzing' to us never happened, however long we sat. Anyway, that would be Mum's last orders and kind blessing as we left the house for the day.

Waking up on a warm summer's morning in the attic was one of the most memorable times of living at 'Som Pee Air.' Unless, of course, it was a Sunday morning, when we would all be prematurely woken up and deafened by the bells of Trinity church urging in the faithful and those ready to indulge in local and social gossip together with the general nitpick of life. Those bells seemed to clang on forever, and whilst you may have wanted a lie in, we would find ourselves getting up anyway as a distraction from the call to church. Once up, the sun would be bright and the new day fresh. We would hear the rumbling bustle of the visitors below in their bedrooms, each with their doors slightly ajar to cast an eye out of their rooms to see if the wholly inadequate washroom was now free and now this bijou lavatory was made complete with its newly fixed schoolmistress-type red and white sign over the toilet-roll holder inviting the visitors to 'Now Wash Your Hands'. I suppose this was to remind visitors to raise their standards now that they were on holiday and had that unique access to 'The Bay of Naples'. We would smell the aromas rising from the kitchen as Mum prepared breakfast. She would be busy frying the bacon and eggs, boiling the eggs and making toast. The smell of this inviting nourishment would waft up the stairs and would hasten the visitors downstairs to the dungeon dining room ready to fortify themselves for another lazy day on the sands. For all the visitors to gain use of the one lavatory-cum-washroom and be present for the single allotted time for breakfast must have caused some to either miss a call of nature or make one and have not-so-clean hands, one or the other or both, although Mum never made an inspection prior to the visitor entering the dining room.

The breakfast room was filled with happy holidaymakers eager for a day of relaxing on the sands followed for some by a liquid lunch. Fresh bread was always needed so I would rush from the attic, down five flights of stairs, adding speed by using the slide, or banisters as some liked to call them, and into the dungeon where the kitchen would be hissing, spitting and bubbling away in its stride. Money was passed over and the same order given and it was off to Dunning's bakery in Hope Square for the fastest collection of bread in the South. The seventies' Hovis television advertisement wistfully says of the newly made bread, 'you could smell it all the way down the street', depending on if the milkman's horse had just been by, but this ode may have been written with Dunning's bread shop in mind.

All the morning smells would be combined with the smell of the sea and the sound of the seagulls forever circling overhead and splashing at the same time, the paddle steamers would all be doing their do-se-do as they readied themselves for the day's steaming. What shall we do today? This was the daily decision we had to face each summer holiday morning. Once the visitors had gone, the house was quiet. Dad had long gone to work with his sack full of sandwiches and bread pudding for his lunch and tea breaks; Pat, who had served breakfast to the visitors, had hurriedly gone to the Turf Accountants where she worked. Peggy, always on strike, would still be in bed, the only sound was the kitchen help, cleaning and gossiping with Mum or sometimes the wireless would be quietly broadcasting a Guy Mitchell song as it made its way across the air from a BBC *Housewives' Choice* programme.

Would we try to re-explore the Chapelhay bomb damage, do a 'recce' of the Nothe to see if the 'itta' boys were around ('Itta' boys were the older boys who beat up the younger kids), or really make a day of it and

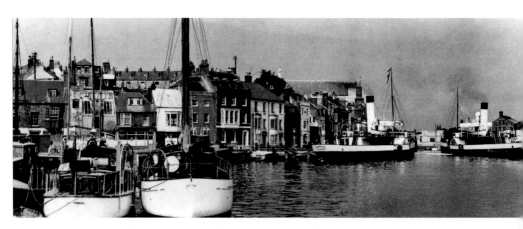

Summer morning in Trinity Road in the 1950s. Paddle steamers as they make ready.

visit Chaffeys Lake along the backwater and look for frogs? Once, while slipping and sliding around the seaweed base of the Nothe Fort, we found an injured seagull, a Heron Gull, looking distressed as it seemed to have a broken wing. We managed to pick up the bird with the intention of taking it to the vet's surgery in the town but it was struggling as we tried to hold it in our arms and pecking hard at our hands, soon causing them to bleed. We decided to tie up its beak and the only material we could find to do this was lengths of grass. After some effort, we managed to tie the poor bird's beak together and with that we four walked and took turns to carry the gull to the vet's surgery located in Fredrick Place, nursing and cursing the injured gull as we walked. After the two-mile walk, Mr Vet came to inspect the gull only to declare it dead, whilst we protested that the bird was alive just a short while ago. Mr Vet told us to go away and leave the dead gull with him, as it was a bird no more, not unlike Monty Python's dead parrot sketch seen in later years. We all nursed our wounds and went home to collect and apply an assorted array of six or seven sticking plasters each, so that type of eventful day was not to be repeated.

With each new day, we would make a sandwich from the bacon leftovers from breakfast, throw an apple in a bag and we would be gone. Not saying where, not saying who with and not saying the time we would be back, we would come back at the biological clock time of 'hungry time'. Never once were we in danger from 'funny men', only 'loopy locals' who were harmless and not the perverted kind; the only dangerous thing was ourselves. For example, someone would suggest: 'Let's fish for spider crabs, that's what we will do.'

With a simple hook, line and weight, we would lean over the side of the Stone Pier and hey presto we had hooked a crab, a giant of a specimen. It was odd that when the crab grabbed the bait and was dragged out of the water, it rarely let go. You would think the crab would say to itself: 'Hello, I'm now out of the water and I'm rising up in the air. This can't be right for a big spider crab like me, so perhaps I should now let go of this piece of food.'

But no, they really did hang on …

Some of the bigger boys would use long poles with a right angle set of forks at the end, to lift the crabs off the tops of the shallow, submerged rocks. On one particular warm summer's day at about midday, the four of us caught eight spider crabs, two each, some, I think, with some help from the boys with the long hooks. We knew the Yank's ships were moored in Portland on a goodwill visit, as we had met a small crowd of them at the Nothe Gardens the day before, drinking Devenish beer from large, brown glass bottles, which they would pass around to each other and to ourselves.

'What an awful taste beer is,' we unanimously said to our hosts.

'Yal come to the states and git some proper beer when you old enough, boys.'

All of them were friendly guys. Our plan was to sell the crabs to the Yanks, as they always seemed to have more money than the British 'holidaymakers'. So, armed with eight bright-pink spider crabs, *Macropodia rostrata,* we set off for the Esplanade, starting at the harbour end. Holding the now-comatose crabs away from our bare legs in case they woke up, we walked all along the full length of the Esplanade to the pier bandstand. On route, we would stop each group of cheerful Yanks, dressed in their immaculate navy uniforms and little white hats, to ask them the same question: 'Would you like to buy some spider crabs to take back to your ship, mister?'

They would answer, 'No thanks, sonny. Here, what do ya call this?' They would hold out a handful of British coins pointing to a 'two bob bit' or a half crown, which they generously gave to us. Many would ask the same question: 'How many of these or those to a dollar?' We knew that half a dollar was 2s 6d or half a crown and that there were eight to the pound, so a dollar was five shillings, or two half crowns. Were the Yanks confused? You bet. We ten-year-olds could really confuse them, not intentionally of course. We would explain, 'There are 960 farthings to the pound.' The Yanks had none of those. 'There are 480 halfpennies, 240 pennies, 80 three penny pieces, 40 sixpences, 20 shillings, 10 florins or 'two bob bits', 8 half crowns, 4 crowns (not that we used them), 10 shilling notes and, of course, at the race track, 21 shillings to a Guinea – simple!'

The Yanks were very confused. To the Yanks, the decimal system was, and is, a simple way to calculate currency. 'You Brits sure make it hard for yourselves,' they would say to us all with the usual friendly grin. (I would have liked to say that, as we ruled the biggest empire ever on this planet, we never made things easy for ourselves, but as a ten-year-old, those words seemed to evade me.) The Yanks didn't buy our spider crabs, but they were right about our complicated monetary system. It would not be until 1969 that some sense would come into play, although the farthing was no longer legal tender by 1961. In days past, people must have felt very rich with a pound's worth of farthings in their pocket or purse, all 960 of them. The farthing is about the same size as a modern 5p piece, so it would have been some pocketful. By the time we had reached the pier bandstand, we had not sold a single crab, but we were well in pocket from the generous Yanks, who had each given us 'two bob' (20p) or half a crown (25p).

At this point of our enterprise, we decided to cross over the road from the Esplanade and try our luck walking back on the other side of the front. Having lugged these now-fast-deteriorating crabs for some hours, we needed a plan that would release us of this burden of beasts, as it was

clear that nobody seemed to want them. We reached the area with Lennox Street and Victoria Street and noticed some narrow back alleys.

'Why don't we just leave them here? No one will see us.'

'What if the crabs are still alive; they will walk all over the place and people will think it's an invasion.'

'We had better kill them so they don't scare people.'

As a ten-year-old, you may do some things that are not good but probably don't harm anybody; now, as an adult, I am horrified at what we did next. We each took our crabs and smashed them against an alley wall leaving a pile of crab legs, bodies and all the innards scattered over the ground of this narrow alley. Then calmly went home to tea, whilst the cats in Lennox Street, Victoria Street and perhaps Hardwick Street, all had crispy hors d'oeuvres on their way out to dinner.

Whilst we would venture all over the surrounding area, the Nothe was always our best place for adventure, as it was quiet, and Barrie and Ron lived in Cove Row, so we would make our way to their house, which was conveniently on the way to the Nothe. The Nothe Fort, or as it's otherwise known, 'Palmerston Folly', is a fort built in Victorian times with its foundations laid in 1860, which was the year when Lord Palmerston through the Royal Commission on the Defence of the UK advocated a number of forts to protect our fleet at anchor. Those critics who opposed the plan considered the forts to be 'Palmerston Follies', since the money, as they probably rightly argued, would be much better spent on building up the Royal Navy, rather than the more costly and lengthy process of building fortifications.

Difficulties with this costly construction resulted in the contractors going bust after just two years, so the Royal Engineers completed the work with assistance from prisoners at Portland Goal. Such was the lengthy construction time that it was not completed until 1872. The use of prisoners to help complete the construction is not new, as they were put to work on various worthy structures. The work was probably hard, but compared to the prospect of languishing in a seventeenth-century prison, the prisoners would have been willing recruits, especially as extra rations were promised.

The protection of Portland Harbour was a collection of four enemy defensive installations, The Portland Breakwater Fort, The Verne Citadel, Verne High Angle Battery and, of course, the Nothe Fort. Whilst all were ready for action, the enemy never arrived, and as time passed, the fort's guns became out of date, so either the protection of the forts fulfilled their purpose with the unseen enemy thinking twice about attacking a place that had the protection of the Royal Navy or the enemy were looking for an easier target in other countries.

In 1881, the dwelling in Trinity Road, between No. 15 and 16 was known as the 'Brig Inn' and residing there was a retired, sixty-five-year-old prison warden named James Burgess, who ran the prison at Portland. It is probable that he had overseen and detailed the most suitable prisoners for the fort's construction work. After retirement, he could have strolled from his new home in Trinity Road to admire the fort's construction with some pride.

The building of such an edifice would have had a very long-term building time-scale, which is not surprising when you consider that each block of stone had to be carefully hewn to form the rounded fortification design and couple this with the half-hearted efforts of some willing but unskilled labourers. One wonders how the prisoners made the daily journey to the fort; it is hardly a twenty-minute walk from the Portland prison to the works at the Nothe, perhaps some locked rooms at the old fortifications allowed the prisoners to be retained overnight. It is likely that most could have been ferried across the designated Portland Harbour area by Cosens' new paddle steamer fleet.

The fort now seems more an architectural sea defence than a military construction. Other forms of fortification had been in place to protect the harbour entrance; the earliest was known to be in the 1540s with other fortifications built to protect the town during the Civil War in the 1640s, which again must have caused some confusion, as the fortifications would have been located on the Parliamentarian side – Weymouth – but administered by the Crown, with the Royalists on the opposite Melcombe side.

The whole area of the Nothe and its gardens, laid out in 1889, made a very good playground. It was safe with many places to hide with many trees to climb and plenty of the enemy to contend with. From the Bincleaves side in the south to the Nothe Fort in the north, we had the run of the whole place, and with great skill, we could always dodge the gardener. To us, he was public enemy No. 1 with his frenzied war cry of 'Bugger Off'. Public enemy No. 2 were the 'itta' boys, so called because, if we were caught by them, they would 'hit us' hard with additional hurts such as 'Chinese burns' and 'dead legs', then steal our weapons; the weapons had been manufactured into works of art, honed to be a sharp, deadly fighting tool, which we had only made a few minutes ago from a broken tree branch. On one occasion, our gang had each bought a four-foot-long bamboo stake with our money pool from Therman's hardware store in St Thomas Street. We fixed a four-inch nail to the end of the bamboo making that our weapon of choice. However, we were out of luck that day. The 'itta' boys were well concealed, and without warning, we were surrounded and they pounced on us. Once caught and all held down on the ground, they

confiscated our new protective arms. The ring leader, Victor Spetch, had a new bow and arrows with him, but all this big boy's new arrows were now lost amongst the undergrowth of the gardens – that's how clever he was. So after hitting us all, he let loose our new bamboo weapons out to sea with his new bow so that these new weapons were now lost for good, just as his arrows had been. That was a rare occasion to be caught like that; we needed to keep our eyes peeled at all times. Usually, each of us would take it in turns to be the forward scout to ensure the way was clear before moving on.

The Nothe was also an area of gardens that skirted the sea area. These beautiful gardens with herbaceous borders, large shrubs and a variety of trees made concealment easy and all with the benefit of a sea view to keep watch for an incoming enemy. The two strategic points we sought to maintain our territory were at each end of the gardens and both were old Second World War pillboxes. The Bincleaves pillbox on Bincleaves Hill, gave a wide sweep of the bay and shore. The other pillbox was nearer to the Nothe Fort and level with the rocky shore. Both were the starting point and both were the target point for us to attack and both were also an unofficial public lavatory, thus it was decided that, although we could overrun the enemy, the enemy would be allowed to keep these pillbox strongholds. We reasoned that the interior was far too toxic for the enemy to stay for long, so a quiet wait was all that was needed for the enemy to

Wartime pillbox.

surrender, all without a pointed stick being thrown, as the enemy would be eager to be in the reviving fresh air. These two strongholds, which could resist strong assault by men and machine, would later fall victim to nature's landslips rather than to noxious and toxic oblivion.

From anywhere along the gardens, the view to Portland and its harbour could be seen, and when full of the Royal Navy's splendid ships, it was a formidable sight to witness. The harbour is made up of three breakwaters, which allow ships to enter through two openings. In the 1850s, with the breakwaters complete, ships sailing to and fro would have had their own self-defence systems as well as the surrounding forts to protect them. This was a belt-and-braces defence formula; such was the importance of this strategic naval establishment. Also around about that time, in 1859, the most modern ship of the day entered the new Portland Harbour. This was Brunel's steamship, the *Great Eastern*. This huge vessel, then the biggest ship afloat, arrived to take on coal as part of her acceptance trials, but, new and untried, she had an explosion en route that blew out her forward funnel, which resulted in the scalding of six of her crew, who tragically died.[6]

At the start of the First World War, it was decided that, on 4 November 1914, the battleship HMS *Hood*, named after Sir Arthur Hood, the first sea lord, was to be scuttled at the southern entrance to reduce the harbour from the three entrance points to a now-manageable and secure two. The old ship, HMS *Hood*, was now the permanent guardian of the harbour, and was still submerged and ready for continued unseen duties at the beginning of the Second World War. The reason that this large and supposedly important battleship was selected for now-stationary submarine patrol was that this early HMS *Hood* was found to be a bit difficult to maintain control of during rough weather, as it would take on much water at speed, although the Admiralty decided to move it to the calmer waters of the Mediterranean in peacetime. It would have been a liability in war. Scuttling this huge ship proved useful as a deterrent for enemy submarines or fast E-boat raiders, protecting this important naval port.

The upturned *Hood* could clearly be seen at low tide when visiting the harbour and was a great area to fish. Dad and a friend of his, who owned a small boat, would take my brother, myself, and the friend's two sons out for fishing trips in Portland Harbour. The small fishing boat would be positioned very near to this wreck where we would drop our baited lines into the deep water as the ship attracted many fish to congregate around it and, of course, we were always rewarded with a good catch, plenty of pollock and squid. I would have thought this valuable load of scrap metal of a sunken ship would have been removed by now, as the harbour is no longer a naval port, but not so; it still lies there in fourteen metres of water with a two-metre clearance at its high point. I would think HMS *Hood*

would make a great dive today as many items from the ship have been brought to the surface and are displayed in Weymouth's museum.

The harbour breakwater was built by the prisoners from Portland and became a tourist attraction, which was capitalised on by Mr Cosens who took sightseers out in his paddle steamers to both view the work's progress and also to see if any of the prisoners would try to make an escape. Mr Cosens would also keep in the good books of the contractor, J T Leather, as much toing and froing was needed to bring both materials and labour to the site. Completion of the harbour breakwater was visited by the future Edward VII, and such was the importance of Portland as a naval port that it must now take its rightful share as part of the long and proud naval history of Great Britain, as so many chapters of events started and finished there. As kids, we were very unaware of its importance. We just saw it as an interesting place with warships, a bit like the fine herbaceous borders at the Nothe Gardens. We were not at an age when we would plan visits to admire the *flora* and *fauna* of Weymouth. These were just good cover whilst we awaited the enemy.

The many warships of the fleet that used Portland Harbour would gather in an annual peacetime visitor Navy Day. This would bring large numbers of the fleet to be at anchor – a very impressive sight to be seen. Ships would be flying all their flags from stem to stern decorated with additional bunting. The most impressive were the big ships, the Battleship Vanguard with aircraft carriers *Indefatigable, Illustrious, Indomitable* and *Implacable* and the many cruisers – *Exeter, Belfast* and *Glasgow* – all with a host of destroyers and frigates. Small boats as well as our friends the paddle steamers from Weymouth would take the summer holidaymakers on tours around Portland Harbour to see Britain's splendid ships. The small boats taking these visitors around the ships on these navy days would offer a double bargain with mackerel fishing offered on the outward and the return journey, although none of the 1950s visitors ever wore a life-jacket, just a round, cork lifebelt positioned somewhere on the small boat. I don't remember any incident of 'lost overboard.'

The sight of the impressive ships, more impressive if the visitor was viewing the ships in a small boat, as they would tower over you, would make the visitor feel proud of our navy then and, of course, still today, even if it is a bit reduced. In fact, so dramatic has been the reduction of the fleet that the total number of ships in 1958 was 645, which included ten aircraft carriers and 127 frigates compared to today's total number of ninety-nine ships of all types. Our proud naval traditions aroused this interest in 1910, when Britain had the largest navy in the world. But a silly and perhaps useful hoax was played by one of Britain's eminent writers, Virginia Woolf, who together with friend William Horace de Vere Cole and four other hoaxers pretended to be members of the royal family of

Abyssinia (now known as Ethiopia). They were convincing enough dressed in African robes and faces blacked up to gain access to the 18,110-ton displacement of HMS *Dreadnought* when she was moored at Portland in that year of 1910. One of the party pretended to be the emperor, whilst Virginia Woolf, with hair cut short, pretended to be a princess. Now, this was not a navy day and to have six black Africans swanning around in isolation and in flimsy robes on a cold February morning must have looked quite bizarre; nonetheless, however bizarre it seems to be, the hoaxers got away with it. When this ruse was exposed, someone must have been in hot water over this lack of security check, and worse, the Royal Navy was made a laughing stock. Still, it must have been a welcome security wake-up call to tighten up the weak points. If a few blacked up people can board one of His Majesty's capital ships and can deceive its crew, then a few faux drunken sailors mingling with the real drunken matelots would not have had a problem getting on board their ship. The irony of this escapade is that the humiliation caused by Virginia Woolf would also cause humiliation of a different nature to another future HMS *Dreadnought* with the 'Portland Spy Ring' written about later.

HMS *Vanguard*, Britain's last battleship, which never, thankfully, fired a gun in anger, left Portland Harbour on one fine summer's day and, as a farewell salute, fired its big guns as it manoeuvred itself around Weymouth bay. Never having completed military service, this was our opportunity to witness the power and noise that a battleship could make when in action, yet we were aware how vulnerable these big ships were to aircraft attack. The Quads Gang rightly lined up, saluted and fired our cap guns in the air to return the salute. With the generous financial 'donations' the crew on board HMS *Vanguard* had given to help the fortunes of the poor brewers and pub landlords with their visit to Weymouth, the sailors must have welcomed the loud booming of the guns, as the noise would have helped concentrate their minds on the job in hand and off the crapulent condition they may have been in after leaving the pubs dry and now wealthy.

Up until the mid-fifties, we would read this name on the outside of the Nothe Fort as two words, NO THEFORT, as there didn't seem to be any gap between the 'e' and the 'f' but there was a gap between the 'o' and the 't'. We knew straight away this was to mislead the enemy, although we could not pronounce it; how the enemy pronounced it we never knew. Very clever, we thought.

As a working military defence establishment, we were able to watch and listen to the booming of the guns practising target shooting. There would be a fast boat with a long line in Weymouth Bay towing a floating barge with a target. This looked like a large willow-woven beach ball on its fast moving stand. The guns would boom and the water splash, but not a shot

seemed to hit the target, unless the shell went straight through its target, of course. One wonders what the danger money paid to the crew towing this marked quarry would have been, although as it was the fifties, they just got on with it – the 'claim culture' had not arrived yet. 'Right, men, we have got to tow this bally target thing around the bay as fast as we can and the fort will fire its powerful guns at it. Are there any questions? Right, off we go, keep your heads down. Anybody who takes a direct hit report to the MO as soon as we moor up.'

The whole of the Nothe area was strategically placed for the military to protect both Weymouth and Portland harbours from attack or invasion, more so during the last world war as D-Day was getting nearer; the place would have bristled with many anti-aircraft guns. The Georgian army barracks at the top of the central Nothe area, the Weymouth or Red Barracks, which were later converted into apartments now known as Wellington Court, date from the Georgian period and were complete with some family quarters. I would imagine that up to the thirties or even later, the name of Smith was quite prominent within the rank and file at the barracks, men losing themselves with no questions asked, leaving a poor woman behind somewhere with many hungry mouths to feed as the pre-war depression worsened. My sister Pat worked there for the army as a clerk for a short time, no doubt administering, in peacetime, redundant wartime systems in this forgotten barracks, although it was a place she seemed to have enjoyed working at.

The barracks would probably have been the central headquarters for the military billeted at 'Som Pee Air.' The soldiers were probably marched from No. 19 Trinity Road up to the barracks for either parade drill, a weekly bath and haircut, or to receive orders. These soldiers from the Royal Artillery would have been responsible for the Gun Operations Room controlling all of Dorset's anti-aircraft sites, which, locally, would have covered the surrounding protection for both the harbour and the immediate coastline, with the men manning the many AA guns and search lights dotted around the Nothe area. One of these AA gun emplacements was in the area near the fort end of the Nothe, near to the public lavatories used by visitors for the gardens. The AA gun area had an underground wartime control point that was manned by soldiers from the Red Barracks. As war had ended some six or seven years previously, this underground control point (my description, as it could have been a secure ammunition store) had been shut down but its secret remains were still there and, although very overgrown with brambles and other weeds, its entrance was there to be found. Of course, with war ended, the anti-aircraft guns surrounding it were also long gone. The control point consisted of a deep underground cavern with steps leading down into the dark from beside the footpath. This was a real 'I dare you' place. We had had many attempts in the past

to descend into this mysterious deep hole, each of us daring each other to venture down through this now-overgrown entrance. One of us would pretend bravery and squeeze past the barbed-wire gate and venture down the dark, damp steps, only to have that bravery evaporate, scampering quickly back to the top. Whatever lurked down there was neither man nor beast we surmised, but none of us ever got beyond the halfway point, as there was talk from rival gang members that human bones were scattered all around this cavernous lair.

After much failed bravery, we sat down one day and thought up a plan that entailed all four of us, Barrie, Ron, Frank and myself, working together as a team, to make an important, adventurous plan work.

The final agreed plan was made and we all agreed to obtain the candles and matches needed to make the plan work. So, with sharp sticks, cap guns strapped to our waists, and with candles and matches hidden in a rucksack, we made our way to the old military control point. We waited for the coast to be clear of passers-by, nervously held our candles ready, sticks pointing forward. We were ready to enter the barbed-wire entrance. Gingerly moving down the steps, the daylight was fading quickly, so now, halfway down, we lit our candles and then proceeded very slowly a little further forward, all four of us not saying a word in case the imagined abominable, ten-headed bogeyman should wake up with nothing but breakfast on its mind. Peering hesitantly, we turned left and entered a large room that had water covering the floor and many pieces of rusty metal mixed up with some old wooden boxes. As we could not yet see the worst object of our imagination, we sat down on the wooden boxes and wondered and whispered what the room was used for. Military, that's for sure, and no doubt used during the war, as it seemed bomb proof. We imagined all sorts of urgent commands given to the AA guns to open up as enemy aircraft were overhead, with the pounding guns guided at night-time by powerful searchlights to the incoming enemy planes.

Once we had explored, we decided that the scary devourer of small boys was not at home but, nevertheless, still felt uncomfortable at being down this one-way-out dark lair, not that we each admitted it. We started to make our way back to the steps only to be stopped in our tracks by the sound of footsteps coming down the steps. Was it the 'itta' boys coming down to give us another thumping? Who else could it be? Or more importantly, what else? We whispered to each other that if we made loud ghost noises, the 'thing' might clear off. With trembling lips, we each made enough combined ghost noises loud enough to invite the devil home; the footsteps stopped, then we heard running feet going back up to the entrance. We waited five minutes or so and then gingerly climbed the steps ourselves. Relief. No one was there, not even hanging around outside near to the entrance or even a short distance away. We crept out and ran off

ourselves in the direction of the Nothe steps that overlooked the harbour and sands, to make our getaway. Whoever that person or 'thing' was, they must have fast sought and found refuge in the nearby public conveniences to, no doubt, try to make good some soiled lower garments.

After one particular busy, late, springtime day on station, our gang was now through with the Nothe Gardens. We were on our way home and I picked a bunch of the sweet-smelling May blossom from a hawthorn tree, thinking that Mum would like some of these bright, perfumed flowers. At home, finding Mum in the kitchen, I took the bunch of attractive May flowers from behind my back and with a big smile presented them to her. Horror of horrors! Mum took the bunch from me very quickly, ran outside with them and dumped them in the rubbish bin. Taken aback by this unexpected reaction, I was both upset and confused by what she did; had they become encrusted with dog pooh on the way home or had a load of seagulls relieved themselves from on high on them? Mum explained that May blossom is an omen of bad luck if brought into the house. I could see no logic in this action, and Mum did not explain why a bunch of lovely-smelling May blossom was considered bad luck if brought into the house; after all, they are just the innocent hawthorn flower.

Since then, I have learnt that the smell of May blossom is associated with the flowers that people would carry with them to ward off the Black Death, thinking that smells caused disease; hence 'a pocket full of posies'. From there grew a superstition derived from the smell of the poor old May blossom, such was the ignorant mind of past generations; they thought that it signified that death was on its way. Mum was always looking for bad luck omens; spilt salt was quickly picked up and thrown over her shoulders. Putting a pair of shoes on the table, which I did once, resulted in them being quickly removed with an accompanying admonishment, not for the unhygienic thing I did but for the bad luck it was bound to bring. None of these bad luck omens have I carried through into later life, as logic, as boring at it is, takes first place. The Nothe was always full of surprises and the innocent May blossom was one of them.

With mischief in mind, we surrounded the fort; our giggling was what the bemused visitors had not sought.

Sandsfoot Castle was regarded by us as a great place to be. We felt it was full of mystery, with the battles we imagined happened there. We would visit the castle and the surrounding area quite a lot, using the coastal path from Bincleaves Hill, the location of our protected pillbox position. This path wound its way along an area known as the Western Ledges. This coastal walk was also a short cut, not that our gang would make grown-up comments about a 'coastal walk.' The Castle Cove sands area near the

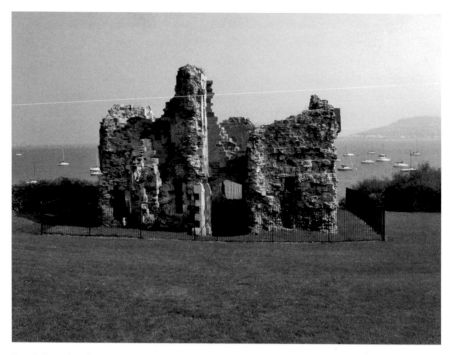

Sandsfoot Castle.

castle at Sandsfoot had a large, beached, wooden ship. This was fun to clamber about on, shouting out the classic lines from *Treasure Island* and other pirate stories as we walked the imaginary plank with its fearful drop on to the sands a few feet below. We suspected that this old ship was a smugglers' ship washed ashore in a storm with all hands lost.

Smuggling has always been an occupation of gain along the Dorset coastline with France and Holland, where the contraband could be collected, within easy reach. This illegal activity caused the smugglers to be constantly chased by the Customs men. Real smuggling is a far cry from the romantic notion found in storybooks of old. Weymouth's own writer John Meade Falkner's *Moonfleet*, with its smuggling theme, is much based on local lore from around the hamlet of Fleet with its proximity to Chesil Beach and the shady people of Chickerell. Savagery and violence were often the lengths men would go to to protect their contraband, which seems hardly different from today's drug smuggling: same bad people, new illicit goods, now a different date. Smuggling persisted, as it was deemed to be 'free trade'; even the most supposedly upright citizens subscribed to this illegal trade, including lords, the vicar, and even corrupt Customs officials. The best hiding places for the contraband were chosen because they were the least likely to be searched. Churches and graveyards, even the tombs housing the dead were used; those reluctant occupants never needed to be asked to be quiet or would not

interfere with the barrels of contraband brandy. Any sought-after luxury items were considered fair play by the government to raise taxes on. With smuggling reaching its peak in the 1820s, the revenue men, or 'Preventy men' as they were called, were wholly inadequately protected to seriously thwart the level of smuggling, thus making little inroad into stopping the rich rewards gained from their contraband. A telling reminder of the vicious actions taken by the smugglers is a headstone in Weymouth's museum telling of an incident with the chief revenue man, Lieutenant Thomas Knight, who was beaten senseless and thrown over the cliffs at Lulworth as he attempted to apprehend some local smugglers who were hell-bent on retaining their ill-gotten gains. This brave man left a wife and five children.

The little Sandsfoot Cove beach, then, could be accessed by some long narrow steps from the coastal path, perfect for smuggling parties. The narrow steps, we imagined, would also be used by enemy secret agents, who would land on dark nights, climb the narrow steps and carry out espionage acts, such as sabotaging the now-closed railway link to Portland, before returning to their rubber dinghy and then to the waiting German *Unterseeboot*.

Sandsfoot Castle was built by Henry VIII in the 1540s and is located at Old Castle Road, Weymouth. Would this, perhaps, have been known to the change of guard as New Castle Road in 1540? Built as a coastal defence, this castle would have been very vulnerable to attack by land, causing it to change hands on a number of occasions. The castle was used during the Civil War to mint money, no doubt to fund the cause. Sandsfoot Castle also saw a siege during the Monmouth Rebellion. The castle's original purpose was to protect English shipping, using Weymouth and Portland to shelter from foreign raiders. This was before the giant breakwater that now forms Portland Harbour was built by the inmates from Portland Jail in Victorian times. The garrison of fifty men stationed at the castle would keep a watchful lookout in case an invasion force thought to land and would prevent these invaders from forming into an army.

It is suggested that, after Henry VIII's dissolution of the monasteries, stone from Bindon Abbey near Wool, was used to build this small castle. This certainly could be the case, as the window designs are more in keeping with an abbey than a fortified stronghold. Portland, with its wealth of stone, was a short boat trip away, but the builders chose to drag all this stone from the further distance at Wool, probably because the stone was already formed ready for building and could be used like a giant Lego kit. After falling into a dilapidated state in later years, Sandsfoot Castle was bought from the Department of Woods and Forests in 1902 for the princely sum of £150.00 and as today's estate agents sales patter would say, 'An interesting property with far-reaching views to purchase; needing some TLC,' very des res if the TLC was in abundance.

The castle has, for many years, been out of bounds to the general public due to its precarious and dangerous condition. Railings were installed to surround it, thus preventing access, or so they thought ... We four could get into the fort by clambering up the short side of the cliff face that faced the sea. This brilliant climbing area was marked 'Danger Falling Rock'. Huge lumps of the castle had already broken away and rolled onto the slowly receding shore line below and there was danger of more falling at any time, although, surprisingly, much of what should have disappeared is still there today. Written on part of an internal wall on the sea-facing side, hardly legible now but easy to read in the fifties by the fort's visitors standing on the grassed area that surrounded the fort, is a small area of black, painted graffiti of a man's face with horns, with the words of 'Old Nick'. Mum told us 'Old Nick' was another name for the devil; of course, Mum would know those sorts of superstitious things. Was this to ward us off from the dangers of falling rock or written by a discarded female who was loved and left at the castle by her 'devil' of a boyfriend?

The castle gardens, which are very splendid and give good views of Portland and its surrounding sea, were, to a group of children like us, just another playing area. On one occasion, after much running around on a hot summer's day, we found shade under the wooden footbridge that formed part of the path that led from the garden to the castle. This wooden bridge was made up of slats of wood with large gaps between each slat. Lying under this shady, wooden bridge looking up at the sky through the slats, we realised that we could see the legs of people that walked over this bridge. We were amused by the fact that some of these people were ladies wearing dresses or skirts. Whilst we were ignorant and had little interest in the female anatomy, we were a little bit fascinated by some of the ladies, because, due to the warm weather, they had chosen to wear 'less restricting' undergarments. The bridge has now been replaced by a new, closely slatted footbridge, although not that closely slatted. Perhaps this new replacement bridge was built because the tranquillity of the garden was being disrupted by the giggles of hidden small boys?

The Shape that Died of Shame

What we saw was sublime, but our minor creation was a crime.

Whilst many holidaymakers and visiting navies from home and abroad visited Weymouth's resort to enjoy the pleasures of the area, the wider area of Dorset was of much interest to film companies as a film location. Dorset has been used as a backdrop to complete many film settings, using its sea, countryside and coastline. Many films were made, all had a nautical flavour, as Weymouth and Portland were interesting and natural settings. These included, *The Cruel Sea*, some of *The Dam Buster* scenes, Noel Coward's *In Which We Serve*, and *The Key*. Weymouth Bay was used as the North Sea for *Heroes of Telemark*, and Weymouth Sands used in *Far from the Madding Crowd* with many other locations used in later years for both the large and small screen. The making of a 'Hollywood picture' was always an exciting act to watch.

We were pleased if the film was classified by the censors as 'U' rated, as this meant that we could see the film without an adult holding our hand to shield us from the vile and bad things shown in 'A'-rated films, such as too much kissing and sexy smiles with the heroine using such odd Americanisms as 'you trying to get fresh with me?' whatever that line meant. A 'U' certificate meant the film was acceptable for boys of our age, even if it had John Wayne standing knee-deep amongst hundreds of dead Red Indians who were shot whilst protecting their land, whilst some kissing was thought to corrupt us. The latter was bad for our moral outlook and likely to send us off the rails in later life. As for 'X' and 'H' films, we had to wait until we were much, much older to view these, and then, often, we were completely bored by them. Anyway, our gang would try to see the film later at the pictures and have fun looking out for the scenes we had watched being enacted.

The arrival of a film crew with their apparatus was most common during the summertime, obviously to make best use of the weather. We would try to seek out the locations the film company had selected for the scenes and watch the 'stars' perform, although mostly it was very boring with retake after retake; that's if we could get near enough in the first place. In 1955, the film named *The Ship that Died of Shame* was released.

Many outdoor scenes had to be shot sometime before that release date and one known scene was filmed at Weymouth Harbour. The film had George Baker, Richard Attenborough, Bill Owen, Virginia McKenna and Bernard Lee. All of these names were destined to make an even bigger individual name for themselves in later years.

The scene we watched took place by the harbour near where Cove Road stops and Nothe Parade starts, about 150 metres from the lifeboat station. At the time, there were some harbour steps that ran down from the quayside to the water where the star of the film was moored, a sleek and very fast motor torpedo boat from the Second World War. The story is that, after the war, a redundant motor torpedo boat named 1087 is purchased from the navy by its former crew led by George Baker. They intend to use this very fast ship for honest, quick shipments across the Channel. With Fascism defeated and Great Britain back on form, it is an optimistic start, but in spite of Mr Attlee's government promising all the best things for Britain, the country has descended into spivvery, which forces the good men of 1087 into trafficking drugs and becoming criminals. Anyway, the result is that the ship is so 'ashamed' of all this bad stuff it's been asked to do that it dies of shame by sinking. The End.

During our bored moments of watching take after take, we became most intrigued, not so much by the filming, but by the red telephone box near the steps of the location. Whilst, at first, we thought nothing of a standard red telephone box the film company were using (after all, we had seen them all over the place), we were surprised to witness the film crew simply move the phone box a short distance to a new location. 'It's not a real telephone box,' we whispered excitedly to each other. 'It's a "prop".' This perfect replica of a red telephone box could be lifted and moved to any part of the film set that they wanted; a false but real enough telephone box. We watched this with great interest, thinking what a great prank we could play. We could make April Fools' Day the best we had ever planned. Our problem was how to get our hands on a dummy telephone box. We couldn't steal the film company's, as it would, of course, be too heavy to carry. Also, it would be dishonest. We ruled out wandering up to the film crew and asking if we could borrow the telephone box for a few days or weeks, as we knew that we would be met with a laughing rebuff, or worse. The only solution was for us all to make one. This would be simple. We could borrow some of Dad's tools, scrounge some wood from the bomb damage at Chapelhay, buy a tin of red paint with next week's pocket money and we would have a perfect likeness of a red telephone box. Well, the best efforts of reworked orange boxes, bomb-damaged timber and red paint would not fool a three-year-old; in any case, only a three-year-old was able to stand up in it, but what a hoot it would have been if we could have pulled it off. We had planned that the receiver would have had ink

spurting from it, and the best bit was to divert the fourpennies that the user had put into the slot to make a call. It would have rolled into a secret hidden box inside to make us rich.

The film *The Ship that Died of Shame* went on to critical acclaim and no doubt made lots of money. Our telephone box also died of shame; it was a shame we could only build it three feet high, a shame we did not make the fourpenny per sucker, and a shame we were told off by Dad after blunting his expensive tools.

One of our more usual days out was spent in the continual honing of our ability to just mess about, nothing planned, just on the look out for something to happen. Then, seeing the 'itta' boys at some distance on this particular day, we decided to not hang around, so, running fast to make our getaway, we could see a huge ball of black smoke billowing up from the sands and harbour of Weymouth. We rushed over to the top of the harbour steps that lead to the Nothe and saw that the Ritz Theatre was on fire. 'Wow!' we said, 'The Ritz is on fire!' None of us had ever seen such a big blaze. The date was 13 April 1954, but what a big blaze that was; we all wished it could have happened on 5 November. I don't remember the comedian's name, but he had over a lifetime, built up a huge catalogue of jokes. These he would refer to over the years as part of his ever-changing act as he worked the halls around the country. He lost the lot, which was not quite the laugh he had expected: 'Yes, misses, it's all gone up in smoke.' He must have had a 'blazing' row with his insurance company, which might have been one of his new jokes:

'You promised me that all I would lose would be replaced, like for like.'

'Yes, sir, we have a team who, as we speak, are all "pulling together" with a Mr Tom Smith, the result of which will, in due course, bring a "cracker" of a wealth of replacement jokes.'

The fire was started by a workman's blowtorch burning off the old paintwork. The old Ritz, or, more correctly, the 'new' Ritz as it was reopened in 1950 after war closure as the Ritz cinema, was converted back to a theatre with similar acts performing to the original Victorian music hall, which was built and opened in 1908. With its elegant, domed, turreted architecture, it probably had rather a lot of well-seasoned timber and, of course, fire and old paint do get on well together. The new, renamed theatre, The Pavilion, was rebuilt in 1960 and, of course, looks like it was built in 1960, with expediency and lack of big finance kicking out style, which went down in the history books as sixties' style, but who can tell, each period has its 'classic' style.[7]

It was about this time that we had to stop playing with Barrie and Ron. Mum heard Barrie swearing. I think it was the Nothe gardener's war cry that he would replicate well and often; anyway, we were told never to play with them again. This was a pity, but we were going to lose them as

friends anyway. After this parting, the family moved away to the North East of England. They were not upset with Mum's order not to play with them (in fact, we never told them what our Mum had said), it was just that their mum was homesick for Gateshead. I also think their errant gasman dad had cleared off anyway. All Barrie said to us as he and Ronald left was 'we've all got to bloody well bugger off to Gateshead.'

I was saddened to learn that the Alexandra Gardens Theatre had also burnt down. What is it with Weymouth's entertainment venues? Are the shows really so bad? I knew it had changed from a place of intelligent entertainment to a place of simple-minded energy with slot machines and other dubious entertainment to lose your pocket money on, so therefore the theatre was not in the original state of the fifties. I was sad to hear of its fire, as I had spent some very memorable times there. One memory of the theatre had a huge impact on me; this was when I attended to hear the Chris Barber Band perform. The most influential of the evening was the accompanying act of two Blues musicians from America, Sonny Terry and Brownie McGee; they made a much bigger impact on me than the very popular Barber Band. I still have the programme.

On another previous occasion, I visited the theatre with brother Frank and Rob (a new replacement 'Quad' to cover for Barrie's resignation, although Rob had not qualified as a full gang member yet) together with his mum and his older brother. Rob's family lived a few doors away from me at No. 21. His mum was a widow whose husband had been killed in the last few days of the war in the Middle East. To make ends meet, she was working as housekeeper to the doctor who owned the house. Rob's mum was a very kind and generous person in spite of having very little money. I helped one day to cut the grass with her and Rob; each of us was given a pair of scissors, no mower, no shears, just domestic scissors. The grass of the lawn, which was located with its boundary next to Trinity church, had not been cut for some time and was quite long. However, with our best efforts, we managed to make the lawn look like the head of hair of a one-handed man who had cut it himself in the dark.

Rob's mum would invite me for tea with her two sons and we would eat cornflakes and bread and jam with cups of tea. The simpleness of the food, of course, was not important, as the company was such good fun. Mum never returned the invitation to her two sons, to whom she could have offered omelettes, cake, and lemonade. Rob's mum's generosity extended further to inviting Frank and I to join her with her two sons to the 'free' film show at the Alexandra Gardens Theatre. 'Gosh, what a treat,' we thought. Once we were all seated with a bag of boiled sweets between us, we waited in eager anticipation for the films to start. The films shown were unique, as they were in full colour and opened showing birds flying or bees buzzing around a hive in slow motion, all filmed at fast speeds then

showing the effect at standard speed to produce the slow-motion effect, demonstrating the fascinating actions of nature. Whilst all of this was very interesting, I wondered what would be the main film, making sure I saved some of the boiled sweets for the best bit to come.

We had worked our way through all the little titbits of the 'B' films in readiness for the 'A' film so, with anticipation, the 'big' film started with an American voiceover. That's a good start, I thought. Would it start with rustlers stealing the landowner's steers, firing their Colt 45s in the air with the good guys chasing after them? I hoped so. As the film quickly developed, it became clear what the 'big' picture was about. It had a man, tanned, well-groomed, eagle-eyed and flashing a beaming, white smile, an American named Billy Graham, a forerunner to Ned Flanders, and he was asking us all to come out of our seats: 'Come right up now. Come out of your seats.'

Could he mean us? I wondered. Have we all got to stand up and go on the stage? Rob's mum just sat there, so we all followed her example and stayed in our seats. Whilst this was going on, a number of dowdy-looking people took to the stage offering to bless us and take us into their church. Not a single gunfight at the O.K. Corral nor Jessie James and Billy the Kid robbing a bank; still, he was an American named Billy even if he had no horse. So another lesson learnt. If it's free, there's a catch. So beware of evangelists with free tickets for the pictures. Afterwards, we thanked Rob's mum for a nice evening watching all those people queuing up to become good.

Cal McCord was a real American cowboy who did have a horse, a real horse, and he could twirl his six guns. This American cowboy performed an act at the Alexandra Gardens Theatre singing cowboy songs and performing cowboy tricks. The songs included 'Old MacDonald had a farm', 'Shortening Bread' and a fifties' song of the moment 'Maisy Dotes and Dozy Dotes'. His rope tricks were very well practised; one would involve him sitting on his horse and, using a forty-foot rope, completely encircle his horse whilst sitting on it and not touching the horse with the rope. He could also quick-draw a gun and twirl his guns as he threw them up in the air and do the usual other cowboy tricks. His horse was stabled in one of the thatched seating huts within the Alexandra Gardens. Here was this American cowboy over from the States with his horse in the 1950s.

Cal McCord either rented a horse over here or came by ship and it may have been lifted off by a tall, dockyard crane. For a small fee, children could sit on the horse and have their picture taken. His autograph was interesting: a name was written in capital letters, CAL McCORD, with the letter M drawn as a cowboy's hat with a face and neckerchief underneath it. Whilst he was billed as the singing cowboy from the USA, I don't think he lived in New Jersey, USA but certainly he hailed from Old Jersey in the Channel Islands.

They wished us well as we bussed off to hell. With beasts on all fours we were lost without doors

Uncle Fred had given me a small ridge tent as a birthday present and the four of us in the Quads Gang decided one day to go camping. We were not bored with the sands or the Nothe, we just felt we wanted to be a little more adventurous; not an overnight camp but a day camp to investigate the impenetrable jungles of the Dorset countryside to be explored with tent, primus stove and many chips, cut and ready to cook. After preparing the ex-army surplus rucksacks with that important single item of a bag of ready-made chips, we set off with pen knives in readiness as a substitute for the absence of machetes. It was with much trepidation that we contemplated our objective: Upwey, near the Wishing Well and its surrounding fields, rapids and swamps. The past name for the Wishing Well was 'The Springs'; however, the writer Hawley Smart, whose name we thought sounded like a Far Eastern rickshaw puller's nickname, used the Wishing Well for the setting of his book *Broken Bonds* in the late nineteenth century and so the 'Springs' became 'The Wishing Well' for the gullible Victorians to spend their time and money visiting.

We caught the bus from the Town Bridge, the Southern National double-decker green bus to Upwey, sitting on the top deck as we discussed the adventure to come. The slow, plodding bus took us on the Dorchester Road route, which then, as now, was very much an up hill and down dale sort of a journey to the little outpost village of Upwey. The bus terminated by reversing into its parking space outside the Wishing Well. This parking place was also the exit and entrance used to move cows and wildebeest from one field to another, which, on hot summer days, would drain the area of fresh air and attract a plague of flies and locusts as they followed the massed herds. After the cautious alighting from the now-motionless green bus, we, now riding high on optimism, looked around to find a suitable spot to set up camp. This proved to be difficult as the fields either had cows and roaming wildebeest in them, or our camp would be seen from the road by the natives; they, of course, would inform the farmer, who would then come over and tell us in an unpronounceable form of address to 'clear off', as farmers do.

Wandering along the main dirt road that lead out of the Upwey outpost towards Martinstown, we soon became hungry, hot, exhausted and irritated by the buzzing flies. By now, the heavy load of prepared chips had sunk to the bottom of the rucksack that we were taking turns to carry. We were sat by the side of the road, discussing what to do next, when, suddenly, we heard a motorcar coming in our direction. The mud-splattered, black car stopped and a young lady asked us what we were doing sitting there in the middle of nowhere. After explaining our plight, she offered to let us

use a field on her farm as long as we were gone by 5 p.m., and better still, she even offered us a lift.

Frank, Rob and Macky, the last new Quad to join, climbed into the back seat with all the gear and I sat in the front, next to the driver, with the rucksack, guarding the chips. I told her that I hadn't seen many lady drivers, and she told me that she had driven an army car during the Second World War. She drove back in the direction of the outpost of Upwey Wishing Well. She asked us our names, which we gave, but I don't remember her giving us her name; perhaps she did but the car ride seemed more fun than knowing her name.

Looking recently at the old parchment OS map, I have worked out where she gave us a lift from, which was a point that seems to be just before Higher Aston Farm. Higher Aston Farm is located in the high hills surrounding Upwey and is on its way to Martinstown, a place famous for having the highest rainfall in the UK in one day; 279.4 mm, nearly 11 inches of rain fell on 18 July 1955, some four years after we were there. Anyway, after a few minutes, the car turned right into a narrow road, which I now know goes around Corton Hill.

Just before Corton Hill, this kind lady stopped the car by a footpath on the left-hand side of the road and told us to go up the track to find a suitable spot to camp, saying that her husband had no cows up there; we did not ask about the wildebeest. We thanked her for the ride, and began a walk, which turned out to be more of a climb than a hike up to the top of a ridge. On arriving, we looked around for a suitable place to camp but were put off by the many cowpats and wildebeest bones that had been cleaned white by the vultures that were circling high above the place. Eventually, we agree on the best place and set up camp. The tent was put up, primus stove lit, guards now stationed, and the already-turned-grey-brown, limp cut-up chips were sizzling away in the frying pan. This is the life, we thought; so what should we do after our feast of multiple helpings of chips? Should we explore the surrounding woods? Or perhaps investigate how much further the track went before we reached a wall of impenetrable undergrowth? Or ambitiously just mess about? After an hour of indecision, we did what we knew best, and that's larking about, which is just a little more energetic than messing about.

Suddenly, our attention was caught by the sight of black and white cows (or were they wildebeests?) in the distance. Now, the lady had said her husband, the farmer, was not going to put the cows in this field, so either we were in the wrong field, or that nice lady was wrong about her husband's cows, or perhaps he had been annoyed to hear she had let us use the field so he had let the cows loose. Well, cows being curious things, they made a stampeding beeline for us and the tent. We didn't know whether to shoo them away, climb trees or what. These cows did not want

to be shooed away and, much worse, began producing very large, smelly cowpats, which attracted loads of flies, all of which were very near to the tent; in fact, the cowpats were now splashing on to the tent. Nothing for it; we quickly took down the tent and we packed everything away so hastily that we managed to step into at least two or three cowpats each. Both shoes and the camping equipment became covered in the worst that the cow's outlets could offer.

From my memory of the lie of the land, the Wishing Well outpost area should be just to the north and over to the right of us. Not that we were much interested at the time. Upwey in medieval times was sometimes known as Weybayouse, which seemed far too posh for the Upweyians to continue using. 'Arrr, it be Upwey to us; that Weybayouse nonsense is for them that are posh enough to wear clogs.'

Anyway, to continue with the story, this fleeing journey turned out to be down a very steep hill that we hoped would take us to the bus terminus point. Well, the trudging, moaning, the stumbling and slipping caused us to lose our bearings and we ended up in a wooded area that skirted the River Wey. Our plan was to follow the river back to reach the Wishing Well outpost, and from that point, we should find the bus terminus point. After a short time, we did find the Wishing Well, but we were now inside the Wishing Well area. We needed a way around the Wishing Well itself, which seemed quite secure with no obvious escape route out, unless we walked – or better still, ran – through the tea rooms. We reasoned that the surprise would take the waitress off guard, and we would be gone before the alarm could be raised, but then the bus-stop we needed was only a few feet from the tearooms, so all the waitress had to do was demand payment for the Wishing Well visit as we waited for the bus and we didn't have that sort of money. We could see a few visitors gathered around the well to drink the water and, I suppose, make a wish. If we could get near to the well, we could all make a wish to whisk us out of here; other than that, how do we now get through this?

Carrying the tent, I peered around from our high-up, concealed position at the Wishing Well to see if we could somehow creep around the Wishing Well and avoid the guards; however, I lost my footing and slipped, and in so doing, I hit my head on some of the walled area around the well. Dropping the tent, I put my hand to my sore head only to find that blood was now pouring down the side of my face. I was also standing up in the shallow waters of the river looking for the tent, which I managed to grab before it washed away, but now I was very frightened by all the blood running down my face on to my shirt. All I could remember doing was shouting an urgent, tactical response: 'Help me! Help me!' I shouted as I clambered onto the hard surface surrounding the Wishing Well. This is the same area on which King George III must have stood to take the waters as

he sipped from his gold cup, whilst wishing a speedy route back to good health.

A gentleman by the well took out his handkerchief and mopped my head. He took me into the Wishing Well's tearoom, where my head was cleaned and a bandage applied. I must have turned very pale and dizzy because the kind man and his wife were so concerned that they offered to take me home in their car. This they did but left the other three members of the gang behind to find their own way home. So there I was arriving home after a supposedly relaxed camping expedition, shoes and trousers wet and covered in cowpats, my head bandaged, and my shirt covered in blood. The very kind gentleman took me to the door of 'Som Pee Air', the posh upstairs entrance would you believe, the door where Mum always removed her kitchen apron before opening it, whereas, had this been the downstairs dungeon door, she would not have done so. Apart from a good clean up, I can't remember much else other than that the wound to my head turned out to be only a small cut. Did Mum pay for his petrol, invite him and his wife in for tea, or what? I have no idea. The other three, Frank, Rob, and Macky, did manage to get home with all the gear, despite the fact that the first and second bus conductors would not let them on the bus as they all looked and smelt so awful. For some reason that was the first and last time we all went out on such a dangerous mission to the Wishing Well Outpost. The good thing was that my clever distraction caused none of us to pay the Wishing Well's entrance ticket. 'All's well that ends (at a wishing) well'; so not a bad day after all.

Old Mud's Grizzly Bear and other Residents of Trinity Road

Foot loose and fancy free, big Teddy had gone off for a night out to sea.

Venturing far to seek places to explore, there were some interesting surprises on the home front in Trinity Road. Facing 'Som Pee Air', next door to our left was No. 18, and there resided one of our two near next-door neighbours, a gentleman of whom we knew but we did not know his name. It could have been Mr Mudd or Mudford, Mudland, Mudsmith, Muddi(e)man, Mudditt, Mudie, although, come to think of it, it was Mr Burford. He was a triple-cardigan-wearing, elderly gentleman who rarely ventured out. Mum said he was like Charles Dickens' character Ebenezer Scrooge, but without old Scrooge's joie de vivre. I suppose, for Mum, 'Old Mud' was a reasonably good label for our neighbour, had he been really objectionable his appellation would certainly have been 'Old Vinegar Face.' The front steps to his house were similar to ours with a raised platform above the pavement leading to the front door. His claim to fame, as far as the family was concerned, was that Old Mud had standing on this platform doorstep a full-size grizzly bear. I can't remember if this was a real bear but, of course, stuffed, or a carved wooden bear; either way, the bear was very large and on permanent guard. The most intimidating part of this bear was his eyes, they came alight at night-time, uniquely hypnotic, glowing eyeballs that seemed to follow you from wherever you stood; so no sleeping bear for Old Mud, until one day, or one night, the bear went missing. The usual suspects were sailors returning to their ship after a pub visit.

Now, here we have a situation that involves a full-size grizzly bear, either stuffed or wooden but, in any case, large and heavy, going missing overnight. Nobody heard anything suspicious. All that was known was that the bear was gone. One can only assume Old Mud reported the missing bear to the police and only imagine the possible conversation that took place. At the time, the police station was housed in the old, porticoed Guildhall just over the Town Bridge in St Edmund Street. It was a unique place; as it was built of the ubiquitous Portland Stone but was now black from years of the town's pervading smoke from domestic coal fires. I can imagine the jaded, whiskered police sergeant being bemused when

approached by Old Mud telling his tale of how GB, his friend and minder, had gone missing. 'Er, perhaps he has wandered off and will be back at teatime, sir.' Or perhaps the sergeant sought the 'bear' facts from Old Mud so that they could get some sort of 'bearing' as to where they might find him but, more importantly, to identify the errant animal: 'Does he "bear" any resemblance to anyone. Maybe he's gone to the tailors, as you mentioned that he was very thread "bear". We will do our best, sir, to find him, sir. We can assure you that our search will "bear" fruit quite soon, just '"bear" with us, but please "bear" in mind, it could take a little while, as your description was a little vague. Still, whilst we are looking for him sir, you will have to grin and "bear" it. All the time, poor Old Mud was probably becoming more perplexed with the police line of questioning, with the young recruit engulfed in hysterics now having disappeared to the back of the station leaving the front desk and the stony-faced sergeant and Old Mud to themselves.

In due course, the bear was returned by the police. We knew how but not when, although the bear now stood in his original place attached with a strong padlock and chain. Where had this adventurous bear been? Who had taken him? Dad had heard that it was indeed taken by sailors returning to their ship after visiting the pubs. They had 'released' the bear into their care and had taken it back to the sailor's ship, which if one understands the method which sailors use to return to their ship, one has to admire the skill, determination and ingenuity that HMS personnel were able to show.

The return to ship was always by liberty boat. This was a shuttle service that operated from the moored ships in Portland Harbour to the Pleasure Pier at the mouth of Weymouth harbour. To get to the liberty boat, the sailors would have to carry the bear from its Trinity Road sentry point, quickly over the Town Bridge, down a flight of steps to the poorly lit Customs Quay and walk to the end of the pier, a walk of a mile at least. We don't know how many sailors were involved in this unique task, but at least four must have been involved, maybe more. The trickiest part of the heist would have been taking the bear down a flight of steep steps at the pier end to the waiting liberty boat, which was never moored fast, only 'held to' whilst the sailors scrambled on to the high-sided boat in choppy seas, then the liberty boat would pull away and make its way to the battleship, cruiser, aircraft carrier or destroyer moored in Portland Harbour. Was the grizzly bear smuggled on board wearing a sailor's hat and smart shore leave raincoat? Did someone on the sailor's ship do a head count as the sailors boarded? Under the gloom of a ship's lights, the detail of a sailor's face would be a little obscured and an inebriated sailor's face and a stuffed grizzly bear's face might not look too different, or was there a diversion from their other shipmates who had helped drain the many Weymouth pubs, therefore causing a little confusion with the head

count? If Virginia Woolf and friends in days past could disguise themselves and board ship, then Old Mud's grizzly bear would have cakewalked it. I would swear that after his return, sitting in the front of a police car with two uniformed officers in the back 'just in case', the bear had a permanent smile on his face and his hypnotic eyes were now looking crossed, making him thereafter a useless guard.

At some point, Old Mud moved out of the house or perhaps helped to look for honey pastures new; either way, Old Mud was seen waiting on the pavement with bags, boxes and the bear listening to Old Mud's mutter as they waited for the taxi, he 'bear headed' and the old grizzly standing 'bear footed.'

No. 18 was to follow a little like No. 19, but now in peace time, and be acquired by the military and was in part converted into a recruiting office run by army officer Donkin. Dressed smartly in his military uniform with a welcoming face, a big smile and persuasive manner, he would often say: 'When you are old enough, boys, don't knock, just open the door and walk in; the army is the best life in the world.'

We were not keen on joining the army just yet, if ever, so whilst we missed Old Mud's grizzly bear, we became rather keen on the new and young occupier who had taken the bear's place, not on the steps of course, but living with mum and dad Donkin, a young lady named Miss Wendy.

Wendy, the pretty young maid from next door also lived with her younger sister Elizabeth and the family dog. A dog, which had the same now politically incorrect name as the black dog belonging to Guy Gibson (of Dam Busters fame). This dog would sometimes be called if it came off his lead, with the resultant shouts of its name, 'Nigger, Nigger, you bad boy, come here,' which could, but I don't think it happened, be upsetting for the African American sailors who sometimes walked past our house on shore leave from Portland Harbour on a goodwill visit from the USA. To avoid calling the dog by its known name, should it naturally offend and upset the recipient and damage the goodwill visit, all one had to do was to shout out, 'Come here, you black dog,' which our neighbours would trust to be acceptable to any passing African Americans.

Wendy had become a friend, so Frank and I were invited to Wendy's birthday party. That's two boys and a few girls. Off we went, dressed in our Sunday best, carrying a box of Meltis fruits, a medley of over-sweet, coloured confectionary, as a birthday present and soon realising that there were twelve girls at this party. Of course straightaway I realised this would involve a lot of kissing being carried out. You kiss six of them and I will kiss the other six was the simple arrangement I suggested. If only I could have got Frank to kiss some, or one, or even hold a few of the girls' hands, it would have made my job a lot easier. We didn't row over it. I just asked him to help out as the girls kept running to the back of the queue, as

girls do. I reminded myself some years later of listening to the great Jazz trumpet player, Hot Lips Page, giving myself the new moniker of Sore Lips Page. Still, I didn't want to seem unfriendly and they were our neighbours after all.

One evening, on another occasion, as it was getting dark, Wendy, Frank and myself were playing outside our houses and we decided to cross over the Town Bridge to the opposite side of the harbour, to the Customs Quay near Pankhurst's motorcycle shop. What attracted our attention was the old clanking GWR pannier tank engine 1367; the much-worked train that ran along the harbour side had stopped near the tunnel that takes the train under the Town Bridge. This was the one and only railway engine that daily passed back and forth on this route, which, of course, made 'train spotting' for Frank and I a very limited hobby. Anyway, this train had stopped, which normally occurred at a high tide causing flooding to the area of railway tracks directly under the bridge, as water and a hot engine firebox don't mix too well. Within a short time, the water had receded and the long goods train, no doubt full of recently unloaded tomatoes and potatoes from Jersey and Guernsey in the Channel Islands, had now continued on its short way to Weymouth Station. We had beforehand placed a penny on the line so now retrieved yet another small-sized cart wheel.

It was now getting dark, and during our short time there, we had generally been messing around near the harbour's edge by the corner of the bridge, then for some reason, without any deliberate action or intention of just old-fashioned messing about, Wendy, to our surprise and, no doubt, to her surprise as well, fell into the harbour. After some effort to grab hold of her, Frank and I managed to pull a now-soaking-wet Wendy out of the water. It was fortunate that it had been a high tide or we might not have been able to reach down and grab hold of her to lift her to safety. Wendy was naturally very upset and, of course, very cold and very wet, and we were naturally worried that we would get into big trouble for this mishap. We walked Wendy home over the Town Bridge, and with her lower front door not locked, she disappeared inside. We quickly dived into our own home saying nothing to Mum or Dad.

The next day, we had a message from Mum to say that Mr Donkin, Wendy's dad, wanted to talk to us. This is it: the biggest telling off ever coming up. The local newspaper and hospital are on standby for this, because once Mr Donkin had dealt with us, Dad was going to have a few harsh words, or worse, to add to Mr Donkin's sharp lecture, or even much, much worse. Frank and I, after arguing who should go in first, together gingerly walked up the recruiting office steps at No. 18 with its long, white flagpole and fluttering military flag and there faced Mr Donkin, who was sitting behind his military desk in full, immaculate military uniform,

looking at us in a firm manner, his eyes never leaving us. It's the military way. Mr Donkin was a man holding an office of officialdom who was used to taking orders and, of course, very good at barking orders at the lower ranks; the lower the rank, the louder the order became, and we were lower than the lowest of the lowest ranking soldiers. We stood in front of him using our best Cub Scout attentiveness, while at the same time, shuffling nervously. Then he slowly pulled open the draw to his desk, but took nothing out, did he have a gun, a horse whip, a baseball bat with a six-inch nail protruding through the hitting end? Looking us squarely in the eye, he said that we shouldn't worry about Wendy falling in the harbour and getting wet; what was very important, he went on to say, was that we did not run away and leave her in the water (to drown). He then thanked us for staying with her and bringing her home, then, reaching into his open desk draw, he removed and gave us both a brand-new penknife, one that you could hang on you belt, wow! What a reward for doing something we thought was wrong. Whisper, whisper: 'Let's help her fall in tomorrow,' not that we helped the first time. Not likely, that was a pretty frightening episode. We had probably saved someone's life, but somehow it didn't seem like that at the time.

Dad was very pleased with us because we did not run away and were both rewarded for our actions. It's odd, but both of us had no thought of leaving Wendy in the water and running away. Why would we? You can't leave someone who's in trouble; still, we were in Dad's good books for a while. 'Let's make some lead fishing weights? Dad's not in the workshop.' Frank had other ideas. He walked down to Mr Hayman's fishing tackle shop and carved a lump of wood from Mr Hayman's new and green-painted shop windowsill with his new penknife. Frank told me later that the penknife worked very well.

Our other near next-door neighbour at No. 20 was a gents' hairdresser and we entered this men-only world from the lowered pavement to a similar-size dungeon, only much darker, as the upper pavement was higher. The haircutting arrangement was run by a Mr Bill Pavey. Frank and I used to go there for our prison/national service/austerity-style short-back-and-sides haircuts, where the romance of recent military authority dominated the style of the day, more accurately known as 'conveyor belt no choice'. The interior of this men-only-world hidey-hole was created from his mixture of old cinema seats and odd three-and-a-half-legged kitchen chairs, which we would sit on whilst we waited our turn. Frank and I became transfixed, intrigued and puzzled as we listened to the animated football discussions about the Terras, the Weymouth football team, so-called because they wore 'terracotta' and blue outfits. Dad was a huge football fan and would drag Frank and I off to the 'Rec', near the old gasworks and the now-disappeared Sidney (recreation) Hall at Weymouth,

to watch the Terras play. The 'Rec' seemed to me to be a cold and damp place to stand around for any period of time; unless we stood on the touch line area, you couldn't see much of the match very well, which is maybe why I have never much gained an interest in football, although brother Frank is as devoted to the game as was Dad. The Terras, at a later date, were to play an important London match to gain promotion. The match was Weymouth (the Terras) verses Leyton Orient at the Leyton Orient's ground in London. The long trip was to be made on the old, clapped-out railway, nationalised by the Labour Government, and entailed getting up at some unearthly hour (after just getting into bed it seemed) to catch this train from Weymouth, which was full of local football supporters sporting Thermos flasks and packets of ham and tomato sandwiches as well as the team coloured scarves. It was not the football that was of interest to me but seeing London and the promise of having a cup of tea at a swanky ABC Café, which seemed quite exotic (never mind it being a cold winter's day in the very grimy and smoggy place that London was at the time). The Terras lost the match and we all, now disappointingly glum-faced, boarded the train back to Weymouth on yet another cold and uncomfortable, slow return journey home. None of the tiresome journey would have mattered had the Terras won their match, but a day out is a day out.

So, whilst sitting and waiting our turn, we would puzzle over the previously heard, confusing but interesting Anglo-Saxon words that would describe the performance of the team players. These were words that neither Mum nor Dad used, although he must have noticed them at the football match, so we told Mum the words one by one and asked her what they meant. Result, our 'new' barber was now located in Maiden Street in the town centre. It's strange how learning a few new adjectives gave us a ten-minute walk for a haircut instead of a ten-second nip next door. Ah well, the mysteries of motherhood and the English language. The haircut style didn't improve either, nor (*sotto voce*) did the language.

Trinity Road was originally named the High Street. This was a High Street of some length and was the main thoroughfare that ran the length of the harbour side from the bottom of Boot Hill to where the end of Trinity Street is now, making the length of the High Street the best part of a mile long. Later, divided into three separate named areas, from the Boot Hill end to Trinity church was renamed High West Street, and from Trinity church to Trinity Street was now Trinity Road, which stretched to a point where the road curved away from the harbour, with the rest renamed Trinity Street, all having now been renamed at about the time that Trinity church was built between 1834 and 1836 by the designer Philip Wyatt. It was later extended by the architect, whom Thomas Hardy worked for at some point, C. R. Crickway, in 1886. In the period that Trinity Road was

the High Street, No. 19 Trinity Road, later named 'Som Pee Air' was No. 40 High Street.

The building of Trinity church was the result of the centuries-old chestnut of an argument that, even in the late nineteenth century, the residents from Weymouth resented using a church located in the old, over-the-bridge place named by the Weymouthians sniffily as Melcombe Regis. 'We would rather walk the mile all the way to Wyke Regis than use "their" church.' So Trinity church was built by the contemptuous Weymouthians by subscription.

Boot Hill is the very steep hill that eventually runs into Wyke Regis and on to Portland. When I was small, we would watch heavily loaded lorries, laden with gravel or sand, grind their way up and take an age to climb this steep hill, producing all the sounds of overworked engines and gearboxes whining away and very much working triple overtime to drag the lorry up the hill at a speed slower than we could walk, so slow that our grandmother could walk faster, and that was very slow walking. This was at a time when the engineering quality of large, heavy trucks had not advanced to the standard of today and a truck labouring up and down this type of incline and descent would have played quite a strain on the brakes, which would heat up and then fade causing the lorry to be out of control. Descending Boot Hill in the fifties would lead to a sharp, right-hand bend at the bottom of the hill.

One day, we heard that a car had crashed and gone through the railings at the bottom. The car was a desirable, red MG sports car and had, or did have, two plates of Sunday dinner on the passenger seats, which both, after the crash, were equally spread around the inside of the car – Yorkshire pudding, roast beef, roast potatoes and lots of gravy and peas everywhere. The driver was very drunk and probably collected his two Sunday dinners at the same time he proposed a return to the pub. I think he went to prison due to this crash, as he had already been before the courts many times before, and from memory, he worked as a scrap metal merchant in Chickerell Road.

'You are charged, once again, with wilful damage and gross negligence, contempt and lack of respect for your mum's best Sunday roast.' I can hear the exasperated judge saying yet again.

With the name changes made to the original High Street, the original pavement thoroughfare became the lowered pavement below 'Som Pee Air' due to the building of the later town bridges, which necessitated the height of the road to be raised to enable ships to pass under it. Larger ships, of course, would need the bridge to be opened. The previous bridge construction and the building of Trinity church were almost carried out in tandem, which caused this natural division between the west side of the High Street and the east side, thus making one side High West Street and

the other Trinity Road. Much of what one sees today is as it was during the 1880s up to the 1930s when the current bridge was built, excluding some reworking caused by Messrs Hitler & Co. to now High West Street. Step bridges were built during Victorian times to access the 'new' upper front doors of No. 19 and all the rest of the houses above the old pavement level. I can hear the builders commenting on the 'lots of lovely building work'.

One self-important builder and town councillor, living at Jordan House, which is the property next to No. 23 Trinity Road, is recorded in the 1881 Census as a James F. Brown. I think he put the 'F' in his name so as not to be confused with the other J. B. Although, with a name like that, I assume he also bought a 'brand new bag', an early Gladstone bag probably. However, to complete the Census form in 1881, all one was asked to include was name, address, position in the household, age, occupation, and where born. James F. Brown puts in all that was asked, but adds to his occupation: "Town Councillor, Builder etc. employing 11 men and two boys", which he says out loud to all or any listening as he writes, leaving no room for his wife to add her occupation.

'As you are a wife, I will use your space to tell everybody how successful I am.'

'Yes, husband,' she may say with her hourly sigh. Town councillor ... builder ... contracts ... hmm, now there's a thought. One point that is noticeable when an analysis is made of all the Trinity Road residents who resided in 1881 is that only Mr Brown is listed as from Melcombe Regis, all the other 'local' people are from Weymouth. Is Mr James F. Brown the only outsider or the only Melcombe Regis family, contemptuous of Weymouth, living there? The family did have a fast escape route directly over the Town Bridge should the Weymouth locals cause unrest by putting on their 1881-style Ku Klux Klan outfits and shouting terrorising words at the Melcombe Regis family, although as this would have been chanted with the unique Dorset accent, they might have been mistaken for Morris dancers singing a strange ditty in drag.

The old part of the High Street that runs along the outer harbour quay, had become raised to up-market status with it's new name of Trinity Road whilst the remainder of the old High Street, running along the inner harbour quay now renamed High West Street, was now considered to be down-market. This change of forced social standing to the area was caused by the High Street's separation with the now raised levels of construction of Trinity Church and road bridge. This also necessitated a tunnel to be built over the old, now made lower, pavement. This enabled a scary crypt to be added as part of the church's construction. Since the 1880s, the lowered pavement has led to the very dark tunnel that runs under the church steps and entrance, passing the dark, shadowed crypt. The tunnel

is a very dark place to enter, as it was always without street lamps. Only the brave would run fast through it. The cowards, like us, would run faster than anything known to man, for halfway along the tunnel was the door to the crypt and, of course, to where the ghosts lived. These ghosts must have been related to the ghosts at 'Som Pee Air' and the resident ghost living at the Boot Inn with its sea-shanty late-night singing sessions. Not that this late-night singsong ever took place at 'Som Pee Air', not with Mum around. Woe betide anyone who dared even pause for breath in the Trinity church tunnel; the ghost's long, clawing, bony hands would drag you inside never to be seen again.

Many holidaymakers never caught that return train home again and fourth Quad Gang member Macky lived right next door to the tunnel entrance. He was always the bravest of the brave, but it had taken its toll on him. His comfort was always to suck his thumb wherever we went, even when we were within the safety of Weymouth sands with the sun shining, the sea blue, and ice-creams all round. The thumb was always well planted, although his thumb would move back and forth into and out of his mouth like a steam piston when confronted with an ice-cream to lick as well as a thumb to suck nervously.

Ghostly holes at
Trinity Road.

Sister Pat would sometimes walk through this tunnel, and emerge on the 'other side.' The 'other side' had a gentleman's lavatory on the left-hand side (the ladies would be built at a later date) before the shops were reached, with steps up to the bridge pavement on the right-hand side, but Sis would walk past these convenient convenience steps and alight on the pavement further along. Had the walk through the tunnel affected her? Was she so traumatised by those long, clinging claws that she had missed the steps? Oh no, her reason was that if she used the public convenience steps, people might think that she had used the gents' toilet; the shame of it. The traffic and pedestrians would all stop and all would stand and point at her. That's the thing about being a young lady as Pat, of course, was, you worry what people think about you. Of course, by middle age you don't care what people think about you, then when you reach old age, you realise that people weren't thinking about you at all – all that avoidance of perceived shame for nothing.

Our neighbours, the hairdresser's at No. 20, also had ladies above the gents below; that's Mr Pavey of the interesting blue-language club. Mum never used this convenient, next-door, ladies, upper-located hairdresser's. Mum had a male hairdresser, a Mr Roberts, who would visit her and coiffure her hair using as many bad-egg-smelling ingredients as he could find to stink the house out. 'Oh, it's the bad-egg man again,' we would moan.

Also living at No. 20 were the owners of the house, Mr and Mrs Lawrence, who lived above the 'trade'. They would knock on their window if Frank and I used their top garden to gain access to the 'High Plateau'. As there was no fence or dividing wall between our top garden and the neighbours' property, Frank and I would straddle with one leg on our side of the boundary and the other leg on Mr and Mrs Lawrence's, if, after two boys were straddling for two or three minutes, we didn't hear knocking on the Lawrences' windows, we knew we could stop straddling and venture further afield. The very top of our tiered garden, which backed onto Chapelhay near Trinity Terrace, was out of bounds, of course, too dangerous to climb, which is why we trespassed into next-door's garden to gain access.

This high area was not used by Dad and I don't know why, as it gave a superb view of the town and views out to sea. We never used it much either as it was difficult to transport items up to it for trying to build a camp or fort. The high, rough, stone wall that supported this high plateau was used by one of Pat's 'navy' boyfriends to affix a target and shoot at it with his air rifle, regardless of Dad's mild contention, I think. Even today, on a fine day, no one makes use of this high deck with its vertigo-inducing good views.

chapter eight

Trinity Road Past and Present

Past secrets revealed, old laws repealed, with the chip shop and pub forming this picturesque hub.

Trinity Road, with its Town Bridge over the harbour with Trinity Quay and Customs Quay running each side, represents a picturesque area that has been widely photographed, painted, filmed, moored to, sailed, fished from and fallen into, as well as visited many times over the past and present years. Television programmes have used this area as a backdrop; the current BBC television's local news reports use Weymouth harbour in its introductory shots. Many magazines and books feature this attractive waterfront more than any other scene of Weymouth, perhaps more than any other in Dorset as a whole, and maybe even more than the other two landmarks: the Cerne Giant near the inland village of Cerne Abbas and Durdle Door, and the giant limestone archway, one of the most recognisable sights on the Jurassic coast. Perhaps because the scenery has changed so little over the many years.

Trinity Road and its surrounding scenic sisters have gone through a cyclical pattern in all respects, from much desirability and esteem to the under-funded, poorly held together living conditions of the 1950s, and now back to sought-after prestige and desirability.

Trinity Road in the less-well-off fifties was made up of a few doctors' surgeries, a pub, a few shops, the fishing tackle shop, and a café and restaurant. Our doctor was a Dr Deveraux, who seemed a very Dickensian type of character with his high, stiff collar and waistcoat. Whenever we went to see him, we always had to take our shirt off.

'I have a bad foot, doctor.'

'Take your shirt off.'

Then the cold stethoscope would be plunged onto your chest.

Moving back along Trinity Road from No. 19, 'Som Pee Air', lived Mr Stevens at No. 17. Mr Stevens seemed to be like Mr 'Old Mud' as he was living there by himself, but was not as grumpy as 'Old Mud', and he seemed a bit chattier with Mum. During the spring and summer months, Mr Stevens would keep an eye out for the milkman with his horse-drawn milk float. Regularly, the milkman's horse would make a steaming deposit

outside the general location of his house at No. 17. This steaming mini-roundabout in the road would cause a scurrying out of the house with a small pail and coal shovel to remove the horse's digested breakfast. Frank and I would both watch this public-spirited ritual of tidying up in amazement.

We learnt later that he was not helping to keep the road clean but actually 'collecting' these coveted horse droppings, which, of course, left us speechless. We couldn't believe that this old gentleman would walk around the street collecting horse pooh. We were dumbstruck but intrigued. However, we were informed by Mum that it was to put on Mr Steven's rhubarb; again, we were now more than a little dumbstruck. Each mealtime that Mum served us rhubarb and custard, we would look at Mum then at the rhubarb and custard and then at each other, silent but quizzical, until we finally asked Mum why Mr Steven's put horse dropping on his rhubarb, as we thought that was a horrible, though interesting, thing to do. Mum explained that he put the horse droppings on the rhubarb plants in the garden in order to make them grow. That was our first rural science lesson. Phew.

Moving further along Trinity Road and after a few other houses, there was one of two fish and chip shops. The nearest one was named the Frying Pan, and had a clock made from a frying pan, which we considered very clever. Because of this, Frank and I often eyed up Mum's frying pan and her alarm clock when we visited Dad's out-of-bounds workshop, but we were beginning to learn that this might soon spell trouble. The further-along Seagull fish and chip shop, like the Frying Pan, offered a free bag of chips in exchange for four boys' armfuls or a month's supply of newspapers. We would struggle up to the Seagull fish and chip shop carrying a heavy bundle of newspapers each and be rewarded with one small bag of chips to be shared. This entailed both of us stuffing as many chips into our mouths as fast as we could before the other had the last chip and finished the bag. This frantic exercise resulted in four bulging cheeks trying to down the last of the fatty chips and trying to digest and swallow, while, at the same time, mumbling garbled recriminations, hotly debating who had eaten the most chips.

Newspapers are now not used to wrap up this 'takeaway' food due to the unhygienic nature of the newsprint. One wonders how many people died of newsprint poisoning, but apparently the problem is that the ink contains lead. That bonus of having a meal whilst reading the newspaper the chips were wrapped in has now gone.

'Bung us a tanner's [sixpence] worth of chips, mate.'

'Here you are. Wrapped in the *Mirror*.'

'My good man, would you be good enough to supply sixpence worth of your finest chips please.'

'Here you are, sir. Warmly wrapped in *The Daily Telegraph*.'

There were three other shops, a general store with a back-room library, with the front shop run by a Miss Shaw, a single lady with starched lips to match her wrap around starched apron and 'love me love me NOT, keep away'-type eyes, and the back-room library run by retired husband and wife, Mr and Mrs Morris. This general store was very typical of the forties and fifties: dark interior due to the dim lighting of the single hanging light bulb together with the dark, wooded interior shelves and cupboards. The shop was stacked floor to ceiling with many tins, jars and bottles. Reaching over the counter entailed also leaning over the many large tins of biscuits stacked in front of it, each with a glass top and labelled with makers' names, some of these past names are now gone or swallowed up into large conglomerates, names such as Carr & Co., Crawfords, Huntley & Palmers, and Peek Freans. It is hard to imagine how the shop could ever be efficient at serving its customers, as the counter tops would also be stacked with many new or slow-moving items, and in December, with Christmas coming, its fare would make counter space almost non-existent. Often, there was just enough room to place a few goods into the basket that would be propped on the obligatory chair rather than the customer trying to sit down. Memories of shopping with Mum remind me now of a prison visiting room or confessional box with a small grill set in place to separate the visitor and inmate or priest and sinner, only in this case it was the over-stacked counter space.

Mum had an account with Miss Shaw's shop, which consisted of a small, red book in which the goods were ordered. These goods were then delivered by the elderly Mr Morris who would struggle, out of breath, with perspiration trickling from under his trilby hat, along the 500 yards or so to deliver the small box of fifties' fare. Mum would settle up the account at the end of the week. Next door to this shop was a sweet shop run by a kindly, rounded, middle-aged lady who seemed to have made it her business to test quality control samples of products she sold in the shop and to test them vigorously in consistent quantities. Well, she had standards to maintain and did not care about her dress sizes. Great sweets if you had the money to buy them, but then when the stock had been subjected to this lady's quality concerns, the sweets would possibly been sampled off the shelf.

Then there was Hayman's Fishing Tackle and Chandlers shop, a shop that had a most distinctive aroma, which came from the many ropes and nets, which had been treated in tar oil to help preserve them. Hayman's is where you could buy quantities of its comprehensive range of fishing tackle together with lugworm and ragworm fishing bait, which came on the train each day to Weymouth station from London and was collected by Mr Hayman on his trade bike. People who knew Mr Hayman would

quietly remark, when he was riding back on his trade bike from the station: 'There goes Mr Hayman; he's got the worms again.'

Hayman's fishing tackle shop was a busy place during the holiday period, as many of the visitors would organise fishing expeditions along the coast as well as fishing trips from the various piers and by hired boat – all sought the worms as bait. The bait costing fourpence; it was always wrapped in newspaper and would sell out very quickly. I wonder if selling ragworm bait wrapped in newspapers was also outlawed on health and safety grounds? 'Ragworm Defence League Lobby Parliament.' 'Green Peace Steps In.' Perhaps the name 'rag'worm derives from the slang name for the newspapers in which the worms were wrapped on purchase.

Any fishing Frank and I had ever done in the harbour always resulted in the same catch: either a small crab, as the line had touched bottom, or a 'goggie' (a small dog fish with its goggle eyes). One way to get a more rewarding catch from the harbour area was to make a shallow net from an old bicycle wheel with the spokes removed and with an old piece of net curtain tied onto it, fix it to a length of rope and drag it through the water along the quayside with some bait, such as an old fish head 'borrowed' from the fish shop along the road, which resulted in plenty of prawns caught for tea.

In between the sweet shop and Hayman's fishing tackle shop was No. 12 where Mrs Moggeridge, or 'Moggie' as she was more known, lived. She was known as a kind lady who was living on a very modest income, which was reflected in the worn-out interior of her house. She will crop up again much later in this narrative. The Kings Arms pub, was next to No. 13 and No. 14. This pub was always very busy during the summertime with a typical holidaymaker mum and dad inside drinking. Mum's choice would be the port and lemon while dad would sample the beer, whilst the children would sit or stand outside with a bottle of pop and a bag of Smith's crisps. In the fifties, children were not allowed into the inner temple of consumption. This strict alcohol law no doubt went back to the Victorian days when the youngsters would be allowed to drink with mum and her daily gallon gin ration.

Mum was friendly with the then landlord and his wife, Mr and Mrs W. T. Copp, not that Mum or Dad drank much, only a token glass or two at Christmas. This kindly landlord kept a motor car parked in a lock-up garage in High West Street. In the days up until the late sixties, strict opening hours meant the pubs would close during the afternoon, thus allowing the publicans to enjoy an afternoon off, and on one or two occasions, he and his wife would invite Mum and Frank and myself out for an enjoyable motor car ride into the countryside.

Most of the time, in winter, the Kings Arms would be empty. If a customer walked into an empty bar, there would be a brass bell screwed to the bar

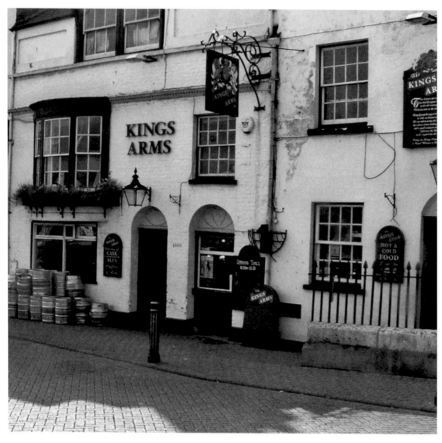

The Kings Arms, Trinity Road.

counter, which could be rung to summon service by bringing your palm down on to the bell plunger. This bell was given to Mum by Mr Copp, the landlord, who got fed up with the bell ringing, even when he was in the bar looking eyeball to eyeball at his customer standing in the bar. This old, very polished, brass bell served as an ornament at 'Som Pee Air' for many years until I acquired it some twenty years ago when Mum sadly died. I'm not sure of the age of this brass, clanking bell, but it could be over a hundred years old. Certainly, it must have had many people ringing it over many years for a pint. Now it sits gathering dust on a shelf in silent retirement.

Many pictures of Weymouth are taken today and published in newspapers and magazines depicting its quaint and picturesque harbour scene taken from Trinity Road or from Customs Quay, and one can understand why, as a picture taken from almost every angle delights the eye. Our old house, 'Som Pee Air', doesn't get shown too much as it is nearer to the Town Bridge where many pictures are taken from. The harbour side properties are now,

and, of course, always were, understandably very desirable with many painted in vibrant and pastel colours of pink, blue, yellow, cream and white, which today reaffirms the area is now back in a prosperity period that would equal the 1880s. It would be difficult to attempt to provide details of each of the current owners of the houses in Trinity Road, other than to comment that purchasing any of the properties would be an expensive investment today; they are not properties for first-time buyer's as they might have been in the fifties if they had been as run-down as 'Som Pee Air'.

Trinity Street, the side-street cousin to Trinity Road in the forties and fifties, was very much an area where the poorer families seemed to live, which I now assume was because they were rented and allowed to become run-down to some degree after the war, as money and renovation skills (especially money) were in short supply. At the very end of Trinity Street, there was a very large, covered coal yard. This we were told was to supply coal for the Devenish Brewery's beer-making machinery. This old, stone coal storage yard had a corrugated tin roof and the sometimes unfriendly boys in this street showed some friendship and told us that some of the residents would lift the roof very slightly, enter and pass out large lumps of the coal to other waiting hands, helping to keep the family warm when money was short. This old coal store has now been given a new lease of life as a restaurant. I suppose coals to nouvelle cuisine.

When I was a boy, Trinity Street was looked down on by people in Trinity Road. If a window was broken or other 'dreadful damage' caused, like a milk bottle being broken, or children were seen knocking on doors and running away (a game called 'knock down Ginger'), the residents in Trinity Road would blame 'the ruffian Trinity Street kids'. Because of the street's reputation as a rough and tough area, we, as boys, would apprehensively walk or run through Trinity Street, home of the *Beano*-comic-like characters, *The Bash Street Kids*. So it came as a surprise in later years to learn how important Trinity Street was as a historical part of Weymouth. It contained the Assembly Rooms, Tudor houses, and the area had been visited by royalty; however, by the fifties, it was a very run-down place where some properties were almost slums. Certainly, we never dithered too long in case we got thumped. Today, of course, the street is now not only restored but probably in better condition now than at any other time, even when the properties were first built. Much of Trinity Street and the Hope Square area to the harbour's edge was built on land reclaimed during the late eighteenth century. It's odd to think that an area that we considered in the fifties to be a rough neighbourhood was, in fact, much frequented by royalty, the well-to-do and the one-time mayor of Weymouth, Thomas Giear, who once lived there.

Whilst the fifties was the austerity period, past residents seemed to have enjoyed the fruits of their efforts. The residents that lived in Trinity Road

in the 1880s were the pillars of society, a mixed group of upper- and lower-middle-class, including the then ruling class. These ranged from butchers, drapers, bakers, coal-merchants, all of whom were proprietors of their own businesses, to town councillors, inspectors of insurance, accountants, a surgeon, harbour master, prison warden, master mariner and a Scottish lord, all people with a profession or money or both. The whole road must have been very much a place to be and a place where people wanted to be seen. The men who administered the town would be fitted out by the best town tailor and the ladies would keep up to date with London's influential fashions, which were brought, along with other influences, by the railway to the town. From research, most of the residents had servants such as a housemaid, cook or a nursemaid.

I will start with the occupants of No. 1 Trinity Road in 1881. This was the residence of Robert Ayles, aged sixty-seven, and his wife Jane, fifty-nine. Their daughter, also named Jane, lived with them; she was aged thirty. Robert Ayles' occupation was Inspector of Insurance, with daughter Jane working as a clerk, and the family were born in Weymouth. My first thoughts were that Robert was aged sixty-seven, not a young man but still working with help from his daughter, age thirty, which seemed at first to suggest that she was a bit stuck at home looking after her parents, as no servant is present (a day off perhaps?), and working as dad's assistant clerk in his insurance business, a business that would have covered all manner of claims that an inspector would be asked to investigate, from shipping losses, to fire claims, theft, accidental damage to property. His beat would no doubt take him along the lengths of both sides of the harbour inspecting goods from the ships and the ships themselves. His work would be a highly regarded and respected occupation, and he was probably offered (but refused) bribes for dubious claims. He may have been concerned about the future marriage prospects for his daughter, as she was thirty years old, although she may have been the new brains behind the business. As the business was in a very thriving port and there was the dowry of No. 1 Trinity Road, it is very likely that a suitor could have been found, possibly a widower with some tailor-made children.

Living at No. 2 was Andrew Curtis, aged fifty-two, and his wife Grace, aged fifty-six, with their servant Fanny Boards, aged twenty-five; Grace Curtis and servant Fanny Boards were both from Weymouth. Andrew Curtis's occupation was as Town Councillor and Accountant and he hailed from Poole in Dorset. I can see him applying for a position with the town council as an accountant, writing long accounts of double-entry bookkeeping to trial balance into large leather-bound ledgers in copperplate writing with a quill pen. His accurate and diligent work would earn him a position of confidence and trust that would come with a councillor's position. His esteem and standing in the town would rise

considerably. His wife was four years older, which does not seem unusual, as quite a few marriages in 1881 had a wife older than the husband, or, of course, Grace, his wife, concerned about being left on the shelf, may have pulled a few strings with papa, who may have been an elder with the council, to seek promotion for a prospective suitor.

At No. 3 lived William Roberts, aged forty, who was a butcher from Weymouth, with his wife Susannah, aged thirty-five, from London. The meat trade must have been profitable or the meat must have been an aphrodisiac, as he and his wife were the parents of seven children – eleven, nine, seven, five, four, two, and eleven months. One presumes that Susannah would request an interval when her breath would be allowed to be drawn.

At No. 4 was Simon J. Fowler, Head of household, living there with his wife and three children; all were looked after by a cook and servant. He was from Weymouth and was listed as a steamboat company manager, although his occupation in 1874 was company secretary for Cosens paddle steamers. Paddle steamer shipping activity in the early 1880s was a hi-tech, up-and-coming industry, putting forward very strong competition against sail. An engraving by William Pye shows a view looking along Trinity Street with a paddle steamship moored in the harbour. This would typically have been a Cosens ship. I might also surmise that Mrs Fowler, who hailed from Somerset, may have met her future husband on one of the regular steamings to Sidmouth or Budleigh Salterton, where she could have embarked and enjoyed a day trip to Weymouth.

Now, an unusual resident was also residing at No. 4. He was a Scottish peer, aged fifty-eight, also confusingly listed as Head. Born in Scotland, his name was Gilbert Kennedy, part of the earls of Cassilis clan, the peerage of Scotland. What could be the reason for this Scottish peer to be 'residing' in Weymouth? Further investigation reveals that he was also resident in Chelsea, London, at the time of the Census. Whilst it would have been possible to complete the London Census form at breakfast time, then catch the fast GWR train from London to Weymouth to be again recorded in a late Census collection, why would he have wanted to? Several reasons could be the answer. 1) He had organised a steam ship to take him to France for a liaison of some sort. 'Ooh la la.' 2) He was awaiting some important cargo, which he would personally take care of. 'Ooh la la.' 3) He was about to invest in Cosens steamship company and a quick decision was needed the very next day, or was in cahoots with Mr Fowler of Cosens about future competition from a solicitor named Mr John Tizzard, who introduced two paddle steamers, PS *Bannockburn* (that's a possible clue) and PS *Premier* earlier on. Either way, a Scottish peer/lord from London is listed as Head of house as well as Head of household in London. It seems

a little intriguing, but probably it was a simple business arrangement that had led him to be in Weymouth on that particular day.

At No. 5 lived William Rashley as Head, thirty years old and working as a grocer's assistant, living with Eleanor and their three children. Also residing at this address was a John Downing with his wife Anne; both were pensioners. It seems just a little odd that a grocer's assistant and two pensioners live next door to a Scottish lord. Very cosmopolitan.

Living at No. 6 was the grandly named lady, Clara Deslandes, born in Guernsey, and Head, but she seems to be the wife of a commercial traveller, he, no doubt, away on business. Interestingly, the two children were born in Kensington, London. Residing there also was Hannah Christy, aged fifty-one, living with her son, William, aged twenty-one, the latter working as a Customs officer, a 'Preventy man'.

At No. 7 lived Thomas Symes, a man of independent means, owning property and land, with his wife, children and servants. Obviously a well-to-do gentleman.

No. 8 housed a GP/retired surgeon and his wife from Kensington, London. They, no doubt, moved back to Weymouth to retire away from the London smoke and the River Thames 'pong' to enjoy Weymouth's fresh air again.

At No. 9 lived Charles Lovell, aged forty, Head, with wife Jane. Mr Lovell is a Town Councillor and Coal-merchant. A coal business must have encouraged some important dignitaries as customers.

Living at No. 10 was Charles Beale, sixty-nine, a retired mariner and coal-merchant, with wife Betsy, living with their two sons, Charles W and John Wm; the latter seems to have taken over the coal business from papa. Both sons were single.

Living on top of the job at No. 11 was Harbour Master, Frederick W. Mace, aged seventy, with wife Ann, aged sixty-five, and, staying with them, the three grandchildren, Emma, Frederick and Sydney, with Ellen Collins, the fifteen-year-old servant, and Anne Beale, employed as a fourteen-year-old nursemaid. Could he still have been working as a seventy-year-old Harbour Master? Probably a fit old bugger who could spot a rogue a league away.

At No. 12 lived James Gibbons, Head, with is wife Mathea. Mr Gibbons is a Coal Porter and his wife keeps a lodging house – No. 12, presumably. Living with mum and dad were the three children, Martha, aged five, with William, three, and two-and-a-half-month-old George, plus a stepdaughter, Anne Bird, age twenty-four, whose occupation is 'Independent', emm?

At No. 13 was the Snook family with Thomas as Head, working as a grocer and wine merchant, with wife Mary Elizabeth and their four children, helped by servants Jessie and Emily.

The Kings Arms pub, for some reason, did not have a house/building number but the then landlord was a William Lockwood, a widower helped by his sister, a widow. Perhaps living with a Lockwood was not a lot of fun for a spouse. Strange that nobody was recorded as being in the pub on this Census date.

At No. 14 lived a 'retired' Sea Captain's wife, Sarah Bussel, forty-two, with her three children, Sarah Junior, aged eight, and sons Ernest and Charles, aged six and two respectively.

The Town Bailiff, John Gibson, and his wife Rebecca are living at No. 15.

In between this house and No. 16 was a dwelling without a number, which is listed as the 'Brig Inn' 'No. 30'(?), and here resided the retired prison warden from Portland prison, James Burgess, aged sixty-five, with his young wife of thirty-nine and their three children; the youngest is one year old. Whilst the Census does not state it, some of his children were born in Portland.

Residing at No. 16 were father and son boot makers Robert, seventy, and John Tomkins, forty, with Robert's wife, seventy-five, and an eighty-year-old sister-in-law, Elizabeth Bezell, together with Martin Pender, boarding and a grocer's assistant. Also living at No. 16 was Fanny Cook, thirty-four, a Merchant Captain's wife, with children Francis and William. Perhaps boot making was attractive for Fanny Cook.

Moving on to No. 17, we find husband and wife Edward and Elizabeth Mace. He was a retired Master Mariner and both were in their seventies. Staying with them was their grandson Alfred Mace and helping out was servant Harriet Kenway.

No. 18. This, the past home of 'Old Mud', was occupied by eighty-one-year-old Mary Reynolds, a retired grocer. Also living there was her sister Martha, aged seventy, with general servant, and no doubt more, twenty-one-year-old Clara Hayne who hails from London.

At No. 19, our old house (Som Pee Air), since 1861, was Caroline Handcock, eighty-one, with live-in maid Annie Sergeant, eighteen.

No. 20 housed Emma Perry as Head with no occupation and helped out by Ellen Greenslake and Jane Smart. Also, there is a visitor from along the road at No. 13 named Emma Snook. This is where, in the fifties, Mr Pavey of short-back-and-sides fame worked in the dungeon.

What comes after No. 20 then becomes a little confusing, as next on the housing list should be No. 21. The Census now records this as Trinity church but states that it is 'unoccupied', i.e., no Gentleman of the Cloth in attendance. Perhaps the ghosts could have helped. It is probable that the Gentleman of the Cloth resided there at No. 21 and was simply out for the night.

At No. 22 lived Elizabeth Fisher, Head, a nurse, with niece Charlotte. From Cork in Ireland is Richard Sullivan, also listed as Head, a Chelsea Pensioner, aged forty, with his wife Betsy, aged thirty.

At No. 23 was possibly a widow, Agnes Notley, with her family of five grown-up children, the oldest twenty-eight and the youngest seventeen and all employed in retail positions.

Lastly was the Mr James F. Brown of Jordon House of whom much has already been written.

All the residents are well-to-do people living in the then-desirable Trinity Road rather than the old, tawdry, previously named High Street of the pre-1880s.

Trinity Road, when it was part of the old High Street, interestingly, had buildings on the harbour side, which had backyards running to the harbour's edge. *The Compleat Traveller*, published by Spencer in 1771, describes the town (of Melcombe and Weymouth) area:

> The houses in the town are low but very neat, being all built of freestone,
> and they have a good custom house on the quay, where much business is
> done, merchants importing great quantities of wine, which they dispose
> of to the dealers in the inland parts of the country.

The construction dates of these properties are also very mixed. No. 2 Trinity Road was once owned by a Ralph Allen who was a quarry owner and one-time mayor of Bath. On a visit to Bath, one can see the large number of buildings built from much quarried stone and very little of most other types of building material other than the Bath stone. I can hear Ralph Allen now. 'I will provide the stone if you make me mayor.' Nudge, nudge, wink, wink. My great grandfather, Joseph Page, was a master carpenter and joiner living with his young family in Bath, so he, no doubt, encountered Mr Allen's mayoral city's grand, continuing construction decisions. Mr Allen must have been a very good organiser, as he was also involved in the development of the new postal system. It is noteworthy that, within his house at No. 2, royalty was entertained, although the date that George III first visited the Weymouth resort was in 1789, after Mr Allen's residence. A plaque is now fixed to the outside of the house to commemorate his past residence there, which reads 'Summer Residence 1750-1763 of Ralph Allen one of the founders of 18th century Bath. Whose patronage first established Weymouth as a resort.'

Weymouth was very much a thriving economy in the 1880s with the transportation of goods coming and going into and from the harbour. With Cosens shipping and ship repair yard now the biggest employer in the town, ships of all shapes and sizes would be moored, loaded and unloaded and would depart for either a coastal or foreign destination, as

well as ships for repair at Cosens shipyard located in the Backwater. The ships would be laden with many commodities, including wool, iron billets, timber and stone, to name a few. These commodities were ready for export as well as collecting from other inshore trading ports. The commodities included coal, copper, yarn, spirits, cloth, tools, food and provisions of all kinds, including some passengers. Whilst much legitimate trade would have been the norm, there was in the area of Cove Row and Trinity Street a shady place known as the Old Rooms Inn, an establishment much used by smugglers to seek out the regular landed gentry customers as well as seeking new contacts for their contraband. This is perhaps where the business of the Scottish peer, Gilbert Kennedy, could have been in 1881. Perhaps he was gambling for the smuggled, forbidden foreign fruits, although William Christy, the Customs officer, may have had an eye on him.

The length of Trinity Road is approximately a third of a mile from No. 1 to Jordan House, the last house and next to No. 23. This is a total of twenty-four dwellings, although the Census reads a little oddly in two areas – both the Kings Arms (no number) and also No. 30, which, of course, is an even/odd number as none in Trinity Road go as high as 30. This is also known as Brig House, a back room behind the pub. Also, a Census is only as accurate as to the small passage of time it represents. It also has visitors who were not long-term residents. So it is only a small snapshot giving a general average number of people who may be in residence. The Census lists 117 people, which is probably about the same number of residents as today.

When writing this account, I was intrigued to know who the previous occupants of our house were, as far as records would show. I also tried to imagine how the house would have looked and been used during the various periods. The properties listed would have none of today's 'mod cons', not even an inside lavatory, but enough servants and maids at your beck and call to carry in the pleasant and out the unpleasant tasks of the household. The past conversations are of course now long silenced with the ups and downs of everyday life, the talk of their past problems and their future plans have now long gone. The same conversations and disagreements that take place today – the weather, money, family and friends and the ever-problematic relations – all would have been discussed then too; all those hopes and fears now no longer of any importance.

The 1901 Census is of interest, as this is the last to be published before the one that was published early in 2009 for the 1911 records. The rules of Census records state that a hundred years must pass before the records office at Kew will release them. This is to protect UK residents that may be still alive. Good health provided by the welfare state and advances in medicine together with a healthy diet, would make it very likely that quite

a number of people would still be alive by 2009 for the 1911 records, which will keep HRH busy rubber stamping her signature on all those birthday cards.

At No. 19, the occupier of our old house was Caroline Handcock, born 1799, now aged eighty-one, at the 1881 census. She is recorded as head of household, born Cerne (Abbas), Dorset, with her income from an annuity. She seems to have been on her own for some time after 1851, as her husband died in the middle of the nineteenth century. Caroline Handcock lived at 19 Trinity Road from 1861 until her death in the springtime of 1881. Living with her was her servant, Annie Sergeant, aged eighteen, from Portland, Dorset. Widow Handcock seems to have made money by owning lodging houses, and perhaps in the early days of 'landlady Handcock', she may have had some lodgers staying at No. 19, but records do not show that; perhaps she had hidden them in case the tax inspector accompanied the Census officer.

Later, at No. 19, recorded in the 1891 census, the occupants were Alfred Bolt, head of household, aged sixty-nine, and his more mature wife Mary, aged seventy-eight. His occupation is described as butcher (I trust retired). They are both from Weymouth. Also living there is Elizabeth Bartlett, widow, aged sixty-three, living on her own means, from Canterbury, Kent. So, in the period before and after 1891 but not before 1901, there were three people, all retired and without any listed domestic help living at No. 19. Good for them.

Recorded as occupying the house in 1901, just forty-four years before the author's family took up residence, was a young family named Dore headed by the young Albert E. Dore, aged thirty-six, his wife Catherine, aged twenty-nine, and son Charles, aged five, together with young general servant, Susan I. Valance, aged twenty-three, the upstairs maid. No. 19 Trinity Road was a reasonably large house with a total of fifteen rooms; six of them at the time were bedrooms. Here was a young family able to afford a desirable house and, according to the Census records, Albert Dore was 'living on his own means', and hailed from Islington in London, so we were not the first Londoners to occupy this house. His wife was from Wiltshire, a small village called Broughton Gifford, which is near Swindon and Marlborough. How did this young man not only make his money but also manage to meet his future wife, who lived a long way from him? So how did he make his money? It would seem that he was left it. His father was a retired butcher, that is, a retired butcher aged sixty-two when young Albert was aged eight in 1881. Young Albert's mum was aged forty-two. So dad was old enough to be his granddad and his mum was very mature given the period. What is a little intriguing is that this is a butcher's family and the previous occupants' head of household was also a butcher. Probably a butcher was a very common, everyday occupation, a bit like an IT consultant today.

Now, either young Albert's father, aged sixty-two, was a very shy man, albeit able to make loads of money, and had married very late, or was a real man-about-town with a large butcher's shop employing a number of people and probably thought it was time for an heir to take over the business. This young Albert did so until his father died, and then mother also died and left the lot to young Albert. He would have gained a butcher's business, the house in London and all of mummy and daddy's savings, which would have made him a rich orphan in his early twenties – so sad. Whatever their reasons for moving to Weymouth, they must have welcomed the clean, fresh sea air of the South Coast. They were the occupants of No. 19 Trinity Road in 1901, plus Susan, the upstairs to downstairs dungeon maid who would live in, of course. She would have slept in that freezing-cold attic, carrying the coal up those long flights of stairs, emptying the 'gozunders' and shooing away those ghosts. She was a local girl, born in Weymouth.

The Dore family were still living at No. 19 Trinity Road up to 1911, with Albert Dore now occupied as a stamp dealer and builder and contractor, his wife also occupied in the same trade and profession, he now forty-five and Catherine now thirty-eight with young Charles Dore, now a fifteen-year-old working as an assistant joiner. Fortunes were probably still good for this family, as they now still employed a servant, Ethel Blanch Terry, born in Weymouth, a name that seems too grand to be that of a servant.

Charles Dore, the son, born in Weymouth, would have been seventeen years of age at the start of the First World War and twenty-two at the end of that war. During the recent 2000 renovations to convert No. 19 Trinity Road into a restaurant, a copy of an old newspaper was found tucked behind a sealed wall on the first floor, dated 1918. This was found hidden in the same room that my brother and I slept in many years ago. The newspaper showed pictures of marching troops in Weymouth. Was the young Charles Dore proudly amongst them or were his mourning parents concealing knowledge of a son absent from this parade?

Well, the answer to this question is frustratingly sad. The First World War had ended on 11 November 1918 and young, alive Charles Dore was now a twenty-two-year-old sergeant in the Royal Army Service Corps, a predecessor of the Royal Logistic Corps. The Royal Army Service Corps had the 'Royal' added in 1918 and was responsible for the movement of all supplies, food, ammunition, equipment and clothing and much more. At the outbreak of war, Tanzania was the core of German East Africa, and on 8 August 1914, the very first recorded action of that war by the British was the shelling of Dar es Salaam, the capital of German East Africa. In 1915, the commonwealth forces invaded to engage a light but skilled German force, which became a protracted campaign with the German

forces finally surrendering on 23 November 1918, twelve days after the war had ended. Charles Albert Dore died on 25 November 1918. He is buried and commemorated in the Commonwealth cemetery in Dar es Salaam, a country far away from his birthplace of Weymouth. His parents moved from 19 Trinity Road where the young Charles has lived and played as a boy, as my brother and I did so many years ago. His parents moving to No. 8 Hanover Terrace, Weymouth. I can understand why; losing your only son with all those memories there.

Headstone of Charles Dore.

A Natural Harbour, a Natural Port?

The boats and ships come and go, but in this natural port they shelter from storm and foe.

The sands, the town and the surrounding sea are the ingredients that made Weymouth what it was in the past and what it is now, but the single most important ingredient forming Weymouth's centre point, its heart, is the harbour. If harbours could speak, it would have a wealth of tales to tell, as thousands of sea craft would have floated over its clean waters. As Weymouth is a natural port, it would have been used for many centuries by its inhabitants and raiders alike, including the Romans.

Evidence confirms that Roman galleys would make their way up the river a small distance of approximately three kilometres to the uniquely named suburb of Radipole for the galleys to manoeuvre themselves. The name of Radipole has always been a bit of a family joke and, for no particular reason that comes to mind, the name sounds amusing, as it might to any visitor who had not grown up with such a name. We only had to say Radipole and the family would fall into fits of giggles. I think that we would mimic the Dorset accent of a local rustic, who would declare to anybody passing his door, 'Ahh, my dear, would you like to come inside to see my old Radipole? I've just given it a good clean.' Anyway, the Roman ships would naturally dock near to the point where the Radipole Park Gardens recreation grounds[8] are sited, near to where the swings, slide, seesaw and roundabouts would be today.

'After that rough channel crossing, Claudius, fancy a go on that seesaw?'

'No, I am much weighed down with cuirass and tunica loricata. Only when we are well clear of the low-life Radipolians will I feel safe to remove them.'

This incursion so far up river was to bring goods as near to Durnovaria as possible. Later, the Westham Bridge was built because the Radipole river area now becomes silted up, but until then, the area would be used by the Roman army who would haul the goods up the steep, now old Roman road at Upwey and overland to Durnovaria, now, of course, known as Dorchester. The Romans used the shortest route and modern-day traffic

used the long, winding hairpin-bend road for years to arrive at the same place.

In later years, ship departures from Weymouth were used for the siege of Calais; ships sailed to fight the Spanish with their cumbersome and unwieldy armada of ships in 1588; and regular shipping occurred to and from the Channel Islands.

One of the many harbour incidents was on 16 November 1902 when the famous writer of boys' books, George Alfred Henty, died on his yacht. He was a writer of many books for boys and adults about his Victorian war adventures, with such stirring titles as *In Freedom's Cause, Under Drake's Flag, In Times of Peril* and *The Lion of the North,* plus a prodigious 140 more books on the same theme of derring-do and other courageous acts for Queen and country, or if written today, what might be described as foolhardy ventures. At the time of his death in Weymouth Harbour, he was part way through writing *By Conduct and Courage*; this last book was completed by his son Captain C. G. Henty. With G. A. Henty having written nearly 150 books, his son must have been very familiar with the style and the plots of his father, and thus could write in a similar style to his father, producing a plot that embraces fighting the forces of evil.

It must be said that George Alfred Henty didn't labour away with quill and paper surrounded with brimming ashtrays and half drunk cold coffee cups to write his many books. Instead, he would pace up and down shouting out the story as he thought it through, allowing his poor secretary to scribble away as fast as she could. One can see him pacing furiously up and down, his old service pistol in one hand and waving his sword in the other hand, confronting the potted aspidistra and challenging it to defend itself. He produced simple and harmless stories; a good bedtime read, I seem to remember.

In later years, all the evacuated inhabitants of Alderney arrived in Weymouth Harbour in 1940, due to the onset of the Second World War, to escape the fast-advancing German army, which would have used the German navy to occupy this small island, but without much strategic purpose in mind other than using it as a lookout point.

In readiness for the D-Day landings, American troops could be seen testing and making ready their landing craft. Amongst the many landing craft and other military shipping was a 43-foot ferryboat named *My Girl,* which was requisitioned from Plymouth in 1939 to run troops, medical teams, ammunition and supplies to Portland Harbour, often under heavy air attack. By the end of the war, nearly a quarter of a million men had been carried by this small boat. Most of the build-up to war movements was masterminded from the war room in the solid protection of Portland Castle. This now-unique boat is still alive and floating and spends its summer months giving pleasure to visitors enjoying the sea air and viewing the attractive local coastline.

As the last world war drew to a close, the German U-boats, under order, began to surrender, with U-249 being the first German U-Boat to do so, arriving and mooring in Weymouth Harbour near the Cove Row area on 10 May 1945 escorted by two frigates. One was HMS *Magpie* and the other ship, which would gain world attention in 1949, was HMS *Amethyst*. *Amethyst*, a modified Black Swan-class sloop designed for escort work, became famous in the civil war between the two opposing Chinese forces of Mao Tse-tung's communists and Chiang Kai-shek's nationalists. This ship was sent up the 3,964-mile Yangtze River to assist HMS *Consort*, which was running short on fuel and was acting as guard ship for the evacuation of the British Embassy. HMS *Amethyst* was shelled by the communists with lives lost on board. This brave ship managed to slip away in darkness to Shanghai. This later became known as the 'Yangtze Incident' and was the subject of a stirring black-and-white film made in the fifties. A trip in later years to China involved a trip up the Yangtze River and I was able to witness the area in which this historic event had taken place.

Other U-boats were also escorted into Weymouth, including U-1023 and U-776, after surrendering to the Allies. Many more U-boats than the number captured, approximately 230, were scuttled in the Baltic Sea under orders from Admiral Dönitz with the German operation Regenbogen in April 1945. All 154 U-boats captured or surrendered were brought into British ports. Under operation Deadlight, 115 U-boats were taken either to Northern Ireland to be scuttled in deep water off Lishally or the deep Loch Ryan in Scotland after all the valuable metals had been removed, with the rest of the U-boats being used for naval experimental projects.

Moored in the harbour during the late forties/early fifties were three smart, purpose-built German boats that Mum told us were some of the spoils of war. These boats seemed not to be military but a sort of *Kustenwaghe*⁹-cum-tug boat and were painted in cream and black. I must admit, these excellent-looking German boats stood out amongst the run-of-the-mill and worn-out dull selection of local boats. It would be interesting to know what happened to them in later years.

All the Quads Gang members lived in houses by the harbour, which meant we always passed the harbour as we adventured to old and new playgrounds. As we wandered past this sea and fresh-water harbour so regularly, we would always find some sort of new activity being carried out with the ships and boats that were either arriving or leaving port, so naturally we developed a keen interest in some of the many ships we got to know by name. The largest of these were the Channel Island ferries, *St Julian* and *St Patrick*, and *St Helier*, three big, black-sided ships able to sail the oceans. These saintly-named ships would take day trippers to either Jersey or Guernsey, or to some of the smaller islands and, at the same time, collect and deliver goods, mainly produce, from the islands, loading and

unloading the goods for exchange as the day trippers explored the island's places of interest.

Some of the visitors that stayed with us at 'Som Pee Air' would optimistically embark on these trips in the morning after breakfast, equipped with Mum's bag of sandwiches, or her 'comprehensive packed lunch'. Their return to dry land would show a very different demeanour, as they would sit at the dinner table with their faces changed to match the green hue of the adjacent harbour, looking exhausted and wearily expressing that they had little or no appetite for the lamb stew, so hardly eating a thing Mum had cooked for them. After apologising, they would make the miserable, jaded comment, 'been seasick on the way out and been seasick on the way back', with Mum's 'packed lunch' being thrown to the already overweight seagulls fed by the other equally seasick travellers.

Friends Barrie and Ronald, when living in Cove Row, would have had a very good view of the *St Julian* during autumn and winter, as the area of water in front of their house was where the towering *St Julian* would be moored for many months. A room with a dark view, that's for sure.

Along the Custom Quay harbour side run the railway lines that terminate at the loading and unloading area at the harbour docks, with its tall, dockside cranes, where the clanking GWR tank engine 1367 plied its trade. Near to the Ritz (now called the Pavilion) Theatre area is where the rowed ferryboats would take holidaymakers from one side of the harbour and back again; an old penny (1*d*) was the fare each way for children and the princely sum of 2*d* for adults each way. The same area is where many of the American military prepared their small boats for the D-Day landings, using the well-worn harbour steps to load supplies. These small rowing boats plied their ferry trade from here to the other side and back. The little rowing boats held about eight people, and whilst this was a convenient and interesting way of getting to the other side, this little trip across the harbour was also an unnerving novelty, as many of the holidaymakers, mostly from London, had never set foot on a small boat before, thus making this short trip a little bit alarming for some of these landlubbers, also bearing in mind that passengers were not issued or fitted with life-jackets, let alone given a safety drill. Clambering down the worn harbour steps, which many a GI would have trod, holding the trusty but rusty hand rail, would be quite daunting for the faint-hearted at low tide; then, the boarding of this very unsteady boat held to by a retired old sea dog, bronzed from years of wind and sea, dressed in the obligatory navy blue jersey, de rigueur uniform of the retired modern-day ancient mariners.

The step down to the boat and the trip over, the harbour became a little more intimidating, as the boat would be very low in the water, just inches from the water level, making the harbour walls at low tide appear to be

very high up. Added to that, the large Channel Island ships, *St Julian*, *St Patrick* and *St Helier*, would be moored only a few metres away, and these were, when compared to their size of the tiny rowing boats, enormous vessels. It must have felt a bit like rowing away from the sinking *Titanic* without that poor, damaged iceberg in sight. Once across the harbour, the nervous and shaking passengers would unsteadily but quickly clamber up the steps and express gladness to be back on terra firma, with, perhaps, nervous talk reminding them that 'the band played on', 'the band played on'. Of course, the same procedure across the harbour had to be endured or enjoyed in reverse. One wonders how many holidaymakers only took the one-way trip and then walked back from whence they had come, over the Town Bridge. Once over on the Nothe side of the harbour, the holidaymakers could walk to the Stone Pier, then brave the rocky and slippery path around the fort to the gardens. Or they could follow the example of the energetic elderly ladies and climb the ornate stone steps to the Nothe area and its gardens, which are a few metres away from where they disembarked the little ferryboat.

With the warm waters of the south coast of Dorset, the harbour is in consistent use by its fishing fleet. This seems to have followed a concertina course of expansion, but overall, has been on a contracting path over the many years, as it has been subjected to EU quotas about what could be caught, which has been consistently lowered. With the added wasteful problem of the non-quota fish types being 'dumped' back in the sea, which causes them consequently to die after being out of the water, the concern for fishing has reached a very critical stage. It is suggested that only 9 per cent of cod reach breeding levels, and by 2050, fish stocks in the world oceans will no longer be commercially viable. So it will be fish-shaped tofu and chips with plenty of vinegar and salt to hide the taste.

Whilst the harbour would have witnessed a large array of sea traffic entering or leaving the Weymouth Port, motor traffic, usually seen on the road, used this watery refuge once to our knowledge. One day, near to the Town Bridge, we were watching the dredger clearing the riverbed of silt when we saw it had caught in one of its moving mud buckets a pre-war black Austin Seven saloon, which had possibly been dumped or driven in somewhere in the Backwater area and had slowly made its way down stream. The police made an inspection and took charge of the old car but no 'Front Page' mysterious bodies were reported to be inside the car, so it was assumed that it had been either dumped, as it was then considered worthless, or taken for a joy ride, then pushed over the Backwater quay to get rid of the evidence. Maybe this happened during the war with errant soldiers hurrying to get back to barracks in some 'liberated' transport.

On usual bright summer's mornings, the harbour near to 'Som Pee Air' and the Town Bridge were always a hive of activity, with sweet, fresh,

warm smells of activity from the ships mingling with the aroma of cooking breakfasts, the smell of local bakers' bread ovens opening and coupled with the gentle, rhythmic exhaust of small fishing boats 'put putting' off for a day's fishing as they headed into the ever-gentle summer breeze from the bay.

Cosens paddle steamers would be getting up steam, adding the burning coal-fired furnaces to the aromas as they manoeuvred into position and made ready to paddle their way astern to steam their skilled way to collect the new day's passengers from the end of the Pleasure Pier. This had been the practice since before both wars, and now, with the post-war-boom holidays of the early fifties, it was getting back into its stride, catering for the many trips these delightful paddling ships would make.

Without doubt, the paddle steamers were our favourite ships, and they made the best use of the natural harbour of Weymouth with its flow of water from the River Wey into a tidal mix of brackish, salty water from Weymouth Bay. Weymouth's harbour has been used to shelter, repair and to manage every paddle steamer that came into the Cosens fleet over the many years since its beginnings in 1848. The paddle steamers, or paddlers as we affectionately called them, were majestic ships born of an age now in the very distant Victorian past, with their names reflecting the same past lost empire as depicted in G. A Henty's 'derring-do' plots, the times when Great Britain really did rule the waves and rode roughshod over its enemies for Queen, King and country.

What we, and the many holidaymakers, loved about the paddle steamers was that they all seemed to have a real personality. The splashing of the water as the paddles turned made those on board feel a real sense of eager effort was being made to move its delighted passengers through the water, a spirited likeness of a willing horse's hooves trotting as it pulled its little carriage. Although the two sounds were different, the likeness of the enthusiasm of both was without doubt. The engines of brass and steel were painted and polished so that that they were almost luminous, while the ship's mahogany woodwork was deeply varnished to a lustre that really shone against the white and black paintwork that surrounded the brass fittings topped with its buff (and black-topped) funnel with its flags flying. The maintenance reflected the love that the captains and crews had for these little ships. *Consul's* engine room was a work of engineered art, with the engines built around a two-cylinder, compound diagonal design with its massive, polished, steel piston rods reciprocating in a purposeful but relaxing motion, not loud, not fast, but just as you expect the ship would behave – as if it were pleased to have you on board. It gave a rhythmic sound that has never lost its appeal.

The *Empress* would be made ready for its scheduled trips, and earlier, in 1949, some excellent work was carried out by the Cosens workshop

engineers to convert it into a look-a-like of an 1830s cross-Channel packet ship for the film of Charles Dickens' book *Great Expectations* starring John Mills.

PS *Empress* would sometimes steam around Portland Harbour to view the fleet – still a major world force even in those austerity times. Perhaps her schedule this week involved making a trip around the Shambles Lightship and Portland Bill or a gentle steam into the calmer waters of the picturesque Lulworth Cove or Swanage area. Whatever the pleasure trip was that day, the white-capped-and-jacketed stewards would be busy with the catering ready to dispense the many cups of tea and other beverages that the thirsty day trippers would require. This early-post-war period would have seen the last season during which the elderly PS *Victoria* visited the more distant places of interest, Swanage and Bournemouth, or travelled an even further distance to the Isle of Wight's Totland Bay. Any last season for these magnificent ships was a sad event; sad because not only was this the ship's last pleasure voyage, it was also the final curtain for her, as there would be no return trip from the breaker's yard, just a quickly made pile of scrap metal, wood and ancillary items to show for her many years of hard work assisted by her dedicated crew at sea. PS *Victoria* was scrapped in 1953, leaving Weymouth harbour on a cold January morning.

Cosens paddle steamers were very much state-of-the-art engineering when built. *Consul, Embassy, Monarch, Emperor of India, Empress* and *Victoria* were names that represented the last in the fleet of paddle steamers that Cosens owned in the fifties and sixties. Some ships previously had a different name, but slowly, these fine paddle steamers were scrapped by Cosens, the ship's owners, who had employed them for work and play since the middle of the nineteenth century, and were now, in their twilight years, steaming for the pleasure of the holidaymakers.

From 1850, Britain was acknowledged to be the most powerful country in the world, thus the use of such regal names for these proud ships, very much reflecting how proud and self-important Britain was in those past glory days. Most of the paddle steamer fleet had been used for war work. The two-funnelled *Monarch* was one of three paddle steamers owned by Cosens to bear that regal name. *Monarch* was crewed by members of the RN reserve during the Second World War to patrol the coastline and search for contraband goods. She, like other paddle steamers, was chosen for this type of work due to her very shallow draught, which meant she could stop and search any suspected small boat, as well as larger ships that were operating in shallow water. The pleasure-steaming bright livery was substituted for gloomy naval grey, with *Monarch*'s balanced lines compromised early on by the addition of two extra lifeboats to comply with board of trade regulations, new legislation having been imposed after the loss of the *Titanic*. (It always seems to take a tragedy to bring craft

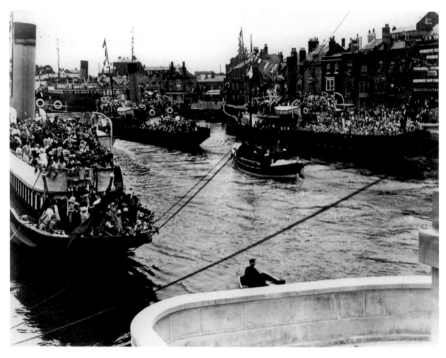

Celebrating the opening of Weymouth's new Town Bridge in 1930 with overloaded paddle steamers.

up to new safety standards.) Thus PS *Monarch* always seemed to have an awkward look to her, as the new lifeboats gave the ship an 'added on' look. However, looking at some old pictures of the paddle steamer fleet in the post-First World War years, no number of lifeboats would have saved the many holidaymakers on board the very overcrowded paddle steamers.

After excellent war service, PS *Monarch* was scrapped at the end of the 1949 season, leaving *Consul* still lying in the Backwater looking tired, dull and rusty after war work and forlornly hoping not to join her late sister PS *Monarch* in the breaker's graveyard. As Cosens fought over compensation with the government, the question was, should we scrap PS *Consul* or not? However, whether for sentimental reasons or commercial necessity, it was decided that she would have that important stay of execution and survive for many more years to come. Cosens bought the third *Monarch* in 1951 (the very first *Monarch* lies at the bottom of the Mediterranean, sunk during the First World War), renaming this last *Monarch* from the British Rail PS *Shanklin*. But after nine years of service, she was also given her last sailing orders and scrapped in Cork, Ireland, after the 1960 season.

PS *Embassy*, with its striking designs on its paddle-wheel housings, was built in 1911 as the *Duchess of Norfolk* for the joint railway services from

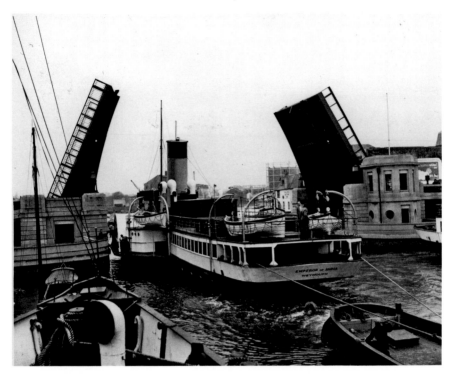

Farewell to *Emperor of India* viewed from Som Pee Air, 1950s.

Portsmouth and Southsea and Ryde, Isle of Wight. She had just one season in Weymouth in 1949, the year, we suggest, that my brother Frank and I are photographed standing with our backs to her bow steering wheel. She made her last trip to Bournemouth in September 1966. *Embassy* carried out important war work with the unglamorous name of J109. She was then laid out in the mortician's watery waiting room in the Backwater to be ignominiously towed to Gwent in Belgium for her *coup de grâce* in 1967. Before this, her slightly older sister, the *Emperor of India*, a hero of the Dunkirk evacuation, was also sent to the breaker's yard in Belgium, just eight years after much rebuilding and conversion to oil in 1948. *Embassy* was the last paddle steamer, although converted to oil in 1947, to be operated by Cosens. Again, this steamer was sadly scrapped at the end of the 1966 season.

The 175-foot-long and 257-gross-ton paddle steamer *Consul* was always our favourite, as it was mostly moored near to us at 'Som Pee Air' to a small jetty on Trinity quay. This proud little ship had a long history, if at times mixed fortunes. Built and launched between 1896 and 1898, she was originally named the *Duke of Devonshire*. She was built by ship builders R. & H. Green in London, entering the service of the Devon Dock, Pier & SS Co. in 1896 and was, with other paddle steamers in the

Consul moored for winter, 1950s.

fleet, designed to run up on the beach to load and unload passengers. The
captain of this ship had to know the tides; if he got that wrong and landed
the passengers as the tide was changing, the ship would have been stuck
for some hours on the sand.

Consul (or *Duke of Devonshire*) was sold to P & A Campbell in 1933
but was not put into use by them. She was then resold to J. Dwyer of Cork,
Ireland. Then, in 1936, this proud ship was bought by Alexander Taylor
of Torquay, who again resold her to Cosens & Co. of Weymouth in 1938,
who renamed her *Consul*. Only a year or so of pleasure steaming was
enjoyed here before the Second World War broke out, which resulted in
large portions of the British Empire starting to be lost. This was also to
be the fate over the next two decades for the paddle steamers, with the
help of the Board of Trade, who sounded the death knell with its rigorous
but essential survey regulations for these older ships. *Consul* remained in
Weymouth until making her last commercial voyage to Lulworth in August
1964 under Cosens' ownership, to be then sadly earmarked, as with
all the others before her, for scrap. However, before that could happen,
a white knight came along in the shape of the late Tony McGinnity, the
entrepreneur and paddle steamer enthusiast who decided to save *Consul*
from the breaker's yard.

McGinnity employed various ideas for the on-going use of *Consul*
but eventually sold her to a Dartmouth sailing holiday company as a
club house, changing *Consul*'s name back to her original name, *Duke*

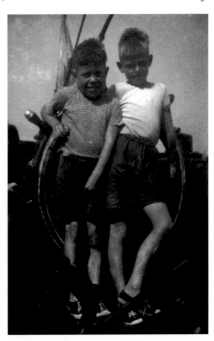

The author (right) and brother on Paddle Steamer *Monarch*, 1950.

of Devonshire, thus giving *Consul* three more years use before negative prosperity reared its familiar head. After this, she was sold again to face the final *coup de grâce* of the scrapyard in 1968 in the nearby port of Southampton. She had many worthy suitors and also some doubtful, fast-buck gigolos, who hoped to take what they could but always spurned her, before she found her only true loves in Tony McGinnity and Mr Cosen of Weymouth.

We were fortunate to be sometimes taken out on these delightful ships. One trip I remember was on *Consul* with Mum, our grandmother and brother Frank. We steamed to Lulworth Cove; whilst this was of interest, the most memorable part was looking through the glass canopy covering the engine room and watching the beautiful engines at work as well as admiring the huge paddle-wheels splashing through the water. The joy was the journey, not the destination. Another enjoyable trip was on the *Empress* together with our sister Pat, Frank and our two gang members, Macky and Rob. It was captained by the delightfully named skipper, the ruddy-faced Captain Francis Merryweather – what a wonderful name for a sea captain. The trip was around the Shambles lightship, with Pat very generously paying for us all, even though Rob's Mum gave him a huge glass jar of pennies to pay his way, which she didn't have to do. This meant Rob ended up lugging a large glass jar of heavy old pennies all over the ship. Disaster struck as PS *Empress* made a rather bumpy manoeuvre just as Rob was descending the upper deck stairs. He dropped the jar,

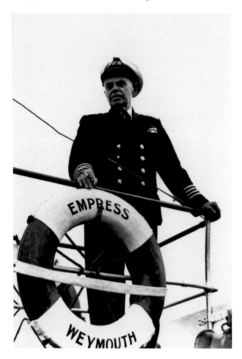

Captain Merryweather of Cosens, 1950s.

shattering and scattering glass and copper coins over the pristine decking. With pockets bulging after the speedy stewards' clean-up, there was no pocket room left to squeeze a penny in, so we all suggested that the only solution left was to 'spend a penny' on ice-creams all round. At a stroke, his hands were free, although his bulging pockets gave him a walk like a deep-sea diver out of water.

Whilst this incident was memorable to us, temporary crew member Rodger Scadden in his student days at Bristol University would regale tales of time aboard the paddle steamers, of which there were many. Here are a few of them …

Returning from a trip to Swanage on PS *Victoria*, the weather had turned rough and a party of nuns must have felt that the sight of waves crashing against rocks as the PS *Victoria* passed Tilly Whim Caves was a cue for some heavenly comfort, and they all knelt on the deck to pray for a safe passage to port, the sight of which must have caused much consternation to the rest of the passengers and a bemused Captain Hollyoak and crew.[10]

A more worrying incident relates to a trip to Lulworth Cove on PS *Empress*, the last of three trips that day. The intention was to bring the earlier disembarked passengers off the beach and return to port. The balmy weather of the day had suddenly turned to not-so-balmy fog, bringing visibility down to a few yards. If the passengers could not be collected from the beach, then Mr Cosens would have to foot the expensive bill

Engine room of PS *Empress*.

for the many coaches transporting the passengers back to Weymouth with perhaps a rap on the knuckles for poor, old Captain Merryweather. Student Rodger, with his good eyesight, had to stand on the front bows to ensure the ship cleared the rocks as PS *Empress* entered the cove. 'Eventually,' he reports. 'We turned inwards to the cove entrance, but suddenly looming from this near-blind state of the ship were the high cliffs of Durdle Door.' Rodger quickly signalled to the skipper to reverse the ship and back eastwards she went. It was not until a rowing boat waving a primitive oil lamp that allowed PS *Empress* to follow that she was able to moor and embark the bemused passengers.

The local newspaper, the *Dorset Daily Echo*, reported that 'IT WAS A CLOSE SHAVE FOR PADDLE STEAMER'. This worrying incident, on another occasion, had Rodger at the wheel of PS *Victoria*'s bridge[11] heading back to Weymouth, when an aircraft carrier was spotted right in the path of their normal course. The order was given, 'Go around her, but not too far off course.' Continuing … 'As we approached the aircraft carrier, the passengers moved over to the port side to get a better view, which unfortunately had the effect of now tilting the paddle steamer slightly as she steamed towards the carrier. Captain Hollyoak by this time was getting a little agitated, I think quite agitated by now and called out "give (turn) her more starboard", but the tilt was now getting more pronounced, and we still appeared to be heading straight towards the

carrier. With bated breath we *eventually* passed almost below the carrier's overhang – with crew members of the carrier now waving down and the passengers of PS *Victoria* now waving upwards at the carrier. The captain let out a huge sigh of relief, saying, "That was a close shave." As passengers disembarked [Rodger was collecting the tickets, it would seem that a casual crew member was carrying out most of the work that day], I heard them remarking how good it was of the captain to take them for such a good view of the carrier.'[12] Finally, Lulworth Cove has some fine terrain that Rodger would willingly point out to the passengers as the paddle steamers approached the cove, such as Lulworth Crumple, Middle Bottom and his favourite, Scratchy Bottom. Very *Darrset* is that.

Very much out of bounds were our sneaked visits onto the paddle steamers moored at Cosens Backwater repair yard. We would sneak on to these moored ships during bleak winter weekends and explore the interiors of the paddle steamers in for repair; some seemed very run down, and some of them seemed destined never to steam again. To look at these sad ships' interiors, even as small boys, we could sense a loss that the ship might never turn its big paddles again for pleasure and perhaps not even for the trip to the breaker's yard. The warmth and smell of the steam mixing with the lubricating oil smells seemed gone for good. Now the ships were silent and lifeless, and in winter, the ships, like us, were very cold, everything these lovely ships were designed not to be.

One of these out-of-bounds visits resulted in gang member Macky jumping off some raised-level part of the ship and hurting his ankle so badly that he could not walk afterwards. Frank and I raced home to fetch our box wheelbarrow and with that we dumped him in, head and feet up, bottom down and wheeled Macky back home. Whilst we were all amused with this ambulance game, his dad told us off for playing around places we should not have been (rightly so), only to thank us later for bringing him home.

Portland Harbour was also a favourite round-trip destination to view all the naval fleet with the little paddlers dwarfed by the mighty battleships and aircraft carriers. In spite of government shortages in the fifties, there were still enough ships to make a show and enjoy a wave back to the sailors on board. The paddle steamers also made pleasant designated trips to the more distant ports of the coastal towns of Totland on the Isle of Wight and Bournemouth.

At home, after tea, we would be watching both the clock and the view along the harbour as we looked out for our friend, paddle steamer *Consul*, to finish its day's work, watching it splash its way up the harbour to be moored. Frank and I would enviously also watch out for the mooring boy, a boy of about sixteen years of age, to ride his bike down to the little jetty and wait, sometimes arriving in the nick of time, for the approaching

Consul's deck-hands to throw a primary rope that the mooring boy would retrieve and use to pull to shore its main, heavy mooring rope. The mooring boy's job was much more than turning up for the ship to come into port. Rodger Scadden tells me that, as a young member of the crew, he would loosen the mooring ropes from the quay to the ship in the morning, then race around to the Pleasure Pier on his peddle bike and be ready to catch the mooring lines so that the ship could berth to take on its passengers. The reverse had to be performed at the end of the day. Rodger, as temporary crew member for either PS *Empress* or *Victoria*, tells me that it was some fast peddling needed to meet the paddle steamer before she arrived at her moorings. This task was made more difficult as the ticket seller on the pier, the ruddy-faced Mr Caddy, made the young crew all walk with their bikes, for safety reasons, whilst on the pier area.[13] This weighty rope would then be hauled, lifted and looped around the fixed quayside mooring point.

Chang! Chang! sounds of the ship's telegraph would be heard to signal the engineer to 'finish with engines', making the hissing of steam slowly die away. With *Consul* now moored and captain and crew now disembarked, the paddler would gradually become quiet. After the captain and crew had signed off for the day, we would stand near to her and listen to the quiet sounds of the ship as she settled for the night, the gentle creaks as the ship and its engines contracted and cooled after unwinding from the day's work into a well-earned, settled slumber. The mooring ropes would have found their own comfortable tension as the tide slowly ebbed and flowed and the engines would be quietly going to sleep as they cooled. *Consul* had now settled into her sweet dreams.

It was no wonder that the late Tony McGinnity loved these happy, paddling dignitaries. If the Reverend Awdry of *Thomas the Tank Engine* fame had lived in Weymouth, some wonderful bedtime stories would have been composed and read of willing and friendly paddle steamers with names like *Sally* for the *Consul*, *Sarah* for the *Embassy*, *Maggie* for *Monarch*, *Clara* for the *Empress* and the very royal name of *Alexandra* for the confident and brave *Emperor of India*, and, of course, *Victoria* for the very formidable *Victoria*.

'Night, night, Sally, sleep tight. It's steaming up the Amazon tomorrow and the natives are very restless.'

chapter ten

Schools Have All Gone

Two twos are four, two fours are eight, our learning was paid for by the brave, new state.

With Christmas not yet in sight and birthdays gone for another year, we came home from school one autumn day to find that Frank and I had received a separate parcel each in the post. Inside, there were conkers from our Uncle Fred. The conkers were bright, shiny, brown baubles he had collected from the horse chestnut trees in his Dorset village of Godmanstone. To receive our own separate parcels was a wonderful treat, not so much the contents but the perceived knowledge that the whole of the Dorset postal service's mission was there to collect, sort, find us and make a delivery to nobody else but us, just us. Uncle Fred was Dad's closest sibling, and from the age of four, I knew him as our favourite uncle. He was already living in Dorset before we moved there, after having a very tortuous route and a complicated early life, which he reluctantly created for himself as a conscientious objector in the war. He lived in Godmanstone, a small village famous for having the smallest pub in England, named the Smiths Arms. Uncle Fred, with his partners, ran the well-known Whines & Edgeler bamboo and cane supplier 'the Bamboo People'. Godmanstone is situated near Cerne Abbas, which lies just north of Dorchester and is home to the 'Cerne Giant', a famous effigy that attracts droves of visitors who enjoy viewing this large giant cut into the hillside, who seems to be wielding a club or two.

Uncle Fred had ended up in Dorset in the middle of the Second World War quite by chance after going on the run from the police. By 1943, being released after serving three months of a twelve-month prison sentence, he was working with two business partners, Bernard and John, running the successful bamboo supply business, with the help of the German POWs to pack and ship the goods from their base in Godmanstone, Dorset. All three men lived in a gypsy caravan, given to them by George Lansbury, the left-wing politician and editor of the *Daily Herald,* also the grandfather of Angela Lansbury, the actress, and father-in-law to Oliver Postgate, another CO and creator of *Ivor the Engine, Clangers* and *Bagpuss.* The caravan was surrounded by Nissen and wooden shed-type huts of various

shapes and sizes for storing their products. The three partners ran this busy bamboo supply company, Whines & Edgeler, The Bamboo People, supplying bamboos for the garden by mail order, as well as other related items such as school canes, which Uncle Fred told us were sold for a 'whacking' profit. The bamboos were shipped all over Great Britain and, in the first instance, were supplied from the English country houses with large gardens or large estates, and from such famous names as Daphne du Maurier and Agatha Christie. The business was run by advertising in popular gardening magazines, which resulted in building up a strong and loyal customer base. Although a busy man, he always found time for his nieces and nephews with birthday and Christmas presents and the sending of shiny conkers.

With the conkers falling and the early autumn in 1947 came school. This was St Mary's Infants School, located in School Lane, Weymouth, and was my first school, excluding the brief period at kindergarten school in Rodwell.

The first day at school was spent, as for most children, hanging up your new coat on the low-level pegs with your name written above it and then going into class to meet the new teacher, a Miss Wills, who greeted us with a smile. Whilst I could read to some degree, I could certainly tell the time very well. This we had both learnt to do by looking out of 'Som Pee Air's' front windows during the winter school holidays at St Mary's church clock in St Mary's Street. At home, on winter days, would be just Frank and I together with our mum. We would shout at the top of our voices to Mum in her bedroom along the hallway, 'The big hand is on the six and the little hand is on the eight,' then a call back would confirm the time: 'It's half past eight.' As we became familiar with the time telling, we would play tricks on Mum and call out clock numerals that were advanced rather then the real time, causing Mum to jump out of bed quickly, thinking it was later than it was, much to our amusement.

At school, we did the usual five-year-old programme of repeating the alphabet phonetically, ah, bu, cu, du, eh, fu, and so on, stories were read, toys were there to play with at certain times and, of course, we drank milk through a drinking straw. The class was dominated by a large coke-burning stove, which Miss Wills had positioned her desk near, thereby keeping her and the front-seated children of the classroom very warm and cosy, whilst the rest the class, like me, shivered at the back. This was a time when the whole country shivered, really shivered. Whilst Weymouth was a little warmer than the rest of the country, the winter we had just seen was the coldest winter ever recorded. The winter of 1947 was so cold that ice packs were floating off Belgium, preventing cross-channel ferries from sailing. As very small boys, we would make a slide in the snow in

our backyard with sister Peggy, the first and only time we saw snow in Weymouth's town. Outside the school, in School Lane, a roof gutter had overflowed with water at some point, causing the children, who were with their mums, to stop and stare at the resulting long and very large icicle hanging down from the roof to the paved lane.

The following day, it was so cold that we would not get up and Mum had to drag us both out of bed. I was going to school and Frank was to be with Mum for the day. Mum walked unsteadily with both of us in tow through St Thomas Street, which was just a thick sheet of ice. We stopped and watched men with road drills break up the snow that had now compressed into thick ice slabs, which were then loaded onto waiting lorries to be taken and dumped unceremoniously into the harbour. At school, we were told to keep our coats on and all the little chairs were moved around the now-glowing stove whilst Miss Wills seemed, during this cold period, to tell us many stories. Whilst I remember those small details, I don't remember being cold, other than a reluctance to get out of bed, which I managed to overcome in middle age. With the learning of basic writing with a chalkboard and improving our reading, it was much like any other infants school in England, and as with all other schools in England at the start of the new term, we had to progress up to the next class. 'Oh no I am not,' I protested. 'I want to stay in the lovely Miss Wills' class near to the warm stove and hear the many stories.' Yes, this class was all right, a story told each day, toys to play with, a bit of chalkboard work and a short lunchtime walk along Park Street to the 'Cookery Nook' for 'food', then a short sleep with our heads resting on the desks, then home.

My protests were adamant: I did not want to leave Miss Wills' class. 'Now, Edward, I will say something once and once only, as you must leave for your next class.' I sat on her comfortable lap facing all the new five-year-olds, including my brother Frank, who was new and perplexed at this incident, as were the other bemused children sitting there. Miss Wills told them that, although I had to go to the next class, I had enjoyed myself so much that I did not want to leave this class. At that point, the new five-year-olds, who were probably a little unsettled by this 'school' thing, must have received a strong impression that Miss Wills' class must be a good place if I did not want to leave it. Miss Wills told me and the other children that I had learnt so much that she could not teach me any more and I had a lot more 'much nicer things' to learn in the next class. Sold, and off I went. Perhaps in each first year's intake, a susceptible child is selected to be brainwashed to spout 'the message' for the benefit of the newcomers at new term time.

This new 'second year' class was the class that I left that day on 12 October 1948 with my conker on a string that my Uncle Fred had so kindly sent. Perhaps if there had been no conkers sent, there would have been no

falling in the harbour; but there I was, conker in hand and the harbour beckoning to me to join it, but very good fortune was there that day to deny it of those sinister treats it had in store for me. I don't remember any mention of my late afternoon dip, either in class from my teacher or from any of the other children. They say that lightning never strikes in the same place twice; that's probably true, but falling in the harbour a second time does not follow these laws of average rules. Once is unfortunate, twice is a teeny bit careless perhaps?

The second occasion took place when Frank was in his first year at school. I, a seven year old, was in charge of him, a five year old, to make sure that he did not get into any difficulties on the dangerous walk home for our lunch, instead of the usual Cookery Nook visit. As we walked along the Backwater nearing the Town Bridge, avoiding the main street, as it was busy with traffic, we were distracted by the moored paddle steamers for repair and the smaller moored boats that seemed to beckon us toward them and the quay's many mooring ropes attached to ship, boat and quayside. We, or I, decided to walk along this quay edge to be as near to the harbour water with its moored craft as I could. It seemed a good idea at the time, as we did not want to be knocked down by that 'thundering steam tank engine No. 1367' that plies between the end of the pier and Weymouth station with its red flag waving safety guards walking in front.[14]

A taut mooring rope lay across the quay's edge and was now becoming slack with the incoming tide, so I stepped on it and it twisted, causing me to fall into the low, incoming tide harbour between the moored boat and the harbour wall from a height of about two metres. This was a narrow, twice-the-width-of-my-body gap. Now, at seven, I knew the ropes, well not enough 'rope' to prevent me getting wet again. I managed to grab the boat's mooring rope and pulled myself up and on to the moored boat. I then clambered up the iron ladder fixed into the harbour wall and stood there angry and frightened in now-dripping school clothes. Looking at the harbour with one thumb planted on my nose with the fingers outstretched and the other hand with thumb in my ear and the fingers also outstretched, I gesticulated a hand wiggling defiance and insult at a disappointed harbour, with the customary 'nah, nah, hah, hah hah.' I hurried home with Frank running, a little perplexed or perhaps worried, behind the dripping trail of water that I was now leaving; Robinson Crusoe could even have followed me blindfolded.

Mum's reaction was, I think, a little 'déjà vu' moment and a re-enactment of last year, so it was into the explosive geyser steaming and spewing hot water filling bath again. Uppermost in my mind was that I must get back to school for the afternoon classes. So, dressed in my Sunday best suit, I asked Mum for a note to excuse me for being late as I had got tar on my

school clothes. Even now I am surprised by my presence of mind as a seven-year-old. What I failed to do, of course, was to drop into the *Echo* newspaper office, about a hundred metres away in St Thomas's Street, and give them the story. Although, visualising the possible headlines, perhaps not. 'He's At It Again' 'Boy Again Falls into …' Oh, and it was back to the Cookery Nook for both of us, whatever the cost, 'queasy' or not – school uniforms are not supposed to get that wet.

The last class at St Mary's Infants was with a teacher whose name I can't remember, as she was not there very long with that class. This teacher told us that our new replacement teacher was to be a Miss Dear and that she was writing to her. She told us that her letter started with 'Dear Miss Dear' which no doubt amused us, 'Will you pull my sleigh tonight?' I said to a class now giggling. I was quickly admonished: 'Edward, that's not funny. Stand in the corner.' As there was a warm corner near the stove, my punishment was not too bad.

Dear Miss Dear made us work a lot harder than the other teachers. I suppose it was to make sure we were ready for the hard work at junior school. One task was to write out the complete Lord's Prayer with plasticine on to a board. This entailed rolling the plasticine into a very thin strips and then forming the letters. The first of which is 'Our', then 'Father', then 'Which', then 'Art', then 'Miss, I have reached the bottom of the board'. Dear Miss Dear replied, 'Children, you must try to get the whole of the Lord's Prayer on the board; all the words have to be small enough to fit the board.' The rest of the afternoon looked more like a bootlace factory than a class of learning children, all furiously hand rolling ever-lengthening threads of plasticine. Nick Park would have been proud of us.

This last class was the last time I trooped to the Cookery Nook along Park Street for midday meals. Every time I smell frying food in lard, which thankfully is now not very often, I think of that dining hall. This hall was a very large, very old, very noisy, and a very smelly type of a Dickensian building situated on the site of a Chapel of Ease of St Mary's church. This blackened, stone edifice was opposite the railway station in King Street and on the corner of Park Street. Describing it now, it reminds me of a large, Victorian workhouse with warders patrolling the aisles shouting orders at children or, if things got out of hand, a whistle was blown. 'Pick it up.' 'Don't put your plate upside-down whilst it's still full.' 'The custard's not for floating potatoes in.' A child holding a bowl and 'asking for more' would seem very out of place; more like: 'I am holding this bowl as I am about to be very sick.' It was suggested that, in those austerity times, we got the prison leftovers from Dartmoor, rather than the up-market Portland prison, but the dinner song was a joy to sing: 'Our din dins come in pig bins', 'so say what you will, school dinners make you ill.'

At Christmas, the teachers said we would have a school party and would we ask our mums for a contribution of some food such as tins of fruit, cakes, jelly, blancmange, a trifle perhaps, or orange squash, all items of food to make a children's party go with a swing. With food shortages, rationing, and very little choice still the norm, the mums seemed to rise to the occasion and a good and generous party was made, as we sat and munched wearing our own class-made party hats, which included a 'threepenny bit' as a present (three old pennies coin) for each of us. How generous was my Mum donating to this feast? She was as embarrassingly generous as she could be. Mum gave me an old bag of dried egg powder left over from the war, which she could not use, hence 'the gift', nor could the school use it either and I brought it home. I was the only pupil to take home what he or she had brought for the Christmas party. Poor kids can be poor because food is where the money goes. We, as a family, seemed to have both money and food, and yet perhaps we were less well off than I probably thought. Well, that was infant school. I could read, write, do sums, get wet and make yards of bootlaces from plasticine.

What I and some other schoolmates could do well, apparently, was larking about.

'You boys, stop that larking about. Haven't you any respect?' a man shouted at Frank, myself and some other boys as we made our way home at about midday on a very cold 6 February 1952, along Commercial Road after a morning of lessons at Melcombe Regis Boys' School, which was our new junior school. We stood there on that cold midday in some sort of bewildered misunderstanding, as most boys do. This man was a grown up and, like all grown ups in those days, felt he had a duty to tell boys of our age off.

'Don't you know the King is dead?' he asked.

Open-mouthed, we shook our heads. Neither Mum nor our teacher had told us about the death of King George VI. His death meant that the whole country would come to a standstill; all wireless programmes would be cancelled, replaced by news broadcasts and solemn music such as *Greensleeves* played over and over. Cinemas were closed, and flags flew at half-mast. The newscaster on the wireless would broadcast in a very solemn, middle-class, stiff accent, 'It is with profound regret that we announce the death of the King at Sandringham at 10.45 a.m.' 'It was announced from Sandringham at 10.45 a.m. today, February 6th, 1952 that the King, who retired to rest last night in his usual health, passed peacefully away in his sleep early this morning.'

I remember listening in the evening with Mum and Dad to this wireless newscaster, who told of the King passing away in his sleep, after he had been shooting in the grounds at Sandringham, his Norfolk residence, the previous day. The King had gone to bed in good health but had not woken

up in the morning. That must have been a bad dream, I thought. I asked Mum, 'What would happen if I didn't wake up in the morning?' I expected her to say that I wouldn't be able to go to school. Instead she said, 'You are too young to die.' Mum also told me that the King had an operation last year for his lungs. As always, I had been given a lot of information but no answers that I could understand. If you are a King, surely this alone means that you will have a long life. Surely you just snap your fingers and everybody comes running, including the best doctors. We were all told that we now had a new Queen, Queen Elizabeth II, and there would be a Coronation and that we would all have a day off school. So that was good news.

The King was buried on 15 February 1952 after lying in state since arriving at Westminster Hall on 11 February, hauled by the steam locomotive *Windsor Castle,* after his funeral procession through London. As there was no television yet in Weymouth, the only pictures available were in the newspapers in black and white, as were cinema newsreels later. As with all old documentary films made of any important event, black and white always seemed unreal and to be in a more distant place and not in the same country we lived in, almost a crepuscular era.

The Coronation, we were to learn, was to crown the new Queen, Queen Elizabeth II as head of state, Queen of England and of the new Commonwealth, and not only would we have a day off school, we would all have a street party. This was to be held in Trinity Street, which was generally quiet to traffic but noisy with troublesome bigger boys, but as with most important British national events and true to tradition, it rained, and as rain was a regular feature in June, we just ignored it; well, not quite, because our street party was undecided due to the weather forecast's dire prediction for the Dorset coast.

The Coronation took place on 2 June 1953 and the Trinity Street party was finally decided on and moved to the comfort of the draughty church hall in Trinity Street named the Hope Reformed Church and Hope Congregational Church. Hope was a good omen; we hoped we were going to have a good time, and we hoped we were going to have lots of good food and drink, and we hoped the rain would stop. With most of the food rationing now removed, unless you wanted bacon and other meats, we were ready to party, and party we did. Orange squash served in large, chipped, enamel jugs was placed on all the trestle tables. We had sandwiches of boiled egg, spam or cheese, finished with a current bun with jelly and blancmange. We were in culinary paradise, imagining this was the sort of food the King must have had each day. Just snap your fingers and a spam sandwich was yours, all served on a gold plate.

The Coronation rationing menu must have been repeated all over the country, complete with government-issue, chipped, enamel jugs. I can

imagine in London, a chief Whitehall civil servant making a directive detailing wagonloads of these chipped jugs to be despatched all over the UK. 'Right, Carruthers, this is a very special occasion, as we will have a new Queen of England to be crowned. All efforts must be made to make the national coronation party go with a swing. It will be much grander than rolling VE and VJ day together, so all chipped, enamel jugs, ref. XCHIP/587JUG/312 must be made ready and are to be shipped from secret storage depot ref. XSO/1953/COR/Chipping Sodbury.'

At home, it felt like an ordinary day. Mum and Dad may have had an extra cup of tea and a cigarette and hung a Union Jack flag out of the window and perhaps shook hands, but other than that, nothing – no champagne ready on ice, a big homemade Coronation cake baked with icing and marzipan – nothing. As we were concluding this rich feast, with lashings more water added to the already diluted orange squash, we were told that there was a surprise for us. Due to the rain persisting and getting heavier by the minute, 'yes, we can hear it', we were all to go on a coach mystery tour. This was one of those pre- and post-war forms of entertainment for holidaymakers and locals alike, which would take place during the day or an evening out in the summertime: a coach tour where the passengers knew not of their destination. The only promise was there would be a pub somewhere along the 'mystery' route. It could be to an area along the coast, or into the countryside.

In later years, while living in Berkshire, I remember someone telling me of a very busy husband and father who worked very long hours at his place of work, so on a rare day off, his wife and children booked a mystery tour as a family outing. The husband was glad to be with the family, as this was to be his only distraction where he could forget about work for a few hours, so he sat back to enjoy the evolving mystery tour. 'Where will we all be going to?' wondered his family. They soon found out after the coach headed east along the A4 Bath Road towards London then, the coach making a right turn, the mystery tour now began to reveal itself to be a tour around London Airport. All very interesting, of course, the only problem was that the husband was now attempting to enjoy a trip around his busy place of work and hoping his work colleagues didn't see him with his face partially hidden by his hand as he sat near the coach window.

Anyway, off Frank, I and all trouped in our Sunday best, grey-flannel suits and ties to the waiting Bluebird coaches. Bluebird was a private coach company that advertised itself as 'Travel carefree as a Bluebird' – not that many people had ever seen a bluebird, so who could argue as to what was carefree travel. When seated in these very polished, two-tone, blue buses, which were (for the fifties anorak types) Bedford OB/Duple coaches, we were whisked away into mystery around Dorset. So heavy was the rain that nothing could be seen through the windows. We might

as well have driven around the block forty or fifty times for all we saw, although we must have moved out of Trinity Street at some point, as I remember somebody shouting quickly, 'That's Hardy's monument' (a stone tower erected in 1843 dedicated to Vice Admiral Hardy of HMS Victory-fame who was its captain, and not Thomas Hardy the writer, as most people thought). This 70-foot tower, located 770 feet above sea level, loomed up out of the squalling rain and disappeared just as quickly as it appeared. That was the problem with those Bluebird buses. They would whisk you along at 10 miles per hour and you would miss most things if it were raining, and it was, and we did. So if it wasn't for Hardy's monument located on the summit of the Blackdown Hill, near Portesham, we would never have known that we had left Trinity Street.

Back at the Assembly Rooms of Hope, we were given a souvenir to mark the event, which was either a mug, with our new Queen depicted on it or a propelling pencil, which had a royal crown fixed to it. As far as we were concerned, the greatest moment of the year had been celebrated with chipped utility utensils serving diluted orange squash and a bus ride of rain-streaked windows to visit a damp and misty mystery monument. Of the Coronation itself we saw nothing; only the next day did we see a picture in the newspaper of the new Queen with her crown and holding a sceptre in one hand and an orb in the other.

We had no chance of seeing the Coronation on television. I think, in 1953, a transmission could not be picked up yet in Weymouth, so we would have to wait in eager anticipation for the film of the Coronation to arrive at the cinema.[15] The much-awaited Coronation film duly arrived to be shown and watched at the Gaumont Cinema in St Thomas Street by the whole school, Melcombe Regis Boys' School plus children from other schools, all sitting and watching and, if they were like me, growing very bored by it – no sweets to suck or an ice-cream to lick faster as the film's excitement grew. This was a school trip. As it was the fifties and tough school discipline was the rule of the day, our false contentment was upheld by all in charge: 'Did you enjoy that boys?' 'Yes, sir.'

The Coronation seemed to be a mournful affair, a marriage and a funeral service held in tandem, perhaps the cheering crowd were relieved it was all over and that they could go home out of the rain. On the day, many notable and famous people were watching the event from a VIP vantage point overlooking the route to Buckingham Palace. One of those famous people was Noel Coward, who enjoyed guessing the names of Commonwealth leaders as they rode by in their carriages, although not many could be identified as the carriages were covered due to the heavy rain. The very large and robust beaming figure of Queen Salote of Tonga chose to keep her carriage open. Sitting with her was her companion, a small, diminutive figure wearing a tricorn hat and breeches, to which Coward's friends

asked: 'Who's that?' He famously replied: 'Her lunch.' If we had heard his amusing reply or even been given a full commentary by him, then it would have perked us up with instant laughter. What should have been a happy event seemed just a solemn ordeal.

Many cabinet ministers did not want the event to be televised; in fact, Winston Churchill was concerned that the Queen's concentration on this solemn occasion would be affected if she were subjected to the bright lights needed by the camera crews. Would the Queen have really lost her concentration and broken into some sort of royal song and dance routine? Whilst preparations were being made for the Coronation, a major crisis made itself known in that the anointing oil had all been lost during a German bombing raid in the last war and the makers of this oil had gone out of business. Yes, I would imagine waiting for new orders for anointing oil must have been slack business, with business getting slightly hectic as each coronation day drew near. All was saved on the day as one of the past, retired employees was able to knock something up.

Due to the Second World War ending only eight years previously, the Coronation was still subject to the shortages felt by a lack of money and royal staff of the establishment with the conundrum that the etiquette that each of the members of the royal family should have their own coach, complete with livery men could not be met because there was still a shortage of men and carriages. This meant that lords and millionaires who owned such carriages volunteered to provide the carriages, dress up, and drive the carriages for the Coronation. So the very well off were driving the carriages for the not-so-well-off royal family. Knowing what was really going on behind the scenes seems far more interesting than the event itself.

The real excitement that happened at the same time was the splendid efforts of Tenzing Norgay and Edmund Hillary, who, as part of a fourteen-man team, conquered the highest mountain in the world, Mount Everest. This we also saw at the cinema as a school trip. This was more interesting than the Coronation, despite the poor quality of the camera work in the film, but we have to acknowledge it must have been a very difficult exercise to both climb and take good pictures at the same time, no make-up artist or best boy fussing and running around up there. *The Times* newspaper wanted to be one of the first to report the news, and its young foreign correspondent, James Morris (now Jan), had arranged to send a series of coded messages that when read gave generally disappointing, mixed or just neutral news, 'heavy snow, still at camp X STOP, advance base abandoned STOP', and so on. The reason was that, should the messages be intercepted, they would look informative but also meaningless and would not be of much use, but in truth they were concealing the real meaning of the message. Once a certain empty message was matched to the secret coding sheet held by

The Times newspaper, the true message would become all too clear; thus *The Times* were first to announce the success of the climb with the very negative message 'snow conditions bad STOP'.

A year later, after the sadness of the King dying and a few months before the Coronation, this country's sadness was replaced by cheers and partying in many parts of the world by the death in another country of the Soviet leader Stalin. Joseph Stalin, ruler of the Soviet Union, died on 5 March 1953, aged 73. Whilst the people of Russia were weeping in anguish, some concerned as to what the future would hold, others were sighing with much relief, especially those people in labour camps and prisons. One such prisoner was the writer Aleksandr Solzhenitsyn who was released at the same time that Stalin died. That knowledge gave him a wide grin but he kept his cap drawn low to hide his contentment. Mum showed me a picture in the newspaper of Cambridge University students partying at Uncle Joe's demise. As a ten-year-old, I found it odd that such happiness could be gained from someone's death.

The irony is that it took an oppressive regime to keep most of the western world free during the Second World War, in which millions of Russians died to help retain our freedom, but with the aftermath of that war was the shackling of many countries to the Soviet Union, or as Mr Churchill said at the time: 'An iron curtain has descended across the continent.' These shackled countries would not taste real freedom until the Berlin Wall came down with the short-lived communist Soviet Union going bust. So whilst most people were not sorry to see Stalin go, the truth to emerge from Soviet Russia, which became clearer as the Iron Curtain was lifted, was that Stalin's Soviet Russia had an estimated 150 concentration camps, whilst the Nazi party had eighteen concentration camps, and it's probable that twice as many died in the Soviet Russia camps than the Nazis put to death in their camps. But we all must acknowledge the huge sacrifice the Russian people made in that war.

A month or so before the King died, there was a story that gripped the nation concerning the *Flying Enterprise* captained by the brave Captain Carlsen. We would listen in on the family Sobell wireless to the urgent voice of the BBC newscaster as he gave news of the latest situation about the stricken ship. The fifties still had the inhibitions of class with the news broadcasts read by cold, stiff and clipped-voice newscasters still focused on the monochromatic island of yesteryear that we called Great Britain, but the narration was, without doubt, clear and without ambiguity with the known facts. The weather at Weymouth during the winter can sometimes be a bit rough, generating huge waves thrown over jetties and piers. One look at Weymouth Bay during a storm is enough to instil concern and foreboding, so the plight of a stricken ship on the high seas in stormy weather could be easily related to.

The *Flying Enterprise* was a 6,700-ton merchant ship that had left Hamburg in December 1951 bound for New York with ten passengers. Christmas Day came and the ship's cook, a black man, which the newspapers found to be very newsworthy for the time, had prepared Christmas dinner for both crew and passengers. Dad switched on the wireless five minutes before the programme to allow the set to 'warm up' for the 1.00 p.m. BBC Home Service broadcast for an update of the ship, which we all eagerly listened to. It reported that, since the ship had set sail, the weather had been very bad and was now becoming worse. Even with a gale warning on Christmas morning, Christmas dinner was to be served, whether or not the passengers felt like it. As the ship approached the open Atlantic, it hit the vortex of the storm. The winds reached hurricane force and the seas were hitting the ship with a torpedo slam. Whilst lightning flashed, the now seasick crew and passengers were being hurled from side to side in their cabins. All over the eastern Atlantic, ships were giving out distress signals, and at the time, the *Queen Mary* had its worst crossing ever. This was the worst storm in thirty-five years. On Boxing Day morning, our ears were glued again to the Sobell wireless for the 'precise' BBC 1.00 p.m. Home Service news once more to hear that the hurricane had reached its height. With the ship now in perilous conditions, a sudden very loud crash was heard on board the ship, to which the captain called for all hands to be on deck. This maritime event drew the nation to listen to all the latest wireless bulletins and to reach for the daily newspaper updates.

As we were off school for the Christmas holidays, we followed the story with eager concern. Back at the ship, the loud noise that had been heard was the sound of the ship cracking in two from starboard to port. The captain called for help but the nearest ship was an American freighter some 400 miles away. Dad said that this rescue ship would take many days to reach the *Enterprise*, which would be too late.

We thought this saga at sea was better than a film at Saturday morning pictures, although we could see none of the actions taking place, just an imagination let loose to fear the worst. The state of the ship was getting worst with the list now at 45 degrees and Captain Carlsen putting out an SOS message. By now, the order was given to abandon ship with the passengers told to jump in the sea where they would be fished out by the ship's lifeboat. Captain Carlsen was determined to stay with his ship for insurance purposes. With all hope of saving the ship now gone, the Culdrose helicopter station in Cornwall called Captain Carlsen and stated that the helicopter, then very new technology, would leave to make a rescue for him and his mate. I remember drawing a picture of a helicopter flying over rough seas with a ship drawn in a half-sunk position. With some hesitation, the captain agreed. He was also told that the helicopter would only have five minutes to hover and make the rescue. However, the

helicopter had reached its maximum endurance before reaching the ship and had to turn back. With that news, the captain made the decision for them both to abandon ship and chance their luck with a ship standing by. They stepped off the ship and were soon aboard another ship standing by called the *Turmoil* – an apt name, we thought. The *Flying Enterprise* then sank and all but one member of the crew was saved.

This rescue saga went on for over two weeks and was followed by the world's radio stations and newspapers to such a degree that other affairs were pushed out and removed from the front pages, although I wonder what the news would have been had the King died at the very same time. The *Flying Enterprise* incident was a drama full of hopes, fears, heroes and the struggle with the sea. This saga was better than listening to our favourite wireless programmes, *Dick Barton Special Agent*, *Riders of the Range* or *Journey into Space*. It was a real drama with real people. What a ruined Christmas the ship's passengers had, Frank and I thought; all the crackers and wrapping paper would be now very damp.

By the time the rescue came, we were back at school and the playground talk was of the brave Captain Carlsen, then it was back in class for an arithmetic lesson or gathering around the wireless for a BBC *Singing Together* lesson/programme.

'Good morning schools, welcome to *Singing Together*,' said the voice of William Appleby. 'Settle down now, boys, listen to Mr Appleby, one two, three: "Early one morning just as the sun was rising …"' Some boys were surprised that this school singing teacher and wireless presenter, Mr Appleby, could stop us all in mid-song and say that we were singing the tune incorrectly and we were to start again. This we did, but were baffled as to how this Mr Appleby, at the BBC in London, knew we were singing the song incorrectly. Some of the other boys even looked out of the window in case Mr Appleby was watching us from the playground rather than it being a radio programme. Of course, hundreds of schools in Britain must have listened to and learnt from *Singing Together*.

Melcombe Regis Boys' School was probably a very good school. It was located on the corner of Westham Road and Commercial Road; the latter had railway lines running down the middle of this busy thoroughfare leading to the docks at the Pleasure Pier. Our school was on one side of this busy road, whilst on the other side of Westham Road, there was a Christian establishment named the Bethany Hall. Each day, a passage from the Bible was displayed in a corner window and so marked for all the passers-by to stop and read, what I can only call 'a thought for the day'. To my surprise, this practice is still being carried on today as though nothing since the fifties had changed. It's even the same Bible and the same dusty window with its small collection of dead flies. 'Praise the lord' we would impart as we passed this gloomy corner building. I imagined a middle-

aged man thoughtfully turning the pages each day since 1950, now the epitome of Rip Van Winkle as he sees the same boys (now looking taller and craggier) reading the same Bible or pausing to count the dead flies.

Melcombe Regis Boys' School was built in Victorian times based on architecture for all public institutional buildings, solid and dependable, also made to be retentive for both knowledge and the misbehaved, whoever those boys were. Two teachers were of note when taught there: Mr Dean, or Dixie Dean as he was called (after the Everton footballer), and Mr Cross. Our teacher Mr Dean and Dixie Dean, the player, were completely different characters. Mr Dean was a quiet, unassuming, rotund, bespectacled schoolmaster who was about fifty-five years old, and Dixie Dean, the player, was rated as the greatest centre forward ever. This was a time when footballs were made of leather and had the laces protruding from the ball, making the wet ball very heavy and difficult to control.

There are many anecdotes about him. One was that after a Spurs match, Dixie Dean was the last to walk off the pitch and a supporter shouted at him: 'We'll get you, you bastard.' A policeman heard this but was pushed aside by Dixie who said to the policeman, 'It's all right, officer, I'll handle this.' He then went over to this supporter and punched him so hard that he went flying. The policeman, who saw this incident, smiled at Dixie and said: 'That was a beauty, but I never saw it officially.' How helpful the police were then.

The only time I crossed our own Dixie Dean was by talking during a lesson, so he kept me in class at going-home time for about ten minutes. He then said to me: 'Off you go.' As I walked out of the door, he gave me a half-hearted cuff around the ear, but I ducked and he missed, which he would have smiled at and left it at that, but me being a big mouth, I uttered the not-so-intelligent response of 'missed'. I was hauled back and given the cane for insolence; so another lesson learnt. Keep quiet in the first instance, and definitely keep quiet in the second.

Mr Cross was my last teacher at Melcombe Regis. His name always amused us. Cross by name, but not really by nature. Mr Cross was a slim, thin-haired, bicycling man, who was about fifty years old, who seemed to enjoy teaching and would buy prizes, mostly small books, out of his own pocket to award his pupils for good work. I received a book about trees from him for my drawing work. He would take us on nature walks to Radipole Lake and its swannery. These nature walks used to cause a small row with Mum and me when informing her of this pending muddy or very muddy nature walk. 'Wear your old boots today.' 'Oh, not those horrible lace-up leather boots, Mum.' I hated wearing those turn-of-the-century school boots. 'Oliver Twist wore better footwear, none of the other boys wear them,' I would protest.

The other boys always wore their proper shoes, even if they also walked home caked with mud. I think Mum must have picked up these boots at

a theatrical suppliers jumble sale. I called these boots, 'onky boots'. This seems to be a Page word, to mean ill-fitting, rough, crudely made, clumsy, ugly, or just of poor taste – one very useful, single word used to fit all those negative descriptions. Mum would use that word to describe anything that was lacking but without precise description, perhaps life itself sometimes, but she knew best when shoes and nature walks were involved. So nature walks with Mr Cross were never mentioned.

'How did your new shoes get in that state?'

'Just by walking home, Mum.'

We would have to make notes of everything and anything Mr Cross pointed out to us as we walked around the lakes: 'Look out for bearded tits and shags, boys.' No wonder our shoes got so muddy. Mr Cross also put in a large amount of his spare time coaching cricket, which was difficult, as we didn't have a grass pitch to play on, only the hard playground. The cricket stumps were fitted to three hinged blocks of wood that enabled them to be stood upright on the playground pitch, allowing each wicket to fall backwards should the ball hit them. No diving for the ball by the wicket keeper on that pitch.

During one history lesson in class we learnt that the Black Death arrived at Melcombe Regis in 1348 AD, and caused the death of 30 million people worldwide (not that the populated world was as large then as it is now). Now, as ten-year-olds we took this news literally and, when we looked out of our school window, and saw the Sea Cadets ship, an old MTB boat, moored next to the school, we thought, 'Gosh, that's where the Black Death came in; no wonder Mr Brown, our headmaster, always seemed grumpy about something.'

Mr Cross also taught us about the Civil War, and it became apparent to me in later life that he must have been politically quite a left-wing supporter. As school children we were unable to differentiate between the mysteries of the left or right wing of politics. He would beam a smile as he taught us about the Roundheads, Oliver Cromwell and the Parliamentarians, then he would frown at the efforts of the Cavaliers and Royalists in defence of King Charles I. One rather keen football fan in our class asked Mr Cross a fundamental question, 'Sir, if the Roundheads were playing football with the Cavaliers, who would win?' to which Mr Cross replied with much enthusiasm, 'Oh, the Roundheads of course.' From then on, the Roundheads were the heroes of the lessons. During break time, it was discussed amongst the keen football fans that if the Roundheads played the local Weymouth team, the Terras, who would win? I am not sure of the conclusion, but the sight of a football team dressed in Terracotta and Blue shirts and wearing shorts on one side of the field and men dressed in Parliamentarian uniforms carrying pikes and swords on the other kicking a ball around would have made a very interesting match. 'Yes, the

Roundheads have been given a yellow card and told to retake the penalty and to not use the cannon to lob the ball in the goal mouth.' Mr Cross is remembered as one of the best teachers I had, as I mostly came away from his lessons having learnt something.

Mr Brown, on the other hand, our headmaster, was a very stern man. I suppose he had to have good discipline to keep 100-plus boys in order, as these were boys from a very mixed background, with no fee-paying parent keeping an equally disciplined eye on their son in that school. When the King was laid to rest, we all had to troop into the main hall and stand for the two minutes' silence. He asseverated to us all that he wanted 'complete and utter silence, no shuffling of feet, no clearing of throats, heads bowed and eyes closed tight. If I see anyone move, just an inch, he will have six of the best, the very best.' As he gave this decree, he would train his middle finger at 90 degrees held like a machine gun at a more-than-disliked enemy. That warning produced a textbook two minutes' silence. His middle finger was worst than his bark. All the boys at the school thought that when not in front of a class, he would permanently have this middle finger up his back side in readiness to add weight to his next pointing moment.

Having made the mistake of falling in the harbour twice, I must have mentioned my well-honed skills, in passing, of course, to some classmates. After end of school, one damp and dark day, I walked to the library located just over the bridge in Westway Road, a small, single-storey building built with a much-scraped-together budget by the council in 1948, who, after building this square block, had a few pounds left over in the kitty to add a small garden to it. After choosing a book or two at the library, fiction to read in bed and a non-fiction textbook, probably on learning how to dissect a stag beetle with step-by-step coloured layers of graphics of a dissected beetle that I could follow with the help of Mum's cooking utensils, I ambled my way home, with books under my arm, in the dark evening, about teatime. On arrival, I found that only my older sister Peggy was there. She was surprised and relieved to see me, immediately I knew something very wrong was afoot. She told me that one of my classmates, Brian Jackson, had called and said that I had fallen into the harbour at the Backwater, or inner harbour as its also called, and a search was being made for me. I suppose these things happen. Mum and Dad must have thought third time unlucky: 'It's got him at last.'

Dad, by this time, was home from work, so my parents went off with a torch to search for my floating, or now-sunken body, in the dark and murky waters, all, of course, without police/ambulance/fire brigade assistance; just Mum and Dad with a torch in the dark to search the black, murky Backwater around the many old, rusty ships moored and surrounded by much flotsam and jetsam. After about an hour, they returned, minus a soggy body under their arms or slung over a shoulder; they were, of

course, very relieved to see me. I can only imagine how relieved I would have been had I been given that news as a parent. Mum, though, was absolutely convinced my clothes were wet and told me to get out of them or I would get a chill, even though I protested that I had not fallen in the water. 'I've been to the library, here's the date stamp in the dry books.' 'I will air some dry clothes for you,' Mum said. What the mind will believe when subjected to a distressing lie. As a keen fan of the radio series *The Goon Show*, I always had a wry smile at Spike Milligan's character who would utter those immortal words: 'He's fallen in the water.' This to much applause, not from my family though, who were hopefully relieved that I survived these outings. As for what happened to the sad messenger? His reputation in fabrication was assured; thereafter, nobody believed another word he said. Frank, my brother, also fell into the harbour at one point, but without the dramatic rescue that I had. His fall was near steps and he was soon fished out, as there were many people around. Boys will be boys, I suppose. Dad's workshop was very important to him as it gave a means to both produce and repair items, thus adding or saving money for the family; therefore, without him being there, it was very much out of bounds for us boys. During the summer, Dad would be involved with Weymouth Sailing Club, starting and finishing the various races with the two small cannon guns, but in wintertime, when there would be no yacht racing, Dad would take care of the two starting cannons and store them in his workshop at 'Som Pee Air' for a service, general overhaul and clean. Small boys have an interest in cannons as with all things that can go bang. Sometimes, whilst Dad was at work, Frank and I would sneak into his out-of-bounds workshop and play various games with these cannons. I say play as there were no cartridges we could have used, but a great pirate game could be played out in his workshop. We were caught once playing with them and we were, metaphorically, made to walk the plank of a shark-infested sea, of course, each blaming the other for this trespass. I think 'very much' told off is an understatement, mainly because, later, we did manage to nearly burn his workshop down whilst the cannons were inside.

We flashed our lead with weighty line, but hot it got as we were called to dine.

We had acquired some old pieces of lead flashing from the bomb damage at Chapelhay, and with a methylated-spirit-fuelled camping stove, we were melting the lead in a little, cast-iron pot until it was molten, then pouring the blister-making lead into a mould we had made to make fishing weights. This mould was a simple item to make. We would, with Dad's tools, drill a large, round hole into an offcut of wood, very near to the wood's edge, then hammer in a metal staple so that the two sharp prongs entered the

internal drilled hole, then with the lead now in a molten state pour into the hole and leave to set. The result was a heavy fishing weight that had been made at no cost, other than some cheap (although not purchased) blistered fingers. The little camping stove was still lit with molten lead when we picked up the long-awaited house signal from the catering department. Mum was calling 'teatime'. Hungry boys do not wait for safety procedures to be enacted; the word 'tea' blotted that out, especially if the word 'tea' was accompanied by the words: 'The chips are getting cold.' Halfway through tea, Mr Donkin, our recruiting-officer neighbour from No. 18, was at the door. He had called to ask if anyone was having a fire in the workshop, which he could see from his upstairs window. Mum rushed to the backyard followed by Mr Donkin, then followed by a slow and hesitant Frank and myself to witness the flames taking hold through the workshop windows. After buckets of water were used and the flames were doused, we inspected the damage. The door of the workshop had been burnt off its hinges and Dad's overalls, which had been hanging upon the door, had also caught fire. In fact, they had disappeared into a small, black, smoking heap. Dad saw it as disappointing news that his two sons had been so careless as to nearly burn his beloved workshop down. Mum saw this as an insurance claim and new overalls and door for Dad. Frank and I saw it as a very sore bottom, no pocket money, a week of early nights to bed and, worst of all, our chips had now got cold. Still, with that camping stove, we could warm them up in Dad's workshop.

Then, in due course, as winter moved into summer, as the ages of the school boys neared eleven years of age, it was the 'eleven plus' examination time, with the important questions: had the school done a good job? Had I listened to all those lessons? The eleven plus was the examination to single out the boys who would go to the grammar school and rule the world, and those who failed and would work as a sewer attendant's labourer's mate, fourth class, forever. We all trooped over with newly sharpened pencils and eraser rubbers to the grammar school to sit this examination. I had a desk on the second floor with a good view out of the window of Radipole Lakes, so with new pencils sharpened, rubber ready to correct the rare mistake, we were off. Working my way through each paper, my confidence would rise and fall, Governor of Hong Kong one minute, and the next a failed sewerage worker, fifth class and sacked for not being good enough. Mum and Dad had little interest in education. Mum was a little more interested but never any thought of extra education, such as a crammer to get through difficulties with exams. You are all clever and we love you was the unsaid encouragement we got. Never once did they visit senior school to discuss progress; like themselves, we were left to get on with it. Independence of mind and spirit, perhaps. So after all that hard work it was off to Broadwey County in Dorchester Road for continued scholarly enlightenment.

chapter eleven

The Ghost of High West Street

The crypt is old and the ghost's bony hands are cold.

As she wheeled her wheelbarrow
Through streets broad and narrow,
Crying 'cockles and mussels, alive, alive, oh' [...]
She died of a fever
And no one could save her [...]
Now a ghost wheels her barrow
Through streets broad and narrow [...]

So go the lines in the old folk song on the life and death of Molly Malone, whose young life was cut short by a fever, the selling of her shellfish being taken over by her ghost; well, why not? We had plenty of idle ghosts half looking for employment at 'Som Pee Air'. Living near our harbour-side residence, we had our own 'Molly Malone'. Well, I don't know what her real name was but there was a lady, helped by her (we assume) husband, who lived in High West Street, which was on the edge of North Quay and the Town Bridge, and she sold cockles from a wheelbarrow. She was not a young person nor, I believe, from the Emerald Isle; in fact, we always thought the couple were quite elderly and had to sell cockles to help out with a poor pension. Of course, anybody over eleven years old was ancient. Both her husband and 'Molly' always wore black, as though they were in permanent mourning for someone or perhaps she was the ghost of Molly Malone and had sailed out of Dublin to more favourable climes as she heard that 'The Bay of Naples' was warm and sunny, but instead ended up, after some optimistic navigation, in Weymouth to recuperate from her fever.

The house they lived in was on the edge of the bomb damage and I seem to remember the house next door to them was an empty shell due to the bombing, a place we would sometimes explore. The remaining end house that this mournful couple lived in had the position in High West Street where the sun never shone due to its north-facing aspect and the position of buildings, which included an old warehouse directly in front of it. The

parachute mine that dropped on the night of 17 November 1940 would have fallen almost on top of the house where this phantasmal couple lived and maybe a person or persons near and dear were lost, hence the black attire.

'Molly' and spouse would push their parsley-plant-decorated wheelbarrow carrying all the fresh cockles with their tiny china plates, vinegar bottles and pepper pots, all spotlessly and hygienically clean, along from their house and under the dark tunnel of Trinity church, where, no doubt, the ghosts were able to return that special cold, bony, ghost handshake as they passed through, pausing only at the crypt entrance to pass unpleasantries. It was an enthralling sight as those two stygian figures emerged on a warm summer's evening from this black ghost hole pushing a wheelbarrow. Both Molly and her man would be very silent. Not a word of conversation would pass between them as they came along the lower pavement of Trinity Road to pass our dungeon windows. The only sound was from the grinding of metal-tyred wheels on a hard pavement. The wheelbarrow was pushed as far as the junction of Trinity Street and Cove Row where they had a pitch to sell their wares – a convenient spot to sell, as it was next to two pubs, the New Rooms Inn and the Old Rooms Inn. I can't help thinking that when it came to original names for the new inn there was something lacking. So, with both inns adjacent to that all-important seaside facility, the public convenience, Molly positioned herself and her cockles.

The same haunting scene would be played out each evening in summertime. Two elderly people attired ready for a wake on a warm summer's evening but spoiling it all by arriving at a holidaymaker's party to sell small plates of cockles from a brightly decorated wheelbarrow. They were surrounded by dozens of happy smiling holidaymakers who would mill and spill around with their pints of warm beer to help in demolishing tiny plates of vinegary peppered cockles, or pink and yellow bogies we would call them. How did they taste? Wonderful, just wonderful, even to young boys whose taste was far removed from the sophistication of the cultured London holidaymakers. Ten pints of beer and half a dozen plates of cockles, covered in vinegar and pepper would soon decorate the pavements of Trinity Road, Trinity Quay, Hope Square and Cove Row. These design formats were known to all devotees to be work from 'The Heaving Concept School' and could be created, mostly inadvertently, after such generous purchasing of this delightful snack; such was their artistic influence.

You must stay Molly with your fevered past and faithful groom, even if today's mayor now parks the taxpayer's limousine in your lost garden and leaves you no room.

High West Street was the west end of the previously named High Street and above it, sitting on the high ground, was the suburb of Chapelhay and the reason for our vengeful German Rock plan, where this much-bombed-out area spilled over to the street far below it. But, of Chapelhay itself. Chapelhay, which means chapel boundary, is a high suburb of Weymouth and is accessed from all sides, including from the Nothe and the return from Sandsfoot Castle or from the town across the Town Bridge. From there, you can ascend a set of steps next to Trinity church, then you continue from Trinity Road, walking with a gentle rise to the top of Chapelhay. During the early fifties, most of the bomb damage was just as the Germans had destroyed it. Some dangerous buildings would have been demolished, but most of the damage and destruction was left alone. There were, however, some houses still occupied, as these had not been damaged. Living in a building when all around you has gone must have seemed akin to an oasis in decimation.

At the top of the easy-to-climb last steps was Chapelhay Heights and there stood, or held on by little else than luck, a shop named Amos Stores. After the bombing, this general store of a shop was now left hanging very precariously on to the steep bank that overlooked the harbour and High West Street. To suggest that this shop had seen better days would have been an understatement. That this fragmented shop never slid down into the street below was nothing short of a miracle. A damaged Heath Robinson funicular on a one-way decent is how it is best described. This shop and the rest of the buildings were badly bombed when hit by a German parachute mine destined for the harbour and its important town bridge. That November date in 1940 was the worst bomb explosion the town was to experience. Seventy-seven building were destroyed with 879 damaged, with twelve people killed including some children. The noise of a bomb of that magnitude must have been tremendous.

Hanging by a thread, Amos's shop would sell us bottles of lemonade and sweets served from large jars on the now-sloping shelves at the back of the shop. My memory of the brand of lemonade sold was that it had a picture of a fireman on the label. We called it 'fireman's drink'. I assume this was to suggest that it quenched your thirst or, as we joked, was to remind the owners of the shop to call the fire brigade should their dilapidated premises start to slide down into High West Street then, or, if it's too late, to greet the fire service with thirst-quenching lemonade from the street below, then change the address for continued business. 'Amos General Stores now relocated from Chapelhay Heights to High West Street. Business as usual. Now easily accessed from town centre.'

Marching GIs on Weymouth's Esplanade, D Day. Perhaps marching to Chapelhay for another exercise.

Rubble Fun

We surprised the enemy in the dark alleyways, hands tied we took them prisoner, then burnt them for their wily ways.

Those words underlined the make-believe play we all enjoyed with friend or foe.

The various bomb-damaged houses would have been a source of bricks to overcome the national shortage resulting from much rebuilding work after the war; however, before the houses were finally razed to the ground and the bricks gathered for rebuilding, Chapelhay, because of its shattered and dangerous state, made a brilliant playground and was easily accessible for us. Any game that needed a place to hide, ambush the enemy and make their demise complete was played out in full force in this ruined suburb. Small chunks of fragile mortar were used and thrown at the enemy as we shouted *Achtung Achtung*. These simple plaster portions made useful exploding bombs. Anyone who died would scream an Oscar-winning, agonising death. Any weapon was used to fight the various enemies who came into view as we rampaged under the roofless voids. The Germans would die from the sword of Excalibur, Red Indians would be machine gunned from a pillbox, and Tarzan would end a dugout stronghold filled with Japs with just a swing on a rope and a Bowie knife fashioned from a piece of wood, and a good English bow fashioned from yew would be replicated from the bamboo canes found in some of the bombed houses.

We would use catapults fashioned from a 'Y' shaped tree branch, which could pierce a neat hole through a glass jar or bottle without causing the projectile to smash it.

There was no particular gang of friends, just a load of boys turning up for an ad hoc recreation of the 'now' conflict event. Hopalong Cassidy would be brought in to mount an attack on Pork Chop Hill with his six guns blazing in the Korean War. Robin Hood would send the shivers down Geronimo, and Geronimo would scatter the horses of the Martians. Whatever the game was, it involved 100 per cent fighting by short flannel-trousered beasts at the end of civilisation and as to agreeing a battle plan, well, there were none. 'I want to play at the Korean war.' 'Let's all do Robin Hood and the Sheriff of Nottingham.' 'No, Germans and Japs, with the English fighting them.' 'Who wants to be a German or a Jap?' Nobody ever wanted to be a German and certainly not a Japanese soldier. 'Okay, what about Red Indians?' 'Okay, it's agreed. We will be the English army in the desert of Africa fighting the Apaches.'

Whatever the conflict, perhaps it included building a small wall and throwing bricks at it as we made Dam Buster noises of approaching aircraft releasing deadly half bricks at a cowering enemy. Whatever the part we each wanted to play, none of us would, or were able to, dress up in the appropriate outfit. The Apaches would all be dressed in Fair Isle jumpers and the ubiquitous grey-flannel short trousers, as were the Martians. Some of those boys may have worn zip up jerkins or their old school blazer as they acted out being the 'Desert Rats' from the eighth army.

Once the ground rules were established, of which there were none, the battle cry would go up. 'Let's get armed.' This would entail being split into the two sides and an empty, bombed-out building being selected for the plaster on the wall of a room to be prized off and broken into small, handy throwing pieces. Whilst there were mishaps, such as a bad cut, grazed shins, bruises and the odd broken bone, most of us managed to limp home unaided. A bad accident did happen with a stick in which one boy lost an eye. Unfortunately, he also had a bad stutter so he was never nominated to shout charge at the enemy but would be the first into the affray, although this accident made his stutter much worse. Furnished with a glass eye thereafter, he made it into a great party piece by removing it to show it to friends or to frighten our foes. I only hope that in later life he did not swallow his eye when carrying out his party trick, as the eye would have worked its way to the end of the rectum, and conscious of the eye now looking at him, the consultant surgeon would have had to turn to his patient, as he looked at the eye looking back at him, and utter: 'I can assure you that you can trust me.' His painful loss made a small item of news in the *Daily Echo*. We all kept on friendly terms with him, because for any game we played, he could supply the most guns – toy, of course.

Without a wrist or pocket watch nor a church clock, the consortium of boys would become so engrossed in the conflict that they were lost in time. We only knew it was lunch or teatime when parents or older brothers came and yanked each of us off one by one to go home.

Sometimes boys from another area would venture onto our playgrounds. This prompted the mass cry of 'Who are you?' followed by a chase that sometimes went on for ages until we all became exhausted, lost and scattered, leaving us to make our way back to the happy hunting grounds of Chapelhay. I assume all the boys who contributed to these democratic games all became Liberal Democrats.

One bomb-damaged house, located a few houses along the sloping path leading to Amos's shop, was a Victorian terrace with a hinged roof light hidden under a layer of ivy in what I assumed to be the storage or workroom of the building. The four of us 'Quads' managed to open this roof light to allow us to climb in and explore this otherwise more or less intact house and rooms. As we were about to have a good look around, the roof light suddenly slammed shut turning the whole room black, which now locked us into this dark, damp and unfamiliar secret place, an oubliette. Despite our best efforts, we could not reopen the now-hidden trapdoor. As there was no other way out of this dungeon, we all started to feel a little frightened, and began to wonder if some bigger boys were responsible and had run away leaving us to die, gathering a cobwebbed canopy over our mummified bodies. Just as we were beginning to give each other the last rites, the trapdoor opened bursting with blinding light and peering down on us was a man telling us we were trespassing on his property and that he would not let us out unless we gave him our names and addresses, as he wanted to speak to our fathers. Knowing this would cause some problems, we debated whether to continue with the last rites or have a Quads Gang plan. I spoke for all of us and gave a false name and address, which was the name of a bigger boy who had chased us and duffed us up. The address I gave was in Trinity Street, not Trinity Road. With this information, he let us go. Afterwards, we did wonder if this man really went to this boy's address in Trinity Street, and if so, did the boys who we knew that lived there get a whacking from their dad? 'We can only hope,' we said as we smiled.

The bombing by the Germans started in 1940, and No. 12 Russell Avenue became the first house to be bombed as well as the Devenish Brewery in Hope Square. Houses were also bombed in Hope Square, Rodwell, with much of the bombing falling on Chapelhay, but also destroying the bus depot. Chapelhay seems to have been bombed twice in 1940 and again in 1941. Whilst the general region of Weymouth and the Portland areas were of some strategic merit to the enemy, the unfortunate people of Chapelhay seemed to have got the worst of the bombing without there being any

significant gain for the Germans. If it was the Town Bridge and harbour that the Germans were after, then they very much missed their target. In 1940, Hitler gave the order to the Luftwaffe (air weapon) to destroy our ports and harbours, hence the bombs that missed their targets falling on Chapelhay. As tragic as this was for the victims and their homes, destroying this vital Town Bridge would have caused quite a few problems for both the residents and military alike for years to come.

Chapelhay, it would seem, is not a very fortunate place to live. During the Civil War, the old chapel of St Nicholas, which was the chapel of ease to the parish church, after which Chapelhay is named, was badly damaged, as the Civil War defenders used it as a fort, which eventually caused it to be destroyed, after much fighting and bloodshed. Then, the later Holy Trinity schools were also badly damaged in the bombing. So much for being a chapel of 'ease', the dictionary meaning of which is 'freedom from worries or problems'. Yes, one would definitely have experienced that had one been inside when the bombs dropped. Moving house in, perhaps, 1939 might have been a bit of an issue to some of the more superstitious inhabitants.

'I ear you's movin' to Chapelhay?'

'That's right.'

'A lot of bloodshed they had in that Civil War you know; could 'appen again you know.'

'Nah, all the fighting was over years ago. Can't be anything much can appen na, can there?'

As Weymouth's Town Bridge and harbour were the intended target, as well as all road and rail connections to Portland, with its large naval dockyard, right up to 1944, Weymouth continued to be bombed, although as the war for Germany was running out of steam and its resources were drying up, by 1944 the bombing had lessened, but as a small boy, the Chapelhay bomb damage made a very lasting impression me. King George III, of German extraction, put Weymouth on the map as a resort, and it would seem that his future countrymen were trying to remove the town off the map. Why I think that Chapelhay became a good 'playground' was that the older boys knew that, for the preparations for D-Day in 1944, the US military would use the bombed-out houses to practise its war games, gaining experience in the hazards of house to house combat. This sad, bombed-out suburb of Weymouth had hopefully proved very useful for the Allies when they arrived in France after D-Day. The final push would no doubt have had much hand-to-hand combat amongst the many ruined and bombed-out buildings in the occupied countries of France, Holland and any settlements in the path of retreat as the Allies pushed forward. Knowing how well the Americans were equipped, with their superior transport and weaponry, as well as better food, they would have thought

American soldiers march on Weymouth's Esplanade (Weymouth at War).

the Chapelhay site was more than suitable for a bit of war practice. It must have given them pause for thought though when Chapelhay showed them and gave them a real taste of what real war damage was like.

Up to half a million American forces passed through Weymouth and Portland en route to Normandy. With the combined efforts of the Allied forces of the British Empire, the USA and Canada, together with the Russian Army, the last of the Axis powers of Germany and Japan were finally defeated.

As an adult on a business trip to Germany, my hosts suggested a visit to Cologne at the end of a number of lengthy meetings. The visit was very interesting, but much was made of the huge damage the city had suffered during the last war, not finger wagging as we were now all good friends, but an acknowledgement of the terrible damage both countries inflicted on each other. Photographs were on display of the bomb damage and the many buildings that were destroyed and lives lost, most of little military consequence to the Nazis. This reminded me of Chapelhay and the destruction I used to play in, and the effect it had on me. It was also a poignant realisation that all the bombing in Cologne took place on the night I was born, which I mentioned to my German hosts. We said nothing. What could we say of a past generation?

The bombed remnants of the pre-war shops and houses were still standing on High West Street, some of which were occupied. One such establishment, still with its temporary sticking plaster and string repair work, was a large fishmonger's and wholesalers where we could watch the

slate-bloom-coloured crabs and lobsters being placed in large cauldrons of boiling hot water to die of heat exhaustion. Cooked to a warm orange and pink colour, then prepared ready for the shops, hotels and guesthouses for 'Sunday Tea'. As we watched the crustaceans placed in the boiling water, we could hear the 'cries' from them: 'Let's go and listen to the lobsters singing,' we would say, only to hear the song fade quickly away, lost to the sound of boiling water. 'Okay, lads,' the head lobster would remind the rest, 'we will be in the hot water soon. What's it going to be? What about singing something to get us in the mood ready for the next step? How about 'Tea for Two'? Okay, here we go, one, two, three ...'

Next to the fishmonger's was a bombed-out shell of a double-fronted shop, which might have been a grocer's, draper's or a high-class sweet shop displaying its row after row of boiled sweets in large jars on strong shelves complete with an expensive glass counter displaying boxes of chocolates, or maybe this shop could have been Olives, a fish and fruit business since 1900, before the bombs closed it down for good.

We watched with amused interest one day, as a film crew fitted a set of gold-finished pawn broker's balls to the outside of this derelict shop front, then watching two actors play out the scene. Two actors (we didn't know their names or the name of the film) began to act. One chap clambered onto the other's shoulders to swing on these golden balls; both acting the part of being drunk, or perhaps they were poor performers and were drunk. The cameras rolled and that was the end of that scene, fame and then permanent obscurity in an hour's work for this sad little street. All of this area is now used as a council car park.

Near to this fishmonger's, on the other side of the High Street, was the Tudor house, which faced the Backwater as part of the North Quay. We used to play in this house, which Mum told us was a 'mock'-Tudor house, as at the time the historians and the council were at odds about whether the building should remain or be demolished. I can remember the house being used for storing lobster pots and various items of fishing tackle as well as a fisherman's makeshift 'you could find it blindfolded' lavatory, which no doubt made an excellent form of security to keep out trespassers. The Quads Gang, of course, was made of sterner stuff. Well, we managed to stay for a few minutes anyway, last one out wins.

People at the time did wonder whether the Tudor house was genuine or not because it was so well built. As an old building of the Tudor time, some 400 years old, it should have had more exterior dilapidation and perhaps a lean, but it had none of that. This building was, even after some bomb damage, very well built and in a very sound condition, although it did need some care and attention. Later investigation has confirmed that the house was a genuine Tudor property. Planners of the sixties have a lot to answer for: out with the tired, friendly old but familiar and in with the

brave new world where modern design and style make poor bedfellows with the existing and established architecture. Now, of course, sits the out-of-character council offices. The only thing that seems to have been saved from the Tudor house is the staircase now installed in Radipole church; trust them to get the only part worth saving.

High West Street was an area that felt lost and ill at ease, almost an alien, out-of-the-way feel about it, a feeling that would pervade across those lost, bombed and still-empty houses and made more poignant by the concealment of people still living in the pockets of the untouched remaining properties. Not a thing had seemed to change, other than the clearing up of debris, since that fateful night in 1940; the only life left to blossom in the destruction was nature's obligatory bomb-damage plant life, the buddleia, slowly taking over with its partner in grime, green moss, which was spreading in its sun-starved haven. Rolling tumbleweed along the street would not have looked out of place with an out-of-town drifter leading his tired horse to the last-chance saloon, the aptly named Boot Inn near Boot Hill.

Before reaching the Boot Inn pub, the drifter would pass a lost, Dickensian toy shop hidden and begrimed on a corner of the left-hand side of the street with its small window display showing one or two lead soldiers, a few tin-plate toy cars and a sad-looking teddy bear, all still covered in the shaken dust of the bomb damage. Just a glance from the resigned and non-expectant-looking owner would help move the drifter on past this nineteenth-century, now-lost dark gem, which is now used to park the council officers' cars on.

On reaching the top of High West Street, you would reach the seventeenth-century, ancient and haunted Boot Inn pub, reputed to be the oldest pub in Weymouth. Why it was called the Boot Inn, I am not sure; perhaps it was a bootmaker who sold ale, or a pub that sold very strong ale that left the drinkers in a belligerent way, which obliged the landlord to 'boot' them out while earlier he had 'Booted them In(n)'. I suppose, if it were for those reasons, perhaps it should be named the 'Boot Out Inn'. How wonderfully confusing that would be. Appearing on the left-hand side and on the opposite side of the small road junction was a junk shop, although today it would be called 'Antiques and other collectables', then it was just a junk shop, selling second-hand items that were scarce or expensive to buy such as an old, galvanised bath or a scrubbing board, all in very worn-out condition, probably all 'ex-bomb-damage artefacts'.

On the other side of the road in the fifties was a building that most interested us, the Old Town Hall. This building was our Cub Hut for the 1st Weymouth Cubs. Some Cub Hut this was, as it was built of Portland Stone and had a bell in a belfry. This is where Arkala and Bargeara would instruct us as to the mysterious workings of being a Cub Scout. We were

not the first citizens using this building to be subjected to its mysterious workings. The cub hut, otherwise known as the Old Town Hall, was originally built in Tudor times, although most of the Tudor construction had been lost to the more-recent, Victorian restoration work. This is the same town hall that administered Weymouth as a separate place to its adversary and neighbour, Melcombe Regis. One can imagine the recriminations and animosity the Weymouthians made about those trade and profits deals that each would lose to the other. After the amalgamation of the two towns, this old town hall was used for all sorts of other uses including, we were told, by steely-eyed grown ups, as a prison and, no doubt, by other short-lived enterprises. For now, we can concentrate our minds on the delights of Bargeara.

Bargeara, the second-in-command at the Cubs, was a rather plump young lady who would make us all giggle with her attempted pronunctiation of various words: hospital would come out as 'hos spit ah'. With words like this, you would need an umbrella if standing too close to her. This kindly young lady was destined to be a career spinster for the rest of her days, probably looking after mum and a few overfed cats, as she waited for the chocolate bars to be delivered by an exhausted car man grappling with her regular daily order. Although rumour had it that the Boot Inn pub, on the opposite side of the road, had a ghost of a young lady waiting for her lost lover; could this be Bargeara on a night off from the Cub meetings? Although rumour also says this ghost was a lady of easy virtue, so perhaps not. The energy of 1st Weymouth Cubs meetings would have been an exhilarating time for Bargeara; by comparison, her life seemed a muffled existence. Like a lot of people, Bargeara was hard working, honest, and trustworthy and could be utterly relied on.

Two stripes promotion and I was made a 'Sixer' in the Tawny Pack. This award made me very proud of my two hard-earned new stripes. All the packs in the Cub Scouts were named after owls, with Bargeara giving us her unique imitations of all the owl's calls. 'Twit to wooo', words and squeaky impressions can't describe the effect of attempted sounds she managed to portray for the poor owls, but giggling cubs always felt better, if not a little weak with suppressed giggles, after her renditions. At one Cub meeting, which included some new Cubs (the owl sounds were for their benefit), all the cubs had to be led outside by Arkala to refresh their aching sides and over-worked lungs afterwards and to receive a kindly reprimand. It was worth paying our 'subs' just to be inspired by Bargeara's contributions. The 'Sixer' had a charge of five other Cubs, of which another was a 'Seconder', who could take over in my absence should the 'Sixer' be caught and finished off by 'Sher Khan' whilst patrolling the jungle of the North Quay.

Initially Dad took us along to see Arkala, he to enquire and she to confirm that we could join. Mum took us to the Scout supply shop in Weymouth

to buy our uniforms, which consisted of a jumper, cap, scarf, woggle, belt and tags for the socks. Mum looked at the price of the jumpers and that well-established light bulb above Mum's head flashed into life with 'bright idea', but the other established symbol, the 'poor church mouse', would be found clinging to the now-dimming light bulb. Mum said she would make the jumpers, which she did. We had the money to buy the real McCoy but she could save money if she made them.

After furious knitting, the result was that two new Cubs joined the 1st Weymouth pack, wearing a well-made and well-fitting jumper each, but it was of a different colour green to the rest of the young wolves. We looked on the bright side. We stood out in a crowd, 'bespoke Cubs', nobody could match our individualism.

Once I was made a 'Sixer', I had to take on more responsibility with the pack. One evening Arkala announced that she wanted to have a Sixers-only meeting the following week but this was to be on a different evening to the normal Cub night. I did not attend, so at the next pack meeting in the same week, Arkala asked me why I did not turn up for that special, responsible 'Sixers' meeting. Arkala was probably expecting the usual excuse about a cold or tummy upset. No, none of those, I said, 'I couldn't be bothered.' Well, we had been taught to be honest and truthful by Mum and Dad and Wolf Cubs were not supposed to lie. In fact, when we joined the Wolf Cubs, we were told that the following week we would all be 'swearing oaths'. Mum wouldn't like that but our old friend Barrie would have loved it. I think that Arkala recognised my veracity; however, she was going to give me some 'jolly good advice', free of course, advice for which I hold much respect for her and have never forgotten. She told me that if people take the trouble to arrange something on your behalf and you agree to be there, be there, or say you won't be there – do not mess people around; put yourself in the reverse position and see how you would feel if you made the same arrangement and the people you asked did the same thing. A sheepish 'yes, Arkala' followed by a 'sorry, Arkala' was my unhappy reply.

That's the thing about Cubs and Scouts, you are there to become a better person, even if you still have not got to grips with your woggle and dyb! dyb! dybs! and dob! dob! dobs! 'We will do our best' (sometimes). We did jobs such as painting all of the lower pavement walls at 'Som Pee Air' in white snowcem, a sort of whitewash mixed with cement, added to give good bonding, all this work for the princely sum of six bob, a lot of money to us but this was for our 'bob a job' week contribution. We learnt to work for the collective betterment of the whole thing rather than personal reward, although the poor old Girl Guides had some difficulty with their 'bob a job' (10 pence) slogan, as they would knock on doors and announce that they were there to earn a 'willing shilling' (10 pence). Many an elderly gentleman passed out on the spot.

One evening, after we both had earned and been awarded with some new proficiency badges, we arrived home to show our rewards of hard work and were met with a shhhh from Mum. Television had arrived and been installed just twenty-four hours before. We were now in the new era of the 'gogglebox', and conversation would have to wait for another day. The claimed end of civilisation had also arrived with television, which might have been recorded in *The Times* with a typical letter.

Sir, I've just seen this damned television nonsense. I urge all people to engineer a forced collection of these damned sets and have them loaded onto a large ship to be sunk in the middle of the bloody ocean. Yours, 'Don't let civilisation go to the dogs Brigade' Tunbridge Wells.

Of course, television has gone on to be the most used form of entertainment today, but in those early-post-war days, the novelty television was a small box of wonder. Every programme, no matter how simple, attracted a multitude of viewers. 'Today's programme will be about how to knit a pair of grey socks, and for the millions eagerly watching, here's how.' To have someone on the television that we knew was almost unreal, only important people hailing from the planet Zog that nobody ever meets were on the telly.

John, our Uncle Fred's business partner was the subject of one of those fifties television shows, a programme called *What's my Line?* with Gilbert Harding, Barbara Kelly, David Nixon, and Isabelle Barnet, compered by ex-boxer Eamon Andrews. All of these names were huge household names in the fifties, who were very well known to most people, even those without a television. This programme was of an age when decorous, genteel presentation was the norm for television, the time for vulgar ostentation encouraged by television networks today was yet to come, and, of course, those programmes were always broadcast live. The panel line-up all wore evening or dinner dress, dressed as though it was a visit to the theatre. The theme of the show was to guess the contestants' occupation or line (of work).

John won with his 'line' not guessed by the panel as a 'Bamboo Bundler'. Thinking about his line of work, there could not have been many people, if any, with that occupation in Britain, let alone Dorset. John's generous BBC prize was a certificate signed by the *Whats my Line?* team. I can remember how excited we all were because we knew a person who was on the telly.

Both Frank and I went on to become Boy Scouts, swapping our caps for wide-brimmed khaki hats and khaki shirts and long shorts, both of which Mum thankfully avoided making, especially those wide-brimmed, hard-felt hats, although it would have been interesting to see how the wide-brimmed hats would have turned out – two floppy, beige-hatted

leprechauns, perhaps. We were very much excited about joining the Scouts because they had a proper Scout Hut, which I think was in Old Parish Lane off Knightsdale Road near the Marsh. This Scout Hut had kayaks held in the roof space and piles of camping equipment made ready for the next camping expedition. This was short lived because of two factors: the advent of rock and roll, and girls.

Boys of twelve plus became interested in music created for teenagers and would gather in dad's garage or spare room and form a 'skiffle' group, which was a simple band made up of guitars, washboard and a tea chest and broom stick to make a bass sound, not rock and roll but a near English version of American guitar music. The effect was to reduce the numbers of boys now attending scouts. The second was an interest in girls, not that Frank and I had progressed or fallen by the wayside yet to this interesting phenomenon, but a senior Scout had. After transferring to the Scouts, the Scout master, 'Skip', told us he was leaving to join his wife with their fifties austerity transport – bicycles – at another pack. His wife was our Arkala in the Cubs, and I think his or her daytime job had moved and they had moved with it. A senior Scout was put in charge temporarily until a new Skipper could be found. The senior Scout would invite his girlfriend along to the weekly meetings, which meant his attention was somewhat distracted, he and we in our shorts and wide-brimmed hats with our woggles out on display, she in slinky dress, high heels and lipstick, which is not quite how we expected Scouts to be. Camping, log fires with sing songs in those big, wide-brimmed hats (which caused instant blindness to the younger small-headed scouts or those of us who just had a haircut) and very long khaki shorts, all that was to be expected but not girls, especially ones sitting around doing their nails. Our woggles were on alert and up for it but the campfire could not be lit. Scouts reluctantly fizzled out. Still, there was that rock and roll stuff and perhaps girls.

chapter twelve

The Bug Hole

'B' films and 'X' films, 'A' films are 'U'. All was make-believe magic, that was projected to view

The 'Pictures' or the 'Flicks', is what we called going to the cinema. What a great treat that was, either the Saturday morning junior matinée or with Mum in the evening or afternoons during out-of-season holiday times and by ourselves during the school holiday period, mostly in the afternoon when wet. It wasn't unusual for us two boys to arrive late after the 'B' film had started, then watch the whole programme through until the beginning of the next showing of the 'B' film later in the early evening showing to see the beginning of the 'B' film we had missed. When I think about it now, it seems such an odd thing to do, watch the end of a film that was halfway through, then an hour or so later, watch the start to that previous film of which we had already seen the ending. How we made some sense of what the film was about I am not sure, but getting our money's worth and staying in such a unique place of make believe would be the main reason, I think. Sometimes Peggy took us to see a film, more, I think, through Mum's wish to get the three of us out of the way for a few hours.

Even when we could not go to the cinema, perhaps because it was a Sunday, Mum would sometimes give Peggy some money to take us on a return-trip bus ride somewhere, anywhere, and buy us an ice-cream each. Were we really so disruptive that Mum needed to pay for us all to go out? I remember Mum gave us the money for this bus trip, which Peggy held for safe keeping. Arriving at the Kings Statue bus terminus on a Sunday morning, we then waited for a bus. Peggy, in the meantime, had noticed, unbeknown to us, a large bar of chocolate in a nearby shop. She disappeared inside the sweet shop and then, after returning, gave us a small two-ounce bag of cheap boiled sweets each and said that we would go to Melcombe Regis Gardens, instead of a bus ride, and play on the swings. We didn't want to go on the swings and we were not pleased with a little bag of sweets either. 'Where's the bus ride and the ice-cream?' we cried, but we went to the gardens anyway as the fare had been spent. We played on the damp, muddy swings, whilst Peggy sat alone some distance away on a park seat eating a large, only-ever-seen-at-Christmas-big bar

of chocolate, all to herself. I can't remember what Mum's reaction was to this, but the next day, Frank and I were given money for the pictures, just the two of us, and it was a cowboy film.

On the occasional wet summertime day, the Weymouth holidaymakers would have gone to one of the four cinemas. The Gaumont in St Thomas's Street was the biggest and best cinema whilst the Odeon in Gloucester Street, was a bit of a basic, flat-roofed establishment, which I think was once the garage to the Gloucester Hotel, or the other cinema, the uniquely small Belle Vue on the corner of East Street and Belle Vie. I have been told of the old Regent cinema, near the old Gloucester Road church, but I find no trace of it; certainly it never existed whilst we were there. The Belle Vue was known either as the 'Bug Hutch' or 'Bug House' or the 'Bug Hole', whatever the patron's social standing and pet name was for this cinema. Most people had many a pet name for this cinema but all carried the same appendage of 'Bug.' It was also the smallest of the three cinemas, and the only one to have so many pet names. Built in 1910, the Belle Vue was a place where the interior had not been subjected to bright lights in years, so the word 'cleaning' would have been one that rarely crossed the management's lips with maybe the odd annual shovelling up to allow patrons to get to their seats and put their feet on the floor. We once picked up an empty chocolate box found under a seat and Mum told us that brand of chocolates 'hadn't been made since before the war'.

We saw many films there, mostly black and white, but one film that Mum took us to see on a wet, winter, school holiday weekday, had a lasting influence on me. It was *The Glenn Miller Story* with James Stewart, who played Glenn Miller, and June Allyson playing his wife Helen. The story was designed to cater for the typical mixed audience with romance first, June Allyson's dresses second and the Hollywood star himself, Jimmy Stewart, in third place. Amongst all this gloss were some snippets of memorable music. To hear and see the playing of Chick Webb, Louis Armstrong, Gene Kruper, Cozy Cole, Ben Pollack and many more on the big screen was wonderful. It killed stone dead the Meccano set and the Dinky toys, and Hopalong Cassidy's twin silver guns and holsters were hung up for good. *The Glenn Miller Story* was a great, influential film that changed my interests hugely, not the time-wasting romantic bits but the interest in jazz.

Sadly, the truth about the real Glenn Miller learnt in later years is a lot different to the portrayal in the film. The decent, kindly, avuncular character played by James Stewart was, in real life, a very hard-driving task master and very tough on the guys in the band. He would typically give directives to the band, such as no one must wear a moustache, so those guys who had had one for many years were told to shave it off or leave the band. So much did the guys in the band detest him that when they heard

that the forty year old Glenn Miller's plane was missing and presumed crashed in 1944, the band cheered and clapped. As a jazz fan ever since, I would glue my ear to the Sobell wireless on a Saturday afternoon and listen to the great Ted Heath band. 'Turn it down or you'll go deaf,' Mum would advise me. I did enjoy the old jazz music and was aware or perhaps disappointed that rock and roll was taking over just too soon and before I had enough time to enjoy the many jazz radio broadcasts. I was born too late for the jazz heyday and too early for the better rock and roll but made up for this crossover later in life.

Saturday morning pictures at the Gaumont cinema in St Thomas's Street were always very popular and it was always jam-packed with boys and girls. The mornings would start with singing some songs together, which included the Saturday Morning Club song: 'We come along on Saturday morning greeting everybody with a smile,/ We come along on Saturday mornings knowing it's all worthwhile …' And so on. It was as if we belonged to a single-party state. We all sang from this screen song sheet with gusto with our right arm and hand crossed over our chests as we sang the party's anthem. Other songs were: 'I love to go a wandering along the mountain track, etc.' or 'Old father Thames goes rolling along, down to the mighty seas.' I had never wandered along a mountain track – a mountain is where the sheriff headed off the outlaws – nor had I witnessed the rolling Thames – this I imagined to be a great surging mass of water, a bit like the Ganges, swirling down to the ocean. As children, the imagination of the songs and the written word would create a much more interesting image than the reality. We would also sing the National Anthem, a regular deed carried out reflecting the attitude to Crown and Country: Great Britain in former times.

The lights would dim and all the kids would kick the backs of seats and stamp the floor at once, making a noise like rolling thunder. This was greeted with the first film, a Mickey Mouse cartoon, then the next part to the weekly serial, a Hopalong Cassidy saga, or Roy Rogers praying with his horse before he reaches for the gun that has hung on the peg for many years to fight evil with good, or a serial about a racing car driver named 'Burn em up Barnes' who crashed in each episode but always won the last race. All the characters were white and made by white American film makers with not a black face to be seen in any of them, unless the film maker wanted a halfwit sweeping with a broom – then an unfortunate black man would be used.

One such Saturday serial was *Gene Autry and the Phantom Empire*, although we always referred to it as 'The Thunder Riders'. This film seemed to have a most bizarre plot. Gene Autry, a thirties singing cowboy, actor and recording star, would always be dressed in his immaculate cowboy outfit with his perfectly groomed horse Champion and would

sing one of his songs and ride across the plains looking out for Indians or
cattle rustlers. As the story progressed, Gene Autry is suddenly stopped
in his tracks by a distant roaring sound coming towards him. Listening
to the rising volume, he hides himself behind a rock and watches as the
thunderous noise passes, a noise that is made by hundreds of mounted
galloping horses. From his hiding place, he witnesses a posse of Thunder
Riders going by, not that he knows the name for them. Gene Autry realises
that these riders are not cattle rustlers or Red Indians but men who seem
to be from outer space, not that he knows that at first either – well, you
wouldn't. If I saw a person from outer space, I would take it to be one
of our near neighbours. The Thunder Riders resembled futuristic British
Horse Guards with their metal helmets and flowing cloaks. Gene decides
this looks interesting and follows them at a discreet distance, although it's
odd that none of the Thunder Riders ever turn around to see if anybody
is following them; after all, they are making such a racket of a noise, as
Thunder Riders do. Gene Autry is curious at the fact that they ride straight
towards the bottom of the sheer face of a mountain ahead, which he knows
to be a dead end. The Thunder Riders, without hesitation or stopping,
arrive at the same time that a secret rock door opens up before them and
they disappear inside the mountain. Of course they would. Why would a
group of Thunder Riders from outer space want to hang around outside
with the cattle drovers? Thunder Riders are not used to riding into town,
hitching up the horses at the saloon and ordering three fingers of whiskey.
They had mountains to hollow out.

Inside the mountain, some 20,000 feet down, is an empire thousands of
years old called Murania 'The Scientific City'. The scene was of a world
unknown in the Wild West, a place of futuristic aeroplanes and control
stations brimming with dials and flashing lights. The Wild West was always
a bit of a land grab where planning permissions would be unknown,
but to build this vast city underground under a mountain aroused no
curiosity as nobody knew it was there; even the indigenous Indians never
had a Thunder Rider scalp. Until now, these reclusive aliens had not been
discovered.

This was not the stuff of children's cowboy films, but was, nevertheless,
very watchable as it had both cowboys and spacemen, with twelve episodes
to watch, each episode having a name such as 'From Death to Life' or 'Jaws
of Jeopardy' and 'Prisoner of the Ray'. Gene Autry, an upholder of all things
right and proper, was not going to have these outsiders (in fact, insiders)
messing up the mountains and the prairie, so he gets into a fight with his six
guns, and when the bullets run out, it's hand-to-hand combat fighting with
a Thunder Rider. He would smash a futuristic chair over his opponent's
head as though he were in the saloon fight. All the action seemed to be at
twice the normal film speed, which made the action look much faster and

more exciting, the excitement quickly permeated to the kids in the cinema, who would stamp, clap and cheer at the same furious speed as the film's action sped along accompanied by equally *presto* music. The film ends well. All the Thunder Riders, the Queen and the whole underground city disintegrating with Gene and friends all saved, followed by a song sung to his horse – well, you would; having just destroyed this underground futuristic world, the first thing you would do is sing to your horse, which is tied to a tree outside the mountain – all very typical of 1935.

No Gabby Hayes shouting, 'Git the varmints' as he fought off Red Indians who outnumbered him by five hundred to one, or Hopalong Cassidy dressed in a spotless black outfit with not a single item out of place, twin guns in silver, very clean shaven and not a tooth missing, a white horse perfectly groomed, even after a two-week ride over a sweltering desert – that's what a real cowboy film is about. Kids wanted to see cowboys riding fast in a chase after the bad guys, shouting, 'cut 'em off at the pass.' This type of fast action would make a sea of heads ride up and down in unison to the film with all sitting or standing in their seats, going faster and faster as the riders in the film close in on their quarry, egged on by even faster and more furious music. All this, of course, was drowned out by the noise made from the squeaky cinema seats and feet stamping than the sounds from the film. Little did we all realise that the Indians were the innocent people whose land had been taken by force, so the truth was that all of our heroes, now the bad guys, killed the Red Indians, the innocent good guys.

Finally, the main feature would be something like a George Formby film riding in the TT races on the Isle of Man. The kids would shout and yell to urge him on and if a character plotted a dastardly deed, the kids would all murmur disapproval, with much hissing and booing – more Victorian pantomime that cinema. At the end of the show, all of us kids would come out of the cinema with sore throats and exhausted limbs for the Saturday morning finale act of enjoyment, 300 to 400 boys and some of the girls would gallop in all directions along St Thomas Street slapping their thighs whilst the bemused and scattered shoppers looked on. The power of just running a strip of cellulose through a projector, just magic and very exhausting – but, boy, were those cinema seats well made.

The types of films we saw with Mum (never Dad but sometimes with a sister or two) would have been very typically Ealing comedies with actors such as Ian Carmichael or Kenneth Moore, which would be very English, all speaking good Queen's English, and all playing quite wealthy, good characters, hardly reflecting the real economic situation in the fifties – well, who wants to pay money and see real life? A western with Alan Ladd or John Wayne would be a treat. These major American films always had a dialogue that was straightforward.

By comparison, the most mysterious of films were the American gangster 'B' films in black and white. The story would always be about the 'Numbers racket', a gambling activity a bit like today's Lotto, where each character would accuse the other of being a 'Stoolie'. Each gangster would be wearing a large, pinstripe, double-breasted suit and trilby hat worn at a swanky angle of ten degrees and would mutter from the corner of their permanent-cigarette-holding mouths, replying, 'Yea, who says?' 'Lefty says you're a stoolie.' 'Mum, what's a stoolie?' we would whisper, 'Sshh … a stoolie is a stool-pigeon.' 'Thanks, Mum?'[16] Other lines of American dialogue were just as mysterious: 'Yea, the Feds grabbed him up on Queens carrying a piece.' For us to understand the meaning of this colourful language, Mum would reply in a way that would allow my brother and I to put it into a familiar context, so this last dialogue would mean: 'Yes, the policeman arrested this wicked gentleman in Radipole because he was carrying a gun.' Well, we knew what the people of Radipole were and looked like; Queens, New York, must be about the same sort of place.

The pictures were a great place of escape and a place to lose yourself for an hour or so. In the summertime, it was a place to escape from the rain, which did happen from time to time. 'Downpour Hits Bay of Naples', 'Pacamacs Cleared from Shelves', 'Deck-chair Revenue Hit', 'Slump in Bucket and Spade Sales', so the headlines might read in the local paper. Holidaymakers would arrive to spend their days on the sands and their evenings hanging around the pubs or taking a gentle walk with an ice-cream. Should it rain, however, there were very few shelters to escape to during the day, unless you like browsing the shops, which in Weymouth, like all shops in the fifties, had very little to offer for the casual shopper, even if they had some spare cash to spend; also the pubs had very limited opening hours. Even so, only a handful of shops were large enough for the wet holidaymaker to hang around inside as they dripped around the various counters, such as Woolworths, a two-storey building, where at least the discerning could buy a selection of broken biscuits gift wrapped in a brown paper bag for sixpence (2.5 p), although today of course you would need to hold a séance there. The crowds would stand nose to nose in Clintons Arcade and dart across the street for yet another ice-cream in Forte's Ice-Cream Parlour. Excluding the pubs, the picture houses were the next comfortable place to get out of the rain and kill time, as hanging around at the guesthouse was 'verboten'. If none of the options were available, then a walk in the rain was necessary.

Near the George III statue and the then Southern National bus terminus, the Esplanade had a very large shelter, which was used by the holidaymakers should rain suddenly start, rather than, as far as I know, 'installed to protect against sunstroke'. The Jacques Tatti film, *Mr Hulot's Holiday*, has a scene at the railway station where all the holidaymakers

are waiting for the train to take them to their holiday destination. The incomprehensible announcements on the French station Tannoy cause the gathering travellers to rush *en masse* from platform to platform and then back to the original platform as they try to work out on which platform their train will appear. This French farce would remind me of the Weymouth holidaymakers rushing, with hastily gathered accoutrements to this large shelter, then standing, nose to nose, bucket and spade to bucket and spade together for perhaps an hour with regular intervals of spontaneous *en masse* movements in and out of the shelter in unison depending on whether the rain was falling or stopping. It was like watching a four-sided people tide moving in and out very quickly. If the rain persisted, out would come the 'pacamacs' from the holidaymakers' bags. A pacamac explosion in a fetching lift-the-spirits shade of grey to match the colour of the leaden sky. But what do the poor holidaymakers do then? 'We can't go back to the guesthouse.' 'On ze back of ze door ve have ze rules you must read and obey. No coming back before 6.00 p.m., zen be here SHARP!' 'What about the pub?' 'What about the kids?' 'Let's go to Forte's for an ice-cream." 'Look at the bloody crowds; everyone has the same bloody idea.' 'Let's go to the amusement arcade.' Ah well, it will be fine tomorrow. That's the thing about Weymouth Sands – it nearly always was fine tomorrow, but don't forget the pacamac or *viva España* it will be.

As a fashion item, the pacamac was way down the list if you wanted to make a design statement. Holidaymakers would arrive for their holiday with this pacamac rainwear concept, a ubiquitous foldaway raincoat that would fit into a jacket pocket. Some up-market pacamacs had a 'pacatrilby', which was a foldaway waterproof cover for a trilby hat; one wonders what the stylish French or the Milanese made of such sartorially elegant rainwear: 'Ze roast beefs vear plastics with ze rain.' The optimistic ex-colonial wallahs would bring a Pith Helmet or Topee to either keep out the sun or protect from the unseasonal monsoon. In fact, during the 1948 Olympic Games, ex-colonial pith helmets or topees were on sale to protect the head from the August heat, with the headgear purchasers subsequently taking them on holiday. The austerity stretch was still with many people and the standard rainwear for men and, of course, some ladies, was the double-breasted gabardine raincoat, warm when dry but weighing a ton after a lengthy walk or queuing in the rain, with ladies resorting to an umbrella as well as the transparent, plastic raincoat.

The rain would bring queues to form outside the cinemas waiting either for the film to end to gain entry for the next showing or for the commissionaire to announce that there were 'Two (seats) at two and nine' (14 new pence). 'Cor, not paying that,' the man with the pith helmet and pacamac would say to his already wet girlfriend, both now getting even wetter. 'It's the one and nines for us, girl' (9 new pence). So here we have

a large crowd of holidaymakers marooned at the 'Bay of Naples' in the pouring rain, about 500 sodden rank and file standing outside the cinema thoroughly soaked to the skin, mostly dressed in the gabardine raincoats and a few wearing an oversized pith helmet, with the sodden gabardine garment now feeling like a rucksack of house bricks over their shoulders, all feeling relieved that the previous audience is now coming out. In would troop the walking sponges and take a seat. If they took off their coats and hats, they could only put them on their laps or on the floor, which was now littered with things left behind from the previous audience; otherwise, they would sit there in uncomfortable, soggy silence, interrupted by the film soundtrack, surrounded by wet and steaming raincoats.

Within a short period of sitting there, the temperature in the auditorium would begin to rise from the new audience's body heat. The new audience sitting with wet attire would start to generate steam clouds, and as most people smoked cigarettes in the fifties, the smoke and steam would mix to form a smog so thick that it would make people cough, with the rising orchestrated coughing now drowning out the sound of the film. It must have been worst for the people in the circle, as all the assembled smoke and steam from the stalls would rise and linger. So bad did the fug become that, although not used, a foghorn would not have been out of place to guide the audience to the exits at the end of the film.

Did they enjoy the film? Well, it was in the dry and they had a seat. It was just a little uncomfortable, as most of the scenes in the big picture took place in a hot, sweltering, steaming and humid jungle. Had the audience caught the early afternoon showing, they would have reached the end of the first house film showing and would emerge at about 4.30/5.00 p.m., teatime, by which time the rain would have stopped and brilliant sunshine was now back in evidence. So there they were standing in the warm late afternoon with still-damp gabardine and soggy topee around them, squinting at the bright sunlight and wondering why on earth they spent the afternoon wrapped up in such clammy confinement, when the sun was shining outside, as it hopefully is most of the time.

During winter or summertime, the matelots of the Royal Navy with their ships moored in Portland Harbour would also visit the pictures whilst on shore leave. A message would sometimes be flashed across the screen for the sailors. 'All Personnel Must Return to their Ship HMS *Glasgow* IMMEDIATELY.' As the country was no longer at war, other than the distant Korean War, it seemed odd that the sailors had to leave the cinema and head for their ship, causing much jumping from seats and a rush for the door. Now, if I were an astute manager knowing I had a long queue outside, I would look at some of the ship names on the hat bands worn by the sailors as they trooped into the auditorium and engineer a sign to be flashed on the screen calling all from that ship

to return to their ship IMMEDIATELY! which would be followed by the commissionaire calling out 'fifty-five at two and nine, thirty-three at one and ...' Followed by another on-screen message: 'All personnel from HMS *Zest* ...' or whatever ship was in Portland at the time. What good business this is: the more picture-goers who don't get to see the full film, the more money the management makes. All those poor sailors running around looking for the liberty boats or buses to take them back to their ship, which is quietly moored and dozing in Portland Harbour with the captain fast asleep in his cot.

There was another cinema in the town, which was called the Palladium and 'Som Pee Air' faced the Palladium across the harbour next to the bridge. This now-empty picture house was Pankhurst's motorcycle shop. We watched in admiration one day as a large picture of a racing motorcyclist was being painted on the wall facing us and the harbour. That the artist could correct his work without standing back was very skilled indeed, as he was standing high up on scaffolding; perhaps it was an early work from the 'painting by numbers' school. This high-rise motorcycle artwork had previously been, in pre-war days, the large advertisement for the cinema, which displayed the cinema's three viewing times daily, which were 6.00 p.m., 8.30 p.m. and 9.45 p.m. The Palladium, which was opened two years after the Belle Vue in 1912, was, since before the Second World War, no longer showing films. The building had previously been converted from a furnishing store run by Hawkes and Freeman. As a cinema, it closed its doors in 1931, perhaps a bit of a wrong shape for a modern cinema, as they work better if they are purpose-built rather than converted from stores, although the Belle Vue's previous life was as a school named the 'British Boys' School', open to all unfettered by class or sect ... or perhaps the lease may just have run out and it was not to be renewed. So it returned to its original concept of being a store. No more laughter from Buster Keyton or Laurel and Hardy nor any more evocative looks from Greta Garbo or Gloria Swanson displaying themselves on the hallowed screen.

The building was now replaced with another form of game bird and other delights, plus pheasants, grouse, chickens, turkeys, and every other type of meat was now to be sold. This was now a butcher's shop on a grand scale called Lawrence's Store. An old, posed photo at Weymouth's museum shows row upon row of poultry hanging outside the store all handled by over thirty smiling staff, almost a meat-only supermarket. Mum would have loved it. After the building's 'meaty' exercise, a 'matey' exercise replaced it, turning this now very versatile building into a Second World War Forces Club where male and female military personnel stationed within the area could relax, enjoy a drink and meet new friends. Then, in the late forties up to the sixties it all changed yet again with Mr Pankhurst managing to buy a few hundred ex-army motorcycles, 'surplus

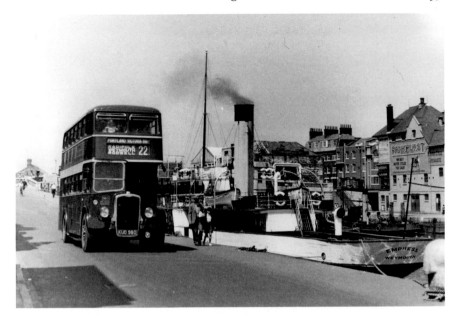

Trinity Quay 1950. Note Pankhurst's motorcycle store in the background.

to requirements' at the end of the war, and he changed the nature of the business to that of motorcycles. It certainly held a lot of motorcycles. Whatever the old furniture/cinema/butcher's/Forces Club takings were, the motor bikes were certainly doing a 'roaring' trade in the fifties by providing cheap and fast transport. Today, it's back to its wartime trade of wine bar socialising or providing a 'Rendezvous' (as it's now named). But then, in the 1950s, it was 'room in the 2/9s to view the Nortons and BSAs.'

chapter thirteen

The Tale of Two Baskets

We chipped in and dipped out, but two mugs were left with toys that were naught.

Walking from Trinity Road and then crossing over the Town Bridge into the old town area known as Melcombe Regis, the direct road through the town would be through the main street of St Thomas Street; alternatively, you could turn right into St Edmund Street and take the route through St Mary's Street, although in the fifties, this was a one-way street, which headed traffic towards the harbour. Near to St Thomas Street and St Edmund Street, there was a large shop located immediately on the left-hand side. This was called Guppy's Toy and China Emporium. From time to time, lucky dips would be placed outside the shop in tea chests each filled with straw. Frank and I with our pocket money would eagerly visit Guppy's toy shop to see what we could buy with our sixpence. Even in the fifties, sixpence would not buy much, but there were often two or three large tea chests filled with mysterious parcels of goodies from this toy and china shop and it was cheap to have a go. So with much anticipation, we paid our sixpence pocket money over to a member of the ancient shop staff as they cleared the cobwebs from the old mahogany till, and we excitedly rummaged around in the tea chests.

On one occasion, as we prodded about in the chests, we discovered that all the parcels felt the same and were satisfyingly heavy. We both picked (surprise, surprise) the same type of parcel shape, in fact all of the lucky dip prizes were of the same shape and type. We ran home thrilled with our surprise purchase and were soon eagerly unwrapping our surprise toys. Would it be a new Dinky toy? Something we could add to out Hornby train set or a disappointing but acceptable jigsaw puzzle? We both happened to finish unwrapping our parcels at the same time. 'Oh!' we both exclaimed in disappointed unison as we both surveyed the same mysterious, now 'unlucky dip'. They were two very heavy, 'surplus to requirements' shaving mugs. One each. It would not have been so bad if we had started shaving, but at eight years old, this would be a few years off yet. Still, it would be Dad's birthday in a few weeks and we felt sure he would like his matching presents, one for weekdays and the other for weekends. The lesson we

learnt was that not all that glistens is gold, well, not after the old newsprint is unwrapped anyway.

St Thomas Street had the important shops and civic buildings along it – the Crown Hotel, the *Dorset Daily Echo* newspaper office, post office, gas showrooms, the cinema, an art gallery and an artist's shop, together with many other shops and, of course, some pubs. The gas showrooms had from time to time used their window displays to show off the art department's skills at paper folding and produced the most remarkable life-sized figures from cut and folded white paper. These would, for instance, be of a king sitting on his throne or a minstrel with his lute and many other well-crafted figures and objects, a real 1950s crowd stopper. Living and working in St Thomas Street during the 1870s was the writer John Meade Falkner, at No. 82, famous for his good smugglers yarn *Moonfleet*. Living next door, at No. 81 was G. R. Crickway, the architect of Trinity church's extension and one-time employer of Thomas Hardy. Next to the post office was a hardware shop named Thermans. This was a typical pre-war old-fashioned hardware-cum-builder's store where you could buy, from amongst its many wares, a single six-inch nail and have it wrapped, and if requested, there was a chance it could be delivered. All the male assistants were super attentive, all wearing brown warehouse coats, highly polished shoes and smart shirt and ties. If I were making something out of wood, I would often buy, even as an eight-year-old, a pound of nails. The assistants would show me the various different types and sizes and wait with much patience whilst I selected the most appropriate nail type to be wrapped in newspaper. The shop assistants gave the same attention to me as an eight-year-old as they would an eighty-year-old, with a final 'thank you, sir'.

As you entered St Thomas Street from the Town Bridge end, the first shop on the right-hand side was Darches cycle shop and next to that was Darches second-hand furniture shop, the latter of which was used to furnish most of 'Som Pee Air' over the years, and the former was where Frank and I were bought our first bicycles, on the 'never never'. I think two shillings a week forever was the long-running charge to pay for our then-expensive bikes. Now, of course, bikes are cheap enough to buy two for the price of one.

Near to these two shops, on the same side of the road, was a large general hardware store, named Hawkes, Freeman Ltd. This large store was taken over by Webb Major, a local builders' merchant, in later years. Towards the start of 1950, we both heard that this store was having a sale to clear out all goods that were no longer wanted. So, with our pocket money ready to be spent and optimism riding high, we wandered in to have a look round at the many 'bargains'. What caught our attention, for 'thrupence' (a three penny coin), was a special type of mask one could wear, and if we

bought one each, we would have change from our sixpence pocket money, so a double bargain, a 'goody' and change to spend still. So Frank and I, with much excitement, purchased one of the sought-after objects each, although we were not really sure what they were used for.

The mask (or goggles) were designed for a grown up but had an adjustable strap to enable it to be used by smaller people, like imaginative small boys. Its design was of a black metallic heavy frame with a sponge rubber inside that fitted against the wearer's face, and each pair of goggles had two holes cut into the shape of an evenly formed cruciform to allow each eye to see through them. These would be brilliant to use with our gang, we thought.

Later in the evening, we showed them to Dad. He told us that they were for Alpine troops for use in the war to protect the troops from snow blindness. Hmm, just what was needed in Weymouth. How lucky we felt to be all ready for that urgent BBC weather broadcast to warn residents that a risk of snow that could result in snow blindness was imminent. What on earth was a hardware shop doing selling this piece of kit?

Manager to buyer: 'Bought any good and much-needed items we can sell to our deserving public?'

Buyer: 'Yes, I managed to get a really good deal on snow-blindness-protection goggles.'

It was not as though they were selling the odd box full. There seemed to be boxes and boxes of them, all of which seemed to be selling like hot cakes.

Frank and I decided to walk through St Mary's Street the next day and acknowledge the nodding exchanges with other like-minded persons who had urgently snapped up these once-in-a-lifetime bargains. We walked to the top of St Mary's Street and then the full length back again. Not a single person had emerged wearing them. In view of this disappointing result, we decided to remove our snow-blindness-protection goggles and go home. Perhaps a masked ball was to be held at a later date complete with music and dancing with a hopeful forecast of snow later.

The thing with brothers, and sisters, is, I suppose, sibling rivalry. Brother Frank and I were born within sixteen months of each other, so grew up a bit like twins, each getting almost the same Christmas or birthday gifts. Same pocket money, same clothes, same portion of cake and the same portion of any whole cut into halves, exactly, not a millimetre either way different, such was the competition for superiority. A bitter debate between the two of us could break out into a real argument as to who had chosen or received the 'best portion'. Mum's kitchen scales were sometimes used to weigh each portion to see who was favoured with the biggest piece. 'Mum, that's not fair. You cut that deliberately in his favour.' Many a time we would watch Mum cut an apple in half (austerity times would never allow

one apple each) and we would only give the go-ahead to cut when we were both satisfied that the knife was well and truly centred in the middle of the apple. A cake cut into segments would be swivelled around faster than a fairground merry-go-round on its dish to ensure one of us was not outdone by the other having a larger portion. Our Gran named my brother 'Mr Large' as a reminder of the time when she brought a homemade cake around one day. Frank made the claim that, as he was the youngest, he must have first choice of this homemade cake, and so he claimed the largest piece. Had we never left home, and this hotly debated allocation practice had gone on into adulthood, each of us would have furnished ourselves with a vernier gauge and pocket scales, with each mealtime consisting of a clanking and clattering of measuring instruments as the portions of food were laid out for selection by this austerity practice.

St Mary's Street was the main shopping street for food with many small shops selling most of what one would need on a day-to-day basis. No supermarkets then, unless one counted the Co-op with its 'Divie'. Mum, however, would never shop there, as it was deemed a socialist-inspired establishment, much against her right-wing politics. Either Peggy or Frank, myself or both of us boys were roped in to help Mum after school or on Saturdays with the shopping for provisions, although we always had a weekly order of tinned provisions delivered from Miss 'starchy' Shaw's shop in Trinity Road. Two baskets were needed for Mum's juggling routine: one to carry the purchases and the other, always empty, to enter the shop with. Mum would enter a shop with the empty basket leaving one of us outside with the other empty basket. I'm surprised that passers-by didn't mistake us for waifs begging for money to go into the food shop as we both stood gormless outside the chosen shop. At the Home and Colonial or Lipton's shop, cheese would be bought and maybe butter. At the next shop, she would take the empty basket, leaving us with the now-part-full basket – so there, it proves we are not beggars. At that shop she would buy eggs and/or bacon, then when she was outside the shop, the purchase would be put into the other basket, now, of course, getting a bit heavy. Each purchase in each different shop started with an empty basket, whilst the other basket grew heavier and heavier, but if we both helped with the shopping, we would argue, naturally, about whose turn it was to carry the now leaden basket. Mum would suggest that we each hold one side of the basket handle to share the weight. We would resist this, as we would claim 'that's how two old ladies carry it', but in the end the basket's weight would necessitate us sharing the carrying of it like the two fictional old dears we both had in our minds, each taunting the other with an old lady style of walking. Mum would suggest that we did not look like two old ladies, but we were not ready for logical positivism yet, if ever. So it was back to the 'your turn', 'no it's not, it's your turn' crude formula of

debate. Mum's thinking was that an empty basket gave a better cut/slice/portion because it looked like the lady had just started shopping and had an empty basket. A full basket meant the customer had been elsewhere and was not going to give the shop its full, loyal custom.

Mum was very good with meat and would show the butcher a thing or two with her expertise regarding every cut of meat. Mostly, she used the butcher's shop in Alban Street with its sawdust-covered floor to soak up the blood from the hanging animal corpses, next door to the Sally Lunn cake shop famous for its shapeless rock cakes. None of today's packaging was ever in evidence during those rationed years. Most provisions such as cheese, biscuits, bacon or any meat were not pre-packed; it was all cut or weighed to the customer's purse and wrapped in greaseproof paper then a white paper bag. Tea, coffee, sugar, butter, margarine, and, of course, tinned food were the few items that came in a bespoke outer wrapper. Nothing at all came in a plastic bag or package. Fruit and vegetables were, again, never pre-packed; this was weighed and placed into the ubiquitous brown paper bag.

The other end of the shopping area was in Westham Road, which had two cake shops. One was called Vauk's and supplied filled cream cakes, which we named the 'erluch' shop because it sold doughnuts filled with cream made from the lining of a cow's stomach, rather than the luxury of real cream from the cow's milk. We could straightaway see that Mum had been shopping at the cheap 'erluch' shop and turned up our noises at this untouchable, cheap, cow's lining food. Poor Mum. She really did her best for us. We ate the cakes anyway at some point, prompting Mum to say: 'A hungry dog eats dirty pudding.' Whilst not admitting it was an apt comment, we sometimes superciliously requoted it back, saying: 'Dirty dog eats hungry pudding.'

After a winter's day of activity at Chapelhay, we would have returned home exhausted and ready for tea, and it was during our teatime that we would hear a quiet knock on the lower dungeon front door, which would be just about heard. We knew who it was, as it had become a regular visit each week after dark. 'It's that sweet girl,' Frank and I would say to each other. This was a young girl, a nocturnal visitor from further along the road. Mum seemed keen to give us all sweets throughout the rationing period, which she was able to do by buying the sweet ration coupons from a near neighbour. Who this neighbour was I don't know, just a quiet knock would be heard on the dungeon front door, and a dark-haired, pigtailed girl of about twelve years old would be standing there. 'Would you ask your Mum if she wants to buy the ration coupons for the sweets?' The dentist awaits; don't do it, Mum. I am sure that some sort of trouble could be had if caught selling sweet coupons. 'Yes, here's the money, bye,' Mum would say and off the girl would go into the night. The young girl, with a

full set of good teeth, had been sent by her Mum, who needed the money. Rationing sweets now would seem a bit extreme, but the forties and fifties were difficult times, as most of the sugar was imported from the West Indies – although most of the sugar plantations were owned by wealthy British families. Whilst we had more sweets than most children, a snack for most families in the forties and fifties consisted of such delicacies as bread and dripping. This desperate snack is made from the fat from roast beef, which, when poured into a bowl, would set with a beef jelly underneath. This would then be spread onto bread and sprinkled with salt. If you are very hungry, no, desperately hungry, it would make a good snack, but seeking some light, sophisticated cuisine, never. Also bread was never thrown away or put out for the birds; it was made into a bread pudding. A mixture of the bread leftovers or stale bread (that is, stale bread before it was allowed to evolve itself into a laboratory breeding experiment), lard, currants and sultanas with cinnamon spice, then baked in a tray to be cut up into muscle-aching, weighty chunks and eaten either hot or cold. Dad would always find a chunk in his lunch bag. This chunk of bread pudding would be a source of amusement for Dad, although I don't think Mum was as amused as Dad was with his comments. Dad would joke that he was concerned about the steep hills the work bus would have to take on its route to Portland. 'The passengers may be asked to leave the bus and walk up the hills as the driver will probably accuse someone of bringing onto the bus a very heavy object.'

Shopping in the forties and fifties was mostly limited by choice, a lack of money, a prohibitive cost, or a lack of ration coupons, or all of those negatives. What a palaver Mum put us through with that shopping experience, carrying and using one of the two baskets, whether it produced the result she wanted, I can't be sure. Mum probably felt it kept the shopkeepers on their toes, or was routine and a hangover from the pre-war depression period and wartime shortages or rationing or all of those mean periods past and (then) present. The shoppers all probably played this juggling game, with, no doubt, the shopkeepers naming them all the 'Empty Basket Brigade', with the side comment of 'here come the EBs.' Good news had at last arrived for the EBs. On 3 July 1954, some fourteen years after it was introduced, rationing was scrapped. Fourteen years is a very long time for what was one of the richest countries in the world to be still scraping the barrel. The country must have been that broke, but how 'par excellence' that generation must have been at 'recycling'.

In Trafalgar Square, housewives, in jubilation about this news, ceremonially tore up their ration books. A little-known organisation known as the National Federation of Housewives went on patrol with notebooks to monitor butcher shops, as meat was the last to be rationed and if the price of meat was not dropping a protest meeting was held.

'Meat's gone up, stick your banners out, girls,' would be the cry from the agitated legion. As fruit was now becoming more plentiful, Mum would bring home either oranges from the 'Outspan' brand imported from Spain or the 'Jaffa' brand ditto from Israel. But waste not want not, each orange was wrapped in branded tissue paper. Some of the wrappers were quite interestingly detailed, which Mum would collect, smooth out the wrinkles and keep ready for us to use as disposable orange-scented tissues, up-market perfumed designer tissues or cheapskate hankies, or whatever Mum's marketing department suggested. Did the studio designers in Spain or Israel have it in mind for the wrapper to be used as a nose-clearing job as well as covering their delicate citrus fruit?

Now it is easier to both purchase and enjoy price competition with today's supermarkets, which makes the late forties and early fifties very quaint, or perhaps normal with today very over-supplied with too much choice. The downside is that the lower the food cost, the larger the girth.

'You know that new size 6 dress I have just bought.'

'Yes, dear.'

'I am ashamed to say I now need a size 8.'

'Oh! You Bessy Bunter.'

Perhaps ration books were not a bad thing, but then we would be back to the black market with dubious sell-by dates, that's apart from the welfare of the poor starving seagulls forced to give up inshore dining establishments at waste landfill sites. Still, Mum always provided us with enough good food every day and every week, whether we liked the simple but plain meals or not. Mum did her best to dress up the food not to look too much like nursery food. I have to comment that Frank and I were a pain in the bottom over food and that any food on the plate that didn't aspire to our tastes, would either be quietly dropped under the table or wrapped in a handkerchief and pocketed for later disposal. 'Waifs Seen Leaving House in Trinity Road, Social Services Dept Alerted.' Poor old Mum, she did try very hard to please us. Perhaps she had the quiet pleasure of thinking we were reincarnated royalty.

chapter fourteen

Sands Good to Us as the Esplanade Entertains

It was match points at five as we four quads came alive.

Weymouth Sands was *the* reason why we had the visitors. The sea was the other attraction, but on the sands you could sit, with or without a deck-chair (don't forget to pay Mr 'I thank you', the collector), take a picnic (but don't drop your food in the sand), sunbathe (beware of the pink lobster effect), build sandcastles (for other visitors to trip over), dig holes (for the same visitors to fall into), buy cups of tea and sandwiches (don't forget to return the cups for deposit return), drink bottles of Pop (don't forget to take back the bottle for return of deposit), and, of course, eat ice-cream (not to be eaten on a windy day) or ride the donkeys (children only), or ride on the small fun fair (ditto), even kick or bat a ball (only when the tide goes out), watch the Punch and Judy show (and witness GBH), or just walk along the shore and paddle (look out for broken bottles). It was what we and the visitors all eagerly came for.

Our gang would arrive at the harbour end of the sands, near the sandcastle man and the donkey point. After putting on our 'bathers', we would swim, paddle, or just mess about in the water. On arrival at the sands, we would march in single file with our secret weapon slung over our shoulders. This did not unduly alarm onlookers, as we were each 'armed' with a Mark I old tennis racquet. Not to create a Wimbledon final on the sands or pretend that they were snow shoes to go with our snow-blindness-reducing goggles or any sporting game whatsoever with a bat and ball, although it did look quite polished to see four young boys arriving with tennis racquets sloped over our shoulders, but for now, we would relax our guard and enjoy some undisciplined but skilled messing about, the more satisfying and rewarding action would come later.

Towards five o'clock in the afternoon, the holidaymakers would start to drift off the sands with those swimming-costume-clad adults now engaged in the comical and uncomfortable tussle of changing from the bathing costume to their street clothes under a now-sand-impregnated small towel, which would and still is to remain a free act of tense comic acrobatics for all to discreetly watch with baited breath. Would the towel slip and the resultant embarrassment cause certain death? Or worse, would they

frighten the donkeys? Obviously, the slyly looking spectators still sitting in deck-chairs wearing shirt and tie and sports jacket would not be allowed to applaud should the 'dance of the single towel' be successful, fifties' etiquette would not allow that, but the big, now very pink lady and the small towel compels a sneak look, I think. The tea huts would start to close, with the washing-up water now deposited in the sands. Downton's donkeys would be led back home for the night, through the town and over the Town Bridge, leaving their trail of digested lunch behind them for the oddball to follow. The small funfair would be giving its last ride with the queue now faded away, deck-chair attendants would be slowly collecting and stacking the deck-chairs, all stamped with WBC on them, although I suppose some deck-chairs were liberated and taken home on the train. 'A present from Weymouth', these folding chairs were known as; after all, most of the visitors were from London.

After watching the crowd now slowly diminishing, our gang would eye up the most promising empty attraction, the small funfair, the tea huts, or perhaps the donkey tethering point? Dressed for action in tee-shirt and shorts and with tennis racquet in hand, we would make our way to whichever holidaymaker spot was free first. Why the tennis racquet? Well, if you lose a coin in the sands, it is very difficult to find it afterwards and the only way to retrieve this lost coin is with a sieve. We, and, of course, holidaymakers, didn't have a sieve but the tennis racquet came in handy and it was less suspicious. So, where the holidaymakers would have stood waiting to pay or receiving their change, we would 'racquet the area.' We would find half 'a' crowns (12.5 p) two bob bits (10 p) a shilling (5 p) a sixpence (2.5 p) and pennies (0 p) and halfpennies (0 p). If you came home with up to five bob (25 p) each in your pockets, you had done very well. The best place to look was where the holidaymakers' children had been given money to pay for the attraction, as often they would fidget and drop the coins. 'Ice-creams and pop all round' would be our departing cry as we left Weymouth Sands Bank Plc (People Lose Cash).

One of the most unique attractions on the sands were the sandcastles, not the useless attempts made by half-hearted holidaymakers to stick little flags in, which always dried out in the sun very quickly, but the masterpieces of castles and other miniature buildings sculptured by Fred Darrington and Jack Hayward, not that we ever knew their names. Both were known to us as 'the sandcastle man'. Jack Hayward modelled intricate sculptures, mostly cathedrals, just after the Second World War and into the early fifties. Sandcastle modelling goes back to the beginning of the last century when more than twenty sandcastle sculptors would occupy various parts of the sands with now the best and only sandcastle man left.

Fred Darrington was a fantastic modeller of miniature buildings in sand; in fact, he was known as the world's most famous sand sculptor.

The holidaymakers would look on in awe and delight at his work and would happily throw money into his collection tin. Had I been running the sandcastle show, I would have removed the copper coins and replenished the tin with silver coins and the odd ten bob note (50 p) for all to see and therefore put off the mean, penny-pinching penny throwers.

There could not have been very many expenses in sandcastle building to declare for tax purposes: 'Tell me, Mr Darrington, what expenses are you claiming?'

'Well, I used six old lollipop sticks, an old bucket and a spade.'

Taxmen have been known to go on a working holiday. You can always spot the taxman, just look out for the pinstriped suit with trousers rolled up to the knees pretending to paddle with binoculars trained on the sandcastle builders and other attractions on the sands.

The interesting thing about Fred was that he did this for nearly seventy summers. 'Where are we off to for the holiday this year, dear?' his wife might ask.

'Well, I have just taken delivery of a new line of old lollypop sticks and I thought we might visit Weymouth, just to try them out, of course.'

Fred liked the sand at Weymouth because it was of an unusually coarse texture, which would bind together firmly by just adding a little water. The only other beach that has sand like Weymouth sand is in Northern Tasmania, as it is both clean and as fine as talc, but that's hardly just up the road. With some rare Weymouth light rain, the sculptures would be better preserved as they would not dry out and crumble away. His technique was to mix a pint of water with two pounds of sand and then, with this sloppy mixture, he would start to build his sculptures little by little, layer by layer, with the help of either an old kitchen knife or a lollypop stick.

An instance with Jack Hayward's sand cathedral, and there must have been several, I remember, was to do with the sailors and the pubs. The walk to the liberty ships at the end of the Pleasure Pier is where the sailors would be collected and shipped back to Portland Harbour and their waiting naval ships. The sailors that passed Jack Hayward's sandcastle pitch, which was left trustingly unguarded overnight, as there was nearly zero vandalism in the fifties. These returning sailors would be drinking the last dregs from the beer bottles at the very point that Jack had his castle, and saw his sculpture as a lovely target. Poor old Jack would be left to clear up and remodel his castle the next day. The only good part, but of little compensation, of this reconstruction exercise, was that he could collect the deposit money on the empty beer bottles. Jack Hayward had a collecting tin inside his pitch, a tin with a cloth covering the top with a round hole cut into it, why he had a cover over the top of his large tin, I don't know; it certainly made it harder to aim the money thrown. Perhaps

he did not want the holidaymakers to see how much he was being given, or attract attention from the taxman's prying eyes.

In later years, Fred Darrington would sculpture the Prince and Princess of Wales, as well as pyramids, sphinxes, a depiction of the Last Supper, monkeys playing poker, racehorses and bowls of fruit. Fred Darrington died in August 2002, aged ninety-one and his site has been taken over by his grandson, Mark Anderson, Fred's first and last apprentice. The duo of art in sand was known as F. G. Darrington and Grandson.

Try as we might, the four of us could never make anything like Fred or Jack's beautiful sandcastles; ours always crumbled away or were mostly stepped on by stumbling holidaymakers on the over-crowded sands. On some days, the sands would be so crowded with the added influx of best winter-dressed day trippers that it seemed like standing room only. Mark Anderson is aware of the unique sand's quality for sand sculpture and whilst competing in an international competition in Los Angeles he found that the sand there had a lot of shell mixed with the sand. This meant that, while completing the sculpture of the Statue of Liberty, he found it would not hold together, as it all started to dry out, resulting in the arm shearing off. He did try to save the situation by turning it into the Venus de Milo, but that broke as well. So what started off as the Statue of Liberty finally became a giant octopus. That's either adverse creativity or maddeningly difficult without Weymouth sand. With luck, Weymouth's sand will not let him down to carry on Fred's tradition in his grandfather's best style, and the good news is that today's empty aluminium beer cans can't be thrown as far as yesterday's heavy, glass beer bottles.

The reuse and return of glass bottles was standard practice in pre-war and early-post-war Britain until production costs and the advent of plastic bottles proved to be more economical to produce, making the redeemable system now not cost effective. A small deposit was paid on the bottle of liquid that was returned when the bottle was either returned or was not charged on the new bottle purchased. We knew that on each soft drink bottle there was a penny deposit paid. The drinks bottles held one of the many but mysterious simple flavours available, such as Dandelion and Burdock or Cream Soda produced by the local company SDT, South Dorset Trades. We would scour the sands after most people had gone for the day leaving us boys to recover the deposit money by taking the bottles back in dribs and drabs (if we didn't do that, we would have the quizzical shopkeeper asking if this is the shop we bought the soft drink from). We often had to hide around the corner with our pile of bottles as we each took turns to take back to the shop two or three bottles at a time. The recycling of bottles was not a new idea, but then it made economic good sense as most glass containers could be reused again and again. We have come a long way with innovative liquid containers since the last bottles

were subjected to a deposit return system but we have also lost the best ideas of reusing the reusable, as we adjust to our technological journey.

Some of the returning sailors to Portland Harbour would dispose of their empty beer bottles by smashing them and kicking the broken glass into the sea as they walked back to the liberty ship, which meant that parts of the beach, with the receding tide, had broken glass in it. On one such occasion, the four of us were honing our 'messing about' skills messing about in the water near the old Ritz Theatre and I knelt on a broken beer bottle resulting in a very large cut to my knee. With blood pouring down my leg, I made my way through the overcrowded sands to the middle area to locate the first-aid hut only to find it had closed. 'So now what do I do?' I thought to myself. With just my bathers on, no shoes to help run in, I ran all the way through the town to home, leg pouring blood and probably looking a bit upset but probably more concerned that on reaching home nobody, even Mum, would be in. Luckily Mum was there and she dabbed TCP on the cut, to help make the pain worse, then she bandaged the injury, to help make the pain much worse. By now, the knee had become very stiff and painful. As soon as Dad arrived home from a hard day's work, dinner was put on hold and he and I went to the hospital.

Portway Hospital was very conveniently located at the end of the bus ride from the Town Bridge to the Greenhill area of Weymouth. I felt a small amount of trepidation as we arrived at the hospital; this trepidation was confirmed by the strong smell of disinfectants mingling with other smells coming from various ointments as we entered the hospital. The nurses wore clean, starched businesslike uniforms that made me feel more anxious about the coming treatment. This visit was at the beginnings of the fledgling National Health Service. I was to have all the best care and attention of a trained, privately run hospital but enjoying the proletariat dictum of no medical bills to pay. Dad promised me a shilling (10 p) if I didn't cry. What? Boys of my age don't cry. What he didn't tell me was that such a cut would have to have a tetanus injection to stop a bacterial disease affecting my nervous system. Don't give me that injection and I won't make my system nervous, I thought, but was too nervous to say so. Five stitches later and I was better off by a 'bob' (10 p) and my nervous system seemed intact.

After a week of playing the wounded warrior, limping here and there and trying to drag some sympathy from all members of the family ('Perhaps an ice-cream would help?' I would mournfully mumble to Mum, although I didn't get much sympathy), I had to go back to the hospital to have the stitches removed, on my own this time. I had instructions from Mum and her friend, the poor old church mouse, to ask for the old, soiled bandage back as it could be washed ironed, put in the airing cupboard and reused

on more blooded boys – there's real recycling. No problem, I thought, a chance to use some grown-up language.

'Mum said to ask you for the bloody bandage back, please.'

I remember the look of horror on the nurse's face when I said that. Was it the smile behind the language I used? Or the thought of handing over a length of soiled grot? Looking at me, she then smiled and took a brand-new bandage out of the hospital's storage cabinet and gave that to me instead. As she did so, she put a finger up to her closed lips. I thanked her, stuffed the new bandage into my pocket as I felt pleased that I accomplished my task and would please Mum. This called for a celebration, so I walked home using now two good legs, the battle fatigue now gone and the bus fare exchanged for a large Rossi's ice-cream now waiting.

On later reflection of this small episode, here I was, a nine-year-old, small boy having to go to the hospital by bus, book myself in, wait for the nurse to attend to me, i.e., take out the stitches, have the nerve to ask for the old bandage back and then catch the bus back home. Would a parent allow a child to do that today? Weymouth in the fifties was a place you could trust, and I hope it still is today.

It was a fast trip that day, faster than light, travelling at that speed was a Weymouth delight.

The sands had two fantastic and futuristic items for us boys (although more for the holidaymakers' enjoyment than ours) – speedboats. Two

Miss Weymouth speedboat, Weymouth Bay, 1950s.

ultra-sleek speedboats named *Miss Weymouth* and *Miss Dorset*, their names painted in big, white letters on both sides of the boats. These graceful velocity pleasure boats would race across the bay with the bow lifting out of the water as they reached 25 knots, not against each other, but with half a dozen or so holidaymakers enjoying the sea spray and wind through their hair or cooling their bald spot as the toupee-wearers soon discovered. Speeding into a small wave would cause the buffeting of the boat to send sea water over all the passengers except the coxswain, or pilot as the coxswains were marketed as, who would remain dry whilst all his passengers would often experience the salty spray that made the occupants howl with delight or dismay: 'Well, what the heck, we are on holiday.' There were oilskin coats available should the day be cool and the sea perhaps a little rough. The boats were owned and operated by Cosens of paddle-steamer fame, and were built of mahogany and finished with a deep, waterproof-varnish finish completing the very beautiful and sleek lines, the style that would be indulged by the parents of rich playboys on the Swiss or Italian Lakes equipped with the accoutrement of a blonde or brunette heiress by his side. As sleek and futuristic as the speed boats were to us boys in the fifties, the two boats were, in fact, made in 1929; when built that far back, they really must have been very special.

The Weymouth holidaymakers could only but dream, he in a forties sartorial, uniquely made, one-size-fits-all demob suit, his best Sunday, interview, funeral suit and holiday posh wear given to him as he left the forces in 1945, she floating in a dream of salty spray in her aquamarine-coloured hand-knitted twin set and pearls. The 'Bay of Naples' today, and tomorrow, well tomorrow's another day: 'Here's looking at you, kid; we will always have Weymouth.' The dream couldn't be broken, even with a walk around the Nothe Gardens with a dripping ice-cream each. It would only be shattered by the guesthouse landlady glowering at them and the hall clock at the same time. What a fuss it was to be five seconds late for the evening meal. It would have helped your late arrival if you had clicked your heels when entering.

These mercurial, mahogany motorboats were moored alongside either a purpose-built walkway near to the pier bandstand or a temporary rickety walkway that went directly from the sands to the boats, where, in this instance, health and safety rules would have been minimal: 'Hold on, Grandma. If you fall off, the lifeboat may have to be called.' 'Just wobble your way out to the boat, hang on to yourself.' What a remarkable sight they were! The speedboats looked pretty good as well.

The Esplanade was one of the most popular places for holidaymakers to spend their time promenading the curve of the sands and bay. The word 'Esplanade' is quite strange, very much associated with pre-war and early-post-war seaside holidays. A word that seems only to be wedded to a

pleasurable walk, typically beside the sea, although its origins are sixteenth century, denoting a flat area on top of a rampart. Who would have such an address and be born so far away from Great Britain but Rudyard Kipling, born 1865, baptised 1866 with the address of 'The Esplanade, Bombay'. It was so much more than just an English seaside town location; in fact, it was a name used all over the world from Great Britain to Australia and beyond.

Weymouth's Esplanade extended from the Ritz Theatre, complete with its new, warmed-up charcoal condition, to the Pier Bandstand with the Jubilee Clock positioned on the widest part of the Esplanade. The Jubilee Clock area has a protuberance that had been designed to control the flow of the incoming tides to stop the sands from being washed onto the shingled part of the beach. It also gave the parasol-waving promenaders of times past more elbow room; so from that point, the sands stop, then up to and past the pier bandstand the far-reaching shingle extends and all the way around the bay to Osminton Mills with the shingle growing into larger pebbles. The Esplanade has, at strategic points, the shelters. These were a filigree of cast iron of Victorian design and age and painted in municipal green with wooden seating. Pausing to rest in one of these shelters would be, with its four-seating sides, many holidaymakers resting or sheltering from sun, wind and rain during the summer season. You would often see couples exploring their mysterious packed lunch and balancing the Thermos flask between one of the pair of legs. Long-retired, now-single ladies would sit knitting a new woolly hat for winter to match the already-finished tea cosy and, sitting alone, the single, also-long-retired gentlemen sporting a Panama hat and cravat, smiling as they enjoyed the company of the distant, happy clamour of the visitors on yet another warm summer's day.

Along the curve of the Esplanade were the fixed, mounted telescopes, which would be keenly used to view the scenic bay surrounded by Lulworth and the Kimmeridge hills in the east, as well as the busy boating activity in the bay towards the Nothe. However, to the disappointment of the few, the angle of the telescopes was fixed to look across and to the sides but not to look down onto or at the costumed holidaymakers on the sands. This was, we assumed, to avoid the temptation of voyeurs, or as us boys would remark, 'To stop old men looking at ladies bums.'

The Punch and Judy man had his booth on the sands near the George III statue. It has probably been located in the same place since Victorian days when all the visitors were attired in outfits that all had a subtle difference, all were shades of black. On hot summer days, this would help to retain a certain level of warmth to keep the wearer cosy, and delicate skin snow white, which would cause the ladies to perspire and the men, of course, to sweat.

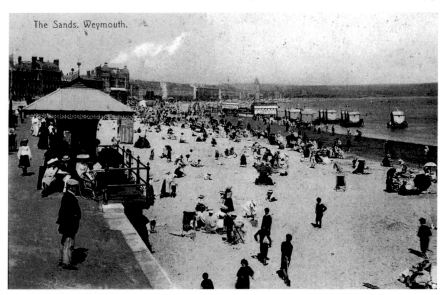

The Sands. Weymouth.

Old postcard of Weymouth Sands, *c.* 1905.

Weymouth has had a Punch and Judy show for many years now and, in spite of much more modern entertainment, it will always be popular. Whilst it could be funny to some, it could also be a little frightening to others of a younger age, especially when the crocodile would swallow up Mr Punch whole. One puppet, playing a well-to-do drunk dressed in top hat and tails, would sing a topical song of the day in his inebriated state. The song, I remember, went something along the lines of 'I've seen lights and diamonds again hic, hic.' This was probably gleaned from the local revellers at pub closing time so would be popular with the adult audience now trying to sober up as Punch rode roughshod over Judy. So Weymouth had for its children's entertainment a gentleman named Punch who beat his wife and baby, then would toss both over his shoulder and out of the way; a crocodile eating people whole; and a drunk wandering about with bottle in his hand. All the characters would meet their end by being hit on the head with the policeman's truncheon, and taken to jail. 'Mister Men' meets 'The Godfather': an everyday story of seaside folk at play. At the end of each show, the puppet showman would walk around with his little wooden box inviting the audience to contribute a coin or two. This was our cue to leave quickly.

The Esplanade was probably the most popular place to be and to be seen, as the Esplanade had all sorts of holiday contrivances on offer, one of which was photography. This is where eager or reluctant visitors would be 'snapped' with the result that the next day your photo would be pinned up at the photographer's booth for all the world and his wife to

see and, of course, make humorous comment on. 'They can't be husband and wife; more like her great-grandfather than er husband', and so on. If the holidaymaker liked the photo, then it would be purchased, if not, the photographer would be the loser. Holidaymakers would be strolling, some arm in arm, others holding hands, with some couples walking side-by-side but silent over a silly row. This mixed bag of strollers would be the photographer's target along the Esplanade. Out of nowhere, the photographer would 'snap' you and hand you a card. Sometimes this was refused by the holidaymaker, who would look rather annoyed – probably a married man with his girlfriend, 'a Mr and Mrs Smith'.

The established photographic studio was run by Chambers, who would develop the black and white prints (with colour prints some years away) overnight, ready for the punter to look at the next day. The unlucky camera-shy would then decide if the photo was worth buying or allow it to be torn up, although unbeknown to the purchaser, the prints to buy are separate and yours, Misses, yours will be pinned right up there for all to see. Courting or honeymoon couples would mostly buy the prints, but a Mum and Dad, laden with buckets and spades, picnic sets, towels, and much more, towing two or three kids behind them never made a good picture, interesting but not the souvenir they wanted. The comments made by the photographer's subjects must have had some interesting remarks, and as the punters were mostly from London, would typically be: 'Cor blimey, is that me?' 'Bert, why didn't you put your teeth in? Can't show Mum that …' 'Your knees, luv, they won't win Miss World.' (slap) 'Cor blimey, there's me with a big smile and you looking like sin.' Or 'I can see why I fell for you. I can see love written all over us, can't you, Jim?' 'Emm.'

An activity that can't be classed as entertainment, though none-the-less entertaining for Frank, Peggy and myself anyway, was The Salvation Army, better known as the 'Sally Army'. This regular to Weymouth Sands gathered the guilty and the curious around its circled gathering of singing, bonneted ladies warbling righteous and stirring songs of praise and all helped with its sand-filled harmonium, which seemed to sink further and further into the sands as its player vigorously pumped away whilst its officer, an avuncular, uniformed bringer of the good news, would be preaching and teaching the good news to the curious sightseers about the great and good from the Bible. Taking part in all this happy singing together was our Granny Willatt who sang in fine form with her high-pitched, falsetto voice. We would lean on the Esplanade railings and all wave a cheery hello to her, while she would try to wave us along as she knew that, if we stayed too long, less than a minute, she would start to have a fit of the giggles. Gran was such a delightful person, never miserable, always laughing about something or other, or as we would often comment, 'Gran has got a

fit of the giggles.' Her personality must have suited Granddad down to the ground. I can't imagine a cross word between them even when Gran had to pawn her beloved sewing machine to pay the rent after he lost his small fortune in the 1929 crash.

'Don't worry, my lovely Rose,' that was Gran's name, 'tomorrow's job will see us through to the end of next week. We can then have Kate and Sydney for tea and the old Singer will be out in no time.'

'Righty-oh, dear.' I can hear Gran saying, but also: 'Where are you off to?' (As if she didn't know.)

'Oh I thought I would drop into the Jack.'

'Kate and Sidney' was cockney rhyming slang for 'Steak and Kidney' pie and the Jack was the Jack of Both Sides, a pub in Reading.

But her saviour when singing on the sands was the approaching Salvation Army collector with the penny rattling box. At that point, we moved quickly away, saving our Gran from more giggles than she could handle. Her eldest son, Frank, seemed to be the very opposite of my Gran.

My Uncle Frank was a man who seemed to enjoy his chip on the shoulder, vexing at all that was wrong with the world but also possessing a small creative happy streak. A textbook dotty inventor, photographer and musician, divorced and living alone at West Bay, Dorset, one of his many inventions was to develop a car headlight system called 'the anti-dazzle lens', designed not to dazzle an oncoming motorist even when the headlights were switched to full beam. This 'patent' was bought by the German manufacturer, Bosch, but as far as I know, never entered production. This crude-looking but simple lens arrangement looked as though it was designed for the blackout nights of London during the last war; perhaps the maker Bosch thought so as well. I'm told that they bought the patent just to keep its competitors from getting their hands on it, but if it was any good, why miss a commercial opportunity?

Uncle Frank's workshop, an apartment overlooking the sea, belonged to Uncle Fred and his business partner John. The unintentionally converted sitting room had slowly acquired a full set of small machines, tools, test meters and many partly assembled gizmos and widgets. Even a very understanding wife would never have managed to live in such perverse conditions and I guess that's the reason that one probably no longer existed for him. Uncle Frank also had a large number of his photographs published in magazines, including one very famous picture of a bumble-bee wearing spectacles published in *She* magazine in the sixties. To make up this photograph, he made a real 'bee'-scale version of a pair of spectacles from fuse wire and fitted them to a dead bumble-bee, then he placed the bespectacled bee on a flower then photographed it. It does not take much imagination to realise the size the spectacles needed to be made to produce such a picture. Uncle Frank, as well as his mechanical and electrical talents,

had his endearing or odd ways as well. Every room in his apartment would also be surrounded by all sorts of musical instruments, as well as cameras and photographic developing chemicals, together with his one and only, unwashed-up piece of catering equipment, a tin mug for his many cups of tea, which had acquired a thick film of tannin that clung to the inside of the mug thicker than the steel mug itself.

Woe betide a visitor who was unfortunate enough to call on him. Uncle Frank would unpack his accordion, don his straw hat and entertaining jacket and play the visitor or visitors a selection of tunes from yesteryear. No matter who the visitor or visitors were, the postman, the Mormons or Jehovah's Witness, the electricity-meter reader or just someone looking for directions, all would be obliged to sit through a squeeze box rendition of 'Tiger Rag' (played very fast as his foot stamped up and down) or 'Come into the garden, Maude' (played mournfully) and many more. I wonder how long the Jehovah's Witness stayed before throwing in the towel or converting to atheism.

This was from a man who went to sea at the age of fifteen by joining the navy in 1918, a few months before the First World War ended. I had no idea my Uncle Frank was even in the navy until the day of his funeral in later years. The family all arrived at his Bridport apartment, 'Des Workshop', after his funeral to sort and clear his 'things'. This proved a much greater task and riskier operation than the six of us imagined. Three rubbish skips were required. One was just for numerous demi-jons filled with acidic photograph chemicals, plus old car batteries, heaps of wire, old electric motors and much more. The other two skips were for the sofas, beds, table and chairs, all of which had been used for many years and were as one would imagine they would be if surrounded with the contents of an engineering workshop. Finally, all his clothes had to go. These were long past their surrender dates and were quickly put out of their misery and binned, although some fought back.

Also dumped was his store of food, ages past their sell-by dates, some of which had price labels on them in pre-decimal-currency era of 1970; a packet of biscuits with the price tag of 2s (20 p) and this was 1988. What remained was a small collection of tools, photographs, books and general documents, bank and saving accounts, birth certificate and his naval record. I had not set eyes on a naval record before, let alone one of that vintage, and was about to bin it as it was *the* grubbiest document in his possessions, S-459 (Late S-536) (Revised-September 1915) 'Certificate of the Service Frank Edward Willatt, in the Royal Navy'. This certificate was made of a cloth-type material, to prevent tearing and looked as though it had been used as a busy pub front door mat since he had left the navy more than seventy years before.

A revealing number of facts emerged. He was born on 19 December 1902, in Deptford, London. His religious donomination was Wesleyan.

There was a record of all examinations passed and conduct for his duration, V.G. (very good). Then the ships he served in. The training sailing ship, *Impregnable. Resolution,* a new ship, which he joined on the 21 October 1918, just twenty-one days before the First World War ended, a war that ended with a loss of over 10 million men, and British warship losses of 9,055,000 tons or 1,069 ships.

Knowing my uncle's unique nature, this last ship, HMS *Vivid*, was an apt ship for him to serve in because its previous name was HMS *Cuckoo*.

For many years, Uncle Frank photographed small, detailed features on well-known buildings in the nearby town of Bridport for the local newspaper. The idea was for the reader to guess where the mystery object was located and to 'win a prize'. This competition ran successfully for a number of years. His downside, or interesting personality, if one can call it that, was the continuing stand-off with the neighbours' small dog next door. This small dog would bark in the evening when it saw a person on the television it didn't like. The dog's barking would annoy Uncle Frank, who would be distracted from concentrating on his latest gizmo design. In an attempt to stop the barking, Uncle Frank bought an old air-raid siren and set it up in the room nearest to where the dog would bark, so when the dog barked at the television, Uncle turned on the siren. Instead of frightening the dog into silence, it had the reverse effect, as it caused the dog to bark in overdrive. That's Uncle Frank – clever, talented, hard-working but used a warning that the might of the Nazi war machine was on its way to crack a little dogs will.

Whilst the sands had one of the best beaches in the South, the rest of the beach, as you walked further around the sea front and past the Jubilee Clock, would gradually change into a shingle beach, small to start with then larger pebbles would appear as you reached the area of Greenhill and its gardens. Whilst this pebbly beach would stretch all the way to Bowleaze Cove, it would have few visitors, only the few looking for more discreet sunbathing, also where sandcastle building was impossible. The simple enjoyment of walking barefooted along the sandy shoreline might take you to the Pier Bandstand.

The small pier was opened just four months before war was declared in May 1939. It had a restaurant at the Esplanade end and a seating and activity area where dancing would be held as well as other activities including roller skating, wrestling and the Miss Weymouth beauty contest. The rest of the pier had seating around the perimeter where holidaymakers would sleep off the pub visit from the night before as well as the recent lunchtime pub pick-me-up, all now noisily slumbering in tune to the afternoon's resident band.

The resident summer band would play for the dancers and listeners alike, most of the music was usually bland, evergreen standards, to me anyway.

It was not the tune but I was interested in the worn out performance, played by the musicians dressed in gravy-stained, thirties dinner suits each having an openly secreted bottle of Scotland's national drink within easy reach behind their enclosed music stands. The tune or song titles were never by name, just number. 'Number 138, lads.' With much scrabbling around the music stand, a dog-eared sheet of music would be unearthed; a quick sip of the hidden sustenance and the music would begin. The music was to young ears very dated, especially when rock and roll came in by the mid-fifties and, although the bands tried to bring themselves up to date by playing the hit tunes of the day, such as 'Rock around the Clock', 'Hound Dog' and 'Blue Suede Shoes', the band's choice of instrument would be typically clarinet and trombone with tambourine accompaniment to add some zest to their rendition. It took much imagination to relate Elvis Presley's 'Blue Suede Shoes' to a clarinet-and-trombone version, but it did allow the dancers to dance a quickstep or foxtrot to it, although some of the older people got up thinking it to be the introduction to dance the Gay Gordons, not knowing it was a big Elvis Presley hit.

There would also be talent contests where young girls would sing songs such as 'Que Sera, Sera' (Whatever will be, will be) or 'Somewhere over the Rainbow'. Boys never seemed to enter these contests, unless it were to perform some poorly executed conjuring tricks, so the pretty little girl with the pink ribbons always won the prize, which I think was five or ten shillings (25 or 50 p). What I wanted was for the band's drummer to embark on a half-hour drum solo, but I think the 'very mature' drummers of the day would have either wanted a month's notice, or worse, have had a heart attack just by a listener requesting such a rumbustious virtuoso performance, let alone if they had tried to play one.

Greenhill Gardens was the name given to the typical seaside municipal gardens. All the flowers were laid out in neat rows with perfectly formed flower beds and very neatly cut, very green grass. The lawned areas had little, cast-metal, embossed signs with small lettering detailed on them, which invited the visitor's curiosity to walk over the lawn and view the important message transcribed, thus instantly compromising the sign's requested compliance with the instruction 'Keep of the Grass'. The main feature for the summer visitor was the cuckoo clock, or floral clock as it is properly named, which on the hour, every hour, would produce the sound of a 'cuckoo' to announce the time. The clock would be made up of succulent plants with each Roman numeral formed from different types of flowers; the single hand also had a variety of flowers bedded into it. This decorated horologe was manufactured by Ritchie & Sons of Edinburgh in 1936. As each hour on the hour grew nearer, the gathering holidaymakers, ice-cream cornets clutched in hand purchased just moments before from Valenties on Brunswick Terrace, with the licking spectators, now slowing

to a token lick, growing silent so as not to miss the 'cuckoo' sing, which was followed by a hushed 'Ahhh'.

What a great evening out that must have been. You couldn't beat Weymouth in the fifties for such sophisticated excitement. 'I need to sit down after that,' we would hear some say, such was the excitement, or perhaps we misheard some elderly people expressing exhaustion after walking to the gardens. Sometime in the early fifties, a weathervane was erected called the Schneider Trophy to honour the fast seaplanes of the thirties. In fact, the weathervane was in memorial to Wing Commander, then lieutenant, George Hedley Stainforth RAF, who set the world-record air speed in a Schneider Supermarine S6B seaplane in 1931 at a speed of 407.8 mph. He was a local student at Weymouth College, hence the dedication. Sadly, he was killed in action in September 1942, aged forty-three and is buried at the Ismailia War Memorial Cemetery, on the west side of the Suez Canal in Egypt. Weymouth College was another project for local architect Crickmay. Weymouth College was also the teacher training college in the 1950s.

The gardens had a shelter, which we always thought was an old bus shelter, but was in fact donated by one of Weymouth's mayors, Mr Bennett. Underneath the garden bowling-green and tennis area, facing the sea, was a row of built-in beach huts. These tiny, private shelters gave you your own little world to sit and enjoy a sea view in comfort from your own deck-chairs and to boil a kettle of water for tea and provided a chance to prise open the much-worn cake tin of many seasons past campaigns to this little hideaway, which was now filled with yet another heavy-going fruit cake made a week ago at home. Whilst this gave you your own little world, it came with an intrusive fault and that was the dozens of holidaymakers who would stroll past you and gaze at your bandy legs eating your cakes and tea or sleeping in the deck-chair, so these chalet beach huts were as private as a busy town road junction.

As small boys, our understanding of the wider world would be both limited and a little mixed up with our knowledge of history, geography, and the scriptures. Frank and I attended Sunday school at Weymouth Baptist Church, near the Alexandra Gardens, and at Sunday School we would, in our best unbroken voice enthusiastically mumble the words to a well-known hymn of which the lines were.

> There is a Greenhill far away without a city wall,
> Where our dear lord was crucified, He died to save us all.

Now we only knew of one Greenhill, and that was just up the road and, yes, it didn't have a city wall, it had railings around it, but to us that's where 'our dear lord was crucified', with sea view. We imagined Jesus

nailed to the cross at Greenhill (Gardens) and there crucified. 'Could you stop hammering a minute, the cuckoo clock is about to strike.' The cross was probably nowhere near the clock. It was probably in the middle of the bowling-green, which is the highest point, where those large, round ladies, who would sport size twenty-six knickers, a pair for each leg, would be playing bowls. Such is the influence that stories and hymns had on us. Although research shows we weren't that far off the track, as Greenhill has a very grim past. It would seem that wrongdoers met their end there with hangings as early as the late sixteenth century and onwards, with a Monmouth rebel's grisly body displayed for all to see, sentenced by the 'bloody' Assizes Judge Jefferies in the late seventeen century.

Another story from the Bible is the parable of the two builders; Matthew 7 verse 24 to 27 is of 'the man who built his house on sand is a fool and the man who builds his house on rock is a wise man.' The beach huts that sold cups of tea on the sands were, therefore, built by fools. We would impart this important knowledge to Mum or Dad. 'They are still standing, dear,' and a year later they still were. The vendors of the scalding Typhoo clearly never went to the same Sunday School as us.

'You are Lobby Lud and I claim my five pounds' These spoken words were the tantalizing claim that invited the holidaymakers to state the magic sentence for a newspaper competition or promotion that was invented by the *Westminster Gazette* in 1927 with the name 'Lobby Lud'. This was derived from the newspaper's telegraphic address (Lobby Ludgate). The changing of hands of the *Westminster Gazette* newspaper, which became defunct, was taken over by the *Daily News*, which in turn became the *News Chronicle*, and then finally became the *Daily Mail*. So, in the fifties, the then daily paper, the *News Chronicle*, promoted this competition in which the participant had to buy that particular newspaper and in that paper would be a description of the mysterious 'Lobby Lud' character, together with the likely indicated places that he could be found, and, of course, the long Esplanade at Weymouth was the ideal place for him to stroll, or make himself scarce or even be non-existent as some believed. It was important that, if you approached 'Lobby Lud', you had to say the correct words: 'You are Lobby Lud and I claim my five pounds.' The only way 'Lobby Lud' could be recognised was by the fact that he also would carry a copy of the competition newspaper.

Now, if 150 holidaymakers, all keen to receive the £5, carried a copy of the newspaper and each asked each other that special question once, that would mean that the Esplanade would ring to the massed chorus of hundreds of people stating to each other: 'You are Lobby Lud and I claim my five pounds.' Although I suppose one could still carry the newspaper just to read or do the crossword puzzle but, in addition, hang a notice

around your neck with the words: 'I am NOT Lobby Lud,' so any person carrying a newspaper without the 'NOT, Lobby Lud' sign hanging around their neck could be the man himself. For five pounds, much money in the fifties, almost a week's wages to some, meant the effort might have been such a waste of holiday time, but think of all those newspapers that were sold. 'Lobby Lud' was shown in cartoon form as a gentleman dressed in a suit with trilby hat and smoking a pipe, looking a bit like the comic detective character Sexton Blake, 'the Prince of the penny dreadfuls'.

Frank and I were fascinated with this competition, as winning five pounds would be money beyond our dreams; we would be 'fiveraires.' One day, we bought a copy of that day's *Daily Chronicle* and read where Lobby might be on that particular day and, as he wore a trilby hat and smoked a pipe, we were sure that we would soon see him, so off we went in search of the area. Amongst the fifties summer-holiday-clad holidaymakers, would Mr Lud be very hard to spot? You would be surprised how many holidaymakers in the fifties did dress like that, no shorts and tee-shirts, nor jeans or bare, tattooed chests then in that era. Those sorts of ladies would visit in later years.

Most people would just wear their normal day wear, with the gentlemen disposing of their tie and putting the shirt collar over the outside of their jacket collar, but still smoking a pipe, even during a heat wave. We overheard a couple outside the newspaper shop who were after the same quarry. 'Let's try the pubs love, there can't be many.' (She didn't know Weymouth.) We overheard the husband saying: 'We'll try them all, even if it means we have to buy a drink or two.' We did wonder whether we should follow these people, but they soon disappeared into the very busy and crowded Esplanade.

We carried on walking up and down for most of the day until we thought we had found him. Our suspect wore a Trilby hat, but no pipe, 'perhaps his pipe is in his pocket,' we wondered, but more importantly he was carrying the right newspaper. Then we began to argue about which of us would approach this giver-away of fivers.

'You go, you're the youngest. He will warm to you, not an older boy like me.'

'No, you're bigger and he will listen to you.'

So the argument went on. After a short while, we noticed that Mr Lobby Lud had now disappeared. So we began arguing again.

'You were too slow. You've missed him.'

'Well, you should have gone.'

We had no fiver in our pocket, only a wasted day and pocket money spent on a silly old newspaper: 'It's your fault.' 'No, it's not,' and so it continued.

At home for tea, we still made grumbling noises to each other, until Mum asked what we were arguing about. When we both explained, each pointing to the culprit, Mum brought a well-timed spanner into the argument that silenced us immediately. 'You have to be over twenty-one years old to enter this competition.'

'Oh,' we both said, followed by 'even so, it was your fault.'

It was a summer Sunday evening treat for our family to go for a walk along the Esplanade, one of our few and rare occasions where a full complement of the six of us did go out on a family outing. No evening meal to cook for the visitors, just a simple salad of crab or mostly tinned salmon, making washing up an easier job. Rossi's ice-cream kiosk on the front, near to the Royal Hotel and the amusement arcade, was the place to buy a good ice-cream, and there we would be treated to a delightful, creamy ice-cream cornet before continuing on our walk. A walk that would continue up to Greenhill Gardens and the singing flora superabundant *Cuculus canorus*[17]. On the stroll back, we would again be treated at another ice-cream kiosk, at 'Valenties', which is near the Pier Bandstand in Brunswick Terrace. Both ice-cream parlours were Italian and, no doubt, both in competition for the best ice-cream in town, although Mr Forte's was also very good. Whether there was bad blood between them, being Italian and all having Godfathers, I couldn't say. Weymouth was such a gentle place then, where a dog barking after 10.00 p.m. would be an item for the *Echo* newspaper; still, I can imagine a genteel feud of hot-headed cool ice-cream makers putting a contract on each other. 'Mr Rossie has been apprehended on a charge of a drive-past cornet-throwing incident in which a loaded ice-cream cornet hit Mr Valenti.' Sicily remains on high alert.

One such evening walk, Frank and I were a little ahead of the rest of the family, so we sat on an Esplanade seat licking our ice-creams waiting for Mum, Dad and two sisters to catch up with us. When Mum got near, she said: 'That's just how we found you, sitting on a seat all by yourselves, so we took you home.' This was our first introduction to the 'facts of life.' Mum would never discuss anything remotely related to how a birth happens; our being on earth was by a birth-giving seaside seat. This must have been a very rare event, as we never saw any other boys or girls seated on these exhausted, now-wobbly-legged seats, crying out for gas and air and waiting for a Mum and Dad to happen by.

At the harbour end of the Esplanade where the Ritz Theatre[18] is located and built on reclaimed land, separating the bay and the harbour, is where passengers and visitors could access the Pleasure Pier via a turnstile iron gate. In the fifties, the cost was just one old penny. The wooden Pleasure Pier had a few things to offer, namely sitting and looking, fishing whilst sitting and looking, or sitting and looking at the swimmers diving from

the dive boards, or you could buy a cup of tea and a sandwich and sit and look at its contents. But best of all, you could embark on the wonderful paddle steamers for a very enjoyable trip to distant shores prompted by the commanding voice of Cosens ticket-seller Mr Caddy, whose voice would boom out the trips on offer: 'Lulworth', 'Swanage', 'the Fleet' ...

The town side of the Esplanade was lined with buildings where its architecture has evolved over many decades with much influence from the Regency to the later Victorian period. Starting from the George III statue to the Pier Bandstand, there are shops, hotels, guesthouses, cafés, amusement arcades and some residential properties, all with sands and sea aspect. The sun of prosperity really began to shine on Weymouth in the Regency period. Ralph Allen owned a property in Trinity Road, No. 2, although this house would have been known as the High Street in the 1750s. This substantial property, we would, as children, walk, run, shuffle or, with more practice, lark about past many hundreds of times, but never knowing the importance of who resided in and visited this delightful double-fronted town house. Ralph Allen would sing the praises of Weymouth's sea, air and sea bathing with its health-giving properties. He would spend his summer season away from Bath, where he was mayor, to spend time enjoying Weymouth from June to October. One wonders who looked after Bath during his absence whilst he enjoyed the sea air? The invigorating sea and air benefits would be related to the Duke of Gloucester who, in turn, would recommend them to his brother, King George III and later King of Hanover, as being helpful with his recuperation. On this recommendation, after his long illness, George III took up residence at Gloucester Lodge, named after the Duke of Gloucester who owned the lodge, which was to become known in later years as the Gloucester Hotel, which, unsurprisingly, was converted to seaside apartments in 1989. It was the only very smart hotel in Weymouth that attracted the great and the good, including Thomas Hardy, who would often take afternoon tea there, and perhaps the not so good.

The Gloucester Lodge sat almost centrally to the sea front area, which, for the King, was an ideal spot to recuperate from his ailing condition with its superb view of the sea and golden sands, with the bathing machines delivering the King into the cool water's edge of Weymouth sands, perhaps hoping to shock the illness out of his body with the therapeutic sea water of the bay. As he plunged into the cool, clear waters, the band would play 'God save the King' from within an adjacent bathing machine. The milky court officials would no doubt twitter around His Highness and babble about the excellent residence in which the King had chosen to stay. 'At the front, you will have a good view of the sea and sands.' 'And at the back, you will have a good view of where, in future years, the Odeon cinema's car park will be.'

The sea front area quickly became 'the place not only to be but also to be seen', although wealth, as it can today, can have its downside as well. John Lowe, a bookseller living at 22 Charlotte Row (now changed to 45 to 51 Esplanade) enjoyed copious amounts of the good food that he bought from his sizeable income from book sales. The unfortunate result was that, in 1793, bookseller Lowe died an early death at the age of forty-one weighing some later century norm of 26 stone (364 lbs), and with that, he had the ignominy, not that he would have known this, of having to have the bow window removed from his house, to get his corpse out and onto the heavy horse and cart. One wonders at his size and coffin. No doubt a bribe of strong ale was forthcoming to remove such an overweight occupant into his jumbo, wardrobe-shaped coffin. His success in satisfying the local bookworms continued with the now-overweight earthworms eagerly turning a leaf or two.

The Gloucester Lodge, now a famous watering-point, quickly became the 'must go to place' for the rest of the royal 'jet-set', or more likely from the amusing Fanny Burney, a frequent resident, 'a jest set'. Fanny Burney (Madame d'Arblay) was Queen Charlotte's Second Keeper of the Robes, who in her diary has given some interesting accounts of court life of the period, including life at Weymouth. These accounts place themselves not far below the volumes of Walpole and Boswell as they rank as good reproductions of eighteenth-century life. Fanny Burney was able to relate in a very spirited way, adding vivacity to gaps other writers left. Dr Johnson called her, 'a little character-monger'. One, of course, wonders what she would have made of the 'new front' of the 1950s with the sands and Esplanade absolutely chock-a-block with people, all or some of the visitors indulging in Lobby Lud competitions, wearing his and hers, blue and pink 'kiss me quick' cowboy hats and seeking out the 'snapper' with his camera on the Esplanade whilst stuffing their faces with bright-pink candyfloss. 'Oh, my dear, it's so much more fun now, people showing their ankles and, dare I say, interestingly much worse, buying and eating food in the street wrapped in newsprint which is then discarded for the delightful seagulls to fight over, with agitated and riotous queues forming and shouting with their 'cor blimey' accents for the chance to visit the underground privies and that captivating smell of boiled cabbage that follows one everywhere. It's so intoxicating that sometimes the fresh sea air vitiates the aroma.' Whatever her sagacious comments might have been to the effervescent fifties, I shall leave to the imagination the eighteenth-century sarcasm and ribald accounts of the late Fanny Burnley, rather than attempt to replicate them.

The Gloucester Hotel in the fifties was *the* place to stay. Any visiting film 'star' director or VIP stayed at the Gloucester. The film comedy star Norman Wisdom stayed there at one time and, knowing this, Frank and

I stood outside for what seemed ages waiting for 'Norm' to make an appearance; that's us and hundreds of other people as well. After an hour of waiting, there was a ten-second burst of him rushing to his chauffeur-driven car, a quick wave and he was gone. This was at the time he made the film *Trouble in Store* and was at the height of his success, although that film was not made in Weymouth. The one I know made there was called *The Bulldog Breed*. I saw Norman Wisdom in the Isle of Man in recent years. He got out of his NW-registered car and strolled along the breakwater at Peel Harbour for a couple of minutes, not recognised, it would seem, by anyone, then back into his car and then was slowly driven off. Still, it is the Isle of Man where he now lives, not Albania, where past communist 'royalty' begged an audience with him.

The Gloucester Hotel was listed in one of Ward Lock's guide books dated 1923 and described itself as 'The Ancient Palace of King George III. Electric light throughout, bathrooms on each floor.' No lift, of course, but 'Hotel of the County'. Although four years later, in 1927, the hotel was to offer a warmer welcome as it had a serious fire. The upside of that was it was able to add another floor. The other big hotel on the front is the Royal Hotel, a grand-looking hotel with its large, domed towers at each end. Neither the Gloucester Hotel nor the Royal have I had the pleasure to visit and stay in. The Gloucester had converted to apartments before I had the chance to stay and the Royal, which was a second choice, was greeted by the tourist office with, 'Oh no' the young lady was saying in her rich Dorset accent, 'you don't bain't wanna stay there, it all old people who stay there,' a kind thought, but I do have one foot edging a little nearer.

The Royal in Ward Lock's Guide had one up on the Gloucester Hotel by stating that it had a motor car inspection pit. Yes indeed, an inspection pit to enable the driver to clamber underneath his car and inspect the drive shaft or perhaps tinker with the engine.

'After that first-class dinner and excellent vintage wine, my dear, I thought I would give the old girl a bit of a decoke and do some valve grinding.'

'Oh! gosh, how soon can we start?'

Not to be outdone is the Isis Boarding Establishment near the King George statue, which offers 'Separate Tables'. 'Oh we are staying at the Isis; they have separate tables, you know, so posh', and at only 2.5 guineas a week full board (£2.65), a real bargain, even in 1923, I would think.

chapter fifteen

Smoke and Fair

The jacks jumped and the rockets displayed, the bonfires burnt and none of the boys behaved.

November the fifth was bonfire night, an event for us boys to look forward to. Each week, right up to the Guy Fawkes night, we would buy a new firework each from Whites the newsagents in St Edmund Street. Such was the excitement that we drew up an inventory, adding our new purchase to this already-growing list of each new firework bought: Golden Rain, Catherine Wheel, Whizz Bangs, or Jumping Jacks, Roman Candles, and Rockets. I suppose we were a form of early nerds with the inventory culminating in a planned schedule as to the order we would allow Dad to let off the fireworks. Yes, we were very nerdish.

As with many great plans, Dad just let them off as he thought best, claiming not to be able to read the list in the dark. The best laid plans of mind and pen, gone up in smoke. So weeks of writing up the planned display and, whizz bang, it's all over. Weeks of anticipation with plans drawn and redrawn were extinguished in minutes. Any competition plans we had with Weymouth's firework annual regatta now fizzled out.

The hapless Guy would be made from an old pair of Uncle Fred's much-repaired trousers, one of Dad's old, many-times-mended shirts, which were not good enough even to made into rags, and lots of newspapers used to stuff the whole of the inner body. Although we were a bit quick off the mark with the scrunching up of the daily paper, forgetting that Dad had not it read yet. He made us undo the whole lot until the paper, with its complete sports pages, was now intact, albeit it was now in a very crumpled form. This caused some amusement with the rest of the family, although Dad failed to see the funny side, as the newspaper was now a bad hair day. It reminds me of the old joke where an old, out-of-work actor was trying to change a dubious cheque at various outlets, pubs, hotels and shops, etc. After passing this now-becoming-very-crumpled cheque to all without the success of having it cashed, he called on the last establishment, a laundry. Again, they refused to cash his crumpled cheque, with his parting words, he said to the owner: 'Would you mind and do me a favour: run your iron over this cheque before I leave?'

A bonfire would be lit in the backyard, the Guy burnt and the fireworks would be let off, although the first time we did this we both ditched our bravado and watched the scary bangs from the dungeon's kitchen window. After the small bonfire had burnt itself out, we would either go to the sands and watch the other bonfires get out of hand or were treated with a trip with Dad to Portland Fair.

Many large bonfires would be made along the sands, some very large indeed. Boys would spend days before the fifth collecting any old combustible and discarded rubbish that could be burnt, welcoming any grown up who decided to have a clear out at home and drag the old, worn-out Chesterfield sofa that had been searched for any missing coins umpteen times before that urgent visit to the pub could be made, that rickety kitchen table, made level by putting an old book under its short leg for the last twenty years, or that old mattress that the fleas had complained about Granddad on so many times, all now dragged to the sands and given the last rites. Much of the old furniture was replaced by families now modernising their home with the 'contemporary' designs of the fifties, with its five-legged coffee tables and three-legged armchairs plus other less-than-comfortable items of furniture.

There was fierce competition about the boys, and some girls, to produce the best, junk-infested pyre in Weymouth. Each effort demanded a twenty-four-hour guard or it would be dismantled by the other boys who would create even grander bonfires by turning their own bonfires into colossal edifices, or worse still, you would have all your own hard work set alight by the other boys before the fifth. Any sense of 'Health and Safety' regulations or environmental concerns were non-existent although it was always the busiest night for the fire brigade with the smoke and smell both strong enough to drift everywhere, although not a problem if the wind was blowing out to sea. When the dense and smelly, choking and polluting smoke blew into the town, some of the local residents donned their retained Second World War gas masks.

Each bonfire would have a Guy on top, and each bonfire party would try to make the best Guy, which had, in the previous weeks, been dragged around the town on or in an old pram where the boys would beg for money by asking passers-by to donate a 'penny for the Guy, mister?' This now-worn-out, poorly made Guy could only be hauled up to the top of the bonfire once it was built, making the climb over the loose and combustible pile of rubbish a precarious job, although the now totally battered state of the Guy made it difficult to be identified amongst the debris of the bonfire. None of us could equal the efforts of the best-made Guy, as this always came from the lucky children of the Punch and Judy man. They would produce a Guy Fawkes that looked like a big puppet and was so well-made that it seemed a shame to burn him. Of course, it was burnt, as

that was the whole point, to burn the effigy of Guy Fawkes, the Roman Catholic gunpowder plotter.

With half-term normally coinciding with the fifth, we would go onto the sands the next day and look for any fireworks that had not 'gone off', which meant lighting the firework with a gloved hand as there would be no 'blue touch-paper to light', just a simple quick bang in your face, a ringing in your ears and tingling of fingers that would last hours – great fun: 'Would you like to have a go, Grandma?'

Given a choice of visiting the sands' bonfires and watching the other boys' fireworks or a visit to Portland Fair, the Portland Fair always won. Dad would take us on the bus, the ubiquitous Southern National green-painted double-decker that would leave from the Town Bridge, which we caught after having quickly let off our own fireworks. Arriving at Portland Square, we would make our way to the streets of Chiswell and High Street, both of which ran along the side of the regular, stormy Chesil Beach. This part of Portland had some very derelict old houses that edged onto the pebble beach. These we tried to explore on other visits to Portland but we were always shooed off by the bronzed and gnarled old fishermen who would shout incomprehensible Portland expletives at us.

Portland Fair in the fifties featured various stalls, side shows and attractions, many of which were displayed or constructed without any concern as to what was 'politically correct' or 'safe'. A boxing-ring promoter would invite the general public to try their hand at beating the resident 'champ'. This would be a big bruiser of a fighter, bent nose, huge hands and muscles, although her husband was, by comparison, quite a small man. The public would be invited to go in and watch this mad or foolish person being clobbered and, of course, not winning the prize money. Dad told us that a member of the public would come out of the crowd and make himself a contender as part of the show, the faux contender would act as though he was a poor contender but would put on a show to make him look a worthy opponent, easily knocking out the 'champ'. This was used as bait to attract a real contender for the prize money and, of course, the 'champ' would soon remember it was a champion fighter and the challenger would soon be on the stretcher wearing a new, flat, crimson nose. We failed to persuade Dad to volunteer for this handsome prize. 'Go on, Dad, you could beat him.' His reply would always be the same: 'No, I've got a bone in my leg.' Hmm, you can't fight with a bone in your leg; we puzzled over this comment many times.

Other attractions included the bearded lady. This seemed to be just an old lady with a beard glued to her chin who sat there doing her knitting. Then there were the Siamese twins swimming in an aquarium of formaldehyde, or a sheep with five legs. The latter was a stuffed sheep with a fifth leg stuck onto its underside. There were the Dodgems (dodge

them), or bumper cars as we would call them, the big wheel, or Ferris wheel as it is correctly named, roundabouts and a helter-skelter. The Wall of Death seemed a daring, death-defying challenge that amazed us as to how the rider never fell off the wall as he whizzed around on this motorbike. Dad showed us later how this was done, by swinging a bucket of water around and around over his head to show that gravity prevented the water from dropping out, we called it the wet-shirt trick. The simple treats of candyfloss, toffee apples and a cacophony of noise mixed with the many smells from the cooking of anything and everything that was no doubt unhealthy but very tasty would add the final touch to the over lively atmosphere.

The fair was on the juvenile social circuit and a very exciting night out for us boys; in contrast with everyday life, a night at the fair was just a wide-eyed and a magical moment, a great night out. Now, of course, fairgrounds are considered a waste of money as other entertainments have overshadowed these simple pleasures. Our memories of Portland Fair are worth every penny that Dad spent.

The Portland Fair was originally a general animal fair with the usual sale of cattle, pigs and sheep but has developed and changed completely over the many years with the animals now long gone, other than the cooked or roasted kind. In its early days, the task of getting the animals over for the original purpose of the fair would have had to be carried out at low tide when an exposed sand bar assisted the animals across, as, before 1839, no bridge existed from Weymouth to the Royal Manor of Portland. Until then, movement of small goods or people was conveyed with a boat slung between two supports, and a ferryman would pull the slung boat over to the mainland and then back to the Portland side. This operation would have been very precarious, as strong winds would cause the ferry to swing violently over a rough sea and the fast running Fleet, an eerie strip of water that separates Portland and the mainland.

The eerie Fleet seems to evolve from nowhere in particular and is both described as a calm lagoon and as containing fast-running water. As a past naval port, the name to us was also a fleeting play on words, as the Fleet flows into Portland harbour where the fleet was moored. Later, as fourteen-year-olds, we would swim out to the military pontoons moored in the middle near the Wyke Regis end, sit on these pontoons for a while, then swim back to shore, or rather, we would try to swim back to shore as the water's sedate flow would often, without warning, have shifted itself up to top gear, causing us to end up some distance away from our start point, making such an occasion quite concerning and giving us an exhausted swim. This stretch of water is also famous because some of Barnes Wallace's bouncing bomb trials took place here during the war years in readiness for the Dam Busters raid.

A bridge between Weymouth and Portland was not built until 1839, reasoning that the local people of Portland had no interest in visiting Weymouth, and I understand that, up to the seventies, some older Portland people had still never been to Weymouth. 'We ban't want their funny ways all muddled up with arr funny ways,' I can imagine them saying.

Portland is a mass of land shaped like a giant comma that juts out into the channel and is formed from a block of limestone, a northerly Gibraltar without the easy access to the 'bleeding' sangria. The Romans knew it as *Vindilis* and Thomas Hardy penned a great name for Portland, 'The Isle of Slingers', as the Portlanders would throw stones at any stranger brave enough to visit, who were known to the indigenous folk as Kimberlins. Chesil Beach is one of Britain's geological wonders, and rightly so, as it curves around the coast from Portland to a point near Burton Cliff some four miles distant. Like all coastlines today, Chesil Beach has the added menace of man, litter, with much washed-up plastic discharged by ships now dominating the beach on the Portland area. Today's plastic litter has replaced tragedies of past wrecked ships that would litter the beach with many drowned sailors.

Research does not reveal any legend that the stones of Chesil Beach were put there purely for the use of the Slingers to repel the Kimberlins, although the beach would provide enough ammunition to keep out the entire world of the alien Kimberlins until the end of time. The prize of Portland is its limestone, Portland stone as it's known all over the world. It is one of the most sought-after, durable building materials and is a huge commercial asset. It has been used for the very best construction projects all over the world, possibly making Portland more of an international and commercial place than Weymouth. The buildings include, amongst many others, the United Nations Headquarters in New York and, to mention the most famous of them all, St Paul's Cathedral in London, which was constructed as part of the rebuilding after the Great Fire of London, where over 6 million tons of the stone was used.

Dad's job was at the Portland Naval Base, or the Dockyard, as it was more commonly known, now part of the site for the sailing at the 2012 Olympic Games. He was employed as a shipwright in a position that made the best use of his skills, which he had long sought, after he had worked in a range of temporary positions since moving to Weymouth. I think the original plan was that he and Uncle Dick, his brother, were going to work for Uncle Fred in his bamboo business. As Dad knew Portland from his wartime days and the many ships that were moored for work to be carried out on them. Dad would take Frank and myself to the navy days at Portland where we were able to visit the many ships and boats. On one occasion, we visited a submarine at the Navy Day. We both felt excited to be on this cramped, torpedo-firing vessel, but both of us were not sure

whether we would like to spend any amount of time in one under water. We both remember Dad telling us about the loss of HMS *Affray*, an Amphion-class submarine that was lost with all seventy-five lives, on 16 April 1951. We both thought that being trapped in a small, sealed boat deep under the water would have been a terrible way to die, with no known way of escape, knowing and understanding the awful predicament you are in, and knowing that in a while the air will have turned foul becoming impossible to breath, communications not working, just the terrible knowledge that you are slowly dying. We thought that those men must be very brave indeed to man a submarine.

Dad did have some involvement with the loss of another submarine, HMS *Sidon*. This submarine had a tragic accident whilst moored to HMS *Maidstone*, its depot ship whilst moored in Portland Harbour. On 16 June 1955, Dad told us of a loud explosion heard in the morning by all at the dockyard. He said it was so loud that they all knew that something was very wrong. HMS *Sidon* had fifty-six officers and crewmen on board this submarine and was about to test HTP (High Test Peroxide) fuelled torpedoes when one of the torpedoes exploded at about 8.30 a.m. This explosion was so powerful it blew the bow cap door open to the sea, which at the same time, killed some of *Sidon*'s crew members. Dad told us of the fire, which, with the blast, created toxic gases and smoke. Many of the men at the dockyard stopped work to watch, no doubt feeling helpless about the urgent rescue attempts being made, but the explosion was so powerful that the submarine sank about half an hour later by the bows with thirteen of her crew, now killed. Of the thirteen who died, one was the Surgeon Lieutenant C. E. Rhodes, aged twenty-seven years. He was from the depot ship and went to assist the stricken crew. He was found suffocated at the foot of the conning tower when the submarine was raised a week later.

Dad had helped with the raising of HMS *Sidon* and he showed us a small part of the equipment, now a scrap-metal item, which had been used to raise her. This was a small projectile, about 12 cm long and about 20 mm diameter, which had been used to either secure a steel hawser, or as my brother Frank thinks, to plunge an airline into the hull to feed air into the boat.

After *Sidon* was raised from the seabed, he said she remained along side HMS *Maidstone* for a day, then she was towed the next day to a causeway near to Chesil Beach and by 27 June all the bodies of those killed were recovered and later buried in the naval cemetery overlooking Portland Harbour. I remember cycling with my friend Pete after school to view the rescue operation from a hill overlooking the harbour. Dad had said that it had made a huge but sad impact on the people at the dockyard, as most personnel had worked or been involved with many of the ships and their

Part of the rescue equipment used for HMS *Sidon*.

crew. With *Sidon* now a wrecked hulk, a decision had to be made about her fate. I suppose breaking her up and reusing the steel for another ship would not have been a right and fitting end and certainly using her as target practice would never have been right either. So a useful and more memorable end was decided. *Sidon* was towed out to sea, 15 miles off Weymouth, where she was sunk and used as an ASDIC target. There she lies today at a depth of 34 metres below the surface. For the men that died, now buried at Portland, there is a memorial stone to those brave men overlooking Chesil Beach.

Portland also has a strong connection with the world of espionage with its link to the Portland Spy Ring, as the Soviet spy ring was known that penetrated the Admiralty Underwater Weapons Establishment. The AUWE in the late fifties was the subject of an MI5 and CIA investigation where spies were passing material connected with Britain's first nuclear submarine, HMS *Dreadnought* to the Soviets via its embassy in London. Much has been written about this famous case but it highlights again that the locals may wish the area remained a quiet, remote island but Portland is often drawn into world attention. This reason is why it has attracted so many visitors, including past international navies.

The size of Portland is 4.5 miles long and 1.75 miles wide, rising to over 100 metres in the north from the sea level in the south. The continuous windy bill of Portland faces into the channel, which can suffer some very powerful storms at times with many ships being wrecked. This makes Portland, like its past inhabitants, a bit of a Jekyll and Hyde place. The harbour is one of the safest in the world as well as the largest man-made harbour in Europe, whilst the other side is one of the most dangerous places to ever sail a ship. Over 1,000 ships have been lost over the centuries

with a good many of those off Portland Bill itself. The bill is known for its lighthouse warning ships and indicating the ship's position to the land, although navigation equipment today is so good that ships know exactly where they are, but knowing where you are, of course, is fine if the engines don't pack up at the height of a storm, as the engineer to his captain might enquire: 'Where are we, sir?'

Captain: 'We are precisely at Portland Bill, one of the most dangerous places to see a ship through. Anyway, what's to report?'

Engineer: 'The engine bearings have burnt out, sir.'

During Drake's battle with the Spanish Armada, he found a straggler, the *El Gran Grifón*, behind the formation tip of the Spanish fleet. With a light wind, Drake, sailing with *Revenge*, took advantage of the light wind and swooped on this slow-moving hulk and gave the ship a full broadside, then, with the ease of manoeuvrability, Drake's small ship, now with all guns ready, turned to the other side of the *El Gran Grifón* and gave it a second broadside. Amazingly, the huge hulk of the *El Gran Grifón* with now seventy cannon balls in its two sides managed to catch up with the main crescent formation of the Armada. This action took place on 3 August 1588 at Portland Bill. Although the *El Gran Grifón* fought its way around the tip of Scotland, it sank later that month in the stormy Atlantic trying to reach Spain. Recent times have witnessed that the South Coast storms can still catch the most diligent out at sea. Other than the lighthouse, the other area of interest at the bill is Pulpit Rock. As a young man, this was considered a real dare to climb but it was satisfying to reach the top of it.

One famous ship to flounder near Portland was the Earl of Abergavenny captained by John Wordsworth. His ship struck the Shambles Sand Bank off Portland and, although by evening the ship had refloated itself, it was realised that she was extensively holed and an attempt was made to beach the ship on Weymouth beach; however, so bad was the damage that a sudden lurch and she was gone, wrecked in Weymouth Bay. Although many lives were rescued, 261 were drowned including Captain Wordsworth, brother of the poet William, who is buried at All Saints church at Wyke Regis along with a mass grave of its crew joining many poor souls of past wrecks of seas and storms.

Portland is a place of charm and its charming oddities. A stunning scenery with a backdrop of treacherous sea to sail mixed with wide-eyed magical moments at the noisy and brash annual fair. A place that seeks to exclude the outside world but ends up the centre of attraction, but woe betide anyone who daubes some graffiti *Oryctolagus Cuniculus*[19] around the town, as this would cause fear and panic in the streets for the Slingers. However, with all those pebbles to throw at the Kimberlin graffiti artist the locals need no other entertainment.

chapter sixteen

Radio Fun

Spotted Dick for afters, then laughter bringing down the rafters.

The first thing Frank or I had to do on a Sunday morning, summer or winter, when dressed, was to nip over the 100 yards of Trinity Road to the Town Bridge newspaper sellers and buy a selection of newspapers for Dad, all of which were read back to front for the season's soccer news and in the summertime read with equal interest for all and any seasonal sporting events. Dad's cousin was Arthur Rowe, the Tottenham Hotspur manager, famous for his 'Push and Run' technique. Dad had played for the Spurs second team when he was younger but this was curtailed when his widowed mother sold his football boots to buy beer, which must have really upset and disappointed him, so much so that for many years he would still mention it from time to time such was his anger. I suppose if she had sold his boots for food he might have reconciled himself to it, but beer, that's probably what he could not forgive, although I think he may have had a stronger word for her actions. So sozzled did his Mum and sister, Aunt Lot, become while living in London with its smoggy nights that they would walk past their home a number of times before realising that they were back home and that was with Uncle Fred searching for them.

'Som Pee Air' always had all the family together on a Sunday for dinner, this was Dad's highlight of the week, enjoyed or endured depending on the fare Mum had cooked for us. The dinner was usually at 1 p.m., nowadays called lunchtime, and was usually the low-cost and always very obtainable roast beef. After the main dish of this sometimes grotty, grey, much-chewing-required roast beef (well I don't think it was the roast beef that was the problem; it was two finicky boys who didn't like beef at all. We did suggest to Mum that she screw the manual mincer to the dining table to help us boys digest the beef!) came the second course of 'Spotted Dick and Custard' or 'afters' as desserts or puddings were then called. 'Spotted Dick' was, I suppose, standard lunch fare for Britain, so-called and available for over 200 years. However, in later years, its name revived from traditional English cuisine for the nouveau riche bankers in red trouser braces. Our business friends, in later years, from over the Pond were both highly amused and perplexed at the name of 'Spotted Dick'. 'Is

that the right name?' they asked. 'Surely a spelling mistake, you can't be serious.' 'Yup, that's the dessert's name, okay.' 'Gimme some menus, or the guys back home will not believe me, wait til I tell em I ate a "Spotted Dick" for dinner.' Spotted Dick had to be taken off the menu in a Gloucestershire hospital, as 'guests' were too embarrassed to ask for it, so it was renamed 'Spotted Richard'. Emm, do they know what cockney is for Richard (the Third)? A bit like the excellent fish, 'Pollack'; the same daft people won't ask for it, so its name has been changed to the French name of 'Colin'. Very confusing asking for the fish should the fishmonger also have the same name.

After Sunday dinner, we would all settle down to enjoy the wireless entertainment, where the imagination of each of us would come into its own. The first programme we would listen to would be *Educating Archie*, with Archie Andrews, a blithe ventriloquist's dummy performed by Peter Brough. Only in the fifties heyday of wireless entertainment could you get away with such a bizarre concept. A ventriloquist is a clever enough person to make the dummy talk without seeing the ventriloquist's lips moving, but on the medium of wireless (as it was then known before 'radio' became the norm noun)? It's a wonder that a trapeze artist was not on the bill; just circus music is all you would hear after being told a trapeze act was now performing, and the thing would be that the listener would automatically look at the wood-veneered wireless broadcasting the music with head swaying in motion, or we would sometimes imagine two male elephants swinging around high up in the circus tent. Nevertheless, *Educating Archie* was a very popular show and listened to by millions all over the UK. So popular was Archie Andrews that he was the subject of a new concept in the 1950s, merchandising, with scarves, sweets, slippers and a 'Gottle of Gear' book on how to become a ventriloquist in ten easy lessons on throwing your voice.

It transpired that putting Peter Brough on the wireless was the only medium for him; any public performance was marred by the fact that everyone could see his lips move. It is like a person who can't sing but gets employment miming to recordings on the radio.

Many up-and-coming artists made a name for themselves by performing on this show, including Max Bygraves, Tony Hancock, Bernard Miles, Beryl Read, Harry Secombe, and the very young Julie Andrews. In 1951, Archie was kidnapped and millions followed the story in the press, all probably thinking this was a real child, until somebody sent an anonymous note stating that Archie could be found at Kings Cross station in the lost property office. Who says clever marketing is a modern conception? With Archie now 'found', the show could go on.

After *Educating Archie* came *The Billy Cotton Band Show*. This otherwise excellent band would be brought to life by Billy Cotton shouting

'Wakey! Wakey!' then kicking off with its signature tune called 'Somebody stole my gal'. As a small boy, I had heard of kidnapping and understood it was a very serious crime, so I could not understand why such a rousing song was played on the wireless and on a Sunday as well. The words went something like this, 'Somebody stole my gal, somebody came and took her away, etc.', 'Was she ever found?' we would ask; every week Billy Cotton and his band played this tune, so obviously not.

Billy Cotton's wake-up call 'Wakey! Wakey!' originated from the Sunday morning rehearsals, before the programme 'went on air' in the afternoon. Billy would arrive at the studios, no doubt in style, with the band already assembled. However, this assembled band had been playing at a venue the night before and all were in a very tired state and probably nodding off, so on arrival, Billy would then shout at the band with his now-famous 'Wakey! Wakey!' opener. The band's singer was named Alan Breeze. We said: 'I bet he was called "Windy" at school.' Alan Breeze sang silly music hall-type songs, which in the fifties was probably the taste of the pre-war generation. Even to a ten-year-old, the songs were daft if not odd, with words such as 'Get outta here with your booma de boom and don't come back no more' or 'Two little men in a flying saucer flew around world one day, didn't like the look of it and quickly flew away' or 'Open the door, Richard, open the door, Richard, open the door, Richard, and let me in' and the most ridiculous 'Oh, Oh, Oh, Oh, what a referee he went and lost his pea (etc.) and his whistle wouldn't whistle.' Frank and I were perplexed as to why one should bother about losing your 'pee'; once you have done it, are you bothered about looking for it later? It's all in the spelling, of course. These were songs that would not be out of place at playschool; still, what may be puerile rubbish to one person is possibly a rewarding, exhilarating and intellectual delight to another.

I can understand why rock and roll became so big with its aggressive sounds for the yobs of the day, 'teddy boys'. These young, rowdy males of the time did not want to fight with flick knives and bicycle chains to background music of the hit songs of the day, such as 'If I'd known you were coming I'd have baked a cake' or Rosemary Clooney's 'Where will the dimple be (etc.), on baby's cheek or baby's chin, where will the baby's dimple be'. Or worse still, two fifties' opposing gangs armed with hammers and axes as well as flick knives and bicycle chains, screaming insults to each other all to the sound of the late Lita Rosa singing 'How much is that doggy in the window, the one with the waggly tail?' Later we all jumped on the bandwagon as rock and roll grew in popularity with Mum and Dad buying a radiogram to play the new format of records, the '45' and the long-playing record known as an 'LP' with the poor old faithful Sobell radio, which gave us so much entertainment over the years now sat quiet and lifeless, although we had by now puzzled out where the mysterious town of Hilversum shown on the Sobell's dial now was.

So with the collective family entertainment enjoyed or bemusedly listened to now over for another weekend, each of us continued with the rest of the busy Sunday programme. I don't think the radio programmes were important. What was important was the whole family listening and laughing together, as all too soon we would go our separate ways. So the rest of Sunday was: Dad to have forty winks, Mum to do the washing up then have forty winks, sisters to meet boyfriends or complete some homework for school and Frank and I would be off (got rid of) to Sunday School, although Peggy also attended this Sunday School for a time. With the nonsense of 'get outta here with your booma de boom' still ringing in our ears, we would sing our first hymn of the lesson, 'All things bright and beautiful etc.'

Sunday School was at the Baptist Church, near the Alexandra Gardens Theatre. We learnt about Jesus on the cross, prayed for the missionaries in Africa, where the Christians were trying to reform the village's bone-rattling Witch Doctor whom, we were told, would dance around to the sounds of the beating of jungle drums. He seemed to us to be much more fun. We were formed into two groups of boys and two groups of girls by age, to study the Bible. We learnt in Sunday School that, as the Second World War was progressing, many more people were now attending church and this brought an end to the war more quickly by this increased church attendance. So the good guys prayed and won the war whilst the bad guys' prayers were not heard, hence the Germans, Italians and Japanese lot lost, simple.

Our Bible class teacher said to us boys that when we have to carry out our National Service duty, we should not be put off by the rest of the young men in the army hut from reading our Bible every night. He told us that the other men would be telling dirty stories, playing cards for money, talking about girls and even drinking beer, but we were to ignore them and read our Bible because, he said, 'You will feel better for it.'

National Service was scrapped before we were both old enough to put this advice to the test of distracting dirty stories, so we both pretended to be carrying out National Service and walked around with our fingers in our ears. We were given books as prizes for attendance, which we chose from the 'religious' book shop in St Mary's Street. We even went to Sunday School on Christmas Day when Christmas fell on a Sunday, although we did protest: 'Can't we miss it this time; it is Christmas after all. I bet no one else will be there.' They were and we all had a little Christmas present each as well as mince pies and Christmas cake. There were other good times for us too. We had outings in farmers' fields near Upwey station where we had sack races and prayers. We even went to the Sunday School boys' club, where we, in a craft lesson, glued our fingers together and then said prayers. I was sent home one evening because I said 'hellofa' as a comment

on how good the glue was that we were using to make a calendar each for the New Year. 'How are you getting on boys, with gluing the back cover on?' (for the calendar) 'Okay, Mr Tolly. This is hellofa good glue.' 'Edward, we don't say those bad words in a house of God.' So off home I was sent.

We had some very good Christmas parties with quite a lot to eat and drink and played some good party games. At one Christmas party, we had a visit from a part-time Sunday School teacher, a naval lieutenant on leave, who showed us a very good illusion. Two young ladies of about twenty years old stood near to this handsome, young, uniformed lieutenant (well, they would, wouldn't they?) and he asked one of them, with the long blonde hair, to hand him a strand from her hair. This she pretended to do. He then gave each young lady an end each of the strand of hair then asked them to tug the hair between them, which they further proceeded and pretended to do. With the hair now stretched between the two young ladies, the lieutenant began to rub or massage the invisible hair strand, making it appear longer and longer until both girls had slowly walked some four metres apart with both young ladies tugging very hard to pull the hair longer. We were all amazed that this lieutenant could make a single strand of hair stretch so far, which received much applause from the audience. For a Sunday School, it was a very good piece of party entertainment. In later years, it would typically have been said that this was a deceitful untruth of a trick creating false ideas, or worse a lie, and should not be used on susceptible young children. MPs of all parties would sign a motion in the house to have such deceptions banned as it would turn the children into murderous monsters that needed years of counselling. Good old fifties; only a limited amount of rubbish was allowed out.

I suppose the only real lesson learnt at Sunday School was the discipline of continuing to do something that I did not care to do, hence the book prizes for good attendance. At about twelve, I finally convinced the powers that be, Mum and Dad, that I didn't need Sunday School any more and we both stopped attending.

A year or so later, at about thirteen years old, I was in Alban Street[20], reading and laughing at the saucy seaside postcards that were displayed outside a novelty shop, which happened to be next to a shop known as 'Dirty Dicks', a shop that sold all sorts of titillating books and magazines for adults, but on that day I was with my school friend Pete only looking at these witty postcards. These light-hearted but amusing poscards were by the well-known and perhaps the greatest of postcard artists Donald McGill, who was the master of some mild offence, and by today's standards, less than tame offence. Some of his 12,000 postcard sketches were banned, and he was prosecuted for obscenity. Fortunately, he had an important writer on his side, George Orwell, who praised the jokes for sending a 'chorus of raspberries to the censors'. The fifties were, in fact, the

heyday of the seaside postcard, which had been slowly growing in levels of rudeness since the late 1800s. Two of the cards I remember reading, from this now heyday of printed depiction and mirth were: Vicar talking to one of his flock who was carrying a loaf of bread in one hand and had his other hand in his trouser pocket; the vicar says to this man, 'I see, my man, you have the staff of life in your hand,' and the parishioner replies, 'That's right, Vicar, and I've a loaf a bread in the other.' The other postcard I remember was: A motorist is lying under his car with the bonnet up and with some tools lying on the ground. A drunken man had wandered up to the car and asks the unfortunate motorist, 'What's up, mate?' The motorist replies, 'Piston Broke.' To which the drunk says, 'Same ere, mate.' This brought a big smile to my face, which suddenly dropped when I turned around after receiving a tap on the shoulder and was confronted by my old Sunday School teacher, the same teacher who took us for Bible classes. He asked me if I would like to go back to the Sunday School saying I would be very welcome there. There I was reading the saucy jokes and being confronted by a man of God. The same jokes we were told not to have anything to do with at Bible class.

What could I say with a red face that was honest? I suppose had I been looking into the other shop window in Alban Street, my red face might have turned deep purple, but Pete and I were already guilty of the naughty act of casting our innocent eyes over the wares at 'Dirty Dicks' shop. The stuff they sold would have made the once-banned book *Lady Chatterley's Lover* a light read by comparison, so I'm told. Needless to say, I gave a spluttered reply to the effect that I would not be returning to Sunday School. Did all that Godly good work hit the dust? I don't think so. The people at Sunday School were some of the nicest people I have ever known, which has helped me to judge the character of the very different people one meets in life. Had my day school teachers all been like that, I may have learnt so much more.

I couldn't help wondering if it was just a coincidence that the person who raised the alarm that saved me from drowning as a six-year-old young boy was the rounded, cuddly, female Baptist Sunday School teacher, and the person who actually saved me from drowning was related to one of the biggest names ever connected with the Baptist church.[21] They do say that God works in mysterious ways ...

St Alban Street joins into East Street and in East Street was the bookmaker's run by Mr 'Bill' Pearce who my sister Pat worked for and in working there created an illegal daily ritual at home and that was the evening knock on the dungeon door at 'Som Pee Air'. This would be a gentleman by the name of Scan. Scan the fisherman liked to bet on the horses as did his fellow Weymouth fishermen. All highly illegal, of course, and I am sure my sister would have got into trouble if caught because, up

until 1961, the only legal way of placing a bet on a horse was to open an account with a bookmaker. For the ordinary man in the street, having an account would be out of financial reach, as only a very well off person with bank accounts and who had a good financial track record would be offered a turf account.

In January 1961, the chancellor Austen Butler laid out before parliament plans to introduce high street betting shops, and heralded accompanying moral decline with it, but surprisingly the Archbishop of Canterbury welcomed the plans as this would give more control by the government to the ad hoc illegal betting arrangements that were run all over the country and in the main carried out by 'bookies' runners' and their bottom-rung sidekicks such as Scan and sister Pat. There are now over 14,000 betting shops in the UK. Back in the pre-betting-shop era of the fifties and the first year of the sixties, the bookies' runners did all the fetching and carrying of the bets to be placed, and if lucky, the winnings, if any, would be passed on to the punters.

Fisherman Scan was the local runner for this illicit gambling pastime. Around six o'clock in the evening, Scan would knock on the door and Pat would hopefully hand over the winnings and Scan would in return hand over the bets to be placed for the next day's racing. Whilst against the law, I think the police turned a blind eye to it, as they probably had better things to do, unless something turned a bit nasty, such as the 'runner' running away with the bets given and not placed or a sizeable win not passed over, all followed by a black eye, or worse would ensue. Pat did place a bet each for Frank and I on a horse named 'Never Say Die'. This horse won the Derby at Epsom in 1954 at the wonderful odds of 33-1; much ice-cream and sweets were enjoyed by the few at 'Som Pee Air'.

While working at the bookmakers, Pat was able to meet many of the entertainers who would be 'doing' a summer season at the Ritz or the Alexandra Gardens Theatres; names such as Mike and Bernie Winters, Bill Maynard, Dicky Henderson, Arthur English and the cocktail-cabinet-carrying violin-playing comedian who would not leave the theatre sober, Jimmy Edwards, whose favourite joke was: 'The band asked me if I can play the violin pizzicato. I told them I could also play it sober.'

The entertainers would earn good money for the season's entertainment, so they would not have a problem in opening an account; whether they were successful with their betting is not known. Where there's a will, there's a way. The general public will always find a way round the 'rules', which is why governments seem to acquiesce to the inevitable, 'odds on' that's democracy.

chapter seventeen

No Proper Tea

It's Christmas again and it's the end of the year, schools are closed so let's shout a three cheer.

Christmas at 'Som Pee Air' was a very exciting time for us boys. Well, all boys and girls love Christmas, even the grown ups have been known to enjoy Christmas, if only for the few days off work. The build up to Christmas was full of anticipation and promise as we anxiously willed each day to pass more quickly. Frank and I had no advent calendar to mark the days passing, so we would make our own countdown board and tick off the days as they passed, just as a prisoner would make a chalk mark in his cell. A surreptitious shopping trip to Weymouth's toy shops would reveal the type of toy or toys we would like as presents.

The best toy shop was Wallace's near the King's statue end of St Mary's Street. What a brilliant toy shop this was, a real Aladdin's cave, head to toe stacked with toys. Twisting and turning in the shop was fraught with the possibility of knocking something over, and at Christmas time, it was filled with toys for all ages. 'What do you think of the steam engine or the train set?' Dad would casually ask. 'Or perhaps you prefer the football boots?' 'I had some once,' he must have thought to himself.

School would close with a carol service, although we would sing our own Christmas carol as we walked through the playground and out of the gates, Billy Cotton's 'Let's get outta here with a booma de boom and don't come back no more.' From then on, the conversation would revolve around nothing but the coming of Christmas. 'The sooner you go to bed on Christmas Eve, the sooner Christmas will arrive,' Mum would suggest, trying hard to get us out of the way. So we would go early to bed and a sleepless, wide-awake and restless excitement would prevail with tiredness eroded for ever as two sets of eyes would focus on the large, marble fireplace in our shared bedroom hung with pillow slips draped from each end of the mantelpiece. Somehow, our vigilance would always fail; perhaps the reindeer hypnotised us as they parked on the roof, we would surmised, so yet again we missed that jolly Father Christmas delivering the presents. We reasoned that if we could meet him, we could help and advise the best choice of presents he could leave. Christmas morning would bring the

pillow slip full of small toys, books, sweets, etc., all opened at about 4.00 a.m., cap guns firing, mouth organs blown and sucked, torches flashed on and off until the battery was flat, footballs kicked around the room, and sweets and fruit eaten. Then by five o'clock we were back to sleep; that's the whole household who had listened to the interruptive fun and had now gone thankfully back to sleep.

One of the traditions on Christmas morning was for Frank and I to go with Dad to watch the Christmas swim across Weymouth harbour. Any swimming event would interest Dad, as he had been a very good swimmer in his youth and won a medal for swimming five miles along the River Thames. He also swam along the canals in North London, winning first prize on a number of occasions. Dad showed us the medal that he had won, now sadly lost, which is a shame as we do not know the name of the River Thames event. Nevertheless, five miles of swimming is a very long way; he must have been very fit in his youth.

Whilst the three of us would be off to enjoy the harbour swim, Mum and sisters would be helping with preparing Christmas Dinner. We would stand in a strategic place, shivering in the cold, Christmas morning air wrapped up in our navy-blue Swallow-brand school raincoats, scarves and school caps, and wait for the race to start. The race would normally be swum from the widest part of the harbour on the Customs Quay side to the Trinity Street harbour steps. The water and the weather from the cold wind that came off the sea would have been freezing, but large crowds would turn out to watch, not so much watching the brave swimmers, but the local hero, Godfrey Chapman. Godfrey Chapman was the first Englishman to complete the *Daily Mail* course to swim the Channel, in little over thirteen hours in 1951 and at the age of twenty-one. Frank and I once waited, with other people, outside the Conservative Club on the Esplanade, where this champion swimmer was presented with his reward honour. We and the crowd cheered and clapped him when he came to leave.

The Christmas swim of the fifties had about ten or more brave souls, who would line up, swimming-costumed, standing on the side of a moored boat, and on the given signal, all would dive in and make for the other side. Godfrey Chapman, in the meanwhile, remained on the side of the moored boat waiting and watching. The crowd was also waiting and watching in anticipation for the local hero to make his move; then suddenly, when the other swimmers were about halfway across, Godfrey would take off into the water, much to the delight of the onlookers. He would power himself through the water, overtaking the rest of the swimmers to be the easy winner. The mayor would present the prizes to the contestants, usually a cheap, plastic comb set to the runners-up, and then give the main prize of the cup to Godfrey Chapman, or Godfrey Champion as we named

him. After the swim and presentation, there would be some horseplay and some of the onlookers would welcome ending up in the water, probably a wonderful, instant reviver from last night's Christmas Eve pub crawl.

Back at home, Christmas dinner would be the once-a-year chicken, and if Uncle Fred and Gran were there as well, two chickens. We considered chicken to be very posh, forsaking the grotty old roast beef or lamb. How things have changed with chicken, now the Everyman food, and a cut of prime Aberdeen Angus beef now a special treat. After Christmas dinner was over with, Christmas pudding searched to find the silver thruppenny piece, which would be exchanged for an ordinary thruppenny bit, and the mince pies eaten, Dad would light up a Manikin cigar to add to the celebration atmosphere, then quietly disappear into another room and bring out the large presents for us. These would either be a Meccano set, a Hornby train set or the miniature steam engine or, as his eyes lit up, football boots and a ball. Whilst Father Christmas had done a reasonable job with the presents, our general view was that Mum and Dad seemed a little more generous.

After the presents, we would be shushed as the Christmas speech from the King, and later, the Queen, would be listened to by all on the wireless set. All those new toys and we had to stop playing with them and listen to the good words and good wishes from the Palace.

At 'Som Pee Air', all of this seasonal fare and fun would be enjoyed in the comfort of the 'dungeon', our below-stairs family room with easy access to the outside house-of-wind. Now, looking back, it does seem strange that we lived in a big house with rooms and views over the harbour and yet we chose to celebrate in the dungeon. The only item of outside interest that might come into view would be a dog's lonely tail going past the railings on the low-walled pavement as it returned from its unaccompanied walk. Nevertheless, I feel grateful that I had a complete family to be with and for the comforts that Mum and Dad brought to us.

One of those Christmas family get-togethers must have been about 1950. It was the Christmas custom in the Page family to have the adult presents given out during the evening, after Christmas tea. Uncle Fred was there for Christmas, as was our Gran, Granny Willatt. Mum and Dad said that the presents would be given out at 6.30 p.m. Two of those presents had been made by myself and Frank for Uncle Fred and our Gran. As we reached the allotted hour, Uncle Fred mumbled something about his van needing moving. 'Som Pee Air' had no parking area as all houses were on the main road and parking on the road with your lights switched on would ensure the consequent flat battery, so the car would be parked in a selected place off the road. Anyway, Uncle Fred had seemingly disappeared from the house at about 6.30 p.m., and a short while later, Mum or Dad started to give out the presents, which had been placed around the old and confused twisted mess of our vintage, thirties Christmas tree. We

were alarmed at this because Uncle Fred was not there and would miss the fun but, just as we got started with the presents, a 'knock knock' was heard and in through the door came Father Christmas. The hearth fire was burning, which we both reasoned made a chimney entrance difficult, so FC must have come down a chimney in another room, we surmised; but there he was, red cloak and hood, black boots, and a long, white beard, singing Yo Ho Ho Yo Ho Ho tunes and saying 'Merry Christmas'. We, of course, stood there agog.

'It's Father Christmas!' Frank and I exclaimed with now wider eyes. 'Uncle Fred will miss Father Christmas. Can't you ask Father Christmas to wait until Uncle Fred returns?' we pleaded in vain with Mum and Dad. 'Can't we make him a cup of tea whilst we all wait?'

'Sorry. If Uncle Fred is not back, Father Christmas will give the presents out without him. He's got a job to do.'

Anyway, Father Christmas gave presents to Mum, Dad, Pat, Peggy and then Gran, leaving us two boys until last. But before we had received our presents, Gran opened her present and said to Father Christmas with those immortal and forever-belief-changing words, 'Thanks, Fred.'

Uncle Fred's sense of humour was for all things silly, absurd or just ridiculous, which was mostly created from puns or clever wordplay. One Christmas we had the 'Best Christmas Crackers in the World', or so Mum told us, made by some dodgy character named Tom Smith. Well, certainly this box was the best if only for its uniqueness. After all the crackers were collectively pulled, the quiet reading of the mottos to ourselves began, then we were to go around the table with each reading their motto's question to the rest of the family for them to guess the answer, which on this occasion was greeted with a unanimous voice from all at the table with the answer to the question, 'He has no proper tea', which startled the reader of this motto, I think it was Pat, who had no prior knowledge of the wording of the others' mottos. The question, of course, was 'Why does a poor man drink coffee?' This motto was somehow repeated throughout the whole box, all the same motto and green hat. We all sat at the dinner table with the same hat and same motto, all looking like a small army of gnomes chuckling child-like over property and proper tea and asking Mum why we didn't have a 'proper tree' with our proper dinner.

One other Christmas, when Uncle Fred was not spending Christmas with us, he left some presents earlier under the tree. This was an imitation tree that Mum had bought in 1934, which was much used over many times, also, as we suspected, held aloft during the wartime blitz, as it always looked like it had been in a fight with a dozen cats. These presents left to us from Uncle Fred had to sit there and were only, of course, to be unwrapped on Christmas Day. Frank and I, as curious boys, looked at, lifted, felt, shook, passed back and forth, read and reread the labels on

these presents trying to guess the contents for the recipient, this constant analysis of the present's condition soon making them a sympathetic partner for the tree's equally dilapidated condition.

One present made us more and more curious as the days to Christmas passed. It was addressed to our cat, Mickey, a tabby cat who was unusual in that he would only drink tap water and not expensive milk. Well done, Mum, you trained him very well. In fact, during the early part of the last war, giving milk to a cat was a fineable offence, so Tiddles, it's water, like it or lump it. Many cats and dogs were put down because of this law. Well, this present was heavy and had a note addressed to Mickey the cat that read: 'To Mickey, Happy Christmas, something to keep you warm during the winter months, from Uncle Fred.' We were intrigued as to what would keep a cat warm. We imagined it to be a warm cat coat, a bit like a dog coat only much heavier, in fact, by the weight of the parcel, very much heavier. Christmas Day came, presents were opened, and we got to open the cat's present; well, cat's have a very take it or leave it attitude to Christmas presents and are not practised in the art of untying string, so we opened the present on the cat's behalf and inside was the object of feline warmth, a log of wood. No doubt it got burnt, no doubt the cat got warm sitting by the fire, but no new overcoat. Uncle Fred was not wrong in his description, but amusingly right to let us all enjoy his quirky sense of humour.

Whilst we were grateful for all those jolly Christmases, we could have made it a more festive occasion by using the posh upper reception rooms. We seemed to have the money to do so but the dungeon's location was always the dull, although homely place for our once-a-year festive celebrations. As a family, we were lucky. Many people were still suffering the effects of the destructive bomb damage from the Second World War which had caused a shortage of housing with food rationing thrown in for good measure. For many families, it was not the time to become confident life was back to normality. I still remember, as a five- or six-year-old, going with Peggy to Weymouth railway station's goods yard with my brother's old, big-wheeled Silver Cross pram to buy coal. We must really have looked like a pair of Victorian waifs gleaning the leftovers. We weren't alone though. Everyone, whether they were rich or poor, were all in the same boat, with the chauffeur loading coal into the Rolls-Royce from the same railway yard.

Coal was certainly needed badly during one of Britain's worst winters, which started in February 1947. This left us with a level of deprivation unknown even during the war. Coal trains were unable to battle their way through twenty-foot snowdrifts, making power cuts with millions of workers idle, recording the Siberian-like lowest temperatures in parts of Buckinghamshire of -21 °C. In Dorset, the army was called out to use its flame throwers to clear the snowdrifts and German POWs struggled in vain to help clear the snow. The great north road, one of Britain's main north to south arteries

Harvesting potatoes in winter, 1947.

had 22 miles of ten-foot-high snowdrifts. This caused severe shortages of food, even more severe than wartime. The police had to break open stranded lorries to gain food, which was somehow distributed to prevent starvation. Farms were completely snowed under with the ground frozen so hard that road drills were called in to dig the vegetables, although 70,000 tons of potatoes were destroyed by the cold. At the same time, parts of southern England had a freak ice storm, phone and electricity poles snapped and trees collapsed with the roads now turned into ice rinks. What seemed worse was the effect on public morale as television was closed down, radio programmes reduced and newspapers and magazines were ordered to stop publishing. Then the much sought-after thaw began. With so much fast-melting snow, a horrendous flood was triggered. Hmm, back to church, our Sunday School teachers might have urged us all; this adverse plague of weather needs some clearing up from Him above, might have been the optimistic sermon.

London had a thousand people queuing, hoping to buy potatoes. By the time most of the freezing customers had crawled to the front, they would have been too numb to both ask for the goods, then carry them home; most could only think of a stiff drink to warm even stiffer bodies. The shortages were getting worse and were now worryingly acute. The winter of 1947 was considered to be the turning point in which Great Britain started its decline from a super power, beginning its rise in 1850 – almost a hundred years of rise and then fall. We could not feed ourselves, let alone fulfil the responsibilities we had for the millions left in war-torn,

shattered Germany, with the winter there more severe with its people living in conditions now worse than the Stone Age.

After the severe weather, food did begin to get through, including such treats as bananas, which had not been seen since the start of the war and were just a memory. When they did return, they were a much-sought-after prize, although a lack of bananas did have its tragic event. Three-year-old Dorothy Shippy from Yorkshire was given four bananas, which caused her to sadly die within a few hours. The same effect happened as troops liberated the prisoners held in German concentration camps. The prisoners' diet had been very plain and in most cases consisted of scrounged or stolen, discarded morsels, so when given a richer diet, their bodies were unable to digest the better food, so they died. From Dad's brother, Uncle Bill, in Canada, we would receive very welcome food parcels. These would consist of all the fruits of a wealthy nation, which had not been subjected to the shortages of wartime interruptions that Great Britain had acutely experienced. Tins of fruit, of pears, peaches, grapefruit, bars of Canadian chocolate, tins of salmon, tea, coffee, biscuits and much more, and all from a thankful Canadian source. By the national standards of shortages in the forties and fifties, our family were indeed very fortunate, although perhaps we didn't recognise this at the time.

chapter eighteen

Farewell 'Som Pee Air'; Our Time's Up

Farewell our 'Som Pee Air'. It's time to go, our sad good-byes will justly show.

As summertime changed into winter, Weymouth Sands changed to be a very contrasting landscape. Summertime, of course, changed the sands into one of the busiest and most crowded places in Dorset, and maybe busier than any other seaside resort in high summer for its size, with it being standing room only on some days when the tide was in. In winter, the sands were a wind-swept no man's land, devoid of anybody other than one or two dog owners walking the hard beach surface made vacant by the receding tide. During late autumn, winter and early springtime, the shelters dotted along the Esplanade, small constructions of draughty cast-iron works of art, would be more or less empty except for the lonely person contemplating life's everything and nothingness. Ladies of a certain nature offering a 'gentlemen's service' would sit and await passing sailors as they came off the ships. Courting couples would kiss and cuddle until the cold sea breeze curtailed passion. Only the single person or couples of a permanent or fleeting attachment would notice the dark evening. Then a cold front would come home to roost and Weymouth became a different place to the one inhabited by the multitudes of summer visitors. The transition of the holidaymakers returning home turned the sands from feast to famine and would be most acutely noticed by local residents enjoying the deserted, if now-cool respite. Whilst the dog walkers were the isolated few, one other more recognisable person on the now-abandoned sands was the lonely beachcomber.

I remember this isolated character to be an elderly, tall man who shuffled about looking at and kicking the barren sand with his string-laced, old, black boots. He wore an oversized, black, faded overcoat with its single button holding the coat together around him to keep out the cold wind. He also had an untidy, becoming, threadbare, grey-streaked beard, which matched his sad grey eyes. Mum told me that he was kicking at the sand to find money that the holidaymakers may have lost in the now-cold sand. The winter inshore breeze would now be gently loosening off the top layers of sand to reveal any objects left by the visitors that may have a

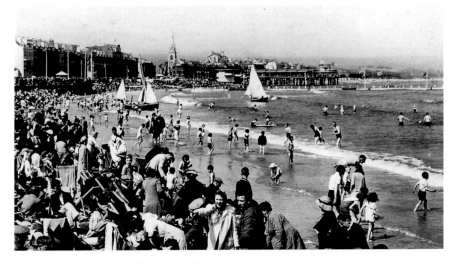

Standing room only on Weymouth Sands.

worth underneath; certainly there were many worthless objects, such as an empty sardine tin or a discarded bottle top to be kicked aside, but as for money, well, who knows what he found. All this drifting, wind-blown sand would be redistributed in the springtime as the bulldozer pushed the sand back into a level pitch ready for the next season's hordes of summertime holidaymakers.

As a small boy, I would watch the bulldozer on those early spring days as it rumbled back and forth and sometimes I wondered about all those lost and left behind coins, never to be seen again by the holiday visitors, coins we failed to find with our ingenious sieve tennis racquets. I imagined myself with a magic wand commanding all those coins, lost over many years, perhaps even those past Victorian lost coins to rise and land in a designated place, just to see how big the pile of the many coins would be. Perhaps the beachcomber had the same imagination too, as his tummy started to rumble with hunger as the rusty bottle-top finds grew, as the silver coins shied away. He seemed a sad figure who was permanently down on his luck and seemed to be nursing a deep sorrow. Once I caught his eyes, and he seemed to be pleading with me for something, whatever it was, I could only look back wide-eyed at him as I held Mum's hand tighter.

The empty sands, the heart of the holiday at Weymouth, now signalled the end of the season. The shutters are put up and hibernation begins; the party's over.

This affected both my brother and I, as with that emptiness, our many good times at 'Som Pee Air' came to an end. Soon it was time to leave dear old 'Som Pee Air', the first home Frank and I had really known. We

accepted the move easily, as young children do, as many things would not change. Mum and Dad would still be with us, we would have the same school and everywhere else would still be the same: the shops, the sea, the town and our friends would still be there. We had our own bikes, so we could go anywhere at anytime, within reason, of course. It was Mum's decision to move to suburbia, as 'Som Pee Air' involved much too much housework. Well, yes, it was a big house, as in the winter months most rooms were empty and unused, with many items of furniture now covered over with white sheets, all seemingly abandoned. My two sisters had flown the nest. Pat had married Dennis and Peggy had joined the Wrens to see the world.

'Som Pee Air' was sold in 1955, ten years after moving in, and after ten years of lots of very hard work carried out by Mum and Dad. Also departing with us in 1955 was our friend the PS *Empress*, we to pastures new and *Empress* for its last rites. The building itself was Dad's baby and the money earned from the guesthouse was Mum's, and that's where the real reason probably lay. Now that her daughters had left home, perhaps Mum didn't want to go through another year of cooking, cleaning and being on hand all summer.

After advertising the guesthouse with an estate agent as a going concern, 'Som Pee Air' was bought by a woman who was to live there with her female friend. The senior of the two was also the dental nurse at the school clinic in Westham Road, so Frank and I knew her from our visits for treatment. Most of the school children had to use this clinic if you had to have a tooth filled or extracted. So not only was she the cause of our sore gums she was now going to take away our home.

The person who felt more of a loss in leaving, I felt, was Dad. He had put such a lot of work into that house but more than that this had been the real home he probably yearned for. His father had died when he was thirteen years old in 1920. Money was very, very tight for his widowed mother, and although the economy was in reasonable order, some responsibility would always be with him for his mother, as his older brother had left England for Canada. Upping sticks and clearing off was not Dad's plan, so for Dad, leaving his mother was not a real option. The economy in the thirties was very difficult, as in June 1930 the Dow Jones index plunged 18 per cent after the crash of 1929, with the major economies entering a depression right through until 1954. Dad had married and, now with two daughters, had his mind and commitments mapped out, although, as a family, they seemed reasonably well off in the thirties, in spite of the Depression period.

Now, adding to the economic woes of the whole country, the threat of war was looming and with the outbreak of war, the hardships, although mostly the hardships were of working away from home, made life even

more difficult. During this time, two more mouths arrived, in the shape of my brother and myself, to be fed, so moving to Weymouth and building a home with a very complete family at 'Som Pee Air' was a dream come true for my father.

However, it was time for us to leave and this involved, like everything before, much hard work. Although the new people who bought 'Som Pee Air' were also going to run it as a guesthouse, the furniture we had was not to go to them. A house sale was organised and I remember the quiet, sad resignation Dad took to all of this, all his handiwork now being carted off to somewhere else, never to be seen again. I think Dad did feel the loss of leaving the most, as he had put such a lot of hard work into the house. The life blood was now slowly leaving the house, becoming emptier room by room, each level, top to bottom, its body slowly drained until the front door would bleed its last table and chair. The visitors' beds, the chests of drawers, now the wardrobes, then the bed linen were all gone. Don't forget the hall tables with all those dining chairs and the oak dining tables. Finally, the three-piece suite, the piano, and all the ornaments. The big brass jug with the embossed picture of men drinking ale in a tavern, which Frank and I would raise each time we walked past it and shout 'cheers'. All those plates, cups, and knives, forks and spoons, all used by many visitors over the years; all gone.

What was left? Our memories of the place where we spent our formative years remained. To Frank and I, living at 'Som Pee Air', or to mock its name no longer and spell its rightful, good name properly as *St Pierre*, was the most memorable time we can both remember of our formative years. As children, our time there seemed to last forever. Weymouth was a brilliant and interesting town to grow up in, a place we felt safe in (once we made our peace with the harbour, that is), and above all, we had a warm and loving home, even if our idea of warm home was to nearly burn it down.

Epilogue

So, forward to 2001: I dragged my dear wife from our home in Berkshire – she wasn't screaming and shouting, rather saying, 'if you must' – into a visit to Weymouth in order that I could examine the records of the *Dorset Daily Echo* held at the library, to research for information about the day that I nearly drowned. I was told the location for the public library was easy to find as it was built on the old site of St Mary's Infants School. The irony is that it was the site of the old school I walked home alone from on 12 October 1948. Sitting at the microfiche machine that held the past copies of the *Dorset Daily Echo,* we expected to be there for some time, as I was not sure which year the incident happened. So I decided to begin with 1948. I knew it was the conker season, so it must be late September or October. After a short ten minutes, I was surprised to find how very quickly this long-dormant and waiting item was found. It seemed to just pop up on the front page of the local news. The *Dorset Daily Echo* had, at the time, two front pages, the front folded left to right was for the national and international news and the back page cover was the front page for local news. Finding the item, I stared at the copy with a mixture of joy to have found the incident, but a quiet reflection on the fact that, all this time, the newspaper confirmed the very real existence of this mishap all those years ago, and there, at last, was printed my rescuer's name, the ship he was from and his rank. This item now staring at me in this newspaper dated 12 October 1948 read:

MIDSHIPMAN RESCUES BOY AT WEYMOUTH

Edward Page, aged six, of 19 Trinity Road, Weymouth, was rescued from drowning in Weymouth Harbour last evening by Midshipman Spurgeon, Royal Australian Navy, serving on HMS *Glasgow*. The boy was playing on the Trinity Road side of the harbour when he slipped in. Midshipman Spurgeon, who was with a friend, noticed the boy's plight and immediately dived in fully clothed and rescued him. After a hot bath and drink the boy was put to bed little the worse for his ducking. Mrs Moggridge, 12 Trinity Road, provided the midshipman with a warm drink and a change of clothes. When he returned later in the evening to inquire about the boy's condition, Mrs Page warmly thanked the rescuer, who declined to give his name.

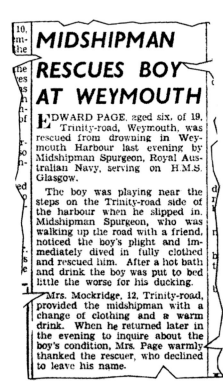

MIDSHIPMAN RESCUES BOY AT WEYMOUTH

EDWARD PAGE, aged six, of 19, Trinity-road, Weymouth, was rescued from drowning in Weymouth Harbour last evening by Midshipman Spurgeon, Royal Australian Navy, serving on H.M.S. Glasgow.

The boy was playing near the steps on the Trinity-road side of the harbour when he slipped in. Midshipman Spurgeon, who was walking up the road with a friend, noticed the boy's plight and immediately dived in fully clothed and rescued him. After a hot bath and drink the boy was put to bed little the worse for his ducking.

Mrs. Mockridge, 12, Trinity-road, provided the midshipman with a change of clothing and a warm drink. When he returned later in the evening to inquire about the boy's condition, Mrs. Page warmly thanked the rescuer, who declined to leave his name.

Above: Press cutting of Commander CHC Spurgeon, RAN.

Left: Echo newspaper cutting. (Courtesy *Dorset Daily Echo*)

Any incident is a collision of events. If one party had not been at a certain point then the other party would not have suffered or enjoyed the unplanned union: a car crash or boy meets girl. What were the two separate parties involved with an hour or two hours before the event and so on. Animals only understand the 'now', whereas humans have two dimensions, knowing the past and understanding the present but aware that a future exists, but are unknowing of what the future holds. Neither party has any idea what will befall them in the next period of time; that collision of critical events had unfolded in 1948 and I would learn how.

From the short but quite informative newspaper item, I learnt that a Southampton-class cruiser, the 9,100-ton HMS *Glasgow*, recommissioned after a refit in September 1948, had arrived and anchored in Portland Harbour. Its crew were going on shore leave, no doubt looking forward to the out-of-season delights of Weymouth town; only the pubs, cinema or the odd chip shop would be open for entertainment; even Mr Hayward's sandcastle display would not be available for returning sailors to throw their empty beer bottles at. The sight of a pretty girl would give some consolation, but this was October and Weymouth had hung up its closed sign. I learnt afterwards that HMS *Glasgow*'s destination after leaving Portland was to sail to Bermuda. This, of course, must have been a great

disappointment, for the crew to leave Weymouth so soon, but, no doubt, some compensation was found in Bermuda on their arrival: no cold, dark nights to enjoy, just round after round of trying to cope and contend with just never-ending warm sun, swimming and beach parties.

Amongst the groups of sailors going on leave was a young Royal Australian Navy officer, Midshipman Spurgeon, who, for some reason, happened to be in Trinity Road. I assume he was taking the bus to Weymouth and alighted before reaching the town. But there he was, passing by 'my area of concern'. He must have seen that none of the locals were going to jump in and make a rescue, so Midshipman Spurgeon, who I was later told by my Dad could not swim, without thought or hesitation for his own safety, took to the water and made the rescue, showing the reluctant onlookers what the Royal Navy, or as I now know, what the Royal Australian Navy could do.

Having now found this informative newspaper item, I began to wonder where I could find my rescuer so I could thank him. After fifty-eight years, it's a bit of a long time ago; he could have died or, as I now knew, was an Australian citizen and had probably returned home to the other side of the world. After a number of dead ends, the search went onto the back burner. The small Berkshire village in which we live had its telephone system upgraded to receive Broadband, instead of the usual Tom Toms on the roof job; this now allowed longer and more access searching various records online. After some interesting false starts, I came across an organisation called HMS *Glasgow* Association, although not having an e-mail address, it allowed me to write to them. After a wait of about ten days from sending the letter, I had a call from the secretary, Mr Allen Mercer, who said that Midshipman Spurgeon was very much alive and that he would pass my letter to him. I was quite stunned by this simple phone call. I had been to and fro with my search and here I was, out of the wilderness and being pointed in the right direction by a simple phone call. Mr Mercer informed me that the incident would have been entered in the ship's log. Imagine! My name had been entered in the log of this famous battle cruiser. This was the ship that brought the King of Norway and the Crown Prince to safety to England just as the Nazis were to invade Norway in the Second World War; this was the ship launched by Mrs Stanley Baldwin, wife of the Prime Minister on 20 June 1936; and this was the ship that escorted King George VI to Canada in 1939. This was the ship that was involved in the largely forgotten 'Operation Fork', the sequestration of Iceland in May 1940. After the Nazi invasions of Denmark and Norway, the British, rightly so, very much feared this strategically placed island would threaten the Atlantic convoy routes. So, with over 700 raw, seasick troops, HMS *Glasgow*, accompanied by cruiser *Berwick* and two destroyers, secured the 'neutral' island of Iceland for the Allies in spite of diplomatic protests.

Further, this was the ship that took part and was damaged in the D-Day landings. Of further interest to me was that ships of the Royal Navy were 'adopted' during wartime by a city or town as part of the National Savings Campaign 'Warship Week'; HMS *Glasgow* was adopted by the county of Lanarkshire in May 1942, my month and year of birth. I also learnt that my saviour was now a Commander, no longer a 'snotty', as midshipmen are called, due to the habit they had of wiping their running noses on their uniform sleeves. This was prevented by many rows of buttons sewed to their sleeves. This once-humble midshipman had risen to be now ex-Commander C. H. C. (Christopher Haddon Corbett) Spurgeon, RAN. I was informed that the HMS *Glasgow* Association had records of all its past HMS *Glasgow* ex-shipmates. Good for them, I thought.

Making contact with someone who may have been keelhauled, cast in irons, reduced to seaman 4th class on permanent jankers with orders to scrub the ship from top to bottom each week with a toothbrush, just because he got his No.1 uniform so wet may not be the best thing to do, but wanting to say 'thank you' seemed to override that. As a child, I always thought of him as a grizzly old sea dog sailing the seven seas. I waited with mixed anticipation as my letter crossed to the other side of the world and passed to the retired ex-commander in Australia. Did I expect a reply after fifty-eight years? After all, he must be at least 90! I was not sure, then one day, glancing at and deleting all the usual junk mail from my computer, my finger hovered over the 'delete' button long enough to realise that this was not junk, it was from down under. I sat there, staring at it, reading it over two or three times to take in the contents. It was, of course, from an ex-midshipman. Was I pleased? To put it mildly, I was thrilled to bits with his reply, but also taken aback at the comments he made.

He remembered the incident well. I learnt he was eighteen years old at the time, just twelve years older than myself and probably, like me, perhaps not shaving yet. However, the most telling points that hit me in his e-mail were twofold. Firstly, and in his words, 'I seemed to remember, you had gone deep under the water.' Those words brought it home to me how close it had been. Secondly, he wrote that, just prior to the incident, he had spent time at the Australian Naval College as part of his training, in which he had to qualify in life saving. This entailed rescuing people in the water whilst being fully dressed and pumping out water from them after rescue. I started to get a lump in my throat and tears started to well up as I realised that he was probably the only person, of all the many people standing there, who could dive, swim, plunge under water, search and locate, then retrieve and pump out water from the casualty. He was, without doubt, the best person imaginable to happen by at that critical moment. Did I feel lucky and grateful? Very. Much more so than I could have imagined. But why did the many local people looking on allow me to stay slowly sinking in the water for that long?

Did he get into trouble when back on board? No, he was wearing civilian clothes at the time. He was lent some dry clothes by Mrs Moggridge at No. 12 Trinity Road, then returned to HMS *Glasgow*; well, no one would like to see a young midshipman, even an Australian, walking around Weymouth in elderly ladies' clothes; it would be unheard of, sailors dressing up as women? However, he was encouraged to change clothes and go back on leave with his mates, which he did. He later called on my parents on his way back to the ship to see if I was okay, still not leaving his name. Fortunately, the local newspaper succeeded with the details, including the single most important part, his name.

I replied to his e-mail, giving an overview of my life, family, career, view on life, how lucky I have been for most of my life. I wrote that I respected his privacy but that I would like to hear from him again and finally, wording that long overdue emotion of gratitude for his wet and, most importantly, his willing and skilful day in Weymouth harbour and saying thank you for saving my life.

Later I wrote and thanked Mr Allen Mercer of the HMS *Glasgow* Association for their help in making contact with the now -retired ex-Commander Spurgeon and made a donation to their funds. He, in turn, thanked me for the donation, and in his letter, he wrote to say that he enjoyed his watch-keeping duties with Midshipman C. H. C. Sturgeon (although a slip of his typewriter reads 'madshipman' instead of midshipman, perhaps one needs a touch of that quality to do what others are afraid of, in other words, to be brave) and having a good time talking about their jobs on board HMS *Glasgow*. He also wrote to say that HMS *Glasgow* sailed for Bermuda to relieve HMS *Sheffield* and that they were on that station for two years, finally saying that the past and current 'event' would be entered in the HMS *Glasgow* Association annual information letter.

Finally, did I have a fear of water after that episode? No, not a bit; I love the sea and still enjoy swimming. I think with much fondness on my childhood living in Weymouth where the summertime seemed to last forever and thanks to a young man at the start of his full and rewarding naval career, Midshipman Haddon Spurgeon, saving me at the start of my full and rewarding life, I am able to write this story. (Midshipman Haddon Spurgeon, although an Australian who was visiting Weymouth that day in 1948, was actually born in Weymouth.)

With all this information, I still knew very little of ex-Commander Christopher Haddon Corbett Spurgeon, RAN.

I have added the research I had made about the commander and his family and the interesting family connection he has to the most famous of Baptist ministers, Haddon Spurgeon.

Research and History of the Spurgeon Family

Research and history for Commander Spurgeon came from the National Library and the naval museum of Australia as well as various search engines.

(I have placed an asterisk against my rescuing *commander, as there are a confusing number of other commanders in this epilogue). So, only knowing that he was living in Canberra near to the famous war memorial, I, with some curiosity, investigated, via the Google search engine, the name of Spurgeon and discovered it is dominated by a very famous Baptist minister, Charles Haddon Spurgeon, who would, in the 1850s, preach to a 10,000-plus congregations. Reading the many items, I can understand why so much has been written about this famous minister. Apart from having the same surname as this preacher, the *commander has the same middle and unusual Christian name of Haddon as the minister. There is a confirmed family link to this famous Baptist preacher and the name of Haddon has also been given to his uncle, Air Commodore C. Haddon 'Spud' Spurgeon, who was the Task Force Commander and commander of the RAAF contingent in Vietnam. Charles Haddon Spurgeon, the Reformed Baptist preacher, who died in 1892, was arguably the most prolific author of material, Christian or otherwise, having more material in print than any other author. The Spurgeon name is from a long naval dynasty as there is a connection with both the Australian and Airforce services RAN and RAAF stretching back to the Royal Navy, with the Spurgeons, stretching back to the 1890s, having father and sons joining the military. There also seems to be a tradition of nicknaming the Spurgeons with the name of 'Spud', no doubt emanating from the USA baseball player Spurgeon 'Spud' Chandler.

Charles Herbert Spurgeon, born 1874, was the *commander's grandfather and was in the Royal Navy as a writer. This important role of a writer has the responsibility for the administration and accounting for the smooth running of every ship. Charles Haddon Spurgeon transferred to the Royal Australian Navy in 1910, RAN, and such was his skilled management of administration that he became secretary to the 'first naval member', equivalent to our UK First Sea Lord, for many years. He also rose to the rank of commander. The offspring of Charles Herbert Spurgeon were no less important. Commander Stanley Herbert King Spurgeon, born 1902, was the *commander's father. He had a very busy time during the Second World War. Commander S. H. K. Spurgeon had the honour of being the first Australian to be awarded the first award for gallantry in that war. Whilst in command of HMS *Echo*, he picked up the survivors of a merchant ship, *Pensilva*, which was torpedoed by the German U-boat U-49. He was also involved with the cover of the Narvik

evacuation, which took place in 1940 in HMS *Hero*, and was awarded the DSO for good service in action against enemy submarines with his ship HMAS *Stewart*. In 1954, he was awarded the OBE. Another important position he held was as Naval Attaché to Washington with the rank of captain. Before the war, during the thirties, the *commander's father, S. H. K. Spurgeon, was stationed at Portland, England, at the anti-submarine school, HMS *Osprey*. During this period, on 7 November 1930, his son, the now ex- *Commander C. H. C. Spurgeon was born in Weymouth, Dorset. The *commander's father, S. H. K. Spurgeon also seems to be known as 'Spuddie' and the *commander's mother, Patti Anglia Wilson, married 'Spuddie', who she met in 1924 when he was a first lieutenant.

With many postings around the world, the family, with the now-young Haddon Spurgeon (the future *commander), were stationed in Scotland, living in the Scottish village of Clynder, on the shores of Gareloch, which adjoins the Clyde River where mother and son enjoyed fishing from the jetty. The interest in fishing gave Patti Spurgeon a welcome distraction away from the war where her husband was also fishing, he for enemy submarines in the Western Approaches of the North Atlantic. Fishing developed into a major interest for Patti Spurgeon and she became a well-known big game angler. By 1947, Patti and husband 'Spuddie' were stationed in the USA where Patti's interest and skilled fishing was put to good use when exposed to the big game fishing there. With the couple socialising in the Washington diplomatic circles, Patti was able to make many friends including the US navy unit that operates the Presidential small craft from Annapolis, Maryland. This enabled her to go Shad fishing on the Pontiac River in the US Presidential boats. On returning to Australia, Patti Spurgeon became a member of the Sydney Game Fishing Club, but it was in New Zealand that she caught the heaviest 'Striped Marlin of Season' for she was once again awarded the appropriate trophy for this prize fish.

The *commander has two uncles, his father's two brothers A. H. Spurgeon was awarded the OBE (Military) for good services with the Somaliland force. He was commander of HMAS *Manoora*, an armed merchant cruiser. He died in 1942. The other uncle was Air Cdre Clarence Haddon 'Spud' Spurgeon, CBE awarded for distinguished service in Malaya and Vietnam, but who also became the victim of being a prisoner of war to the Japanese for most of the duration of the Second World War, which is a fascinating tale in its own right. He was shot down over Kuantan, captured and made a prisoner of the Japanese, where conditions in the camps were very bad with a lack of good food coupled with disease, illnesses and a lack of medication. Cruelty and harsh discipline was the norm but good comradeship was there to help endure those harsh and difficult times until repatriated at war's end, having been held in no less than seven prisoner of war camps. Some ordeal that must have been; harshly difficult with much

suffering. Then he was involved in the Malayan Emergency from 1948 until 1960.

This is some family and any offspring wishing to have a military career has got a lot living up to do, that's apart from having a mother as the top 'Fisherman.' The *Commander C. H. C. Spurgeon has done just that, and it must be assumed that the genes of his past ancestor Charles Haddon Spurgeon, the Baptist minister, as with all the past Spurgeon family have been passed down; they have all inherited that commanding voice of authority, giving them a natural gift of command. Bearing in mind that this famous Baptist preacher could address 10,000 people at a time in the nineteenth century and all without the benefit of a public-address system, he must have been some speaker, albeit rather hoarse afterwards, I would think.

As well as serving on RAN ships, *Commander Spurgeon has competed in six of the Sydney to Hobert yacht races. At naval college, he won colours in rowing and rugby following in the footsteps of his father who also won colours in rowing and rugby, as well as cricket. Joining the navy in 1944, then aged fourteen, as he was born in 1930, he went to Flinders Naval Collage for three years. This was the naval college where he passed his test for that all-important qualification of saving a drowning man or small boys in the water. Then sent to England as a Midshipman or 'Snotty'. In England, he was assigned to HMS *Glasgow* where, of course, we met in difficult, wet conditions, which, due to the circumstances, did not allow us to be formally introduced to each other.

His first Australian appointment was to the defence ship HMAS *Koala*, as a first lieutenant. Not content with the rolling sea, *Commander Spurgeon took to the air, commencing pilot training at the RAAF base Archerfield Brisbane. After finishing training at Point Cook, he joined HMAS *Melbourne* flying Gannet aircraft. Another odd coincidence was that I remember making a balsa-wood model of this type of naval aircraft, as a boy, about the same time. Further promotion was to be divisional officer in charge of cadet midshipmen at the college HMAS *Cerberus* in 1957 and at Jervis Bay in 1958. At about this time, he married his wife Denise Elizabeth Lyons.

Jervis Bay is named after a bay in Australia, but is better known for the name of an Aberdeen and Commonwealth liner converted to an armed cruiser in 1940. On 6 November 1940, this lightly armed, converted liner was hopelessly outgunned by the German pocket battleship *Admiral Scheer*. The *Jervis Bay* ordered the convoy it was escorting to scatter and then went into the attack only to be quickly sunk with loss of the 190 crew, although sixty-five were rescued. This action by the captain of the *Jervis Bay* gave enough time for the majority of the convoy to scatter, thus saving lives and valuable cargos. The captain, Captain Fagan, was awarded a posthumous VC for his brave and valiant actions.

In 1960, *Commander Spurgeon joined the Q-class frigate HMAS *Quickmatch,* commanding her for six months before she was decommissioned. A move to the UK was necessitated by a transfer to the Joint Services Staff College and for further training, then onto the staff of the Director of Officer Appointments. Returning to Australia, the *Commander was back at *Jervis Bay* Naval College as Senior Training Officer, which is now affiliated to NSW University. Further promotion came with appointment as executive officer of HMAS *Duchess*; he had to fly to Asia to join his new ship. More experience was gained at being made first lieutenant to the shore-based HMAS *Cerberus* at Westerpoint. Then he was appointed to HMAS *Melbourne*, and, following his tour of duty on HMAS *Melbourne,* he was promoted to commander and appointed to command HMAS *Harman* in charge of 400 sailors and WRANS at this shore-based radio-communications station until retirement from a service, which, no doubt, he loved. He must have made his mother and father very proud of his achievements. Whilst not involved in any conflicts to equal the Second World War, which we must thank his father's generation for winning, he was a guardian of the peace, which is as much of a worthwhile command, as they have the responsibility of maintaining the valiant efforts to bring peace fought by their forefathers and for that hard-fought peace to be maintained by his and future generations to come.

After reading *Commander Spurgeon's important and sought-after e-mail reply, I strolled into our garden, where my dear wife was attending to some of the plants and told her my news that I had received a reply from Australia. Later in the day, I passed that particular area of garden my wife had been working on and the memory returned as it reminded me of the *commander's reply e-mail. Nothing unusual in that, except as I looked at the turned soil on the garden after some gentle weeding had been carried out, I spied a coin, again not unusual in our very old garden, a soil encrusted halfpenny, which after a little cleaning, I found was dated 1948, the year of the rescue. The halfpenny coin of that period has the image of a ship, in fact, the famous *Golden Hind* in full sail, the flag ship of Sir Francis Drake, one of England's best-known sailors and a son of a preacher. Whilst I am not in any way superstitious or ever looking for 'signs' and 'meanings', it just seems a remarkable coincidence, even though nearly 27 million halfpennies were minted with this famous ship. I still have that coin.

I am also reminded that the Sunday School teacher who first came across me in the water in Weymouth Harbour was a Baptist teacher and preacher as was the commander's famous forebear, Haddon Spurgeon.

Notes

1. From this house we would watch in awe as the bridge opened then closed after letting the big ships through for repairs at Cosens shipyard. This company also owned, ran and repaired the grand fleet of Weymouth's pleasure paddle steamers. These wonderful ships had the grandest of names that very much reflected a past and now-lost empire, *Victoria, Empress, Consul, Monarch*, the *Emperor of India* and *Embassy*. They were our splashing Thomas the Tank Engines.
2. Recent reconstruction work to convert the house into a restaurant revealed that the back of the house's foundations needed underpinning.
3. Like a lot of differences that similarly came between the two sides of Weymouth and Melcombe Regis, the reasons for a dispute always seem to become lost over the mists of time, but until then, much pacing up and down would be routine in family homes on both sides of the harbour, a Melcombe Regis dad saying that no daughter of his is going to marry a low-life Weymouthian, 'the shame of it' and vice versa on the Weymouth side, substituting low-life for ne'er-do-well.
4. From a visit in 2008.
5. Dungeon is a word that has transformed itself. A Norman word, *Donjon*, meaning dungeon or 'lordly house', now, of course, known as a prison.
6. The old funnel was installed at Osminton Mills as part of its waterworks and can be seen today.
7. The Pavilion Theatre complex will be rebuilt along with many other amenities to be made ready for the 2012 Olympic Games.
8. Radipole Park Gardens name was changed to Princess Diana Memorial Gardens in 1999.
9. Coast Guard.
10. When heading back to port from Swanage, the ship could find a good course by first aligning up the mast with the green neon sign at Rossi's ice-cream parlour on the Esplanade, the gasworks' tall chimney and then a simple run into Weymouth harbour. (Very hi-tech.)
11. It is interesting how ship's bridge came into being. The very early paddle steamers were steered from the stern and it became helpful if a long board or platform could straddle the two huge paddle housings to give the captain a better view in front, in fact, a bridge was added, then open to the elements, now closed and protected.
12. Skipper Merryweather of the PS *Empress* would say that 'in the old days' they would get a few more knots of speed if the steamers raised a sail, if the wind was going in the right direction, almost of Brunelian days the

Victorian ships must have looked.

13. Mr Caddy, the ticket seller, would sell tickets to the pier visitors for the trip around the Shambles Lightship. He would stand there in his peaked cap ringing his bell shouting 'Shambles ... Shambles ... Shambles', which sounded more often than not like the Town Crier's comments as to the town's disorganisation.

14. A ponderous train so unhurried due to the fact that the lines were located in the middle of the road and the train had to contend with pedestrians as well as motor traffic.

15. 'In 1951 there were 763,941 television licences in Britain, but by 1955, there were over four and a half million television licences' all due to the ten-hour showing of the Coronation. This caused the number of televisions owned to exceed radios (source: terramedia).

16. An informer.

17. Cuckoo (clock).

18. This was named the Pavilion when it was first established.

19. Rabbits.

20. Alban Street was named after the Duke of St Alban's, one of George III's sons who had a house nearby.

21. Recorded in the epilogue.

Acknowledgements

The author would like to acknowledge his thanks to the people who have given their permission for the photographs used in this book. The credits for photographs refer to the page numbers. For pages 19, 33, 54, 110, 111, 114, 115, 159, 172, I thank Richard Clammer, author of *Cosens of Weymouth, 1918-1996* and two other books on paddle-steamers. For pages 8, 10, 48, 51, 52, 66, 86, 92, 113, 175, 194, 211 the photographs are from the author's own collection. For page 24, thanks go to *Canberra News*. The photograph on page 215 was kindly provided by *Dorset Daily Echo*.

The photograph on page 59 was supplied by Maureen Attwooll, author of *Shipwrecks*, and co-author of *Weymouth Century*, *Weymouth: An Illustrated History*, *Seaside Weymouth* and *Weymouth and Portland at War: Countdown to D-Day*, *Weymouth — The Golden Years* and *Weymouth — More Golden Years*. The photographs on pages 139 and 143 were kindly provided by Weymouth and Portland Borough Council, and on page 208 by Topham PicturePoint.

Cover front and back Cyril S. Perrier/Tom Lee.

Notes on the photographs: the author and publisher have made every effort to establish the origin or ownership of each photo used in the book and apologise if any copyright has been inadvertently infringed.